DES PLAINES PUBLIC LIBRARY

3 1468 00200 0927

P9-DDU-412

DATE DUE

DEC 1 4 1994	
APR 1 3 1995	JUG 1 9 1996
DEC 0 6 1996	DEC 3 0 1997
OCT 2 8 1996	
MAY 1 6 1997	
MAY 0 9 1998	
DEC 0 6 1999	
GAYLORD	PRINTED IN U.S.A.

GAUGUIN
AND THE IMPRESSIONISTS
AT PONT-AVEN

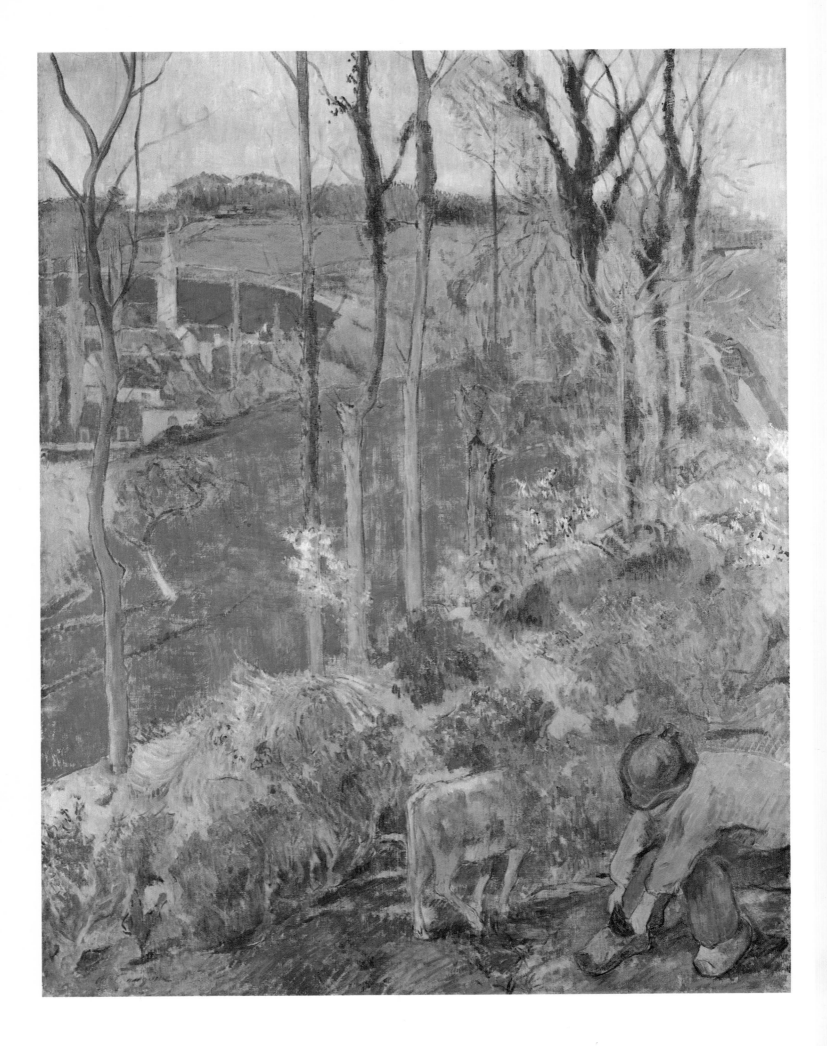

Judy Le Paul

with the **collaboration** of Charles-Guy Le Paul

GAUGUIN AND THE IMPRESSIONISTS AT PONT-AVEN

WITHDRAWN

Abbeville Press **P**ublishers New York

DES PLAINES PUBLIC LIBRARY

Frontispiece:
Paul Gauguin,
Winter, Young Breton Fixing His Shoe,
with the Village of Pont-Aven in the Background, 1888.
Oil on canvas, 35 ⅜ × 28 in.
Ny Carlsberg Glyptotek, Copenhagen.

© 1983 La Bibliothèque des Arts.
English translation © 1987 Abbeville Press, Inc.
All rights reserved under International and Pan-American Copyright Conventions.
No part of this book may be reproduced or utilized in any form or by any means,
electronic or mechanical, including photocopying, recording,
or by any information storage and retrieval system,
without permission in writing from the publisher.
Inquiries should be addressed to Abbeville Press, 488 Madison Avenue, New York, NY 10022.
Printed and bound in Switzerland.

All reproduction rights reserved by SPADEM and ADAGP, Paris.

First American edition

Library of Congress Cataloging-in-Publication Data
Le Paul, Judy.
Gauguin and the impressionists at Pont-Aven.
Translation of: L'impressionnisme dans l'école de Pont-Aven.

Authors' names in reverse order on original ed.
Bibliography: p.276
Includes index.
1. Pont-Aven school 2. Impressionism (Art) — France 3. Painting, Modern — 19th Century France. 4. Gauguin, Paul, 1848–1903 — Influence
I. Le Paul, Charles-Guy. II. Title.
ND547.5.P58L413 1987 759.4'11 87-997
ISBN 0-89659-773-3

Graphic design and technical direction: Atelier Devigne, Lausanne.

The author has chosen *not* to indicate dimensions for all works on paper such as prints, pastels, drawings, watercolors, gouaches, etc.,
as there is no generally agreed-upon standard for measuring such works.

CONTENTS

6

THE EMERGENCE OF A PROVINCE

ROMANTICISM was born during the early years of the nineteenth century as artists began to turn away from the traditional models of Classical Greece and Rome. Interested instead in historical realism and the dress, customs, and settings of the Middle Ages, this generation of Romantics set out across Europe in search of places evocative of the medieval past. This quest led artists to rediscover forgotten provinces, areas that had been ignored by civilization for reasons of geography, economics, and communication.

Brittany was one such province. It became both a home and a source of inspiration to several generations of artists. It aroused the curiosity, interest, and enthusiasm of painters, novelists, and poets, and discovery and exploration of this province contributed significantly to the history of nineteenth-century French art. Isolated at the extreme western tip of Europe, the Peninsula of Armorica discouraged visitors with the poor state of its roads, a lack of exportable wealth, a strange language, terrain that was hilly in the extreme although not mountainous,

a deep attachment to local customs, and a people whose way of life in the years 1820-1830 could only be described as archaic. Yet this anachronistic way of life was exactly what the young generation of Romantics sought. Here, a world reminiscent of the Middle Ages still existed. The first visitors to this province were writers and painters seeking motifs and subjects to support their aesthetic preconceptions rather than scenes to depict objectively. They

Eugène Isabey,
Cape Finistère and the Abbey of Saint-Matthieu, 1836, lithograph.
Private collection, Nantes.

Jules Noël,
Leaving Midnight Mass at Morlaix, 1867, oil on canvas, 45⅝ × 35 in. (detail).
Private collection, France.

Eugène Boudin, *Sailing Ship at Low Tide*, oil on canvas, 19⅝ × 24 in. Private collection, Geneva.

produced astonishing paintings of Brittany, which were exaggerated and artificial but which conformed perfectly to the aspirations of the Romantic soul.

Beginning about 1860 another generation of artists, Les Académiques, appeared in Brittany. These newcomers, well aware of the success of paintings of Breton subjects in the Paris Salons, descended upon Brittany in search of picturesque motifs. Most of these academic artists remained faithful to the aesthetics they had been taught in the Paris studios; their interest in official recognition and a chance to

exhibit in the Salons prohibited innovation. This artistic conformity of the academic artists in style, subject, and adherence to official teaching, despite a facade of anti-bourgeois daubing, paralleled the social conformity of their society and was to endure until the end of the Belle Epoque and the advent of World War I.

During the Second Empire, however, Brittany joined the process of modernization that was sweeping French society. By 1857, the railroad reached as far as Rennes. In 1863 this line was extended north to Dinan and south to Quimper, opening central

Jules Noël, *Sailing Ships at Low Tide,* oil on wood, 11¾ × 18½ in. Private collection, France.

Brittany to even greater numbers of artists and, for the first time, to tourists, including seasonal visitors. These seasonal visitors, most of whom were fairly wealthy, became an important aspect of the local economy. They were responding to a new desire in a growing industrial society to flee the cities during spring and summer and a fast-growing craze for sea bathing. There was also a great influx of foreign visitors, especially from across the Atlantic, who came to learn about art in the great centers of Europe (London, Antwerp, and Paris) and to spend two or three years journeying around the Continent. Such travel was facilitated by both the advances in shipping and the general improvements in banking techniques that occurred during this period.

The map of Brittany soon became dotted with holiday resorts, which were particularly popular with visitors in search of local color. These spots tended to be situated along the coast, where access was easier and where the charms of the sea were added to those of the countryside. Scenes of such villages appeared in the sketches and canvases that artists took back to Paris at the end of each holiday season.

Pont-Aven:
From the Picturesque to the Pictorial

Situated a few miles from Quimperlé on the Paris-Quimper railway line and several miles from Concarneau, linked to Quimperlé by a daily mail and stage coach, Pont-Aven was a particularly attractive, comfortable, and accessible spot by the decade 1860-1870. As elsewhere in Brittany, the changes produced in the course of the century gradually modified the village-like atmosphere of Pont-Aven, eliminating its prior isolation. Beginning in 1865, Pont-Aven was visited increasingly by painters of all

Eugène Boudin, *The Ty-Meur Mill at Pont-Aven*, May 1895, oil on canvas, 21 × 17⅝ in. Private collection, England. ▷

The Ty-Meur, or Simonou, mill at Pont-Aven. Last mill on the left bank before the harbor. Postcard, c. 1895. ▽

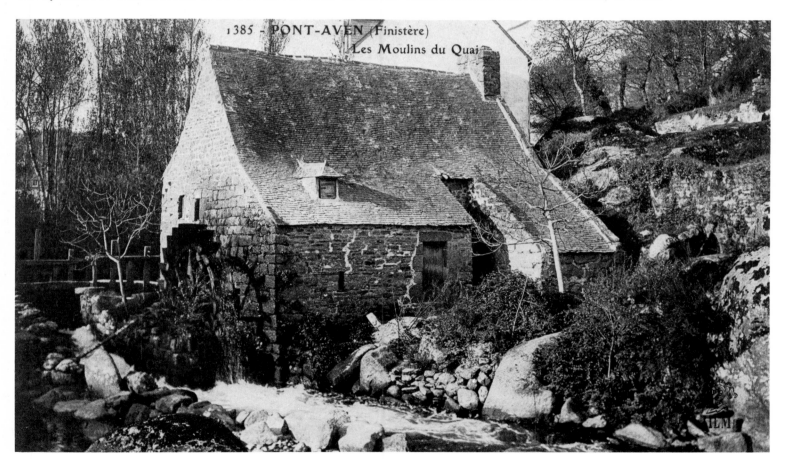

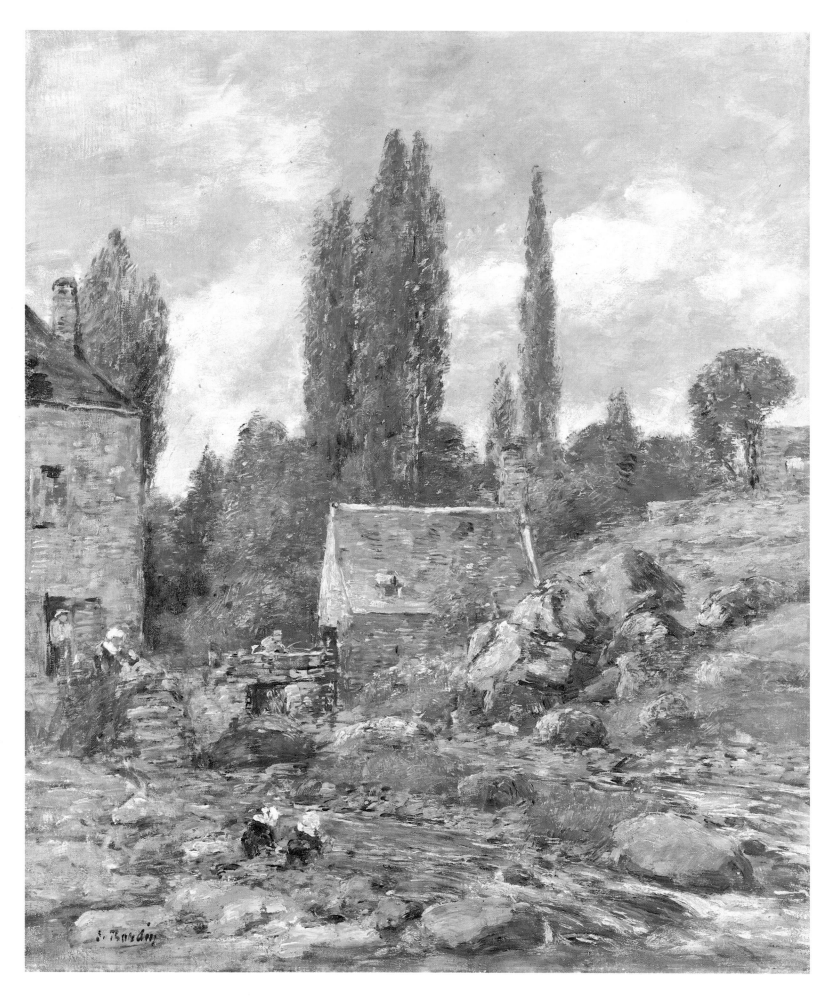

Théophile Deyrolle,
Returning from Market,
oil on canvas.
Exhibited at the Salon in 1900.
Postcard, 1901.

Clémence Molliet,
"Young Friends," or Conversation Between
Two Young Breton Girls at Pont-Aven,
on the Saint-Guénolé Mountain,
oil on canvas.
Postcard, c. 1895.

Goofroy,
Primary School in Brittany
(the girls' school at Pont-Aven), 1896, oil on canvas.
Exhibited at the Salon in 1896.
Postcard, c. 1897.

Lucien Gros,
Setting Out for Market, 1906,
oil on canvas.
Postcard, c. 1907.

nationalities. Most were guests at the four or five hotels and inns in the village, where, on some days, over a hundred painters could be found. The charm of Pont-Aven still lies in the picturesque quality of its houses and its location at the spot where the Aven is transformed from a country river into a navigable estuary.

Théophile Deyrolle,
Breton Girls Dancing,
oil on canvas.
Postcard, c. 1900.

Théophile Deyrolle,
Haymaking near Pont-Aven,
oil on canvas, 31⅞ × 45⅜ in.
Exhibited at the Salon in 1900.
Postcard, c. 1901.

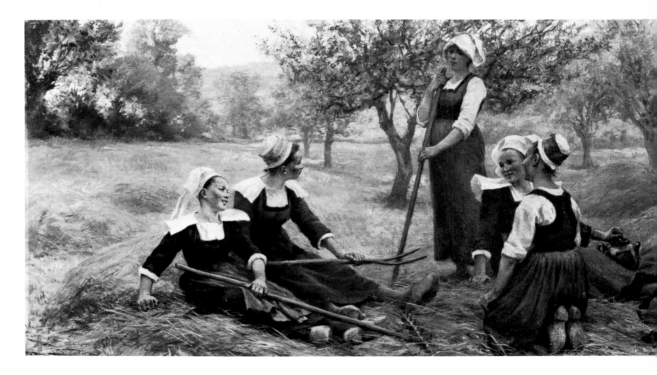

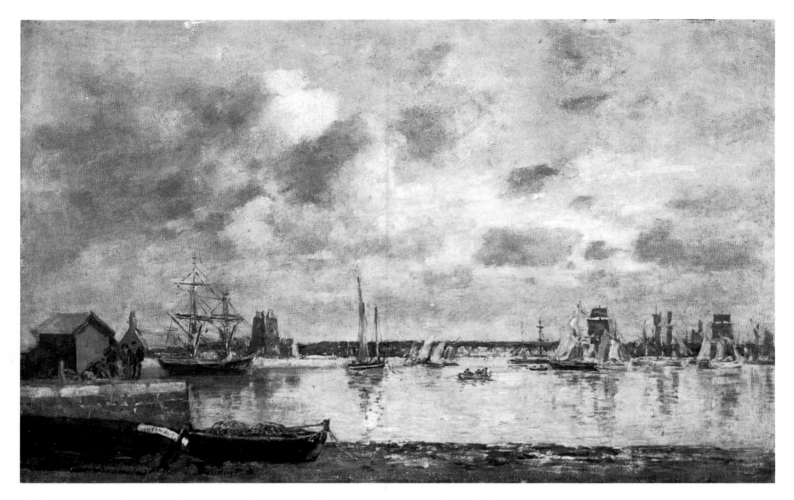

Eugène Boudin, *Camaret: Boats in the Harbor,* 1872, oil on canvas, 14¼ × 22¾ in. Private collection.

Impressionism: Revelation, Revolution

The first signs of opposition to official art appeared in Pont-Aven in the 1880s, with the arrival of the Impressionists. The Impressionists (thus named in 1874) were open-air painters, painting for pleasure and free of preconceived ideas. For them, light and color were the major considerations. They threw off the conventions of the studio. Dark colors and glazes were rejected along with anecdotal subjects. Instead, they abandoned themselves to explosions of color, painting what they saw in a rediscovered nature, far removed from mythology and folklore.

For an understanding of its significance, this movement must be placed in its historic and social context. In France at the height of the Second Empire, a new social class was rising to prominence. Financial empires were founded, technology progressed rapidly, and science was revered for all its revolutionary effects, moving France, in the course of only a few decades, from the iron age into the steel age. An atmosphere of unquestioning belief in progress prevailed. On economic and social levels, king profit was turning established values upside down. Everything seemed possible in this world, where resources seemed to be without limit and horizons boundless. The same causes produced similar effects in painting, evidenced by a series of reactions against the restrictive teachings of the academies and masters' studios. The artists who were to be called Impressionists rebelled against teaching that required them to copy and recopy the works of the

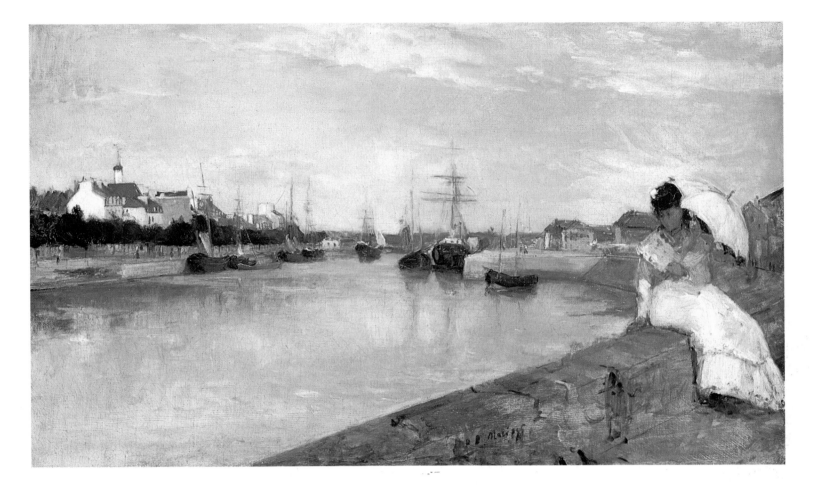

Berthe Morisot, *View of the Small Harbor of Lorient,* 1869, oil on canvas, 16⅞ × 28⅜ in.
Mrs. Ailsa Mellon-Bruce Collection, National Gallery of Art, Washington, D.C.

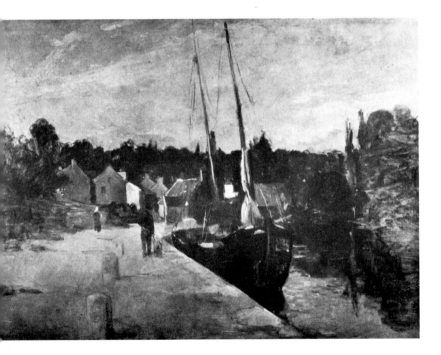

Berthe Morisot, *The Harbor of Pont-Aven,* 1866,
oil on canvas, 21⅝ × 28⅝ in.
Private collection, Paris.

old masters (Italian, Flemish, Dutch, and so on), and link Greek mythology with the legends of the Romantic era and bourgeois realism with well-meaning banalities.

This rejection of conventional teachings and the new interest in open-air landscape painting can be traced back to the end of the eighteenth century. The movement, which included the Barbizon school, continued throughout the nineteenth century, leading to the experiments in painting conducted by the Honfleur school about 1860. Johan Jongkind, Eugène Boudin, and their group can now be seen as the

15

precursors of what was to become, ten years later, the Impressionist movement.

One influence on Impressionism resulted from Claude Monet's and Charles Daubigny's visit to London in 1870, during the Franco-Prussian War. They were interested in the works of the English watercolorists and were very impressed by the large oil paintings of Joseph Mallord William Turner, such as *Sunrise in Fog*, dated 1807, *Frosty Morning* of 1813, and *Yacht Racing in the Solent* of 1827. These canvases now appear as works fifty years ahead of their time. The discovery in English painting that landscape could be treated in an extremely natural way came as a revelation to Monet and Daubigny. Viewing Turner's *Rain, Speed, and Steam*, painted in 1844, these younger painters were fascinated by Turner's ability both to place his subject in motion and to convey the way in which a moving object transforms its setting. Another decisive factor in Monet's and Daubigny's stay was a meeting with the art dealer Paul Durand-Ruel, then an exile in London, who was later to become a firm advocate of the new school. Durand-Ruel was to make Impressionism known and appreciated throughout the world, through his exhibitions both in Europe (in Paris, from 1876) and the United States (from 1886).

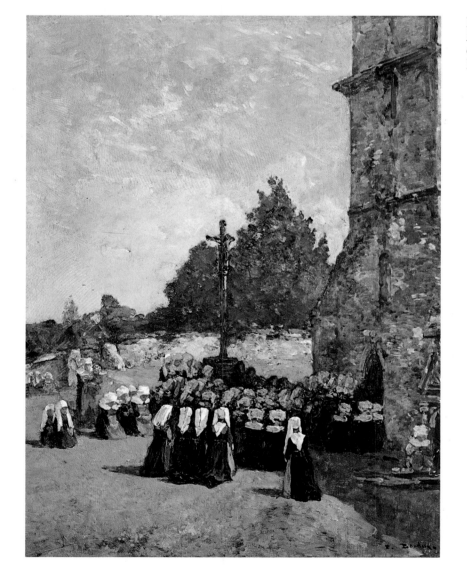

Eugène Boudin,
Pardon in Brittany, 1865-70,
oil on canvas, 16½ × 12¼ in.
Private collection.

Eugène Boudin,
Market in Brittany, 1872,
oil on canvas, 15 × 21⅜ in.
Private collection.

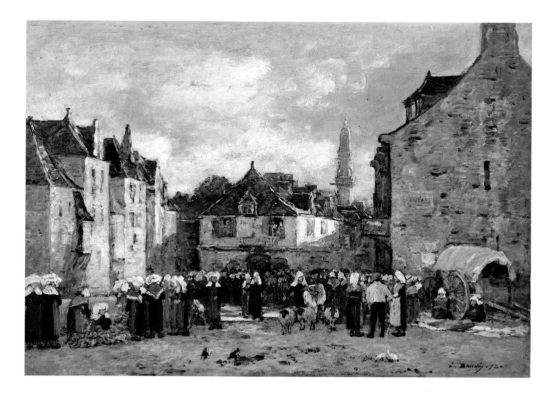

The Impressionist revolution was at first confined to a small group, including Auguste Renoir, Alfred Sisley, Claude Monet, Camille Pissarro, and Edgar Degas. However, after the first Paris exhibitions (first at Nadar's in 1874, then by Durand-Ruel in 1876, 1877, and 1879) it began to spread, attracting a number of younger painters tired of traditional teaching and interested in expanding the ideas of the Impressionist school.

In 1884 the growing schism between the new school and official art became a total one. This date marks a definitive break between the academic painters, the "Pompiers," and the innovators. When the Impressionists were excluded from the annual Salon, a specific group, which included mostly the younger Impressionists, was driven to organize an exhibition of its own at the Tuileries, under the title *Groupe des Artistes Indépendants*. It was here that Georges Seurat first exhibited his famous canvas *Bathing at Asnières*, which laid the foundations for the second chapter of Impressionism: Divisionism and Pointillism. The reverberations from this exhibition were so intense that, by the following year, the veteran Impressionist Camille Pissarro was joining ranks with his younger comrades and experimenting with the Pointillist technique himself.

1886, the Key Year: Rupture and Discovery

The Impressionist movement divided in 1886, producing two diametrically opposed styles. The first, Divisionism, exemplified by Seurat's *La Grande Jatte*, painted in 1886, was the culmination of experiments in optics. The second offshoot, Synthetism, contrasting with this analytical, scientific approach, was exemplified by Emile Bernard and his friend Louis Anquetin. They attempted to define and perfect a new form of pictorial expression, placing emphasis on the imaginative, the symbolic, and the suggestive. Thus, the year 1886 saw a schism in the original group of Impressionists. Of those painters represented at the first Impressionist group exhibition, in 1874, Paul Cézanne, Monet, Renoir, and Sisley broke away, amidst some publicity, from Degas, Armand Guillaumin, Berthe Morisot, and Pissarro (the only one of the Impressionists to have appeared in every group exhibition). This latter group was replaced by a new generation of painters, including Seurat, Paul Signac, and Claude Emile Schuffenecker in 1886.

17

Paul Gauguin, *The Derout-Lollichon Field,* 1886 (second version), oil on canvas, 28⅝ × 36¼ in. Private collection, U.S.A.

Concurrently with this split within the Impressionist group, a number of Impressionist painters converged on Brittany. At the same time that Claude Emile Schuffenecker was leaving the Etretat and Yport region to move to Concarneau, Emile Bernard, with a small allowance from his family, was discovering the beauties of the Breton coastline on foot, starting from Saint-Briac (on the recommendation of his friend Paul Signac, who had been there the previous year), and finishing at Pont-Aven. In Pont-Aven he met Paul Gauguin, another new arrival in the province. Renoir was exploring Saint-Briac during the month of August. Monet spent the months of September, October, and November at Belle-Ile-en-Mer.

The arrival in Brittany of these Impressionist painters was not pure chance. They cannot be described as hunters of images, anxious to track down the interesting anecdote. What they hoped to find in Brittany was no longer the picturesque, the curious, the bizarre, or the Romantic. For many, Brittany and its people, still immersed in Celtic tradition, represented the ideal refuge. The intense religious feeling of the Bretons exalted the mystical leanings of artists such as Emile Bernard, while the legends and folktales and the beauty of the Breton costumes fascinated and enchanted the "primitive" and "savage" side of Gauguin.

These Impressionists, each in his own personal bid for freedom, were to seek and find in Brittany a new vision, far from the industrialization, social collectivization, and intellectual positivism of a mechanical society. Turning their backs on this society, these artists were already dreaming of studios in the tropics long before they were actually to embark on their separate adventures: Martinique and then Tahiti for Gauguin, Turkey and then Egypt for Bernard.

Pierre Auguste Renoir, *Cottages in Brittany*, 1886, oil on canvas, 18⅜ × 22 in.
Private collection, London.

Synthetism and Symbolism: A Reaction Against Impressionism

Impressionism, and especially Divisionism, as developed by Seurat and Signac from the optical experiments on the colors of the prism by David Sutter, Augustin Fresnel, and Eugène Chevreul, responded to a desire for analysis and objectivity. The same interests link photography with this school of Impressionism, in which light is meant to create the same "impression" on the human retina as it creates on the photographic plate. About 1890, however, people began to question the benefits of this scientific approach. A reaction had occurred that placed greater value on imagination than knowledge, on the

spiritual rather than the temporal, on the invisible rather than the concrete. In place of perceived images and geographically specific subjects, artists substituted intuitive emotional expression, attempting to establish a form of osmosis between the individual and the universe. Thus it became necessary to invent a new pictorial language, capable of bringing together rather than dividing, of suggesting rather than describing. A style developed with more of the suggestive and evocative than the rational.

Louis Anquetin and his friend Emile Bernard had already begun to give this problem some thought in Paris. They had noted the creative possibilities evoked by Japanese prints and stained glass, in which an outline of lead emphasized monochromatic areas of colored glass. Their reasoning led them both to the theory of "suggestive color," which explains that some colors emit a feeling of warmth and others of gloom, and to the technique of cloi-

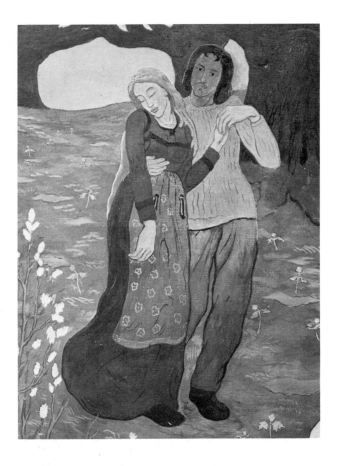

included the Pont-Aven group, was to pursue the tendency toward simplification until it reached a decorative impasse resulting in works more akin to the arts of fresco or tapestry than painting. Such was the case with the work of Paul Sérusier, Maurice Denis, and Georges Lacombe. Yet Synthetism was also to open the way for the innovations of modern art, leading through the work of the Fauves to Cubism.

Georges Lacombe,
◁ *The Ages of Life*, 1892,
oil on canvas, 59⅜ × 94⅜ in. (detail from center section).
Musée du Petit-Palais, Geneva.

Emile Bernard,
▽ *Picking Pears out of a Tree*, 1890-1892,
stained-glass window, 43⅜ × 39⅜ in. (detail).
Musée des Beaux-Arts, Lille.

sonnism, often used in Synthetist paintings. In cloisonnism, a thick blue or black line was used to outline contrasting monochromatic blocks of color chosen for their power of suggestion and combined into as simple a design as possible.

The Breton landscape and atmosphere encouraged the development of this new style. The groves of small trees that formed a dark linear border around the colored masses of Breton fields and orchards lent themselves quite naturally to cloisonnism, while the granite masses of this area suggested a universe situated outside both space and time. Legendary, archaic, mysterious, and mystical, this old Celtic country was the ideal place to shape and foster the new style.

Symbolism in the arts flourished in Europe between 1890 and 1895 in a number of forms. There were two separate currents that constituted Symbolism. The first was a development from academic painting, which often limited the artist to contradictory allegorical allusions. The second current, which

The End of an Experiment: The Return to Impressionism

A counterreaction against Symbolism soon occurred. The approach and aims of Impressionist and Neo-Impressionist painting were ideally suited for those artists who cared little for literary or religious allegory and for whom the creations of the imagination were less attractive than nature itself. As a result, even when the Synthetist experiment was at its height, there was still a strong Impressionist current in the heart of the Pont-Aven School. Although the two currents coexisted in an atmosphere of mutual tolerance, there were occasional clashes, as demonstrated by Gauguin's admonition to Schuffenecker: "Be an Impressionist to the end and don't worry about anything...." Furthermore, of those who used and developed the Synthetist style, many, including Henry Moret and Maxime Maufra, were soon to abandon it. These artists retained only a

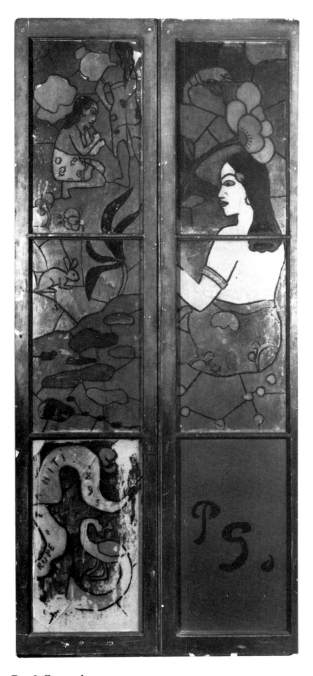

Paul Gauguin,
△ *Rupe Tahiti*, 1893,
oil on glass, 71⅜ × 28 in.
Six-paned glass door, painted by Gauguin
for his house in Tahiti.
Private collection, U.S.A.

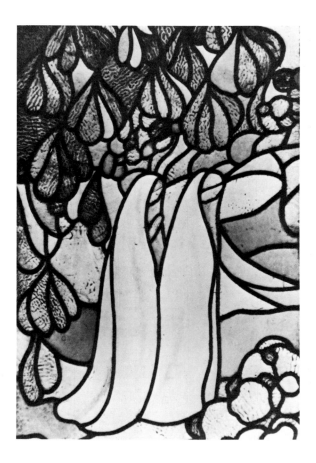

Maurice Denis,
◁ *The Road of Life*, 1895,
stained-glass window, 120⅛ × 39⅜ in. (detail).
Baron Cochin Bequest,
Musée du Prieuré, Saint-Germain-en-Laye.

21

tendency toward construction and simplification, which gave the Impressionist paintings of this period a novel character, easily recognizable by the choice of colors, layout, and structured composition. Many artists in this period did not adopt the Symbolist manner of painting. Yet even these artists could not help but be affected by this dominant trend of the late nineteenth century. Such was the case of Schuffenecker, who created a harmonious and musical form of Impressionism, Symbolist in character, and a graphic style consistent with Art Nouveau.

Just as the meeting between Gauguin and Bernard led to Synthetism, so the meeting between Gauguin and Sérusier was at the origin of the Nabi group. Sérusier was the student in charge at the Académie Julian in Paris. He was a cultivated young man with some influence over his fellow students in Paris, a group including Denis, Paul Ranson, Henri Gabriel Ibels, Lacombe, Edouard Vuillard, Pierre Bonnard, József Rippl-Ronai, Ker-Xavier Roussel, Félix Val-

lotton, and Aristide Maillol. He was also responsible for introducing them to the work of Gauguin. Sérusier's didactic approach and his ardor to persuade inspired a whole new generation of artists who, from 1890 on, made Gauguin's credo their own and followed in his footsteps, calling themselves the Nabis (from the Hebrew word for "prophet"). Even among the Nabis, however, Impressionism was to leave its mark. The traces of Impressionism are evident in the numerous canvases painted by both Denis about 1892 and Lacombe, "the Nabi sculptor," whose Symbolist canvases are not unlike those of Sérusier. About 1904, Lacombe completely rejected Synthetism in favor of a rigorous form of Divisionism similar to that of his Belgian friend, the painter Théo van Rysselberghe. Maillol also went through an Impressionist period, during which he produced such paintings as *Young Lady with a Parasol*, which appeared on the poster for the Post-Impressionist exhibition held at the Palais de Tokyo in Paris in 1977.

Georges Lacombe, *The Pond and the Little Bridge* ▷
(at the Hermitage, the Lacombe estate in Normandy), 1910, oil on canvas, 35⅞ × 25¼ in. Private collection, Paris.

Claude Monet, *Bridge in Monet's Garden*, 1895, oil on canvas, 35 × 36¼ in. Private collection.

Claude Monet and his family on the
Japanese bridge at Giverny. Photograph, 1916.

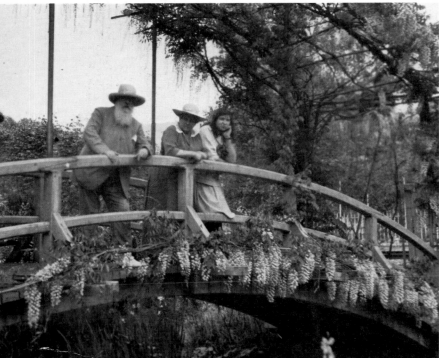

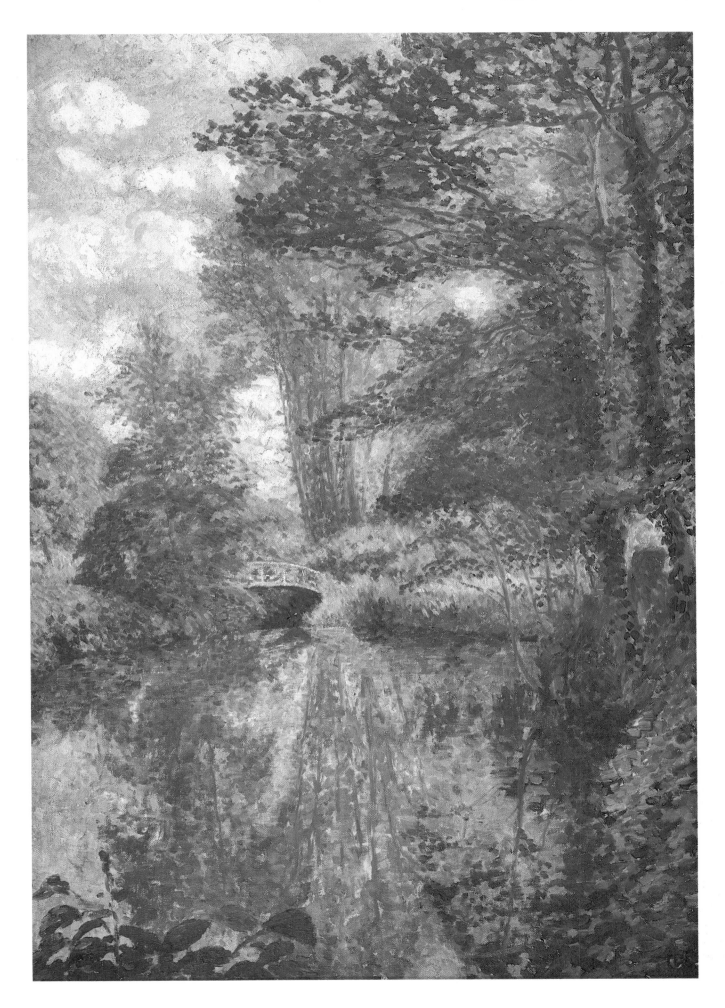

Breton Impressionism: Continuity and Divergence

In the traditional analysis of the Impressionist school, not enough attention has been given to the places in which the movement emerged and developed. The differences between the works produced in Brittany and Provence during the same period show the extent to which the distinctive Breton atmosphere affected the artists.

In Brittany, Impressionism was markedly transformed. Brittany imposes itself through the very nature of its soil, its landscape, its vegetation, its climate, and its light. The landscape consists of rolling horizons with shortened, interrupted perspectives, peppered by hills and valleys, curves and countercurves. Thousands of years of erosion have reduced the ancient Hercynian mountains to a semiplain. The rock of Brittany, the oldest in the earth's crust, exudes solidity and durability. In this ancient land, man himself appears ancient and the marks his hand has left on the landscape seem part of the natural environment: the fields bordered by tree-covered slopes, the sunken roads overhung by branches, the thatched granite cottages scarcely distinguishable from the rocks around them. Gauguin wrote to Schuffenecker in a famous letter dated 1888: "I love Brittany. It is here I find the wilderness, the primitive. When my wooden shoes resonate on the granite ground, I hear a haunting sound, muted and strong, that I search for in painting."

If elsewhere nature has been conquered by man, here the situation is reversed. Nature in Brittany, by sea or land, has created man in its own image — robust, patient, resolute — and has imprinted the same qualities and restraints on his every gesture and artifact. These characteristics were communicated to the Impressionist painters, giving their works a character at the same time savage and gentle, nostalgic and durable. These seeming contradictions give Breton Impressionism, particularly that of the Pont-Aven school, its special individuality.

Henry Moret, *The Entrance to Port-Tudy, Ile de Groix,* 1907, oil on canvas, 25⅝ × 31⅞ in.
Private collection, London.

24

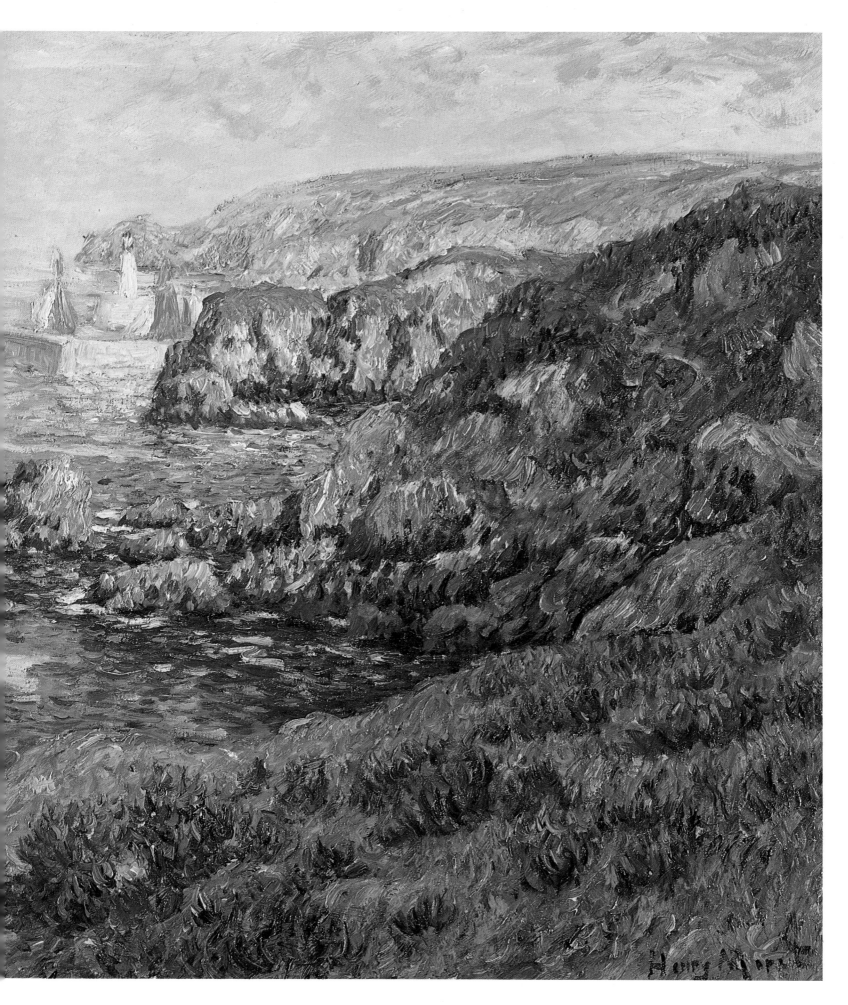

Maxime Maufra,
The Village of Locronan (Finistère), 1898,
oil on canvas, 31⅞ × 39⅜ in.
Private collection, France.

Gustave Loiseau,
The Church of Saint Herbot
(near Le Huelgoat, Finistère), 1903,
oil on canvas, 25⅝ × 31⅞ in.
Private collection, Geneva.

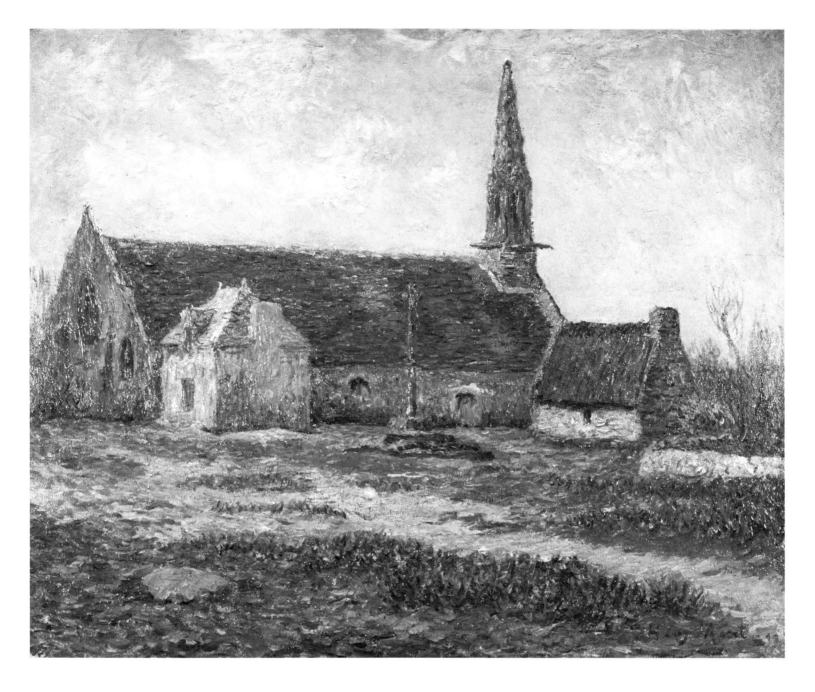

Henry Moret,
△ *The Chapel of Saint-Philibert-en-Trègunc*
(near Pont-Aven), 1899,
oil on canvas, 30⅝ × 36¼ in.
Private collection, France.

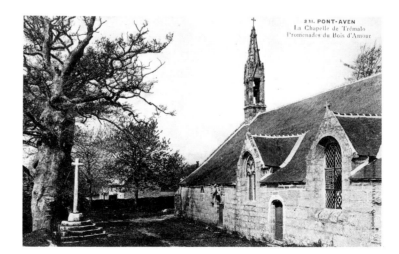

The chapel of Trémalo and its cross (near Pont-Aven). ▷
Postcard, c. 1895.

27

Pont-Aven, general view of the west side, seen from the hills toward Lezaven.
In the background, the beech alleys of the Bois d'Amour. Postcard, c. 1900.

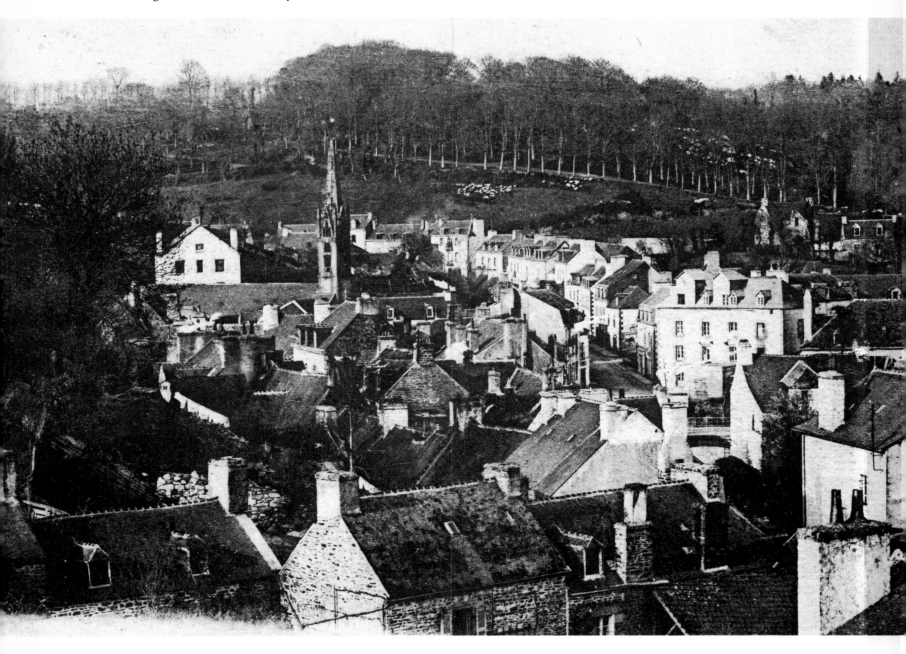

PONT-AVEN IN GAUGUIN'S TIME

FOR a detailed study of the Pont-Aven school, a knowledge of both the physical and social nature of the village is exceptionally helpful. Often such information has been omitted in books on this subject. Thus a map of the village and surrounding area in 1886 (illus., p. 63) and a chapter describing painters' living and working conditions in Pont-Aven during this time have been included.[1]

Photographs and postcards of the area at a slightly later date show the river, the harbor, and the mills, along with the village of Pont-Aven itself. Since this area scarcely changed in the ensuing years, the sum of these documents creates an accurate picture of both the town and the artists' colony established there in the time of Gauguin.[2]

Emile Bernard, *Pont-Aven Seen from the Heights of the Bois d'Amour,* 1892, oil on canvas, 28⅝ × 36¼ in. Samuel Josefowitz Collection, Lausanne.

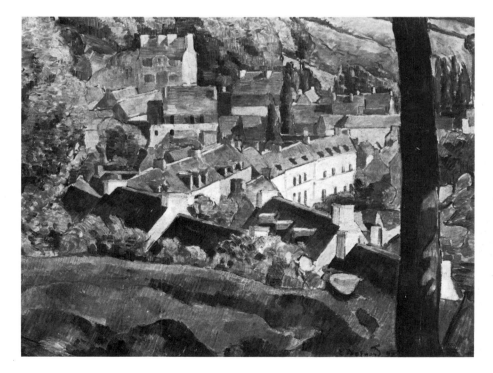

Pont-Aven, north side, general view from the hills toward Lezaven. In the background, Mount Sainte-Marguerite. Photograph, 1890.

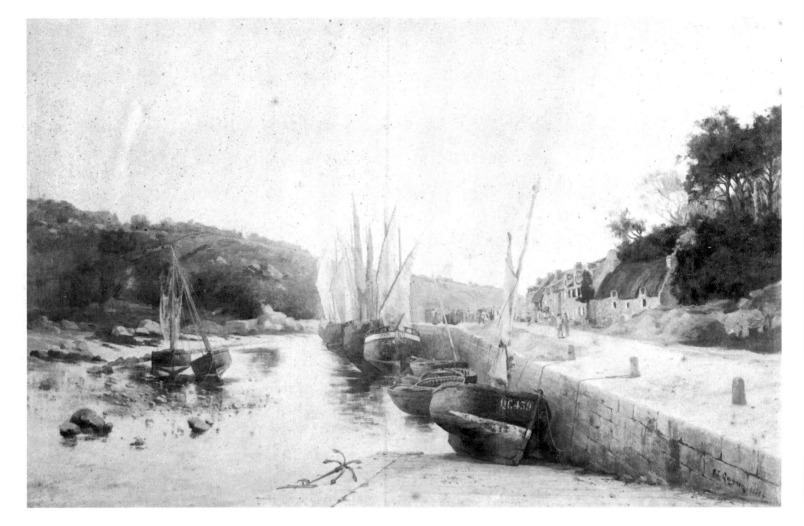

Fernand Just Quignon, *The Harbor and Quays at Pont-Aven*, 1884, oil on canvas, 23⅝ × 31⅞ in.
Exhibited at the Salon of 1884. Old photograph, signed and dedicated "to his old friend Schuffenecker."

The harbor and quays of Pont-Aven.
View from the left bank at high tide.
Postcard, c. 1895.

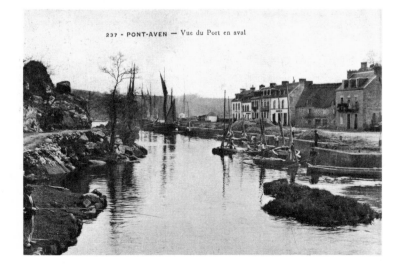

When in Pont-Aven, Gauguin stayed either at the Pension Gloanec, situated at the narrow end of the square on the rue du Pont, or at the Lezaven manor house on Bel-Air hill, where he had a studio in 1889 and 1894. An analysis of the works that Gauguin painted during successive visits to Pont-Aven[3] shows that in his attempts to find scenes to paint he rarely strayed farther than three hundred yards from the place where he was staying. All of his Pont-Aven canvases, with a few rare exceptions when he wandered farther afield, depict this circumscribed geographical area.

An important obstacle is encountered in attempting to define and reconstruct this area. The landscape has been completely transformed as the town has grown extensively during the past fifty years or

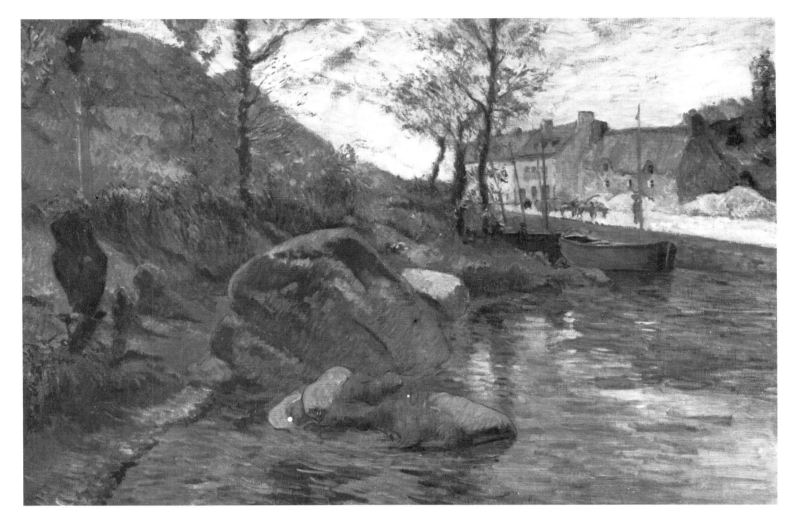

Paul Gauguin, *The Harbor and Quays of Pont-Aven* (painted from the left bank near the Gargantua rock), 1888, oil on canvas, 28⅝ × 36¼ in. Private collection, Switzerland.

so. Now a valley with wooded hillsides, Pont-Aven was at that time a confusion of granite slabs in a torrent of water, enclosed by bare and rocky hills. This change has come about due to a significant alteration in the way of life of the native people. Whereas timber was traditionally cut for various purposes, wood has been replaced by other fuels. From the 1920s onward, felling of trees ceased. In addition, since the end of the last century the owners of holiday villas, either on the then deserted coast or farther inland, have planted trees both to provide protection from the fierce west wind and to create parks and pleasant walks.[4] During this time, most of the large cypresses and vast pine woods that now dot the coastline were planted, like those at Port-Manech, Kerfany, and Le Cabellou.

The harbor and quays of Pont-Aven.
View from the left bank at low tide.
Postcard, c. 1895.

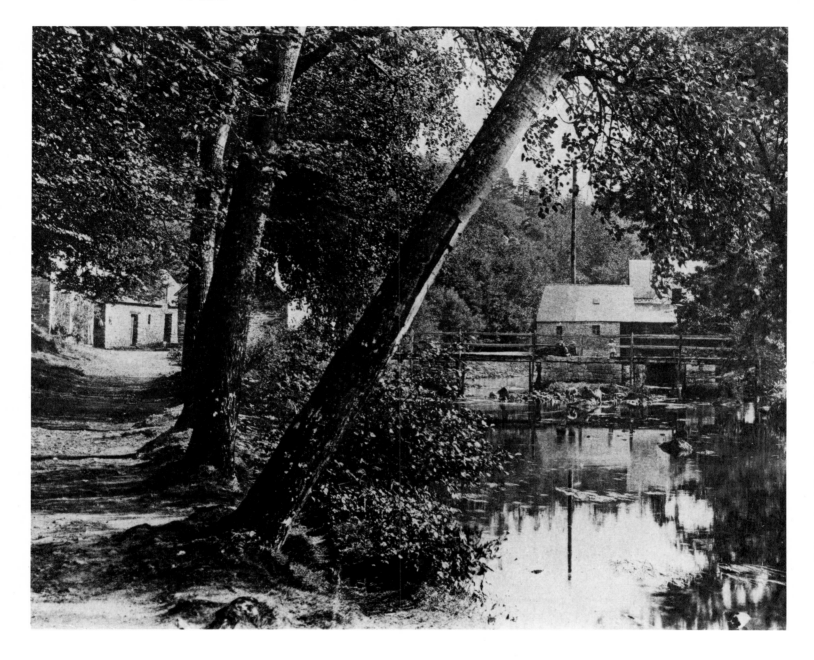

The Moulin Neuf in the Bois d'Amour, seen from downstream.
Postcard, c. 1900.

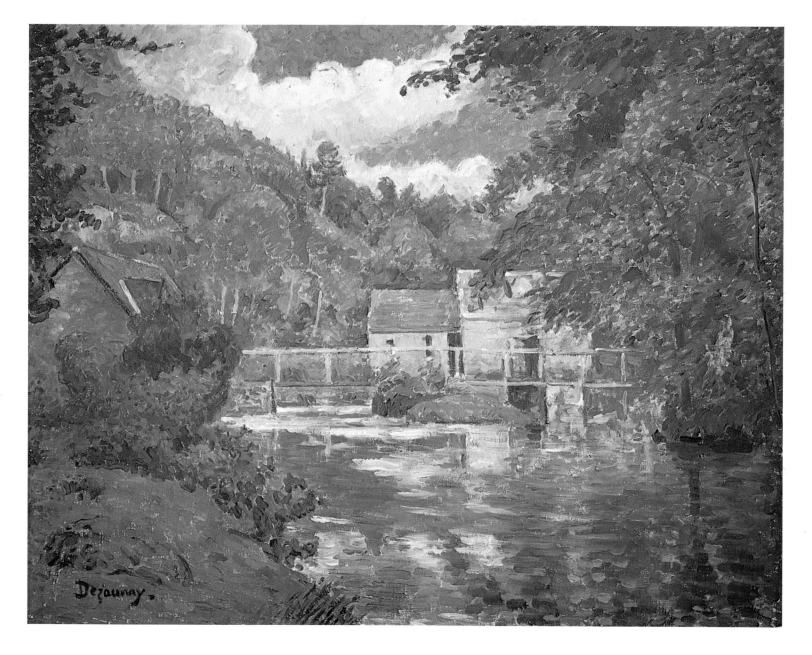

Emile Dezaunay, *The Moulin Neuf in the Bois d'Amour, Seen from Downstream,* c. 1900, oil on canvas, 28⅝ × 36¼ in.
Private collection, France.

As a result, a comparison of the present state of the area with old photographs is quite astonishing. When vegetation was left to grow unchecked and trees were no longer felled or mutilated, the ground soon became overgrown. Masking the ground and its contours, this vegetation has not only completely changed the look of Pont-Aven physically, but it has even altered the quality of the atmosphere, eliminating much of its ancient austerity and savagery. In addition, the wide expanses of heath, which were once an indispensable source of fuel, fodder, and stable litter, have been churned up by agricultural machinery. Today farmers are using land traditionally considered impossible to exploit. Thus, the landscape has become almost unrecognizable compared with a century ago.[5]

An Artistic Tour in Brittany,
title page of the book by Henry Blackburn, 1880.
Illustrated with 170 drawings by Randolph Caldecott,
executed in Pont-Aven and elsewhere in Brittany in 1879.

Breton Folk

AN ARTISTIC TOUR IN BRITTANY

BY

HENRY BLACKBURN.

WITH ONE HUNDRED AND SEVENTY ILLUSTRATIONS BY

R. CALDECOTT.

THIRD THOUSAND.

Young girl wearing a Pont-Aven bonnet. Postcard, c. 1895.

Early Descriptions

Long before the arrival of Gauguin, travelers were jotting down their impressions and publishing accounts of Pont-Aven. Between 1860 and 1914, this little village became one of France's main tourist centers and one of the most visited towns in Brittany. Cambry's description of Pont-Aven, written in 1794 during a journey through Finistère,[6] demonstrates this enthusiasm almost a century before similar words were written by members of the Pont-Aven school:

The commune that goes by this name lies five-quarter leagues [about 4 miles] from the coast.

34

Little girl of Pont-Aven. Postcard, c. 1895.

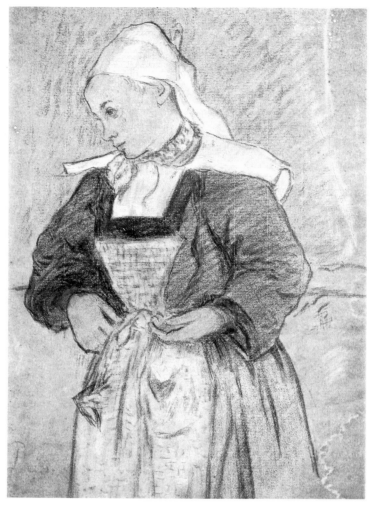

Paul Gauguin, *Breton Girl from Pont-Aven*, 1886, pastel. Private collection, U.S.A.

This little seaport is the most capricious of resorts, if you will pardon this Italian expression. It is situated in the water, on the rocks, at the foot of two lofty hills, scattered with enormous weathered blocks of granite, which look as if they might come crashing down at any moment. They serve as gable ends for the cottages, as walls for the small gardens. These rocks, which have fallen from the mountain, obstruct the course of the river, which leaps over so many obstacles. The mills on the riverbanks make use of them to support the axles of the mill wheels. They are linked by wooden bridges. The hillsides around are wooded, uniquely varied, an extraordinary sight. The noise of the water, the rush of twenty water-falls deafens the visitor like the fullers' mills in Don Quixote, *like the waterfalls of Switzerland and Savoy....*

Pont-Aven headdresses. Postcard, c. 1910.

140 Coiffe de PONT-AVEN

35

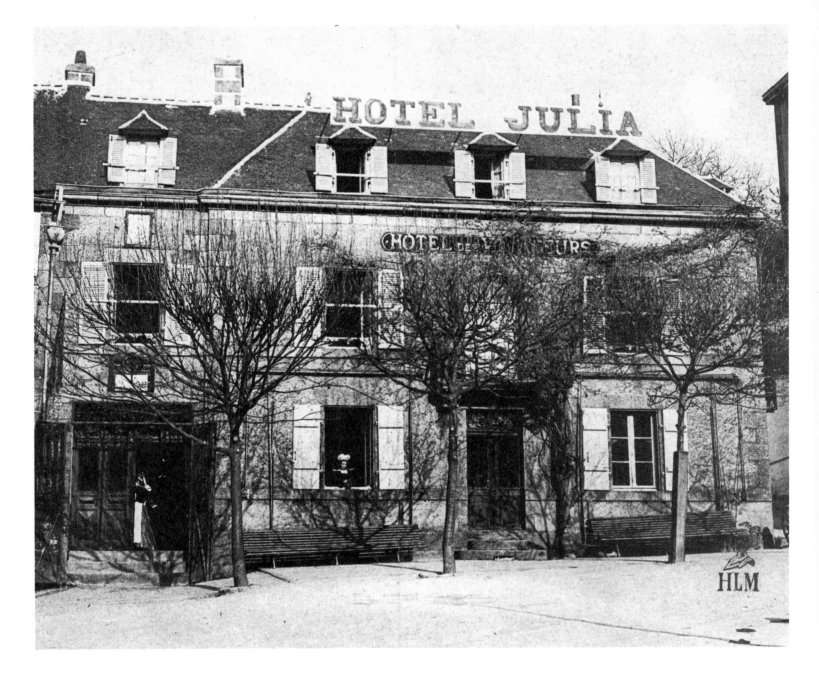

Facade of the Hôtel Julia, Pont-Aven.
Postcard, c. 1910.

Sensitive to the picturesque quality of this charming spot, Cambry seemed to foresee its future. He continued:

> The environs of Pont-Aven, the town especially, could provide a hundred bizarre subjects for the sketcher who chose to study it. From citizen Aumont's yard [on the right bank where the quay stands today] one can look out on twenty unimaginable scenes. In the yard itself one can see a large rock, eaten away by the constant movement

of rain water to form a hollow three feet deep and four feet across.

Half a century later, about 1850, the first painters arrived at Pont-Aven. Thus began a period of artistic activity and tourism that was to last until the First World War. As is demonstrated by the great number of guidebooks and accounts of tours that they published, the English were extremely enthusiastic about Brittany.[7] One English tourist, Henry Blackburn, described Pont-Aven about 1879 in eloquent and detailed terms. His guidebook, *Breton Folk, An Artistic Tour in Brittany*, was published in London in 1880. The 170 accurate illustrations that accompa-

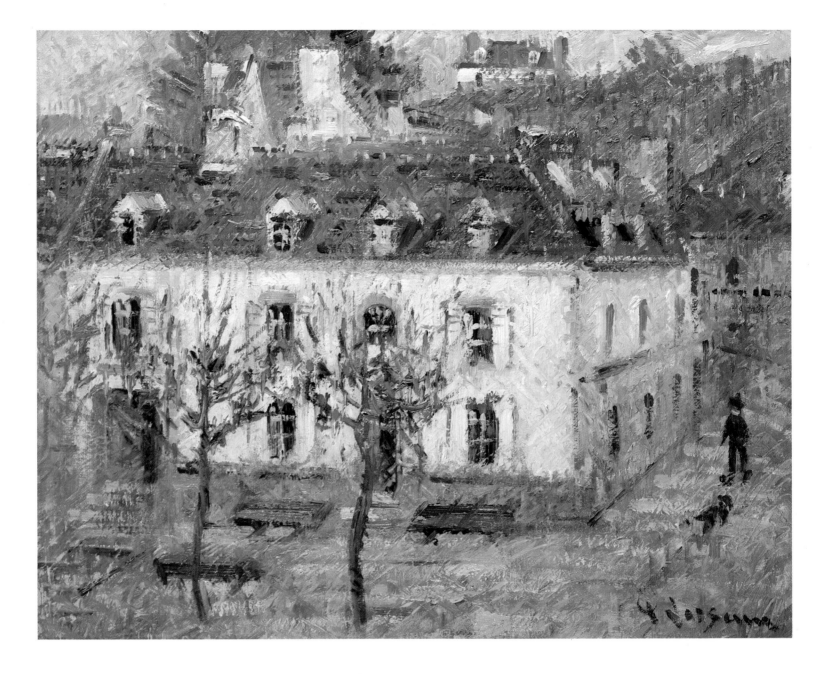

Gustave Loiseau, *The Hôtel Julia at Pont-Aven*, oil on canvas, 21⅜ × 25⅝ in.
Oscar Ghez Collection, Musée du Petit-Palais, Geneva.

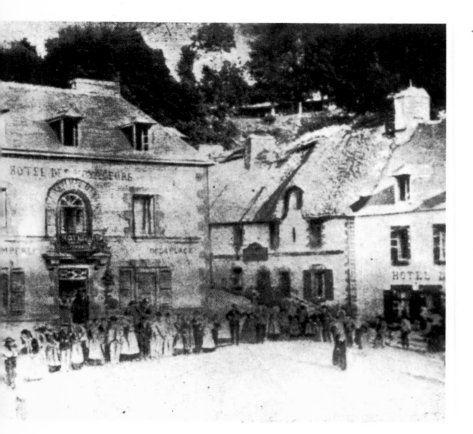

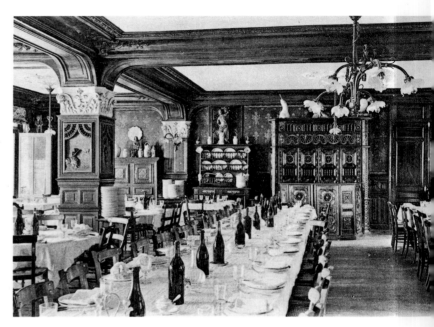

◁ *Southeast corner of the main square in Pont-Aven, 1871. On the left is the Hôtel des Voyageurs (the future Hôtel Julia); on the right the Hôtel du Lion d'Or (now the Hôtel des Ajoncs d'Or). Photograph, 1871.*

△ *The large dining room in the Hôtel Julia annex (now the town hall). Postcard, c. 1910.*

ny the text were drawn in a charming and humorous manner by Randolph Caldecott.[8] Blackburn describes the feelings of an artist discovering Pont-Aven for the first time around 1880:

> At a point where the River Aven, breaking through its narrow channel, dashing under bridges and turning numerous water-wheels spreads out into a broad estuary, is the little port of Pont-Aven, built four miles from the sea. The majority of the houses are of granite, and sheltered under wooded hills; the water rushes past flour-mills and under bridges with perpetual noise, and a breeze stirs the poplar trees that line its banks on the calmest day. The widest part of the village is the Place, sketched [looking northward] from the stone bridge which gives Pont-Aven its name. A small community of farmers, millers, fishermen and peasant-women, is its native population, supplemented in summer by a considerable foreign element.
>
> Pont-Aven is a favorite spot for artists, and a terra incognita to the majority of travellers in Brittany. Here the art student, who has spent the winter in the Quartier Latin in Paris,[9] comes when the leaves are green, and settles down for the summer to study undisturbed. How far he succeeds depends upon himself; his surroundings are delightful, and everything he needs is to be obtained in an easy way that will sound romantic and impossible in 1879. Pont-Aven being set in a valley between two thickly wooded hills, opening out southwards to the sea, the climate is temperate and favorable to out-door work. In the center of the village is a little triangular Place, and at the broad end, facing the sun, is the principal inn, the

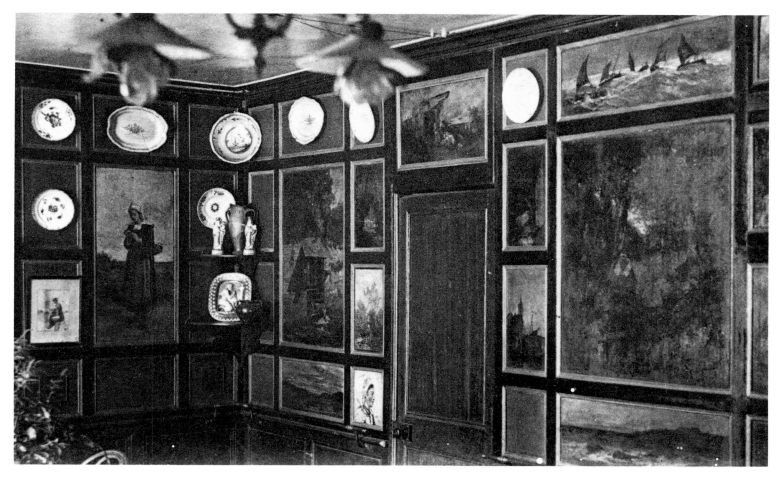

Dining room of the Hôtel Julia.
The wooden paneling is covered with paintings by the artists staying at the pension. Postcard, c. 1890.

Hôtel des Voyageurs, which, at the time of writing, has an excellent hostess, who takes pensionnaires for about five francs a day, tout compris, and where the living is as good and plentiful as can be desired. This popular hostelry is principally supported by American artists, some of whom have lived here all through the year;[10] but many English and French painters have stayed at Pont-Aven and have left contributions in the shape of oil paintings on the panels of the salle à manger.[11]

We have mentioned the Hôtel des Voyageurs; but there are other inns; there is the Hôtel du Lion d'Or, also on the Place, frequented principally by French artists and travellers; and down by the bridge, a quaint little auberge (with a signboard painted by one of the inmates), the Pension Gloanec. This is the true Bohemian home of Pont-Aven, where living is even more moderate than at the inns. Here the panels of the rooms are also decorated with works of art, and here, in the evening and in morning, seated round a table in the road, dressed in the easy bourgeois fashion of the country, may be seen artists whose names we need not print, but many of whose works are known over the world. At Pont-Aven the presiding genius at the Hôtel des Voyageurs is one Mademoiselle Julia Guillou.[12] At this little inn, as at the Hôtel du Commerce at Douarnenez, the traveller need not be surprised to find that the conversation at table is of the Paris Salon, to find bedrooms and lofts turned into studios, and a pervading smell of oil paint. It is said of Pont-Aven that it is "the only spot in Europe where Americans are content to live all the year round"; but perhaps the kind face and almost motherly

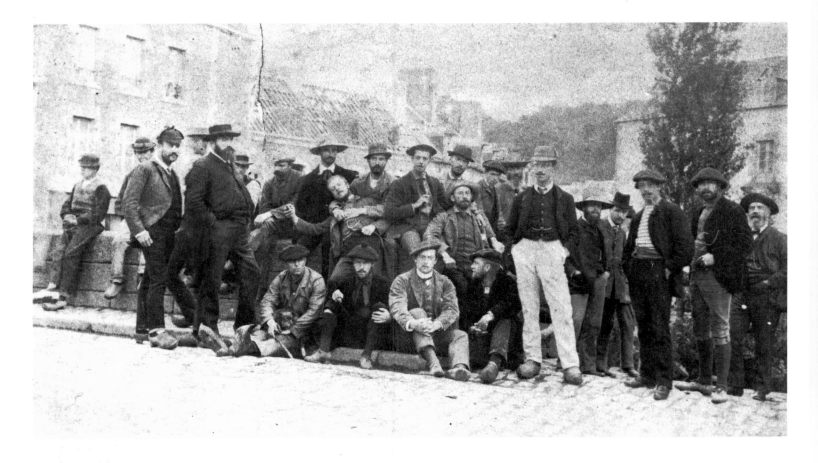

△ A group of painters on the bridge at Pont-Aven.
Photograph, c. 1890.
Bibliothèque des Arts Archives.

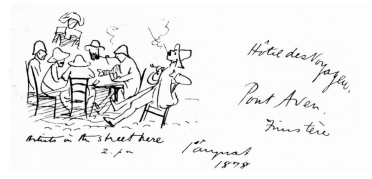

◁ Artists Sitting Outside the Hôtel des Voyageurs, August 1878.
Sketch by Randolph Caldecott.

care of her pensionnaires by the portly young hostess, Mademoiselle Julia Guillou, has something to do with their content.

The views in the neighbourhood of Pont-Aven are beautiful, and the cool avenues of beeches and chestnut trees, a distinctive feature of the country, extend for miles. From one of these avenues, on the high ground leading to an ancient chapel, there is a view over the village where we can trace the windings of the river far away towards the sea, and where the white sails of the fishing-boats seem to pass between the trees.[13] The sides of the valleys are grey with rocks, and

the fields slope steeply down to the slate roofs of the cottages built by the streams, where women, young and old, beautiful and the reverse, may be seen washing amongst the stones.

Pont-Aven has one advantage over other places in Brittany; its inhabitants in their picturesque costume (which remains unaltered) have learned that to sit as a model is a pleasant and lucrative profession, and they do this for a small fee without hesitation or mauvaise honte. This is a point of great importance to the artist, and one which some may be glad to learn through these pages. The peasants, both men and women, are glad to

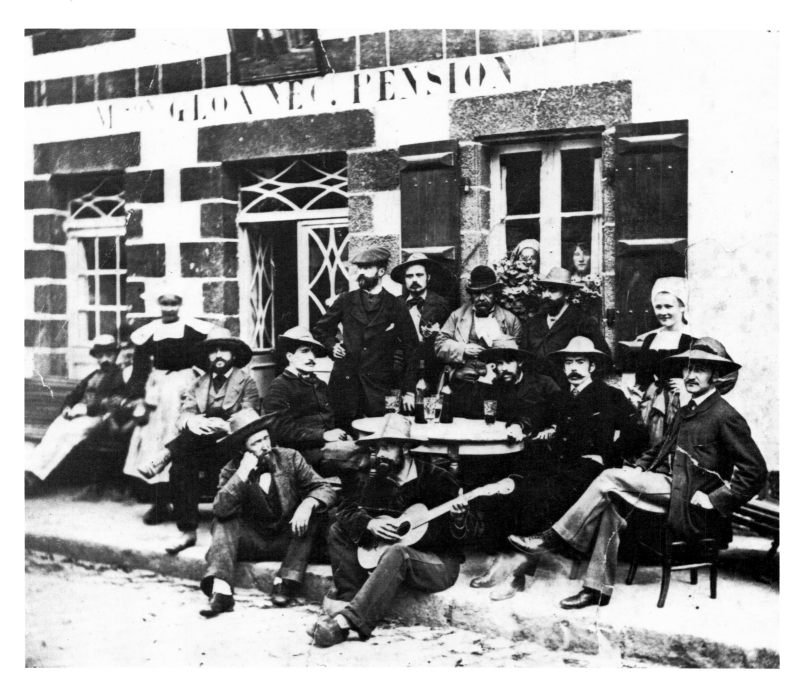

American artists Thomas Hovenden, Alexander Harrison, William Lamb Picknell, Samuel Conquest, and Somersett,
in front of the Pension Gloanec.
Photograph, c. 1876.
David Sellin Archives, Washington, D.C.

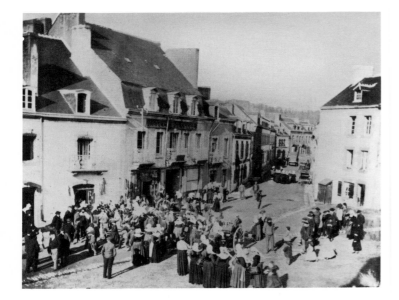

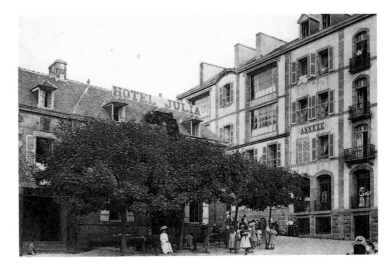

△ *The Hôtel Julia and its annex. Postcard, c. 1905.*

Pont-Aven: corner of the main square and the rue du Gac. △
On the left, the Hôtel de Bretagne and its Café des Arts.
Photograph, c. 1900.

Marie-Jeanne Gloanec with her servants. ▷
Photograph taken in the yard of the pension, c. 1876.
David Sellin Archives, Washington, D.C.

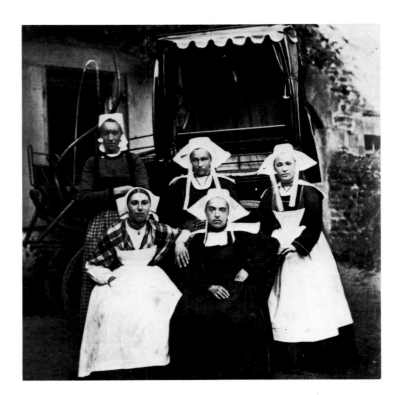

sit for a franc for the greater part of a day; it is only at harvest time, when field laborers are scarce, that the demand may be greater than the supply, and recruits have to be found in the neighbouring fishing villages. Once or twice a week in the summer, a beauty comes over from Concarneau in a cart, her face radiant in the sunshine, the white lappets of her cap flying in the wind.[14] Add to these opportunities for the study of peasant life and costume the variety of scenery, and the brightness and warmth of color infused into everything under a more southern sun than England, and it will be seen that there are advantages here not to be overlooked by the painter.

There is little that can be added to Blackburn's description of the area. All that remains to be done is to draw a map of the town and its immediate neigh-borhood, with names in use at the time, footpaths that have now disappeared, indicating exact distances as well as geographical contours. Since there are no maps in the public registry published between those of 1832[15] and 1957, reliance has been placed upon documents and notes to construct an intermediary map for 1886. The finished map emphasizes specific locations where a certain canvas was painted or a particular meeting between artists took place.

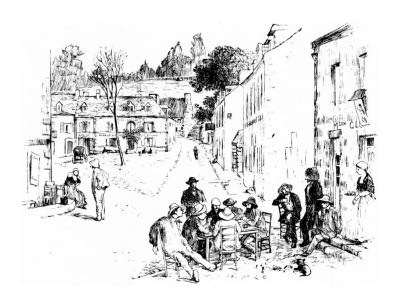

△ *The square in Pont-Aven, view from the bridge.*
At the front right is the Pension Gloanec.
Photograph, c. 1876.
David Sellin Archives, Washington, D.C.

◁ *Artists Sitting Outside the Pension Gloanec;*
Panoramic View of the Town Square in Pont-Aven, in 1879.
In the background, the Hôtel des Voyageurs.
Drawing by Randolph Caldecott.

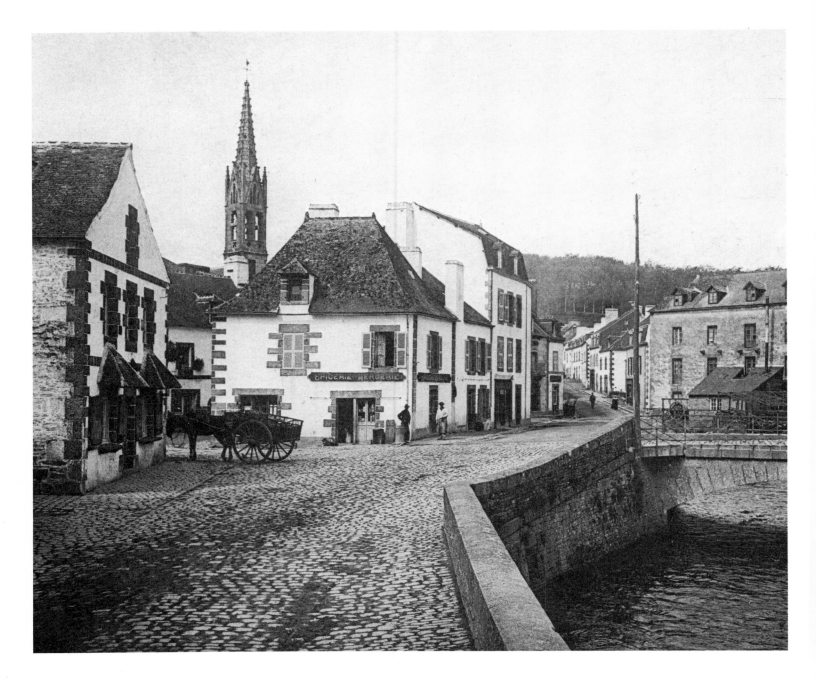

The bridge and the church tower in Pont-Aven. View from the rue Neuve-du-Quai. Postcard, c. 1895.

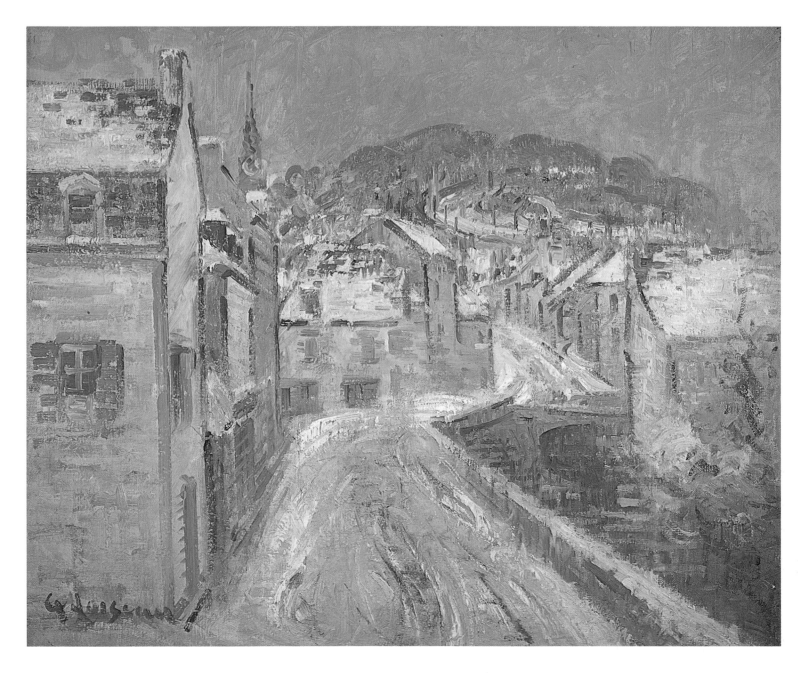

Gustave Loiseau, *Pont-Aven in the Snow*, oil on canvas, 19⅝ × 24 in. Private collection, France.

1

2

First Visit, First Contact: The Arrival of Paul Gauguin

Gauguin began debating about going to Brittany in May 1886 and was probably persuaded to do so by a family of artists, the Jobbés. As regular visitors to Pont-Aven, they were able to recommend the little village for its low cost of living, since they were not much wealthier than Gauguin.[16] In May 1886, Gauguin wrote from Paris to his wife, Mette, who was living with her parents in Denmark: "I have given notice, and next month I'll have nowhere to live. The best thing would be to go off to a pension in Brittany for 60 francs a month." He continued, "I'd love to do

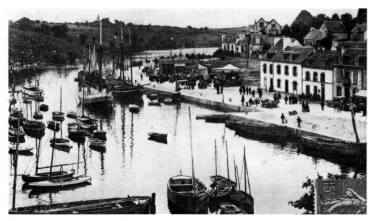

3

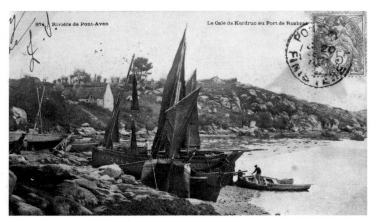

4

1 *Pont-Aven: the harbor with boats tied up to the Gargantua rock.*
Postcard, c. 1895.

2 *Pont-Aven: the harbor, the left bank bare of trees, and the bay of Bas-Bourgneuf.*
View from the quays on the right bank.
Postcard, c. 1903.

3 *Pont-Aven: The harbor, the quays, and the promenade on the right bank.* View from the left bank.
Postcard, c. 1900.

4 *The harbor of Kerdruc on the Aven.*
Postcard, c. 1890.

5 *The harbor of Rosbras, opposite Kerdruc on the Aven.*
Postcard, c. 1895.

5

a few paintings in Brittany."[17] Raising the necessary money for the ticket and meals between Paris and Quimperlé, however, seemed impossible. At the beginning of June, the day before he was to leave his lodgings, he wrote: "I am going to pick up my things next Thursday, the twelfth of the month, and I can't say where I'll be after that, as I have nowhere to go.... I wanted to go to Brittany, where I can paint cheaply but I can't get together the money to pay for lodging."[18] Fortunately, Gauguin was able to borrow the money he needed, and he finally set off on Friday, June 27, 1886, for Quimperlé. Just before he left, he wrote a short note to Félix Bracquemond, in which he said: "I am leaving Paris on Friday evening and I'm going to paint in a real hole."[19]

The train from Lorient left Paris the preceding evening and arrived at the Quimperlé station at

10

9

8

6 *The castle of Poulguen on the Aven (fifteenth century).*
 Postcard, c. 1900.

7 *Port-Manech, at the mouth of the Aven, and its flotilla of fishing boats at low tide.*
 Postcard, c. 1895.

8 *The mouth of the Aven at Port-Manech, seen from the Saint-Nicolas beach.*
 Postcard, c. 1900.

9 *The lighthouse and cliffs at Port-Manech, overlooking the sea.*
 Kerfany-les-Pins is in the background.
 Postcard, c. 1895.

10 *The wild, bare coastline at the mouth of the Aven and Belon.*
 Postcard, c. 1895.

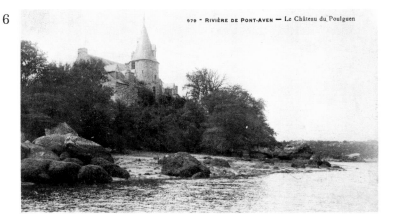

6

979 - RIVIÈRE DE PONT-AVEN — Le Château du Poulguen

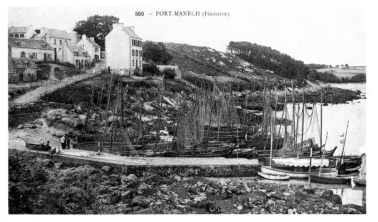

560 -- PORT-MANECH (Finistère).

7

The Ty-Meur mill at Pont-Aven, near the harbor. Postcard, c. 1905.

Adolphe Marie Beaufrère,
The Ty-Meur Mill, 1908,
watercolor.
G. Dudensing Collection, U.S.A.

12:09 PM. Passengers from that train had to wait for the last train of the day to arrive at Quimperlé, at 6:24 PM, before taking the connection to Pont-Aven.[20] This cart, pulled by four horses, transported passengers, mail, and deliveries twice a day between Pont-Aven and Quimperlé.

It was probably about eight o'clock on the evening of Saturday, June 28, 1886, after a one-and-a-half-hour journey that Gauguin arrived for the first time in Pont-Aven. The road toward Pont-Aven led over the nine hilly miles from Quimperlé along the old Riec road through Baye and Riec. An extremely steep hill, the Côte de Toullifo, brought the cart into the square at Pont-Aven, halting in front of the Hôtel

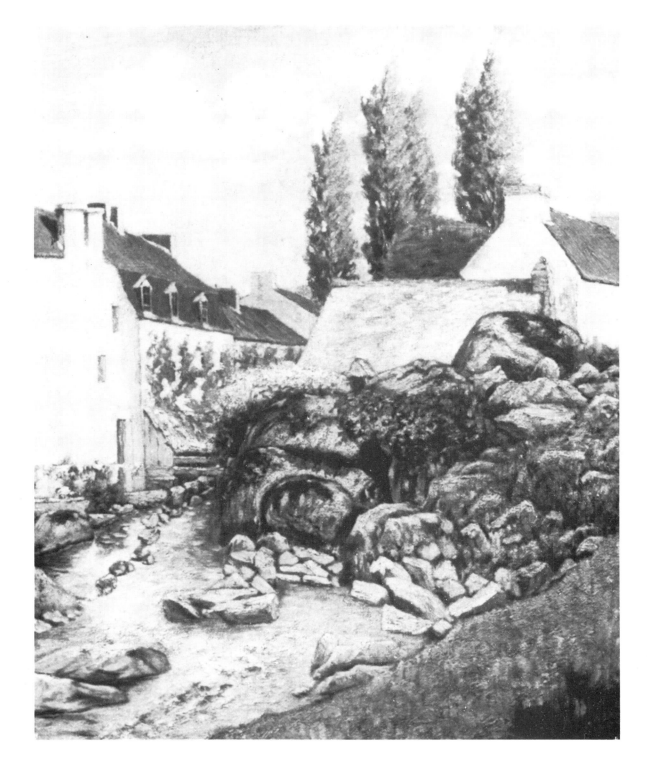

Ernest Ponthier de Chamaillard,
The Ty-Meur Mill at Pont-Aven, 1889,
oil on canvas, 20½ × 16½ in.
Musée des Beaux-Arts, Quimper.

The Ty-Meur mill at Pont-Aven. View from upstream. Postcard, c. 1890.

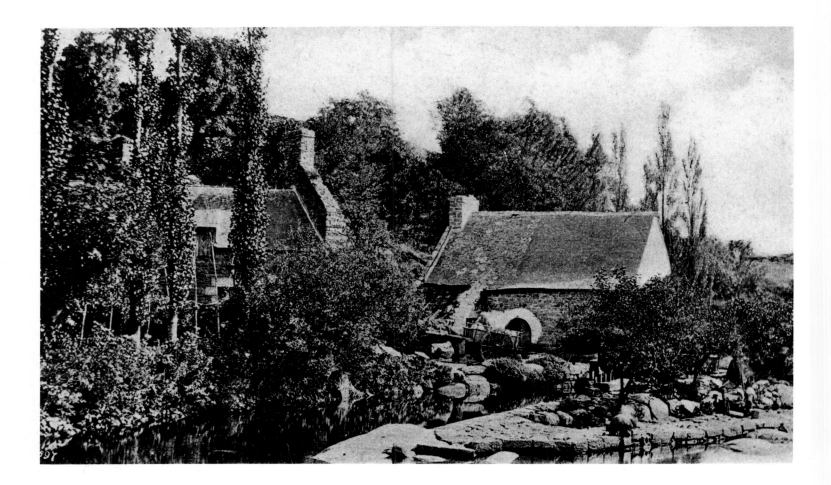

des Voyageurs. Turning his back on this "chic," more expensive pension and making his way past the Hôtel du Lion d'Or, the covered market that has now disappeared, and the ancient town hall with its small belfry,[21] Gauguin headed toward a modest pension set slightly back from the bridge at the bottom of the square.[22]

Owned by the widow Marie-Jeanne Gloanec and her son Armand, this pension, opened by Joseph Gloanec in 1842, had been taking in artists since 1863.[23] In addition to providing artists with board and lodging, Madame Gloanec was also willing to extend credit. As a result, the establishment enjoyed popularity out of proportion to its modest size. The pension was so small that many of its *pensionnaires* had a room in the village and only took their meals there.

Soon after his arrival at Pension Gloanec, Gauguin wrote to his wife to inform her of his whereabouts:

> Gauguin, painter
> M^me Gloanec's
> Pont-Aven (Finistère)

"I finally got the money for my journey to Brittany and am living here on credit."[24] For Gauguin, totally penniless and alone, this last point was of prime

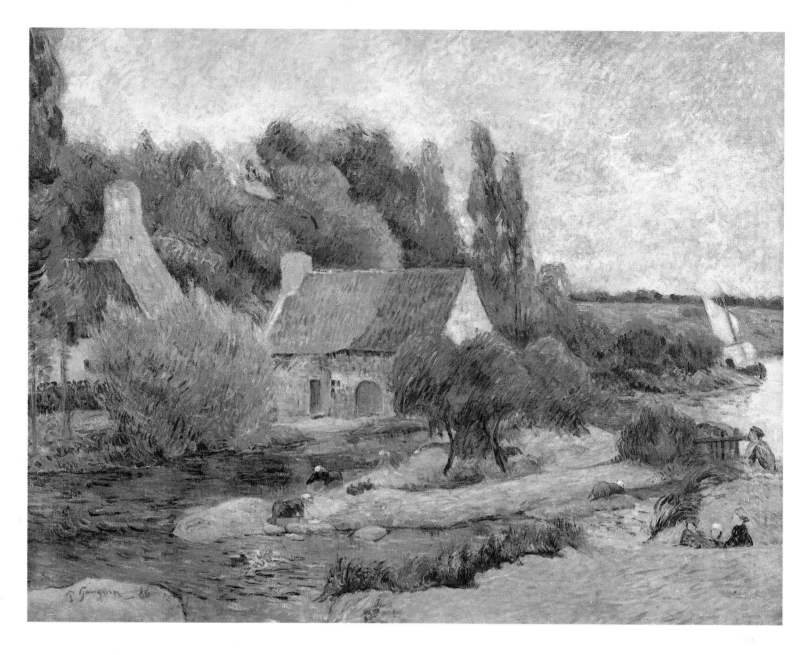

Paul Gauguin,
Washerwomen at Pont-Aven △
(view of the Ty-Meur mill), 1886,
oil on canvas, 28 × 35⅜ in.
Musée d'Orsay, Paris.

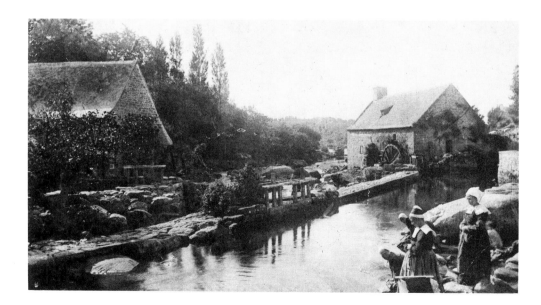

Washerwomen at Pont-Aven. ▷
Postcard, c. 1890.

51

Painter Returning to the Pension at the End of the Day. △
Scene in the Bois d'Amour, Pont-Aven, 1879.
Sketch by Randolph Caldecott.

Panorama of the banks of the Aven in the Bois d'Amour. ▷
Postcard, c. 1900.

View in the Bois d'Amour.
Postcard, c. 1910.

The chapel of Trémalo, near Pont-Aven.
Postcard, c. 1900.

◁ *Breton girls in the Bois d'Amour, Pont-Aven.*
Postcard, c. 1900.

importance. Furthermore, he was so taken with the standard of his lodgings, the warmth of his welcome, the quality of the food, and the charm of the countryside that he added: "What a shame we didn't come to Brittany before; the hotel costs only sixty-five francs a month, full board. I can feel myself putting on weight as I eat. If I can gradually find a steady market for my paintings, I'll stay here all the year round." Gauguin's first glimpse of the little pension on that summer evening must have been like the scene in Randolph Caldecott's sketch (p. 43), which shows a group of artists sitting around a table in the street.

There were many artists at the Pension Gloanec at that time. Gauguin continued in the same letter: "You may think I'm lonely. Far from it. There are painters here winter and summer alike, English, Americans, etc." He went on: "There are hardly any French, all foreigners. A Dane, two Danish women, Hagsborg's brother and plenty of Americans."

◁ Girl seated beside the Aven, in the Bois d'Amour. Postcard, c. 1895.

Paul Gauguin, *Alley in the Forest* ▷ (view of the Bois d'Amour at Pont-Aven), 1886, oil on canvas, 35⅜ × 28 in. Private collection, Paris.

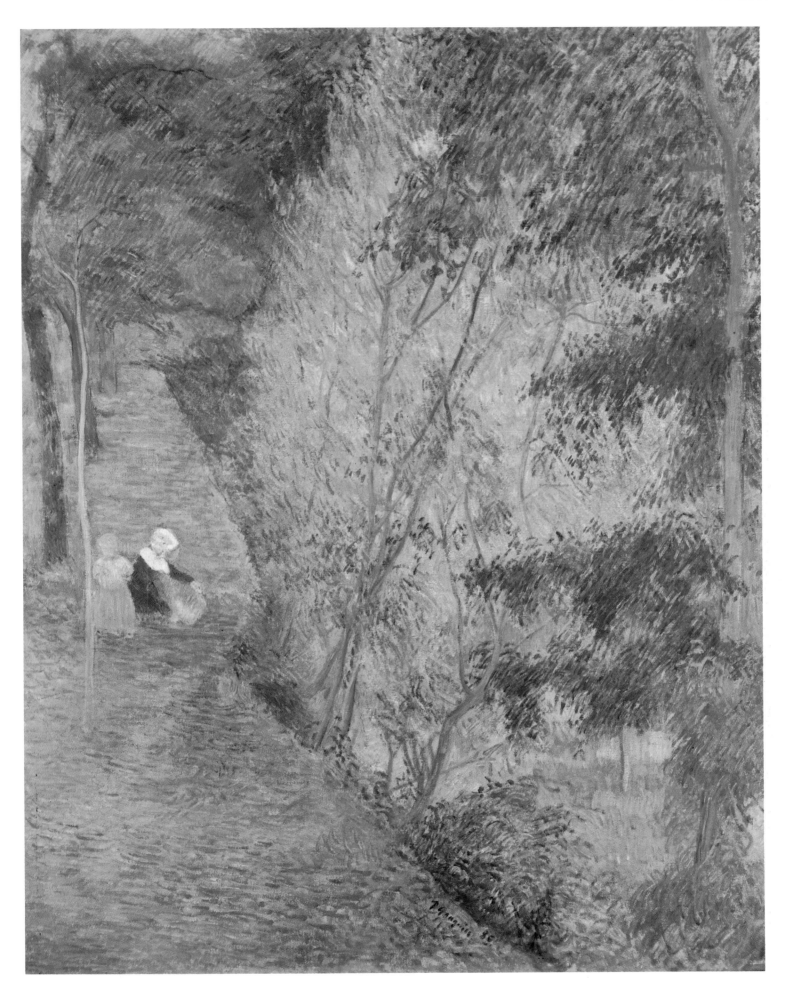

A Walking Tour of
Pont-Aven in 1886

By accompanying Gauguin on a hypothetical but totally plausible walk, it is possible to get an idea of the small town where the artist was to spend so many months. The stone bridge spanning the river gives the village its name. On the left bank is the gently sloping main square of the village, with its more recent buildings, hotels, the covered market, and the town hall. On the right bank is the old village, with its houses dating from the sixteenth and seventeenth centuries.[25] The village extends downstream toward the harbor, squashed in between the mountain and the river. Here the mills give way to moored boats. Fishing boats, as well as boats laden with sand, coasters and schooners, all contribute to the port's nineteenth-century figure of nine thousand tons of shipping a year,[26] making Pont-Aven one of the most important ports on the Breton coast. Here, two tides a day allow boats to sail up the Aven River from its mouth at Port-Manech past the little harbor of Rosbras (illus., p. 46), which lies halfway up the estuary on the left bank, and past the feet of the two old feudal châteaux of Poulguen (illus., p. 47) and Le Henan (illus., p. 259), both on the right bank in the commune of Névez, next to Pont-Aven. The waters, easily navigable, are flanked by steep banks covered with heather and scattered with gray rocks.

At the harbor's end, a sailor is always willing to ferry visitors to the opposite bank, as there is not yet a footbridge. On the opposite bank there are no houses, no quays or roads, just a simple dirt track linking the river with the town square. Ascending a short rise, near the place where washerwomen spread their laundry on the grass and rocks to dry, one is within sight of the back of the town hall, with its belfry, and the rear of the Pension Gloanec. Passing the eastern end of the covered market and

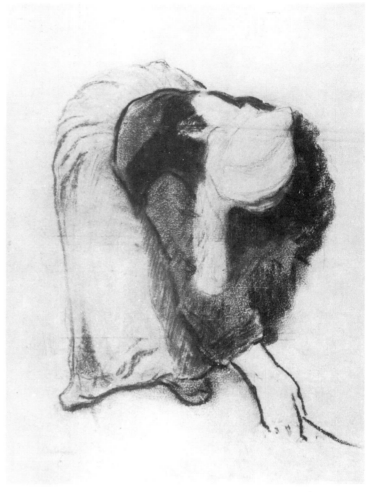

Paul Gauguin,
Breton Woman Bending Down to Collect Wood, 1888, charcoal study.
Present whereabouts unknown.

the side of the Lion d'Or, the explorer comes upon the main square of Pont-Aven. Continuing in the opposite direction and recrossing the river, one arrives at the beginning of the Bois d'Amour,[27] the noble lands of the Hersart du Buron family, whose manor house at Plessis dominates the entire valley. This beautiful walk, frequented by the whole town, is Pont-Aven's favorite meeting place.

Traditionally, after Sunday lunch people put on their best attire and head for the Bois d'Amour: painters in bohemian dress, carrying their easels (illus., pp. 52, 53), bourgeois ladies and young girls

Paul Gauguin, *Young Breton Shepherd* (in the background of this Pont-Aven scene is Mount Sainte-Marguerite), 1888, oil on canvas, 35 × 45⅝ in.
National Museum of Western Art, Tokyo.

1

1 *Wedding at Pont-Aven: leaving for church.*
Postcard, c. 1905.

2 *Fair at Pont-Aven, in the main square
in front of the terrace of the Hôtel Julia.*
Postcard, c. 1900.

3 *The main square in Pont-Aven on a public holiday.*
On the left is the covered market next
to the old town hall.
Postcard, c. 1910.

4 *Young man of Pont-Aven in local costume.*
Note the full canvas trousers known as *bragou braz*
and the leather belt with its large buckle of decorated
copper.
Postcard, c. 1905.

2

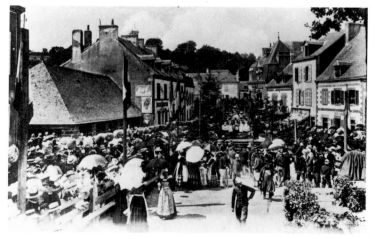

3

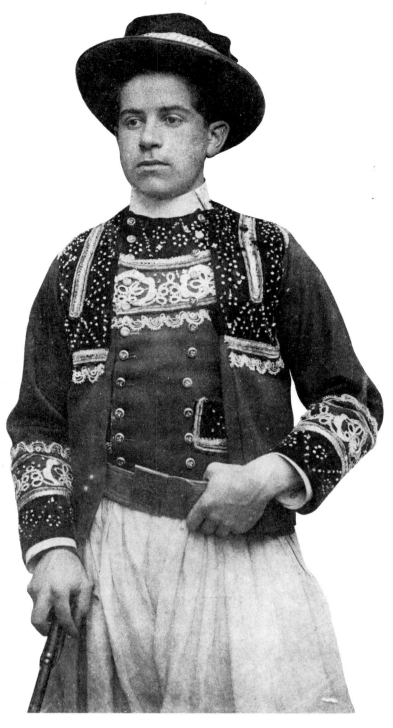

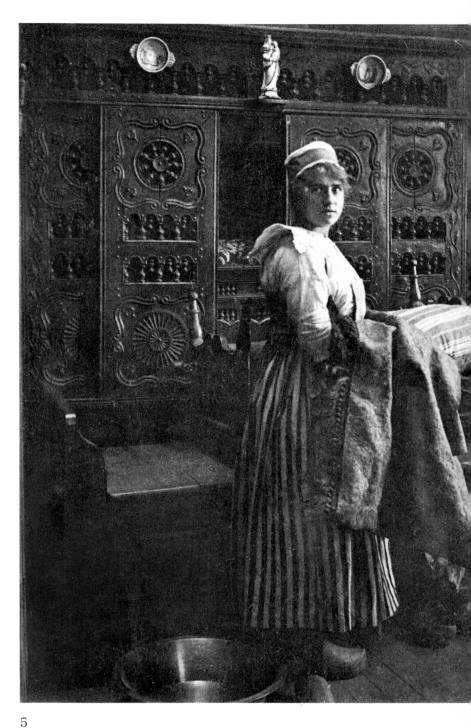

4

5

5 *Typical interior in Pont-Aven.*
Note the enclosed bed with spindle designs. The
combination of carving and openwork reflects the
geographical location of Pont-Aven, situated in
between Breton Cornwall in the north and Hen-
nebont County in the south.
Postcard, c. 1900.

6 *The Plessis ford at Pont-Aven.*
Postcard, c. 1900

6

with their long dresses and parasols, and peasants in local costume and with bare feet or clogs. It was to this forest that Gauguin took Sérusier to paint the famous *Talisman* where, in the background beyond the trees, the slate-covered gable of the Moulin Neuf is clearly recognizable (illus., p. 54).

By walking up the steep slopes of the Bois d'Amour, one soon comes to the chapel of Trémalo (see illus., pp. 27, 53, 252), which overlooks the village.[28] The granite cross and a menhir at the threshold of the church dominate the churchyard and provide dramatic evidence of the timelessness of religion. In the shadowy interior of this obscure sanctuary, with its whitewashed walls, Gauguin first discovered primitive Breton statues with their immense powers of evocation. Gauguin based his famous *Yellow Christ* on the centuries-old crucifixion in the chapel.

Many of Gauguin's canvases were painted from the hills on this side of the town, either on the Bel-Air hill, around and below Lezaven, or the cemetery hill. Small footpaths, steep and winding, thread between the houses. From Bel-Air, there is an excellent view of the whole village. Straight ahead is the bridge, the square, the river, the rocks, and the mills; to the right is the harbor and Mount Saint-Guénolé; and to the left is the Mount Sainte-Marguerite, the treetops of the Bois d'Amour, and the chapel of Trémalo. This setting inspired Paul Gauguin's Impressionist paintings as well as his later Synthetic works.

Paul Gauguin,
Breton Women with a Calf (Pont-Aven), 1888, ▷
oil on canvas, 35¾ × 28⅜ in.
Ny Carlsberg Glyptotek, Copenhagen.

Paul Gauguin,
Cottage at Pont-Aven, 1886, pen drawing.
Dr. Armand Hammer Collection, U.S.A.

Paul Gauguin,
▽ *Breton Women at Pont-Aven,* 1888,
colored pencil drawing.
Dr. Armand Hammer Collection, U.S.A.

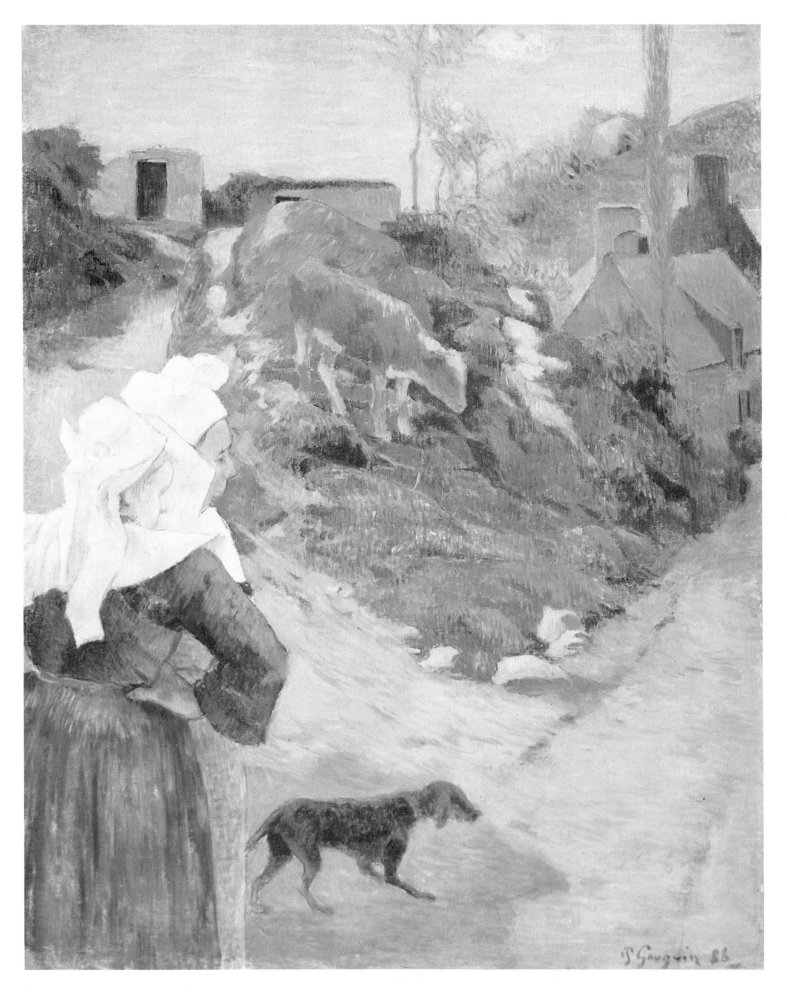

NOTES

[1] Rudimentary maps have been published by various authors, including Pierre Leprohon, *Paul Gauguin* (Paris: Gründ, 1975), p. 145, and Olivier Le Bihan, "Chronologie parallèle, 1886–1895," *Bulletin des Amis du Musée de Rennes, numéro spécial: Pont-Aven,* no. 2 (Summer 1978), p. 11.

[2] Photographic plates were published by *Villard* in Quimper, *Artaud-Nozais* in Nantes, *Neurdein Frères* in Paris-Corbeil marked NO or ND, *H. Laurent* in Port-Louis, *G. Anglaret* in Quimper, *Lévy Fils et Cie* in Paris marked LL, *E. Hamonic* in Saint-Brieuc marked E.H., and two unidentified marks, G.I.D. in Nantes and H.L.M.

[3] The precise chronology of Paul Gauguin's various visits to Pont-Aven is as follows:

1886: Saturday, June 28, to Wednesday, November 12 (five months)
1888: February to October 21, when he departed for Arles (eight months)
1889: February to early May (two months)
1890: From early July to October 2 (three months) he divided his time between Pont-Aven and Le Pouldu
1894: April to November 14 (seven months), when he returned to Paris

[4] The construction of the first villas and holiday homes for the wealthy in this area dates from the 1880s. The craze for sea bathing that developed during the Second Empire produced the first large resorts: Deauville, Biarritz, Dinard. Twenty years later, with the coming of the railway, the wild Breton coastline began to be dotted with houses built by inhabitants of such big cities as Paris, Nantes, and Rennes.

[5] On agricultural life in Brittany in the nineteenth century see P.-J. Hélias, *Le Cheval d'orgueil, mémoires d'un Breton du pays Bigouden* (Paris: Plon, 1975).

[6] Cambry: *Voyage dans le Finistère*, in which he describes the department in 1794, published in Paris in 1836, republished 1979. (Cambry was appointed by the French government during the French Revolution to give an official report and detailed description of Brittany.)

[7] A few of the most important guidebooks on Brittany are:

S. Baring-Gould, *A Book of Brittany* (London, 1901).

Betham Edwards, *A Year in Western France* (London, 1877).

Mrs. Bury Palliser, *Brittany and Its Byways* (London, 1869).

E. Davies, *Off Beaten Tracks in Brittany* (London, 1912).

A. Douglas Sedwick, *A Childhood in Brittany, Eighty Years Ago* (London, 1919).

G. W. Edwards, *Brittany and the Bretons* (London, 1899).

F. Miltour, *Rambles in Brittany* (London, 1905).

Reverend G. Musgrave, *A Ramble in Brittany* (London, 1870).

L. Richardson, *Vagabond Days in Brittany* (London, 1913).

C. R. Weld, *A Vacation in Brittany* (London, 1913).

A. S. Hartrick, *A Painter's Pilgrimage Through 50 Years* (Cambridge, England, 1899).

[8] Randolph Caldecott (1846-1886) was a contributor to such magazines as *Punch, The Graphic,* and *The Pictorial World.* He lived in Italy and earned his living as a book illustrator. He is known for his illustrations of Henry Blackburn's *The Hartz Mountains, A Tour in the Land of the Toys* and Mrs. Comynsocarr's *The People of Northern Italy.*

[9] Many of the Pont-Aven painters worked in Paris in the winter, either at the Académie Julian or at the Ecole Nationale des Beaux-Arts.

[10] On the presence of American painters at Pont-Aven up to 1914, see Denise Delouche, "Pont-Aven avant Gauguin," *Bulletin des Amis du Musée de Rennes, numéro spécial: Pont-Aven,* no. 2 (Summer 1978), pp. 30-39, and David Sellin, *Americans in Brittany and Normandy, 1860-1910* (Phoenix, Arizona: Phoenix Art Museum, 1982).

[11] See postcard edited by Artaud et Nozais under no. 41. *Hôtel Julia, Painters, Homage of the Authors to M^{lle} Julia* (see illus., p. 39). Among the identifiable paintings are: top right, *Fishing Boats Under Sail in Heavy Weather* by Henry Moret, now in the Limbour Collection, France; bottom right, a view of the Ile de Raguénès; left of the door, a portrait of a peasant girl by Henri Delavallée, now in the Dufour Collection. On the left, surrounded by plates, is a large panel showing a peasant girl with a basket by Théophile Deyrolle, now in the Martin Collection, France.

[12] See Léon Tual, *Julia Guillou, la bonne hôtesse* (Concarneau: Imprimerie Le Tendre, 1928).

[13] A scene represented with great precision by Emile Bernard in a painting of 1888. Bernard reproduced the same subject under the title *Bretons in a Ferryboat*, in his series of zincographs which he called *Bretonneries*.

[14] Charles Laval's *Going to Market, Brittany*, exhibited at the Café Volpini in 1889 (Samuel Josefowitz Collection, Lausanne).

[15] The old survey "carried out on the land on 19 May 1832" under the administration of M. Pellenc, prefect, and M. Souffès, mayor, is preserved at the Pont-Aven town hall.

[16] "Père Jobbé still has all sorts of problems, but they make up for their poverty by their unity of heart. To get through their difficulties they tighten their belts without acrimony." Letter dated May 24, 1886, from Gauguin to his wife, Mette; quoted in Maurice Malingue, ed., *Lettres de Paul Gauguin à sa femme et à ses amis* (Paris: Grasset, 1946), p. 85.

[17] Ibid., letter 38, p. 88.

[18] Ibid., letter 39, p. 89.

[19] Ibid., letter 40, p. 91.

[20] Information derived from a discussion in the Pont-Aven council chamber on December 24, 1890, which is preserved in the council records in the Pont-Aven town hall.

[21] The old town hall is now occupied by the *Galeries de l'Aven.* The belfry that surmounted the building is gone. An extract from a council meeting in 1897 reads: "Closing time for the bars will be announced every night by the belfry bell ringer, who is to ring the large bell for at least five minutes from 9:45 pm, with a few additional peals at 10 o'clock."

[22] The building once called the Pension Gloanec is still standing and has changed a little. The ground floor is now a book shop, the Maison de la Presse. In the presence of Emile Bernard and Maurice Denis a plaque was mounted on the facade in 1939 to commemorate the Pont-Aven school.

[23] Information obtained from the original cadastral survey.

[24] Undated letters from Gauguin to his wife. Malingue, *Lettres,* letter 41, p. 91.

[25] There are no buildings still standing in Pont-Aven dating from before the end of the sixteenth century. From this period, a prosperous one in Brittany, dates the old town on the right bank, built on land belonging to Sénéchaussée of Concarneau.

[26] These figures on the volume of traffic in the Pont-Aven harbor are taken from records of a meeting held on November 30, 1893, at the town hall.

[27] Numerous postcards of this site exist (see illus., pp. 52, 53), which can be found in the Archives départementales du Finistère in Quimper.

[28] Notre-Dame-de-Trémalo, in the ancient parish of Nizon, dedicated to Saint-Mâlo, was built as a private chapel for the old Duplessis-Feydeau family. Built in the sixteenth century in the Gothic style, it is similar architecturally to the chapel of Saint-Philibert-en-Trégunc. It is possible that they were designed by the same architect.

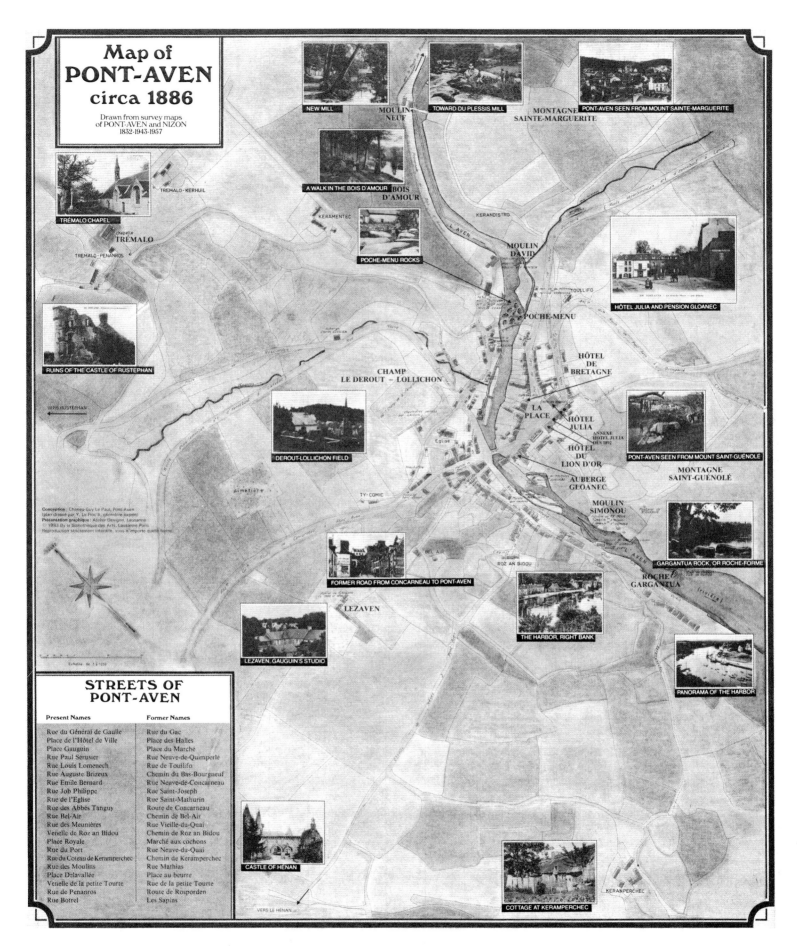

Map of PONT-AVEN circa 1886

Drawn from survey maps
of PONT-AVEN and NIZON
1832-1943-1957

NEW MILL

MOULIN NEUF

TOWARD DU PLESSIS MILL

MONTAGNE SAINTE-MARGUERITE

PONT-AVEN SEEN FROM MOUNT SAINTE-MARGUERITE

A WALK IN THE BOIS D'AMOUR

BOIS D'AMOUR

TRÉMALO-KERHUIL

Chapelle TRÉMALO

TRÉMALO CHAPEL

TRÉMALO-PENANROS

KERAMENTEC

POCHE-MENU ROCKS

KERANDISTRO

L'AVEN

MOULIN DAVID

TOULLIFO

POCHE-MENU

HÔTEL JULIA AND PENSION GLOANEC

RUINS OF THE CASTLE OF RUSTEPHAN

VERS RUSTEPHAN

CHAMP LE DEROUT – LOLLICHON

HÔTEL DE BRETAGNE

LA PLACE

HÔTEL JULIA

ANNEXE HÔTEL JULIA DES 1892

PONT-AVEN SEEN FROM MOUNT SAINT-GUÉNOLÉ

Église

DEROUT-LOLLICHON FIELD

HÔTEL DU LION D'OR

AUBERGE GLOANEC

MONTAGNE SAINT-GUÉNOLÉ

cimetière

TY-COMIC

MOULIN SIMONOU

Conception: Charles-Guy Le Paul, Pont-Aven
(plan dressé par Y. Le Floc'h, géomètre-expert)
Présentation graphique: Atelier Devigne, Lausanne
© 1983 By la Bibliothèque des Arts, Lausanne-Paris
Reproduction strictement interdite, sous n'importe quelle forme

GARGANTUA ROCK, OR ROCHE-FORME

BEL AIR

ROZ AN BIDOU

ROCHE GARGANTUA

FORMER ROAD FROM CONCARNEAU TO PONT-AVEN

THE HARBOR, RIGHT BANK

LEZAVEN

PANORAMA OF THE HARBOR

LEZAVEN, GAUGUIN'S STUDIO

CASTLE OF HÉNAN

KERANPERCHEC

VERS LE HÉNAN

COTTAGE AT KERAMPERCHEC

STREETS OF PONT-AVEN

Present Names	Former Names
Rue du Général de Gaulle	Rue du Gac
Place de l'Hôtel de Ville	Place des Halles
Place Gauguin	Place du Marché
Rue Paul Sérusier	Rue Neuve-de-Quimperlé
Rue Louis Lomenech	Rue de Toulifo
Rue Auguste Brizeux	Chemin du Bas-Bourgneuf
Rue Emile Bernard	Rue Neuve-de-Concarneau
Rue Job Philippe	Rue Saint-Joseph
Rue de l'Eglise	Rue Saint-Mathurin
Rue des Abbés Tanguy	Route de Concarneau
Rue Bel-Air	Chemin de Bel-Air
Rue des Meunières	Rue Vieille-du-Quai
Venelle de Roz an Bidou	Chemin de Roz an Bidou
Place Royale	Marché aux cochons
Rue du Port	Rue Neuve-du-Quai
Rue du Coteau de Keramperchec	Chemin de Keramperchec
Rue des Moulins	Rue Mathias
Place Delavallée	Place au beurre
Venelle de la petite Tourte	Rue de la petite Tourte
Rue de Penanros	Route de Rosporden
Rue Botrel	Les Sapins

Copyright © 1983 La Bibliothèque des Arts, Lausanne-Paris.
Reproduction strictly forbidden in any form.

64

PAUL GAUGUIN AND IMPRESSIONISM

The masters who inspired Gauguin's taste for painting,
Millet, Courbet, Corot, Pissarro,
instilled in him a preference
for the more grave and solid Impressionists
rather than the dazzling Impressionists like Monet, Renoir....

RENÉ HUYGHE

BEFORE the age of twenty-three, Paul Gauguin never held a paintbrush and probably never really looked at a painting. Between 1865 and 1870,[1] he traveled the world's oceans, working as a merchant seaman. In 1871 he gave up his passion for the sea and began a totally different way of life, under the tutelage of his guardian, Gustave Arosa.[2] Arosa introduced Gauguin to the avant-garde artists of the time — Camille Pissarro, Félix Nadar, and Claude Debussy, his godson — while his daughter, Marguerite, gave Gauguin his first painting lessons. In the decade following this introduction to the world of culture and intellectualism, Gauguin emerged as one of the greatest of the Impressionist painters.[3] After 1886, in Brittany, Gauguin's Impressionist painting began its crucial evolution toward the Symbolist style, so celebrated in his later Tahitian canvases.

Paul Gauguin,
The White River
(view of the Aven in the harbor of Pont-Aven,
seen from the left bank below the Ty-Meur mill), 1888,
oil on canvas, 22¾ × 28⅜ in.
Musée de Peinture et de Sculpture, Grenoble.

Portrait of Paul Gauguin
in a Breton waistcoat.
Photograph, c. 1888.

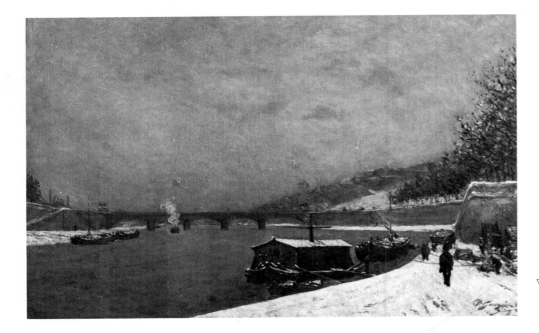

Paul Gauguin,
The Seine at the Iéna Bridge, 1875,
oil on canvas, 25⅝ × 36¼ in.
Musée d'Orsay, Paris.

▽ *Paul Gauguin painting
in Schuffenecker's garden in Paris.*
Photograph, c. 1880.

The Formation of an Artist: Apprenticeship, 1871-1877

The Arosa Family

Before her death in 1867, Paul's mother, Aline Gauguin, took the precaution of planning for the future of her children. Making her will in 1865, she asked her friend Gustave Arosa to act as guardian to Paul and his sister, Marie. The two Arosa brothers, Gustave and Achille, were members of the great Parisian middle class involved in finance. Gustave Arosa owned a mansion at Saint-Cloud, distinguished by its fine furniture and numerous works of art. He was a successful art collector, the owner of seventeen canvases by Delacroix, seven by Courbet, watercolors by Jongkind, and drawings by Daumier.[4] Passionately interested in painting, he invited such artists as Pissarro, as yet unknown, to his home. He edited an important collection of phototype reproductions of Poussin, Raphael, and Le Brun. He was also fascinated by photography and was a friend of Nadar,[5] in whose studios the first Impressionist exhibition was held.[6] Considering photography to be an art form in its own right, he composed elaborate photographs.

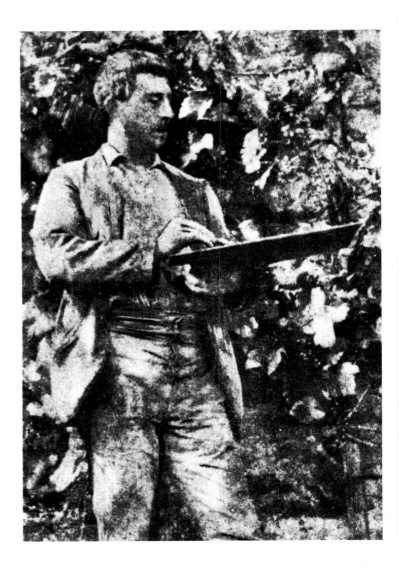

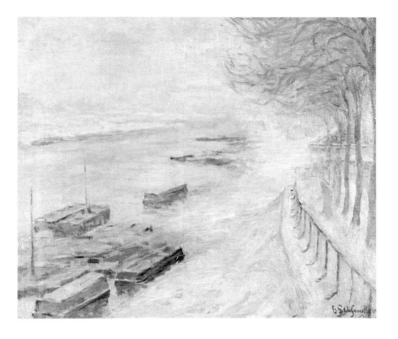

Claude Emile Schuffenecker,
The Seine in Paris,
oil on canvas, 19⅝ × 24 in.
Private collection, Paris.

Achille Arosa, his brother, had similar artistic interests. He commissioned Pissarro to execute four paintings, depicting the seasons, to go above the doorways of his house. Not long after 1871 Gauguin received his first drawing lessons from Marguerite Arosa in the garden at Saint-Cloud. The soirees at which he was present, the discussions to which he listened, the paintings at which he looked, the books he consulted, all demonstrated to Gauguin that, alongside the world he had known up until then, there existed a completely different universe — a universe of taste, culture, refinement, and passion, into which he flung himself with enthusiasm.

Claude Emile Schuffenecker

Gustave Arosa undertook to establish a position in society for his *protégé* and obtained for him a post in a stockbroker's office; there Gauguin met Emile Schuffenecker. This encounter was to alter Gauguin's destiny. "Schuff" was fascinated by painting. Winner of the Ville de Paris prize for drawing in 1868, he worked as a stockbroker strictly to earn a living and often declared that his sole ambition was to devote himself entirely to his art. His enthusiasm reinforced the "Arosa influence" on Gauguin.

Soon the two young men, both of whom were single, were devoting all their spare time to this new passion. Rainy days were spent visiting museums, and when the weather was good they painted in the open air. Schuffenecker's enthusiasm, his sincere compliments and encouragement, helped Gauguin in those early days to recognize his own talent. Nothing could have been more stimulating for the neophyte Gauguin than the spontaneous admiration of his friend.

The pupil, however, was soon to outstrip his teacher. While Schuffenecker continued to attend evening classes at the studio of Paul Baudry[7] and Carolus Duran, Gauguin was already drawing inspiration from Corot and Jongkind. His stylistic progress toward Impressionism was evident in his choice of subjects and his interest in the natural effects of open-air painting. Two views of the banks of the Seine near Paris, one from 1875 showing the riverbank covered with factories and chimneys,[8] the other from 1876 depicting barges moored under a crane,[9] illustrate this tendency perfectly. The quality and precociousness of Gauguin's early paintings were demonstrated by the acceptance of *Woodland at Viroflay*[10] by the Salon of 1876.

The Artist-Collector

From 1876 on, Paul Gauguin's writings indicate that he thought of himself as a painter as well as a businessman. Modeling himself on Arosa, Gauguin surrounded himself with works of art. He devoted his salary to the purchase of paintings[11] and showed great talent in discerning the good from the commonplace; he also continued to paint as often as time permitted. Soon after his first success, at the Salon of 1876, he moved to a larger apartment, in the artist quarter of Paris, belonging to the sculptor Jules Ernest Bouillot,[12] and he hired a maid who had previously modeled for Delacroix. During this time Gauguin became acquainted with the sculptor Jean

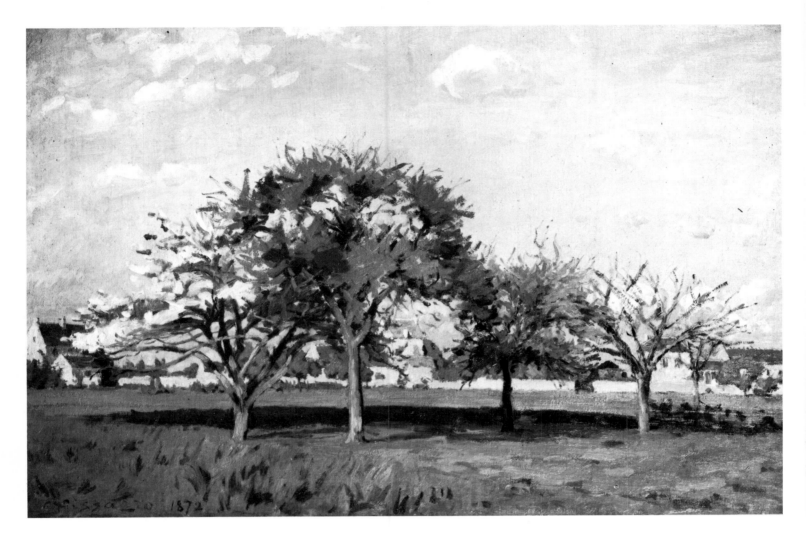

Camille Pissarro,
Apple Trees in Blossom at the Hermitage (Pontoise), 1872,
oil on canvas, 20⅞ × 32⅝ in.
Formerly Mettler Collection, Zurich.

Paul Aubé,[13] who introduced Gauguin to sculpting and modeling, which were to remain primary interests throughout his lifetime. In 1882 Gauguin painted a marvelous portrait of Aubé with his son.[14]

The Pupil of Pissarro: 1877–1881

Camille Pissarro became acquainted with the Arosa family while he was painting at Saint-Cloud, near Paris. After 1874 Pissarro began introducing his Impressionist friends to the Arosa family: "After having been great collectors of the works of Delacroix, Corot and Courbet [the Arosas] became interested in the controversial paintings of scandalous artists such as Manet, Monet and Renoir."[15] The second and third exhibitions of the Impressionist group took place in Paris at the Durand-Ruel gallery

in 1876 and 1877. There, Gauguin decided that Pissarro seemed a worthy mentor, and the younger artist attempted both to cultivate Pissarro's friendship and to follow his example. Pissarro soon took Gauguin with him to the Nouvelle Athènes café,[16] the meeting place for the group known generally as "Manet's circle." To these new companions, who remained distant and even distrustful of him, Gauguin was merely a Sunday painter, making modest efforts at painting in the modern style. Despite his purchases of their canvases, the Impressionists regarded him with suspicion. (Later, with money made on the stock exchange, Gauguin went on a second buying spree and for 1500 francs purchased new

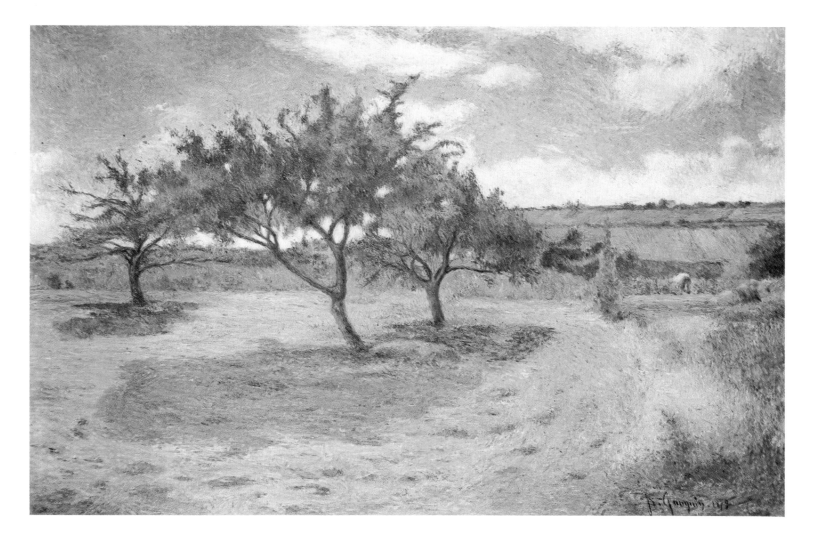

Paul Gauguin,
△ *Apple Trees in Blossom*
(at the Hermitage, Pontoise),
1879 (first version),
oil on canvas, 34⅝ × 45⅜ in.
Private collection, U.S.A.

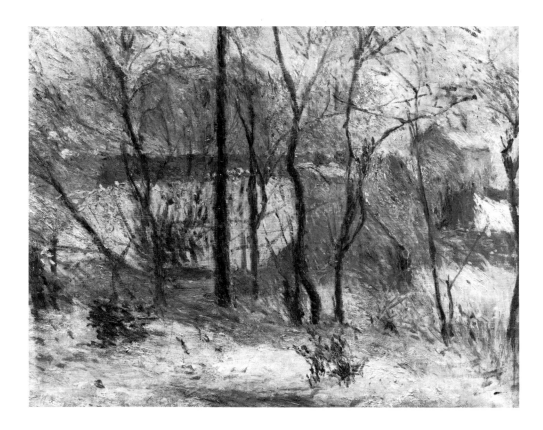

Paul Gauguin,
Garden in the Snow, 1879, ▷
oil on canvas, 16⅛ × 19⅜ in.
Ny Carlsberg Glyptotek, Copenhagen.

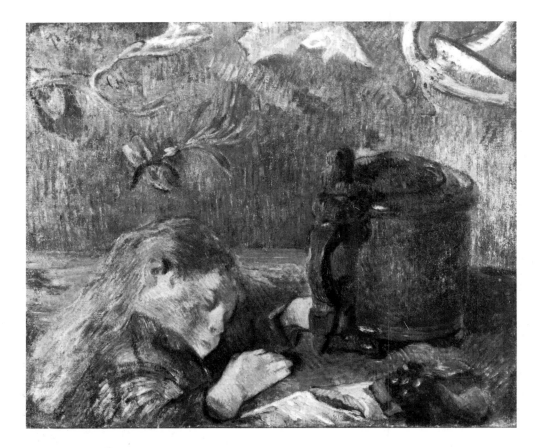

Paul Gauguin,
Clovis Gauguin Sleeping, 1883,
oil on canvas, 20⅛ × 23⅝ in.
Horst Collection, Oslo.

canvases by Manet, Renoir, Monet, Cézanne, Degas, Pissarro, and Sisley.) Only Manet, for whom Gauguin professed great admiration (and who felt himself above their petty quarrelling), offered Gauguin a few words of comfort: "There are not amateurs: there are only good or bad painters." Yet, once he overcame his initial shyness, as René Huyghe explains, Gauguin "carved out a career for himself, modeling himself on the Impressionists he collected and then on Pissarro, whom he was to make his master."[17]

It was not long before Gauguin integrated himself into the Impressionist group. He received the active support not only of Pissarro, but of Degas and Guillaumin. In 1879, the year of the fourth exhibition of the group, Gauguin exhibited with the Impressionists for the first time, showing a bust he had sculpted in 1877. Then in 1880, he added seven canvases and a sculpture to their exhibition. An incursion on this scale was bound to provoke a reaction from other potential exhibitors. In reference to Gauguin's presence, Monet declared scornfully: "This little church is these days a banal school which opens its doors to

the first dauber who happens to come along."[18] Monet and Gauguin, from this time on, continued to treat each other with coldness and hostility.

Changing his residence again in the spring of 1880, Gauguin entered a new stage of his life. Moving even farther from the business quarter and the center of Paris, he established himself at Vaugirard. There, near the church of Saint-Lambert, he rented from the painter Jobbé-Duval a detached house in the rue Carcel with a large garden and, more important, a real studio. He began painting immediately and produced two landscapes which he exhibited in April (*The Market Gardens of Vaugirard* and *Father Dupin's Footpath*) and various portraits of his wife and children. But above all, it was there that he executed one of his first major paintings, *Portrait of a Nude Woman Mending*, for which his maid, Justine, was the model.[19] This powerful and serious work was exhibited the following year at Nadar's studio in the boulevard des Capucines and received well-deserved praise from the critic Joris Karl Huysmans: "This canvas shows the undeniable talent of a modern artist.... Among contemporary painters who

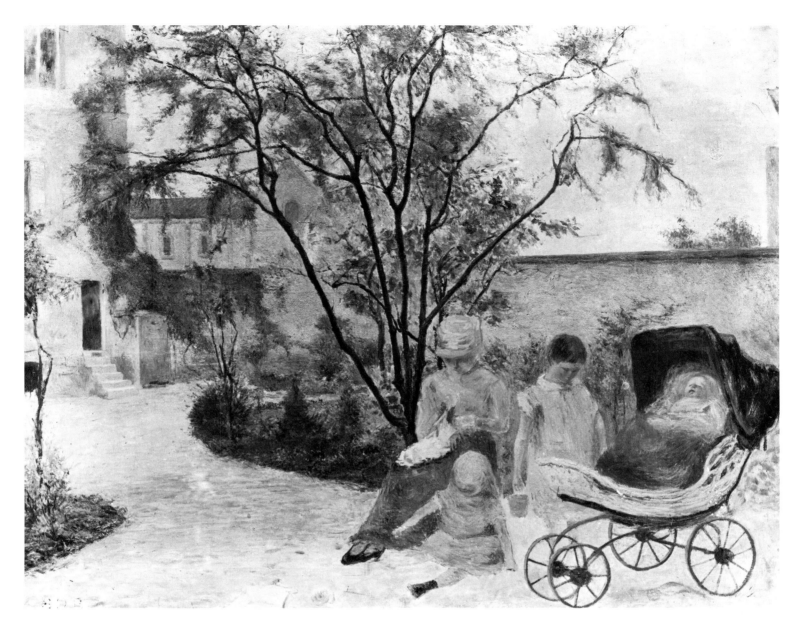

Paul Gauguin, *The Gauguin Family in the Garden, rue Carcel, Paris,* 1882, oil on canvas, 34 ⅜ × 44 ⅞ in. Ny Carlsberg Glyptotek, Copenhagen.

have worked on the nude, no other has so far been capable of portraying Reality with such vehemence."[20] As in the previous year, Gauguin spent the summer of 1881 with Pissarro at Pontoise. There he met Paul Cézanne.[21] The two men were too different in temperament — the one too sensual, the other too cerebral — to become friends. About 1881, Pissarro, "realizing like both Renoir and Cézanne, that Impressionism lacked solidity and structure of form, began a more constructive period. Pissarro's art became more simplified and more synthetic."[22] Gauguin's painting followed this same change in form.

The Impressionist Painter and Exhibitor

Within the Impressionist group Gauguin no longer hid his pretensions but began to assert himself as a leader. In the quarrel that, in the course of the winter of 1881-82, set Degas at loggerheads with Caillebotte, Monet, and Renoir, Gauguin found the courage to take sides and offer opinions. Manet commented: "These gentlemen don't seem to get on. Gauguin is playing dictator."[23] Curiously enough, Gauguin adopted tactics based more on force of numbers than aesthetic affinities, aligning himself with Caillebotte, Monet, and his followers, and against Degas and his "lackey" Jean-François Raffaëlli.[24] Gauguin's voice carried weight, as evidenced by the fact that when the seventh Impressionist exhibition opened on March 1, 1882, at 251 rue Saint-Honoré, the entire "Degas gang" was absent.[25] Never before had the group of exhibitors been so restricted as to include only nine artists.[26] Gauguin, however, showed twelve paintings and a bust, and Durand-Ruel, the organizer of this exhibition, succeeded in putting a temporary halt to dissensions and hostilities, creating his first successful exhibition. "Never have the Impressionists been so united, the detractors so disarmed. The public has stopped its mocking and prices are going up, much to the satisfaction of Durand-Ruel."[27]

The year 1881 marked a turning point in Gauguin's life. At the end of the year he wrote to Pissarro: "Little by little I am forgetting about business, or rather how to carry on business," and he added, "As for giving up painting: never."[28] Whereas the year 1880 had seen Gauguin making record profits[29] and the stock exchange in a state of euphoria, 1881 saw a decline setting in, and 1882 brought disaster. On January 11, 1882, the Banque de Lyon crashed, followed by the Union Générale on January 30. This disaster heralded the stock exchange crash described thus in *Figaro*: "It was not just a matter of speculators ruined, of jobs threatened, this time it was a matter of public credit. It was the national fortune that had to be protected against disaster ... against panic."

Galichon, who had replaced Bertin as Gauguin's employer, was forced by the stock market crash to cut his staff. Consequently, in January 1883 Gauguin was dismissed. He reacted to the news of his dismissal with mixed feelings. Freed from the constraints that had bound him for years, he declared optimistically and peremptorily, "From now on I'm going to paint every day."[30] Yet, Gauguin could not ignore his precarious financial position, and he made a final effort to find a job, this time in an insurance company. His attempts were to prove unsuccessful, possibly due to a lack of real enthusiasm.

By June, however, Gauguin had settled down for the summer in Osny, where Pissarro was living. There he painted *The Poplar Trees*[31] and *The Sluice-Gate at Osny, Normandy*[32] (illus., p. 73), which reveal the birth of a new rustic style that, despite the obvious influence of Pissarro, was highly personal.

Gauguin continued his search for peasant scenes everywhere he traveled between 1883 and 1888: Normandy in 1884 and 1885, Brittany in 1886, Martinique in 1887, and Brittany again in 1888. This quest reveals Gauguin's deep attachment and debt to that inspired poet of the earth, Jean François Millet.[33] Hence, the apt comment of René Huyghe: "His [Gauguin's] forms were to keep something of the compactness and earthy power originally borrowed from Pissarro and Millet."[34]

From this point on, Gauguin developed the warm, muted tones associated with his landscapes and

Paul Gauguin,
The Sluice-Gate at Osny, Normandy, 1883,
oil on canvas, $25\frac{5}{8} \times 21\frac{3}{8}$ in.
Private collection, Paris.

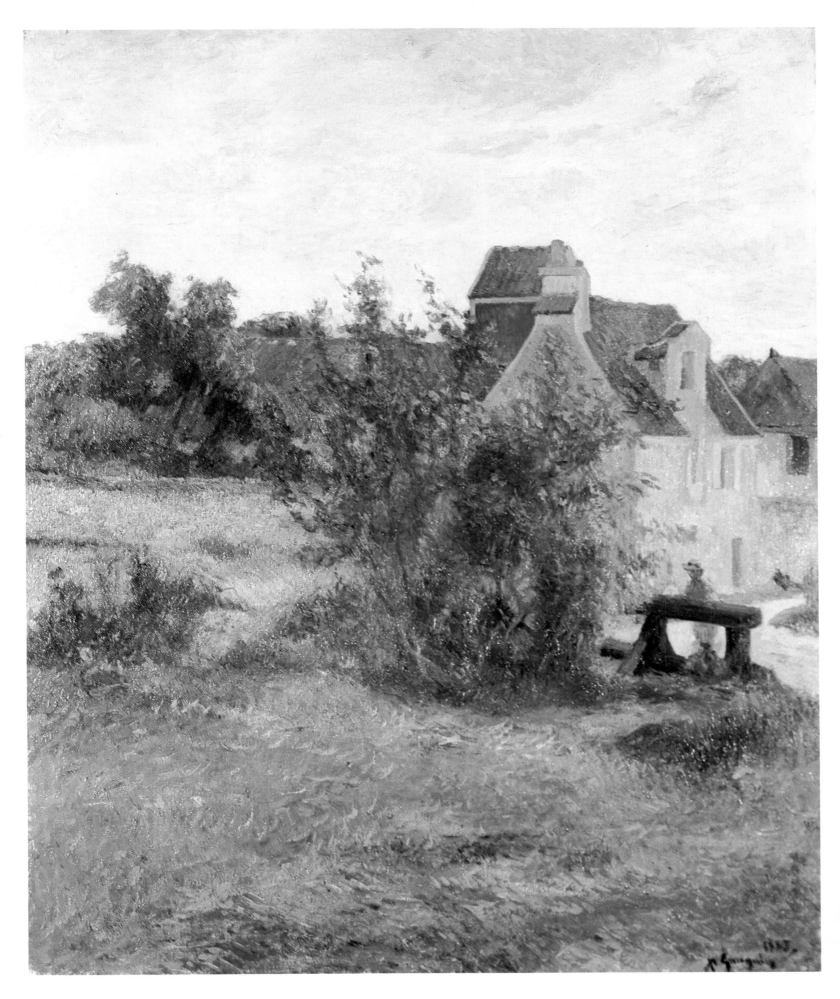

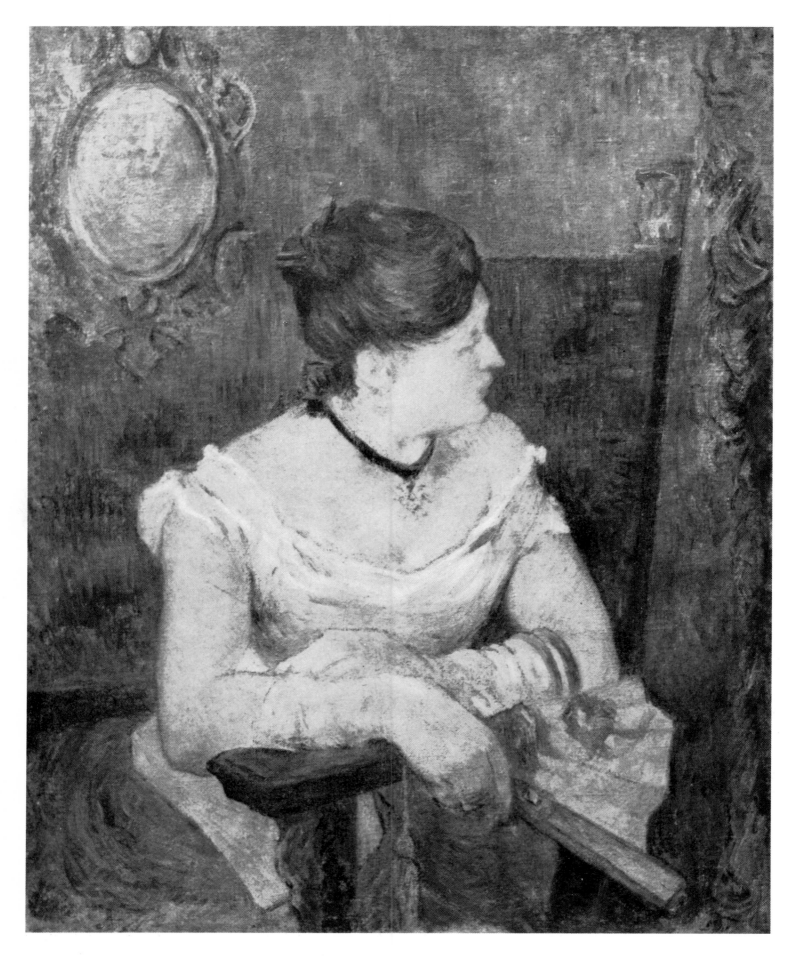

Paul Gauguin, *Mette Gauguin in Evening Dress,* 1884, oil on canvas, 25⅝ × 21⅜ in. Nasjonalgalleriet, Oslo.

peasant scenes. In the final analysis, the peasants of Normandy, Brittany, and Martinique lose their identity; they are subsumed by nature and their rustic settings.

Gauguin's paintings are unique despite the incorporation of the ideas of many of his contemporaries. His restrained power and his concentrated force seem ever ready to overflow and to explode from the canvas. Compared with the other Impressionists, it is this latent power, intense, discreet, and silent, that is the distinctive feature of Gauguin's painting. The frequent and widespread practice of interpreting the apparent clumsiness of some of his works as a result of a lack of skill or error of design or composition is a mistake. Gauguin made a conscious choice when depicting his rustic landscapes with an apparent naïveté of style. Having chosen to create an atmosphere deeper than the superficial portrayal of light, Gauguin set himself apart from the rest of the Impressionist school and paved the way for the stylistic changes to come.

Rouen, Copenhagen, Normandy

Early in 1884 Gauguin and his family moved to Rouen in the hope of reducing their living expenses, and having a more agreeable life.[35] However, despite this move Gauguin brought in no income. As a result, the family atmosphere soon began to deteriorate. In November, Mette Gad, the Danish woman he had married in 1873 and now mother of five, of whom the youngest was only a few months old,[36] left Rouen for her homeland, taking the children and all the furniture. She had married a successful stockbroker and found herself living with a struggling artist.

For Gauguin, Rouen was his first chance to paint in complete freedom. The year showed a marked increase in output: forty-three canvases. They are among the most luminous of Gauguin's works and among the most colorful and brightest, most notably *View of Rouen Harbor*,[37] *Snow*,[38] dedicated "to my friend Théodore," and *Still-Life with Iridescent Glass*,[39] dedicated "to my friend Faure." (Both Théodore and Faure were friends of Gauguin during his stay in Rouen.)

In November of 1884 Gauguin left for Denmark to rejoin his family and the entire Gad clan. There, he made a conscientious effort to find a job. Despite all his efforts he met only with failure, the contempt of his wife's family, hostility, and discouragement.[40] Gauguin continued to paint during this difficult time. He wrote to Schuffenecker, his faithful confidant: "I haven't got a sou, I've had it up to here," but he added, "I'm tormented by art more than ever and it will take more than my money troubles or my search for work to turn me from it.... There's only one thing that I can do: paint."[41]

In the small studio that he set up in the attic of his new home, Gauguin created portraits of his children, a view of skaters in the Frederikberg's Park,[42] the ancient Queen's Mill in the East Park,[43] and also a fine self-portrait,[44] in which he appears with a serious expression and vacant eyes, as if he was looking in upon himself.

Faced with an intolerable existence, Gauguin declared in Denmark: "Every day I wonder if it wouldn't be better to go to the attic and tie a rope round my neck."[45] Ultimately, he had to escape — to leave Denmark, its climate, its people, and also his own family. In June 1885, taking his son Clovis with him, Gauguin returned to Paris. The first stage of his artist's life, which had begun in 1871 in the Arosa household, had now come to an end. His period of artistic apprenticeship was over. He had established the aesthetic philosophy that was to remain with him: "Work freely and passionately.... Above all never sweat over a painting; a great sentiment can be translated immediately; dream about it and try to find its simplest form."[46] Gauguin suggested that a motif should no longer portray a fleeting impression, in the style of Monet. When Gauguin stated that "a great sentiment can be translated immediately," he meant two things: an artist is able to identify immediately the nature of his own emotions; and these impressions should be translated implicitly and easily into a pictorial representation. In 1885 Gauguin wrote to Schuffenecker: "Go for the essential, don't worry about detail. Aim for emotion and sentiment rather than formal reality. Don't confuse the appearance of things with their essence. Boldness and imagination are the best guarantees of truth of expression." In the same letter, Gauguin explained his theory on lines and colors: "There are noble lines, lying lines, etc.... The straight line produces infinity, the curve limits creation.... Colors are more

effective, although fewer in number, than lines because of their power on the eye. There are noble shades while others are common. There are tranquil, calming harmonies, while others excite through their very boldness."[47] Thus, as early as his visit to Copenhagen, Gauguin was already formulating a theory of suggestive color, an area in which Anquetin and Bernard were experimenting quite independently in Paris about the same time.[48]

The canvases Gauguin painted during the summer of 1885 in Normandy show the originality of the experiments that he continued in Brittany in 1886 and in Martinique in 1887. The beginnings of Gauguin's main Impressionist period can be found in the works produced in the Normandy countryside. The canvases painted in this new style (*Cows in a Meadow*,[49] *Cows at the Drinking Trough*,[50] *The Little Cowherd*,[51] *Landscape with Hens*[52]) are different from those of Pissarro. The muted, deep, and rich colors are completely Gauguin's, and the application of his theories of sensation in the interplay of line and color creates a uniquely seductive effect, as in *The Beach at Dieppe*[53] (illus., p. 76).

In Dieppe, during the course of that summer, Gauguin terminated his friendship with Degas, whom he admired so much and whom he so resembled. They argued as a result of the atmosphere that existed among the society painters with whom Degas surrounded himself,[54] not because of differences of an artistic nature.[55] In spite of this disagreement, Degas was later to be the first to buy some of Gauguin's more daring works.[56]

The 1886 Exhibition

The autumn and winter of 1885 were periods of physical and moral misery and total penury for Gauguin.[57] Painting was out of the question in such terrible conditions; almost his entire output for 1885 dates from the summer months, in Normandy. October marked the final breach between the erstwhile master, Pissarro, and his pupil, Gauguin.[58] Pissarro

had met Seurat and had joined the ranks of the Neo-Impressionists, along with his son Lucien. Even though Gauguin experimented in the course of the winter of 1885-86 with Divisionist techniques, as in *Still-Life with Horse's Head and Japanese Fan*,[59] he found nothing satisfying in this new style. His work tended to bring together pictorial elements rather than to separate them and to simplify images by condensing lines and tonal values. Furthermore, the spirit of the cold, rigorous, scientific methods of the adherents of optical painting was poles apart from the intuitive spirit of Gauguin. Thus, in the course of the winter, when the eighth (and last) Impressionist exhibition was held, the members of the group split into three distinct factions. Some of the original members of the group were absent or had withdrawn, such as Monet, Renoir, and Cézanne. The remainder were split between the new Divisionist school, including Seurat, Signac, Camille and Lucien Pissarro, Schuffenecker, and Degas and his group, which included Gauguin, Jean-Louis Forain, Odilon Redon, and Guillaumin.

This exhibition, held above the Doré restaurant, at the corner of the boulevard des Italiens and the rue Laffitte, from May 15 to June 15, 1886, gave Gauguin the opportunity to show nineteen canvases

Paul Gauguin,
The Beach at Dieppe, 1885,
oil on canvas, 28⅜ × 28⅜ in.
Ny Carlsberg Glyptotek, Copenhagen.

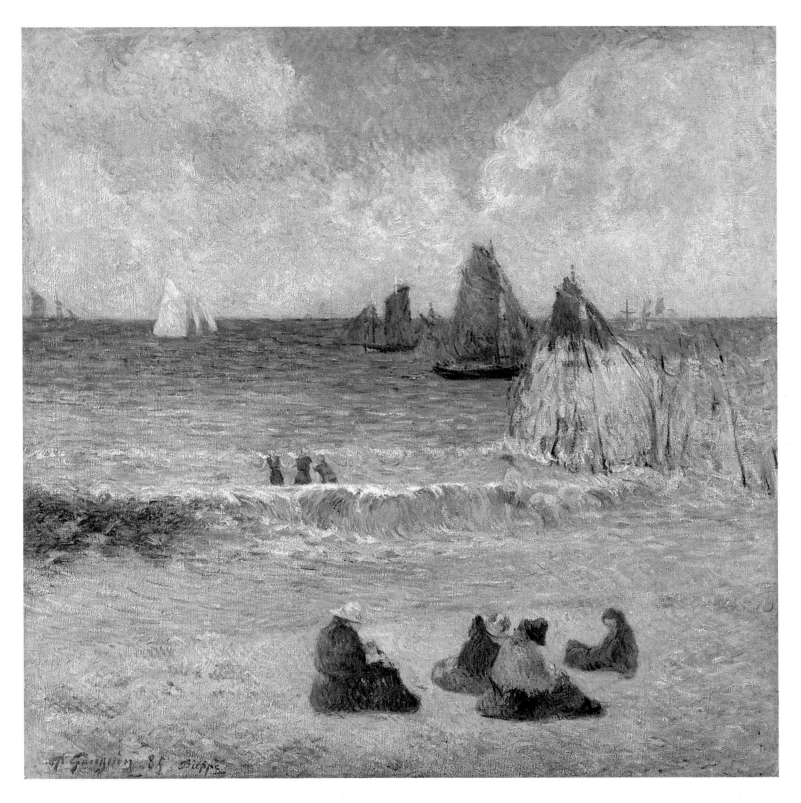

Paul Gauguin, *Bathers at Dieppe*, 1885, oil on canvas, 15 × 18⅛ in. National Museum of Western Art, Tokyo.

painted in the course of the two previous years in Rouen, Copenhagen, and Dieppe: landscapes, portraits, still-lifes. Félix Fénéon saw in those works "a mute harmony.... Dense trees sprout from the rich, fertile and humid soil, over-running the frame and blotting out the sky. A heavy atmosphere...."[60] This predilection for depicting pastoral scenes was to find its fullest expression just a few weeks later, when Gauguin arrived for the first time in Pont-Aven, in June 1886. This farming community, uncontaminated by any form of industrialization, provided the perfect atmosphere for Gauguin's rustic paintings.

Breton Impressionism, 1886

The essential characteristic of the Impressionist paintings that Gauguin produced in Brittany was the continuation of the peasant theme, which he had developed in Normandy. The canvases painted in Pont-Aven between the months of June and November 1886 reflect this theme: *The Breton Shepherdess, Pont-Aven*[61] (illus., pp. 78-79), *Four Breton Women Chatting over a Wall*[62] (illus., p. 81), *Breton Woman Herding Her Cows on the Beach at Le Pouldu*[63] (illus., p. 166), *Washerwomen at Pont-Aven*[64] (illus., p. 51), and *Alley in the Forest*[65] (illus., p. 55) are excellent examples. All show a total fusion of style and subject, of man and landscape. The works painted at Pont-Aven in the course of 1886 show that Gauguin had regained a degree of calm and a certain gaiety, from the favorable conditions in which he was now living. Not only was he able to live on credit, he was also treated with kindness and understanding by Marie-Jeanne Gloanec and her staff at the Pension Gloanec.[66] At Pont-Aven Gauguin found a warm atmosphere and human contact that contrasted dramatically with the loneliness and anguish he had endured in Paris the previous winter.

Almost all the canvases Gauguin painted during this first visit are of people. As John House points

Paul Gauguin,
The Breton Shepherdess, Pont-Aven, 1886,
oil on canvas, 23⅝ × 28⅝ in.
Laing Art Gallery, Newcastle-upon-Tyne, England.

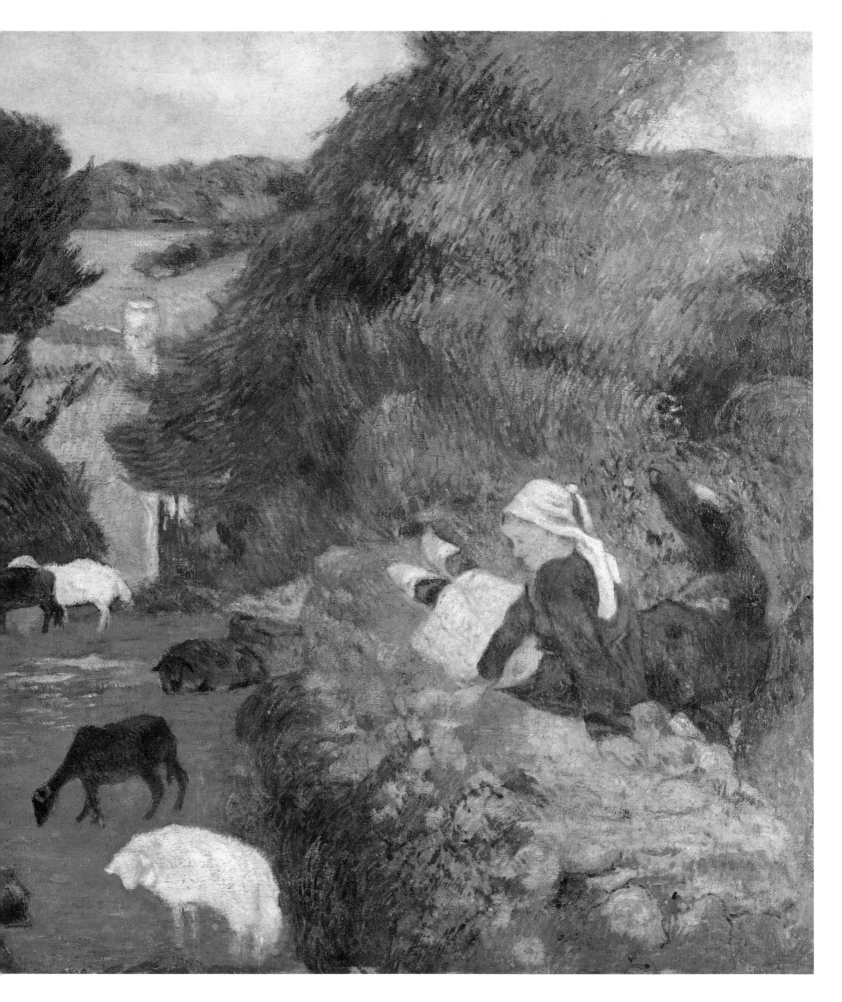

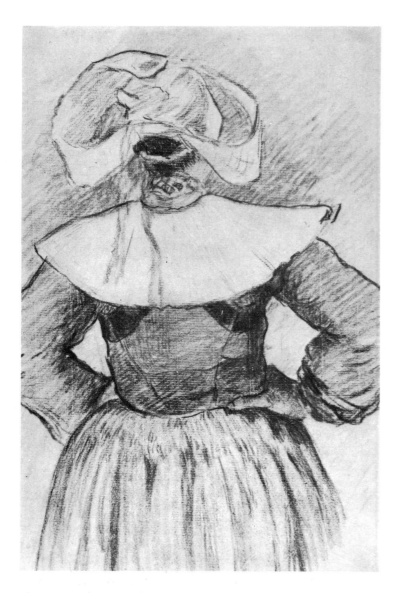

Paul Gauguin,
Breton Woman of Pont-Aven, 1886,
pastel study.
Burrell Collection, Art Gallery and Museum, Glasgow.

out, however, "His figures are generally subordinate to landscape,"[67] even though they take up a large part of some canvases. They are, moreover, figures "in their everyday setting," which demonstrate the bond between man and nature. Aware of the way Japanese artists constructed certain of their landscapes, Gauguin began to turn away from Western influences.[68] The general rule of a centrally placed horizon, as seen in *Beach at Dieppe* of 1885, gave way to a horizon near the top of the canvas or even raised beyond its boundaries. Using a steep perspective, Gauguin narrowed the field of vision, consciously cutting up the landscape to concentrate on one detail or fragment at the expense of another. John House highlights this quality as well: "Compositionally, Gauguin avoids any single focus, creating multiple spatial planes.... This spatial fragmentation echoes Degas' compositions, as does the unexpected

angle of vision on the figure of the Shepherdess."[69]

The reference to Degas is repeated in the same author's analysis of *Four Breton Women Chatting over a Wall* (illus., p. 81). "Degas remains an important influence in the figures; in particular the right figure, that of the woman adjusting her shoe, is so similar to a pose in two of Degas's ballet pastels that the resemblance must have been intended."[70] The painting is, as John House explains, "the most anti-realistic of the paintings which derive from Gauguin's Breton trip of 1886. Distance and horizons are suppressed and there is no suggestion of a specific topographical location."[71] Moreover, this new work encapsulates an atmosphere and expresses an understanding of the people and the countryside. During this period, the Japanese influence on Gauguin's work was restricted to the area of composition. Gauguin remained faithful to Impressionism in the way he applied his paint. To his friend Henri Delavallée he declared: "I use only the colors of the spectrum, juxtaposing them and mixing them as little as possible to give the greatest possible luminosity."[72] In this statement, there are echoes of the Divisionist experiments of 1885 *(Still-Life with Horse's Head and Japanese Fan)*. The reference to the colors of the spectrum and their juxtaposition recalls the method of Seurat. Yet Gauguin's method of painting long, hatched stripes of color was completely different from Seurat's small dots. Ultimately, the two artists shared only the goal of increased luminosity.[73]

Working at Pont-Aven with the Impressionist technique, Gauguin began to achieve a fusion of idea and method, incorporating traditional aspects of the naturalist vision into his own style. It was a question of "learning" the essence of things and of people. As Gauguin put it: "I've never had the mental facility that others find at the end of their brush.... In any region I need a period of incubation so that I can relearn each time the essence of the plants, the trees, of nature as a whole, so varied and so capricious, never wanting to give itself away."[74]

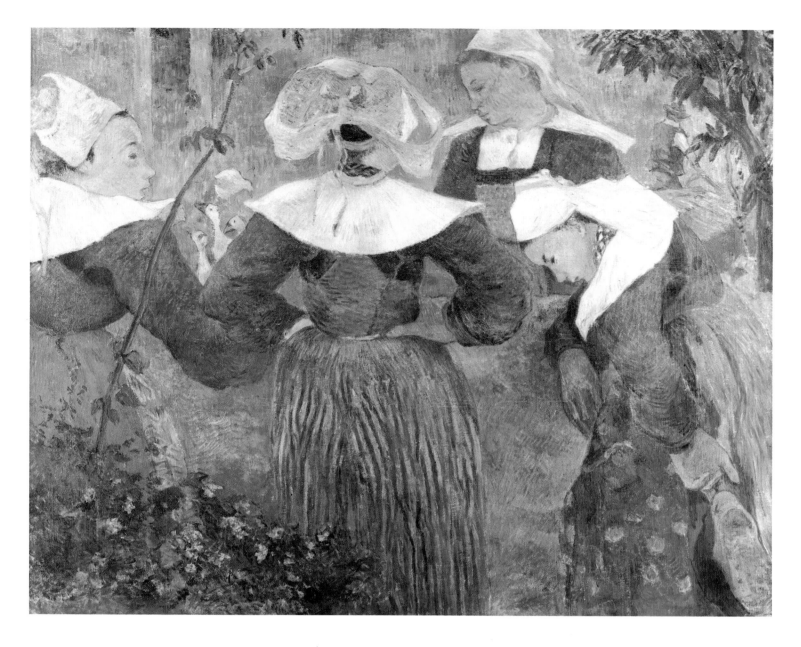

Paul Gauguin, *Four Breton Women Chatting over a Wall*, sometimes called *Dance of the Four Breton Women* (Pont-Aven), 1886, oil on canvas, 28⅜ × 35¾ in.
Bayerische Staatsgemäldesammlungen, Munich.

Paul Gauguin,
Breton Girl in Front of a Window (Pont-Aven), 1886,
charcoal sketch.
The Art Institute of Chicago.

Upon his return to Paris in November, Gauguin resumed his friendship with Degas. Camille Pissarro was particularly unhappy about this friendship, and he wrote in a spiteful vein to his son Lucien: "Gauguin is very friendly with Degas again and goes to see him often. Curious, isn't it, this see-saw of interests!"[75] Pissarro, a recent but committed convert to the Pointillist school, could not accept the defection of Gauguin, which he regarded as a betrayal after so many years spent working side by side, with Gauguin as the pupil and he the guide.

What Pissarro attributed to self-interest was merely the result of a gradual change. Gauguin's independent mind was hostile to the whole idea of a system, and this trait brought him closer to the spirit of Degas. As is demonstrated by his Breton paintings, Gauguin's originality was becoming greater. Pissarro was to speak poorly of Gauguin from this time: "At any rate it must be admitted," he wrote to his son, "that he has finally acquired great influence. This comes of course from years of hard and meritorious work ... as a sectarian!"[76] The influence that Pissarro mentions was first felt by a group of young painters who collected around Gauguin during his initial visit to Pont-Aven. More than in his ideas or theories, Gauguin provided an irresistible example in his life-style and painting. He spoke the language of the young, who were highly responsive to his charisma. Sensing the all-embracing passion of the older man, overwhelmed by his air of self-confidence, fascinated by his work rather than his Parisian fame, Delavallée, Moret, and Ferdinand Loyen du Puigaudeau, among others, were to become his friends as well as his disciples. Pissarro, the erstwhile master, was enraged at this reversal of roles that found his former pupil surrounded by disciples and preaching a message completely opposed to his ideas. Unwilling to recognize the truth, Pissarro wrote: "This summer at the seashore he [Gauguin] laid down the law to a group of young disciples, who hung on the words of the master, that austere sectarian!"[77] These bitter thoughts, confided by an aging and disappointed Pissarro to his son Lucien,

show the gulf spreading not only between the two men but between two diverging currents within Impressionism. On the one side were those painters whom Pissarro called the Romantic Impressionists, among whom he numbered Gauguin. On the other side was the new school of the Divisionists, whose ranks Pissarro had joined. Pissarro's fundamental mistake in his analysis of the situation was his failure to recognize that Gauguin, like Cézanne, Degas, and van Gogh, actually belonged to no group but was following completely his own path.

The Voyage to the Antilles, 1887

Gauguin's return to Paris in November 1886 marked the start of a winter so miserable that the desire to get away became irresistible. He had to leave Paris — if not to regain his health, at least to find the calm and energy so necessary to his work. Thus, in April 1887 he set sail with Charles Laval for Panama and the tropics.

Contrary to what is often postulated, this period, while exotic, did not mark a break with what Gauguin had begun in Pont-Aven. He was still intrigued by the pursuit of rural themes. The scenery of Mar-

Paul Gauguin,
The Pond under the Trees
(Martinique), 1887,
oil on canvas, 35⅜ × 45⅝ in.
Bayerische Staatsgemäldesammlungen,
Munich.

tinique simply replaced the Breton countryside, and Gauguin portrayed it as a fertile and productive land. In his treatment of tree trunks, for example, highlighting the outside edges by a line or border and brushing the rest of the canvas with soft stripes, he continued a technique developed two years earlier in Normandy. Admittedly the light was different; the light in the tropics could not be treated in the same way as that of Brittany and the luxuriant vegetation of the Antilles could not be painted in the same way as temperate woodlands. Gauguin declared: "I have never had my painting so bright, so lucid."[78] If the canvases painted in Martinique in 1887 show a difference of intensity from those that preceded them, this was not the result of any basic change but simply the extension of the same techniques to a different climate. Gauguin discovered in Martinique an environment that matched his deepest aspirations and foreshadowed his imminent exile to the South Seas, far from Western Europe. On his arrival on the island, he wrote to his wife: "It is a paradise beside the isthmus. Below us is the sea fringed by palm trees, above us fruit trees of every kind.... Nature at its richest, a climate that is hot but refreshing from time to time."[79] The rich, comforting aspects of this tropical paradise shine out from the canvases of this period.

Breton Impressionism, 1888

Returning to Paris in mid-winter, Gauguin was able to sell three of his canvases to Theo van Gogh for nine hundred francs. Better still, Theo decided to organize a one-man show for Gauguin at the Boussod et Valadon gallery, boulevard Montmartre, in January 1888. This event marked the first time that Gauguin exhibited by himself in a reputable gallery, and he wrote: "This establishment has become the center of the Impressionists. Little by little Theo is having us devoured by his clients. Things look hopeful and I am convinced that before too long I will be doing fine."[80] The exhibition was not restricted to the Martinique canvases, but also included many from the visit to Pont-Aven, together with ceramic pieces, arranged like sculptures on pedestals. The Breton canvases must have been particularly successful, for he wrote soon afterward: "With things about to take off, I have to make another supreme effort with my painting and I am going to Brittany, to Pont-Aven, for six months to do some pictures."[81] In February, Gauguin moved back into the Pension Gloanec. The pension was empty; the weather was wet and snowy. Gauguin spent his time painting still lifes, the bare trees, and the roofs of Pont-Aven

covered in snow. The return of fine weather finally allowed him to work outdoors again and to paint more light-hearted subjects. Yet, this period brought about no major changes in either style or subject matter.

Surrounded by Laval, Moret, and the newcomer Ernest Ponthier de Chamaillard, Gauguin went on working. His *The First Flowers*[82] (illus., p. 86), *Little Breton Girls Dancing*[83] (illus., pp. 84-85), and *Conversation, Brittany*[84] (illus., p. 87) are joyful paintings, full of seductive charm and without intellectual complication. Although the atmosphere created in them is one of sentiment and emotion, these feelings are not transferred into philosophical ideas; nature is the actual subject matter rather than the pretext for theoretical explorations. Encouraged by his stay in the tropics and by his friends Theo and Vincent van Gogh, and reassured by the warmth of his disciples around him, Gauguin demonstrated new-found skill in combining the Impressionist style with the intimate characteristics of this particular region.[85]

In the month of June, Gauguin became reacquainted with Emile Bernard and was exposed to his novel aesthetics and innovative concepts of art. The personal touch Bernard stamped on Gauguin's style can be seen in Gauguin's *Vision After the Sermon*[86] of 1888. Yet, during the following year, Gauguin continued to oscillate between the Impressionist techniques that he used for his landscapes and the Synthetic manner that he adopted for figures and objects.[87] This dichotomy never completely disappeared, as can be seen in some of his Tahitian landscapes, especially those of his first visit in 1891-93 — *Noa-Noa, Embalmed Nature*[88] or *The Valley*,[89] both painted in 1892.

Moreover, Gauguin remained true to his pictorial inclinations and refused to abandon the central theme common to all his works: the representation of humanity at its simplest and most primitive. Brittany, long before Tahiti, was the cradle in which this relationship with nature, and corresponding artistic theory, formed and matured.

Paul Gauguin,
Little Breton Girls Dancing (hay-making scene in the Le Derout-Lollichon field, above the church in Pont-Aven), 1888, oil on canvas, 28⅝ × 36¼ in.
Mr. and Mrs. Paul Mellon Collection,
National Gallery of Art, Washington, D.C.

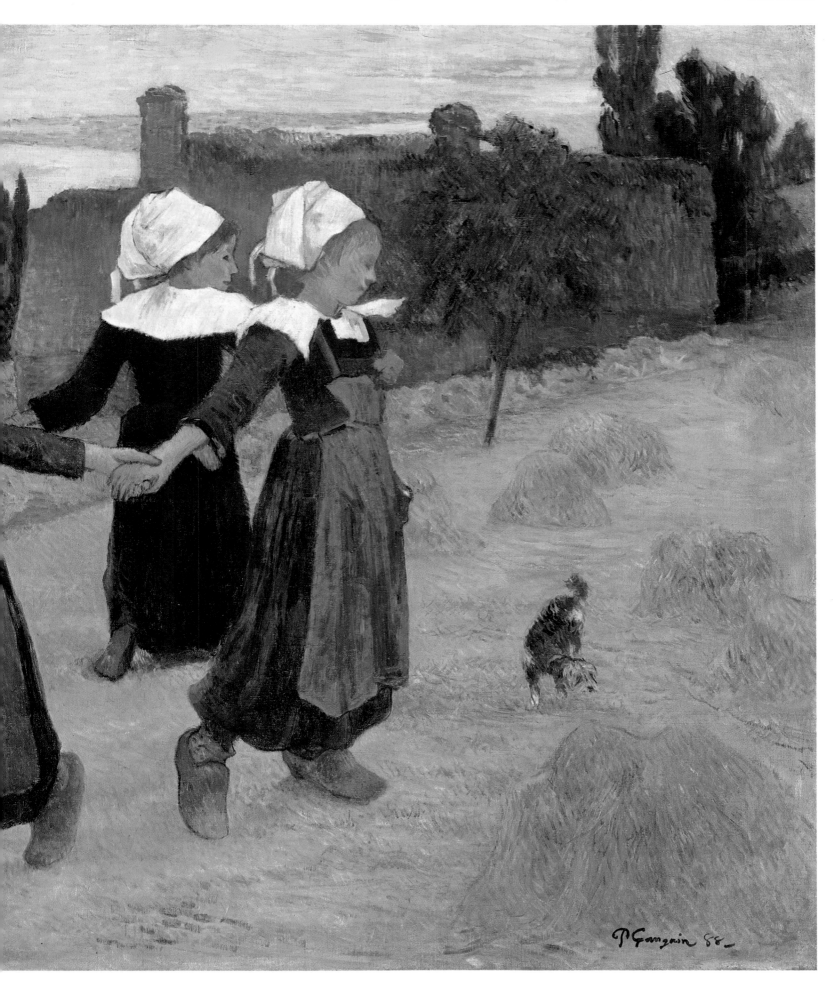

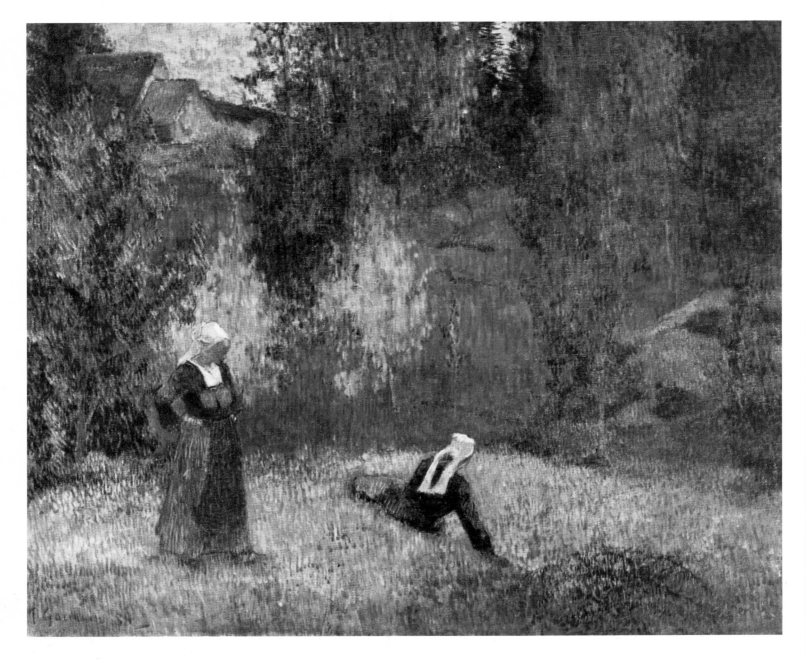

Paul Gauguin, *The First Flowers* or *Breton Women at Les Avins* (painted in the valley below the manor house of Lezaven, where Gauguin had his studio), 1888, oil on canvas, 28⅝ × 36¼ in.
Private collection.

Paul Gauguin, *Conversation, Brittany* (Pont-Aven), 1888, oil on canvas, 36¼ × 28⅝ in. ▷
Musées Royaux des Beaux-Arts de Belgique, Brussels.

NOTES

1 On the life of Gauguin, see Pierre Leprohon, *Paul Gauguin* (Paris: Gründ, 1975).

2 On this topic see "*Gauguin, ses origines et sa formation artistique,*" by Ursula Frances Marks-Van den Broucke in *Gauguin, sa vie, son œuvre, réunion de textes, d'études et de documents,* Georges Wildenstein, ed. (Paris: Presses Universitaires de France, 1958), pp. 35-50.

3 The largest collection of oils and pastels from Paul Gauguin's Impressionist period was originally in the collection of Mette Gauguin and her children, and now belongs to the Ny Carlsberg Glyptotek in Copenhagen.

4 This collection was sold at the Hôtel Drouot, Paris, on February 25, 1878.

5 Félix Fournachon, known as Nadar (1820-1910). Sketcher, writer, and photographer, he produced photographic portraits of the most important artists of his day and was an intimate friend of the Impressionist painters.

6 The official birth of Impressionism is dated 1874, the year in which the term was first used. Thirty artists grouped under the common title of "Cooperative Society of Painters, Sculptors, Engravers" exhibited together at 35 boulevard des Capucines. They included: Eugène Boudin, Félix Bracquemond, Paul Cézanne, Edgar Degas, Armand Guillaumin, Stanislas Lépine, Claude Monet, Berthe Morisot, Giuseppe de Nitis, Camille Pissarro, Pierre Auguste Renoir, and Alfred Sisley.

7 Paul Baudry (1828-1886). Son of a Vendée clog-maker, he gained his reputation through compositions inspired by Greek or Roman subject matter. He was the master of many of the official painters of the second half of the nineteenth century.

8 Georges Wildenstein and Raymond Cogniat, *Paul Gauguin, catalogue raisonné* (Paris: Beaux-Arts, 1964), no. 15.

9 Ibid., no. 14.

10 Ibid., no. 12.

11 Much of this important collection passed into the hands of Gauguin's wife when she went to live in Denmark. Gauguin gradually sold the other canvases he had left in Paris with Schuffenecker, to survive his most difficult periods.

12 Bouillot had a studio at the back of a courtyard at 74 rue des Fourneaux. After Gauguin carved a portrait of Mette in plaster, Bouillot sculpted it in marble. Soon Gauguin was sculpting the bust of his son Emil.

13 Jean Paul Aubé (1837-1916), after studying carving in Italy, first exhibited at the Salon in 1861. The bust of Prosper Mérimée that he showed was bought by the Institut. Well respected during his lifetime, he received numerous official commissions. His wife, who ran a pension for spinsters, gave Mette Gad a room when she arrived in Paris, and it was here that Gauguin met her. The Aubés remained on excellent terms with the Gauguin family.

14 This double portrait is in the collection of the Musée du Petit-Palais, Paris.

15 Leprohon, *Gauguin*, p. 52.

16 The Café de la Nouvelle Athènes, situated in the Place Pigalle not far from the Cirque Fernando, was commonly frequented by artists. About 1875 it replaced the Café Guerbois as the favorite evening meeting place of the Impressionists. The most regular visitors included Manet and Degas, along with such painters and poets as Ary Renan, Jean Richepin, and Villiers de L'Isle-Adam. On this subject see John Rewald, *The History of Impressionism* (London: Secker and Warburg, 1980), pp. 399ff.

17 René Huyghe, *Gauguin* (Paris: Flammarion, 1967), p. 16.

18 Reported in *La Vie moderne,* June 12, 1880.

19 These three paintings are, respectively: W. no. 36; W. no. 35; and W. no. 39. (References are to Wildenstein, *Paul Gauguin, catalogue raisonné.*)

20 Reported in *L'Art moderne* in 1881.

21 A few months later Gauguin wrote to Pissarro: "Has M. Cézanne found the exact formula for work acceptable to everyone? If he discovers the prescription for compressing the intense expression of all his sensations into a single and unique procedure ... come immediately to Paris to share it with us." Letter quoted in Rewald, *The History of Impressionism,* p. 458.

22 Maurice Serullaz, *Encyclopédie de l'impressionnisme* (Paris: Somogy, 1973), p. 147.

23 Quoted by Henri Stanislas Rouart, *Correspondance de Berthe Morisot* (Paris, 1950).

24 "Nobody will ever convince me that, for Degas, Raffaëlli is not merely a pretext for a break; that man has a perverse spirit which destroys everything." Letter from Gauguin to Pissarro, January 18, 1882, quoted in Rewald, *The History of Impressionism,* p. 467.

25 I.e., Jean Louis Forain, Jean François Raffaëlli, and Federico Zandomeneghi.

26 Caillebotte, Gauguin, Guillaumin, Monet, Morisot, Pissarro, Renoir, Sisley, Victor Vignon.

27 Leprohon, *Gauguin*, p. 61.

28 Ibid., p. 76.

29 In the space of a few months Gauguin earned 40,000 francs in commissions, brokerage fees, and profits.

30 "The recent crash had forced Gauguin to abandon the bank and he now was able to paint every day." Rewald, *The History of Impressionism,* p. 490.

[31] Wildenstein, *Paul Gauguin, catalogue raisonné*, no. 88.

[32] Ibid., no. 86.

[33] "This painter had a deep and lasting influence on him [Gauguin]; how many of the pictures painted in Brittany were inspired by the memory of those humble lives glorified by Millet?" Quoted in Marks-Van den Broucke, "*Gauguin, ses origines et sa formation artistique.*"

[34] Huyghe, *Gauguin*, p. 26.

[35] "He [Gauguin] is coming to see me in Rouen to study the place from a practical and artistic viewpoint. He thought naively that the people of Rouen were very rich...." Letter from Pissarro to his son Lucien, October 31, 1883.

[36] Paul Rollon, known as Pola, author of *Paul Gauguin, mon père*, based on memories recounted by his mother.

[37] Wildenstein, *Paul Gauguin, catalogue raisonné*, no. 122.

[38] Ibid., no. 99.

[39] Ibid., no. 133.

[40] On this period of Gauguin's life in Denmark, see "*Gauguin et le Danemark*" by Haavard Rostrup, in Wildenstein, *Gauguin, sa vie, son œuvre*, pp. 63-82.

[41] Letter to Schuffenecker, January 14, 1885. Quoted in Maurice Malingue, ed., *Lettres de Paul Gauguin à sa femme et à ses amis* (Paris: Grasset, 1946), pp. 44-47.

[42] Wildenstein, *Paul Gauguin, catalogue raisonné*, no. 148.

[43] Ibid., no. 141.

[44] Ibid., no. 138.

[45] Malingue, *Lettres*, p. 47.

[46] Ibid., p. 45.

[47] Ibid., p. 46.

[48] John Rewald, *Post-Impressionism from van Gogh to Gauguin*, third rev. ed. (New York: The Museum of Modern Art, 1978), pp. 174-75.

[49] Wildenstein, *Paul Gauguin, catalogue raisonné*, no. 160.

[50] Ibid., no. 158.

[51] Ibid., no. 159.

[52] Ibid., no. 172.

[53] Ibid., no. 166.

[54] These society painters were James MacNeill Whistler, Paul Helleu, and Jacques Emile Blanche, who later wrote about Gauguin: "If the man was not mad, he must have been a customer of those medieval bars in the Pigalle district where we went with the poets." *"De Gauguin à la revue nègre,"* article in *Revue de Paris*, March 1920.

[55] In answer to Daniel Halévy's question "Who is Gauguin?" Degas replied: "A man who is dying of hunger and whom I admire deeply as an artist." Leprohon, *Gauguin*, p. 67.

[56] At the public auction at the Hôtel Drouot on February 23, 1891, Degas bought lot 3, *La Belle Angèle*, for 450 francs; on February 18, 1895, he bought lot no. 2, *Vahiné No Te Vi*; lot 49, a copy of Manet's *Olympia*, for 230 francs; a drawing entitled *Cottage* for 40 francs; and another drawing, entitled *Woman Bathing*, for 28 francs. See the catalog of the Gauguin exhibition held at the Orangerie des Tuileries in 1949, p. 95ff.

[57] Malingue, *Lettres*, letter 35, p. 83.

[58] "When Pissarro returned there one evening in the company of Seurat, Signac and Dubois-Pillet, Guillaumin and Gauguin refused to shake hands with Signac, and after some heated explanations, Gauguin left abruptly without saying goodbye to anybody." Rewald, *Post-Impressionism from van Gogh to Gauguin*, p. 39.

[59] Wildenstein, *Paul Gauguin, catalogue raisonné*, no. 183.

[60] Félix Fénéon, *Au delà de l'Impressionnisme* (Paris: Hermann, 1966), p. 62.

[61] Wildenstein, *Paul Gauguin, catalogue raisonné*, no. 203.

[62] Ibid., no. 201.

[63] Ibid., no. 206.

[64] Ibid., no. 196.

[65] Ibid., no. 197.

[66] Marie Lepape, one of the serving girls at the pension, recounted her memories to Pierre Tuarze. See his *Pont-Aven, art et artistes* (Paris: La Pensée Universelle, 1973).

[67] *Post-Impressionism in Europe* (London: Royal Academy of Arts, 1979), nos. 81-82, pp. 72-73.

[68] On this topic see "*L'Influence de l'estampe japonaise dans l'œuvre de Gauguin,*" by Yvonne Thirion, in Wildenstein, *Gauguin, sa vie, son œuvre*, pp. 95-114.

[69] Ibid. note 67, p. 72.

[70] Ibid., note 67, p. 73.

[71] Ibid.

[72] Quoted by Leprohon, *Gauguin*, p. 95.

[73] "A word that was often on his lips was synthesis, for synthesis interested him already. Gauguin painted in little dabs.... He used his colors as fresh as possible but he especially liked stripes." Delavallée to Charles Chassé. See Chassé, *Gauguin et son temps* (Paris: Bibliothèque des Arts, 1955), p. 144.

[74] Ibid., note 72, p. 95.

[75] Camille Pissarro, *Letters to His Son Lucien*, edited with the assistance of Lucien Pissarro by John Rewald (Mamaroneck, N.Y.: Paul Appel, 1972), p. 81.

[76] Ibid., p. 97.

[77] Ibid., pp. 96, 97.

[78] Letter to Schuffenecker, in Malingue, *Lettres*, letter 57, p. 117.

[79] Letter to Mette, June 20, 1887, in Malingue, *Lettres*, letter 53, pp. 109, 110.

[80] Letter to Mette, December 6, 1887, in Malingue, *Lettres*, letter 59, p. 121.

[81] Letter to Mette, undated, in Malingue, *Lettres*, letter 60, p. 123.

[82] Wildenstein, *Paul Gauguin, catalogue raisonné*, no. 249.

[83] Ibid., no. 251.

[84] Ibid., no. 250.

[85] "My latest work is going well ... affirming my earlier research or synthesis of a form and a color while considering only the dominant one." Letter to Schuffenecker, August 14, 1888, in Malingue, *Lettres*, letter 67, p. 135.

[86] Wildenstein, *Paul Gauguin, catalogue raisonné*, no. 245.

[87] Compare, for example, *The Barrier* (W. no. 353) of 1889 and *The Two Young Breton Girls in Front of the Ocean* (W. no. 340) of the same year.

[88] Wildenstein, *Paul Gauguin, catalogue raisonné*, no. 487.

[89] Ibid., no. 488.

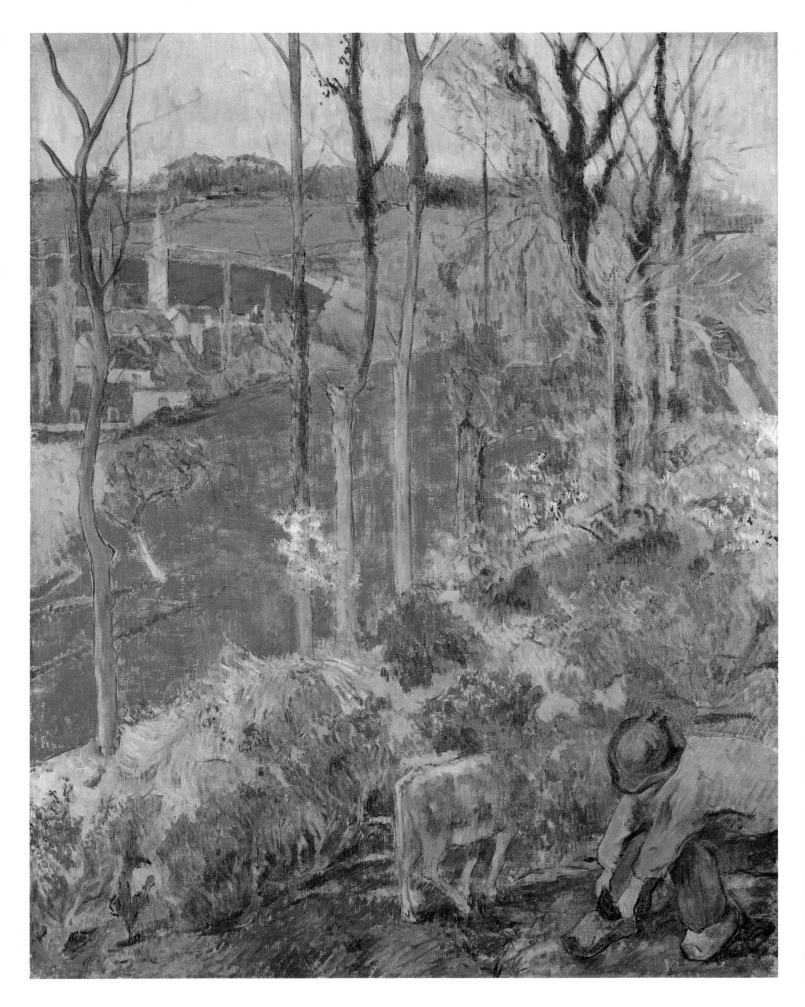

THE LIFE OF THE GROUP AT PONT-AVEN

Birth of a School:
Gauguin at Pont-Aven

FROM the time of his arrival at Pont-Aven in June 1886, Gauguin drew prolifically and filled his notebooks with sketches for his paintings. In July 1886 he wrote to his wife: "I'm working a lot here.... I'm turning out a lot of sketches."[1] The canvases he painted at Pont-Aven that summer were different from the ones painted at Osny the previous year in that the colors were slightly more subdued and the perspectives were often steeper, showing the influence of Japanese art. Yet in terms of technique, style, palette, and the choice of rural subjects, Gauguin remained completely Impressionist during his first stay at Pont-Aven. His meeting with Emile Bernard in August brought no change of style, since the two men remained strangers, each withdrawn into his own aesthetic musings.

Even though Gauguin's paintings of this period appear extremely restrained when compared with the audacious canvases he painted at Pont-Aven in 1888, his works of 1886 nevertheless caused a stir within the artist colony at Pont-Aven. At the end of June, he wrote to his wife: "My painting is causing a lot of discussion," and he added: "I must tell you, it is favorably received by the Americans. This gives me hope for the future...."[2] He continued: "I'm working successfully. I'm respected as the best painter in Pont-Aven.... I'm getting a reputation, a position of respect, and all the painters here American, English, Swedish, French are clamoring for my advice...."[3]

Paul Gauguin,
Portrait of the Painter Achille Granchi-Taylor
(Gauguin made his first journey from Paris to Pont-Aven accompanied by Granchi-Taylor in 1886), 1885,
oil on canvas, 18⅛ × 21⅝ in.
Kunstmuseum, Basel.

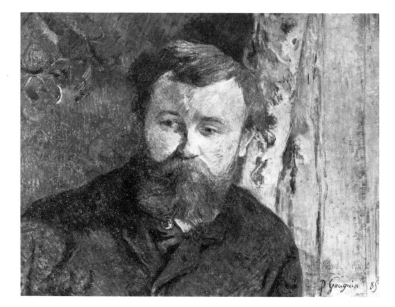

Paul Gauguin,
Winter, Breton Boy Adjusting His Clog, with Village of Pont-Aven in the Background (painted from the Lezaven hills, which overlook the village), 1888,
oil on canvas, 35⅜ × 28 in.
Exhibited in 1889 at the Café Volpini under the title *Winter, Breton Boy Arranging His Clog, with Village in the Background.*
Ny Carlsberg Glyptotek, Copenhagen.

Paul Gauguin,
Breton Boy on a Ladder (Pont-Aven), 1886,
pencil and crayon.
Dr. Armand Hammer Collection, U.S.A.

During this summer, he met Charles Laval, a young man of twenty-two, who was suffering from tuberculosis. Intrigued by Gauguin's strong personality, Laval accompanied Gauguin on his voyage to Panama the following year. Another acquaintance was Ferdinand Loyen de Puigaudeau, who was responsible for persuading Gauguin to take part in an exhibition at Nantes during the summer. "The rich young man who discreetly paid [Gauguin's] bills at the Pension Gloanec," as the English painter A. S. Hartrick says in his account of the period,[4] was de Puigaudeau. He and Gauguin wrote to each other often during 1887, when the former was in Hyères and the latter in the Antilles. Gauguin also met Henri Delavallée, twenty-four years old and a frequent visitor to Pont-Aven since 1881. There was also Henry Moret, thirty years old, who had been painting in Brittany for ten years and was a regular visitor

to Pont-Aven. Moret and Gauguin also spent time together during that year in Le Pouldu, as evidenced by two canvases painted at Le Pouldu: Gauguin's *Breton Woman Herding Her Cows on the Beach at Le Pouldu*[5] (illus., p. 166), dated 1886, and Moret's *The River at Bas-Pouldu*, dated the same year.[6] And there was the colorful artist Achille Granchi-Taylor, whose portrait Gauguin painted in Paris in 1885 (illus., p. 91). Granchi-Taylor, another ex-stockbroker and a skilled draftsman, regularly dressed in frock coats and tophats, with bare feet pushed into a pair of clogs. These and lesser-known artists formed a group around Gauguin during the summer of 1886, which came to be referred to as "Gauguin's gang."

After the departure in the fall of many of these artists, Gauguin wrote: "The evenings at Pont-Aven are a bit long when you are alone and work is over for the day ... there is complete silence around me. It's

Paul Gauguin,
Breton Boy Filling a Jug (Pont-Aven), 1886,
pencil and crayon.
Dr. Armand Hammer Collection, U.S.A.

not much fun, I admit. Every day is like the one that went before, so I have nothing to tell you that you haven't already heard."[7] Gauguin now devoted more of his time to painting. "I have never been so active. I'm not getting fat on this job ... I'm getting as dry as a herring, but to compensate I can feel myself getting younger: the more I work, the stronger I become."[8] In the month of November, when he was about to leave Pont-Aven, he was able to report with satisfaction: "I'm busy packing up my work. A lot of studies."[9]

In February 1888 Gauguin returned to Pont-Aven for the second time. He wrote: "I am leaving on Thursday for Pont-Aven. Obviously the countryside in winter won't do my health any good, but I need to work for seven or eight months absorbing the character of the people and the area. This is essential if I am to paint well."[10] Unfortunately his health, seri-

Paul Gauguin,
Breton Boy Tending His Geese (Pont-Aven), 1886,
pencil and crayon.
Dr. Armand Hammer Collection, U.S.A.

Paul Gauguin,
Breton Boy Carrying a Jug (Pont-Aven), 1886,
pencil and crayon.
Dr. Armand Hammer Collection, U.S.A.

ously affected by the voyage to Martinique and his earlier poverty, prevented him from working as much as he had hoped. In March he wrote to his wife: "Since arriving here, I've been in bed almost continuously.... I am alone in my room at the pension from morning to night. There is no one with whom I can exchange an idea."[11]

According to this letter, written in mid-winter at the beginning of his visit in 1888, Gauguin was living without his artist friends. They arrived later, with the better weather. To Schuffenecker he wrote on March 26: "Thank you for the fifty francs you sent. Although it's not enough to solve the problem [of chronic shortage of money] it's made me feel much better. For the last few days all trace of illness has disappeared and I think I'll soon be up and about again. But God how dreary everything is at present! No snow, just rain and hail. It's impossible to work

outdoors and I can't obtain a model for indoor work."[12] With no model available, Gauguin turned to painting still lifes.[13]

During the following months, as the weather became warmer the first friends arrived at the pension. Life was especially lively that year for the "Impressionist gang." The first arrival was Laval, back from Martinique, followed by Moret, du Puigaudeau, Delavallée, and Ernest Ponthier de Chamaillard.[14] There was Emile Jourdan, who later recalled: "I introduced myself, Gauguin greeted me coldly, looking on me as a high-society type from Paris, the kind of person for whom he had no time! Taking no further notice of me he went on working. He was sculpting a piece of wood that he had set up near the fireplace. I must add, though, that within a few days we were good friends...."[15] There was Emile Bernard, arrived from Saint-Briac. Gauguin wrote, in August: "Little Bernard is here. He has brought some interesting things from Saint-Briac." (Soon after his arrival, Bernard was joined by his mother and young sister, Madeleine, with whom both Gauguin and Laval fell in love.) Gauguin said: "The 'gang' is growing."[16]

These artists gathered around Gauguin, who had just celebrated his fortieth birthday. According to Emile Jourdan: "He was surrounded by young painters whom he was training, young men who had come under his influence or who simply admired him."[17] Nonetheless, during this summer Gauguin found a somewhat different atmosphere and received a much less warm welcome from the other, more academic artists. He wrote in a letter on August 14, 1888, to his friend Schuffenecker: "All the Americans are up in arms against Impressionism."[18]

This little group was joined, in September, by Paul Sérusier, student-in-charge at the Atelier Julian in Paris, a position that made him slightly wary of the "provocative Impressionists." A guest at the Pension Gloanec for several weeks, Sérusier had been watching the "gang" from a distance and longed to get to know them and hear about their ideas. His eventual meeting with Gauguin produced the famous *Talisman*, painted in September under Gauguin's guidance.

Gauguin profited from this summer both by teaching others and by learning himself, from Bernard. Soon after Bernard had arrived and shown him his *Breton Women in a Green Meadow*, he wrote to

Schuffenecker, who was spending the summer in Etretat: "One word of advice, don't paint too much from nature, art is abstraction."[19] Gauguin had been experimenting on his own and, in July, before Bernard had arrived at Pont-Aven, he wrote to Schuffenecker: "I have just finished a few 'nudes' that you will like. They are not at all like Degas'. The most recent shows boys wrestling beside a river, completely Japanese, by a savage from Peru. Not much detail, just green lawns and white sky."[20] Yet, it was Bernard's innovations that proved to have a decisive influence on Gauguin's work, although Gauguin was reluctant to give Bernard much credit for these developments. Gauguin wrote: "My latest work is going well. I think you would recognize it as something special or rather [he corrected himself, afraid of losing the credit for his 'discovery'] the affirmation of *my* earlier work or *synthesis of form and color* to their most dominant form."[21]

In October, Gauguin confided to Bernard: "I am as satisfied as I can be with the result of my work at Pont-Aven. Degas is to buy the painting of the two 'Breton women at Les Avins.' I find this extremely flattering. As you know, I have the greatest confidence in Degas's judgment."[22] The canvas mentioned here by Gauguin was painted below Lezaven, an old manor house built in the late sixteenth century on the Bel-Air hill. He also wrote in October to his friend Schuffenecker who had just returned from Normandy: "I would have loved to see the paintings you brought back from the seaside [the Yport can-

Pont-Aven:
present-day view of the ruined cottage in the Derout-Lollichon field.

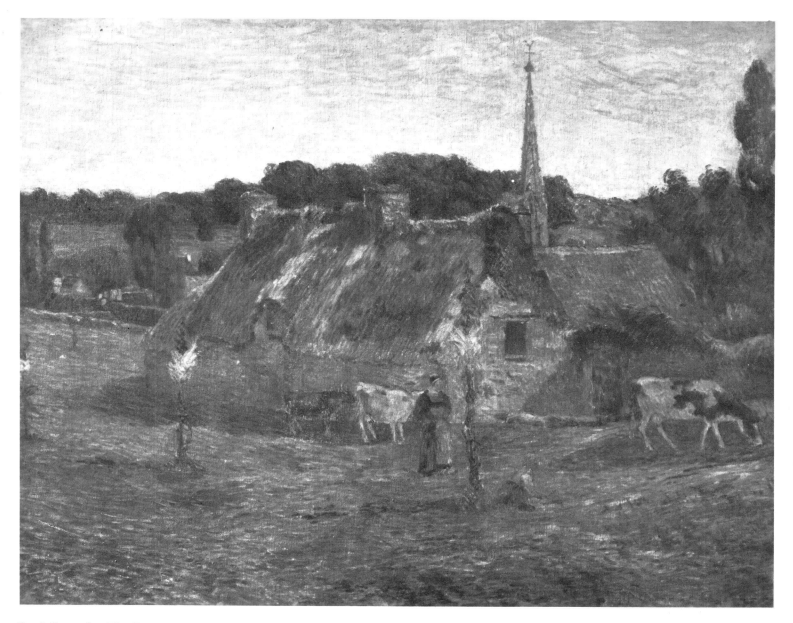

Paul Gauguin, *The Derout-Lollichon Field* (Pont-Aven), 1888 (third version), oil on canvas, 26 × 39⅜ in. Barber Institute of Fine Arts, University of Birmingham, England.

vases that were to be exhibited the following year at the Café Volpini]; I'm sure they must be interesting.... Since your last letter I've been in bed with a terrible attack of dysentery [Gauguin was in fact confined to bed at the pension when Paul Sérusier made his acquaintance in September]. Now I'm up and about again. I've painted a painting for a church [at Nizon], the *Vision After the Sermon,* of course it was refused.... There's no need to describe it, you'll see it." Summing up the nine months spent at Pont-Aven, he concluded: "This year I've sacrificed everything—execution, color—to style, trying to do something different from what I know how to do."[23]

Gauguin was undergoing a period of change when he abruptly left Pont-Aven to join Vincent van Gogh in Provence: "I'm leaving at the end of the month for Arles, where I will stay a long time, I believe."[24] He stayed from October 23 to December 24, when the two men quarreled so violently that they were never to meet again.[25] During the temporary absence of Gauguin, the life of the group continued, with the master advising Laval and Bernard from a distance: "You are discussing the use of shadow with Laval.... My dear Bernard, put in shadows if you think they serve a purpose, or don't put them in, it makes no difference."[26] The result of the work of the summer of 1888 at Pont-Aven was the exhibition at the Café

Volpini in Paris that took place the following year. The Volpini exhibition is considered to be the first sign of the existence of a Pont-Aven group. In the spring of 1889, on his return to Pont-Aven, Gauguin wrote to Schuffenecker: "Bravo, you have succeeded.... Only bear in mind that it's not an exhibition for the others ... [but] for a group of friends."[27] Gauguin included in this letter a list of ten works he wanted to exhibit, of which at least six are Breton scenes. The six listed by Gauguin, in order, are:

2 *The Grand Breton with the Little Blue Boy* (canvas of 30)
3 *Breton Women* (one standing, one on the ground)
4 *Winter* (Breton boy arranging his clog with village in the background)
5 *The Presbytery* (landscape of 1886)
6 *The Dance of the Little Girls*
10 *The Two Child Wrestlers*

In the end, it was not ten but seventeen canvases by Gauguin that were exhibited, of which the following eleven catalog entries were Breton in inspiration:

31 *First Flowers*, Brittany
33 *Conversation*, Brittany
34 *Winter*, Brittany
35 *Presbytery in Pont-Aven*
36 *Dance in the Hay*
40 *Young Wrestlers*, Brittany
42 *Eve*, watercolor
43 *Human Misery*
44 *In the Waves*
45 *The Model*, Brittany
47 *Landscape*, Pont-Aven

As part of his eighteen paintings, Schuffenecker exhibited two produced at Concarneau in 1886, the year of his meeting with Bernard:

59 *Corner of the Beach at Concarneau*
60 *Sunset at Concarneau*

Of the twenty-five works exhibited by Emile Bernard (twenty-three under his own name and two under the pseudonym Ludovic Nemo), at least sixteen were executed in Brittany:

10 *Pont-Aven Landscape*
11 *Saint-Briac Landscape*
14 *Breton Women*
15 *Kerlaouen castle*
18 *Road to Calvary*

Pont-Aven: present-day view of the manor house of Lezaven, where Paul Gauguin had a studio.

19 *Harvest*
19bis *Saint-Briac landscape*
75 *Bathers*
76 *Kerlaouen Castle*
77 *Nudes*
79 *Poplars*
80 *Sketches at Pont-Aven*, 3 watercolors
86 *Women and Geese*
88 *Breton Caricatures*

Charles Laval, whose address was Pont-Aven (Finistère) according to the catalog, exhibited ten works, of which at least three had been conceived in Brittany:

85 *Going to Market*, Brittany[28]
93 *The Willow*, Pont-Aven
95 *The Aven, Stream*

Curiously, Charles Filiger was not among the exhibitors, although his name appears in the catalog as the owner of canvas no. 50, entitled *At Gif* and painted by Schuffenecker's friend Louis Roy.[29] One should not place too much importance on this, since much of the information in the catalog is dubious; Emile Bernard appeared under two different names

and item no. 96, *Race by the Sea,* a Martinique watercolor by Charles Laval, was described as the property of Monsieur Ripipoint. This totally imaginary character was probably invented by Emile Bernard to make fun of Pointillism and "Signac's gang," who were excluded from the "Impresssionist and Synthetist group" exhibiting at the Volpini. Gauguin had the same attitude toward Pointillism and wrote on November 13, 1888: "I'm going to organize in Brussels a serious exhibition in opposition to the little spots."[30] To further mock the Pointillists, Bernard wrote a facetious poem cycle— *"Au petit point, La Naissance de Ripipoint, La Mélopée des petits points avec la manière de s'en servir "*— which was highly successful at Pont-Aven. Bernard's "poetry" remained popular in Le Pouldu in 1889 when Gauguin painted his famous Pointillist still life, dedicated humorously: "From Ripipoint to Marie."

After a few months in Paris, where he met Jacob Meyer de Haan at Theo van Gogh's house, in March 1889 Gauguin set off once more for Pont-Aven. He was accompanied by his new disciple, de Haan, who had agreed to pay Gauguin's bills at the pension in

return for lessons. Gauguin stayed for two months before returning to Paris in May for the Universal Exhibition. This visit to Paris was brief, however, and by the end of May he was back in Pont-Aven with de Haan, where he rented a studio outside the village, at Lezaven.[31]

To Bernard, exiled in Saint-Briac on the orders of his father, who did not want his son associating with a man as "debauched" and "perverted" as Gauguin, he wrote in June: "I have here your letter to Laval which he has shown me. I thought you were in Paris and you are at Saint-Briac on the orders of your father who has forbidden you to come to Pont-Aven. You won't be missing much since Pont-Aven is full of a crowd of abominable foreigners. Fortunately I've got a studio at Avins where I can shut myself away."[32] At Avins he painted *The Breton Shepherdess, The Yellow Christ, La Belle Angèle,* and *The Keeper of Geese.*

Gauguin made a brief visit to Le Pouldu in June with Meyer de Haan, but soon became bored at being alone with him: "I've been at Le Pouldu for a month with de Haan; that's why I've been in an awful state of depression."[33] He was eager to return to Pont-Aven and the friends he made there: "I'm returning in three days to Pont-Aven, since I've run out of money and I can get credit there. I plan on staying there until the winter." He spent the three months between July and September at Pension Gloanec. He wrote to Schuffenecker on September 1: "I thought that you were coming to Port-Manech[34] (see illus., p. 47) too.... Now I realize you aren't.... Not much news here, except that I'm working." He concluded with these words, marking the triumph of the aesthetic concepts of the Pont-Aven period: "The struggle at Pont-Aven is over; everyone is crushed and the Atelier Julian is turning away from the official art. They are shattered by Manet's success at the Centennial."[35]

Gauguin's work had progressed as well, and he recognized it: "Back in Pont-Aven until the end of September, I have just finished two good canvases, good in the sense that they are almost the expression of what I am after at this time. I say almost and I am satisfied.... I have also done a large panel of 30 in sculpture.... As sculpture this is my best and strangest so far."[36] Finally he wrote to Bernard: "For this winter we might have a large house that de Haan

wants to rent.[37] On the top floor there is a studio twelve meters by fifteen overlooking the sea. If we do, Laval and Moret will join us so we would be able to eat very cheaply. You can complete the group if you like."[38] The final move to Le Pouldu followed shortly after and Gauguin remained there for thirteen months "nailed to Le Pouldu by debt with little hope of escape."[39]

When Gauguin departed on November 7, 1890, he left Marie Poupée, to whom he owed 300 francs, all of his paintings as security. She proved to be much less understanding and generous than Marie-Jeanne Gloanec. Gauguin never got them back. When, after Tahiti, he returned to Pont-Aven for the last time, in April 1894, Marie Poupée had moved from Le Pouldu and refused to return the paintings even though the debt had been paid.[40] Gauguin twice instituted and lost his court case against her.

Seriously injured in May 1894 in a brawl at Concarneau, Gauguin had to keep to his room.[41] Although Madame Gloanec looked after him devotedly, he never completely recovered. His failing health, his money problems, the loss of his lawsuits and all his work, the pillaging of his Paris studio by Annah, his mistress,[42] all combined to precipitate his definitive departure for Tahiti.

When Gauguin left for Tahiti in April 1891, the first stage in his development and the most important of his visits to Brittany ended. Nevertheless, the life of the group continued in his absence. In 1891, from April to June, guests at the Pension Gloanec included Jan Verkade[43] and Mögens Ballin.[44] During the summer of 1892 Bernard returned and remained until the end of winter,[45] joining Armand Séguin[46] and becoming acquainted with Renoir, who

was at the Hôtel Julia. New arrivals in Pont-Aven in 1892 included Cuno Amiet[47] from Switzerland and the Irishman Roderick O'Conor,[48] who both met Bernard and his mistress, Maria, before they left for Florence in March 1893.[49]

In 1892 Marie-Jeanne Gloanec bought the Lion d'Or and took over the running of the hotel. When Gauguin returned in April 1894 he met Chamaillard and Filiger there, as well as several newcomers: Georges Chaudet,[50] a friend of Sérusier, Loiseau, Séguin, and O'Conor. Close links formed at Pont-Aven between the British painters: Eric Forbes-Robertson,[51] Robert Bevan,[52] O'Conor, the American Henry Osawa Tanner,[53] and Gauguin's group: Filiger, Séguin, Verkade, Sérusier, and the poet Alfred Jarry.[54] Art students from both sides of the Atlantic chose to spend the summer at Pont-Aven because it had become a center for progressive art.

The last period spent by Paul Gauguin at Pont-Aven, from April to November 1894, was little more than one of painful convalescence: "How can one have the right to assassinate or maim an innocent party, simply because he is a stranger to Concarneau.... In these small towns, justice cares only for those in power."[55] "For two months," he wrote to William Molard, "I've had to take morphine every night and I'm really stupefied at the moment.... I'm limping with a stick and really upset that I can't get out to paint a landscape."[56]

After so many months spread over so many years, during which Gauguin went up and down the roads around the stone bridge that gives Pont-Aven its name, he left Brittany for the last time in 1894, never to return.

NOTES

[1] Maurice Malingue, *Lettres de Paul Gauguin à sa femme et à ses amis* (Paris: Grasset, 1946), letter 41, p. 92.

[2] Ibid., letter 41, p. 92.

[3] Ibid., letter 42, p. 94.

[4] A. S. Hartrick, *A Painter's Pilgrimage Through 50 Years* (Cambridge, England, 1899).

[5] Georges Wildenstein and Raymond Cogniat, *Paul Gauguin, catalogue raisonné* (Paris: Beaux-Arts, 1964), no. 206.

[6] Henry Moret, Brest Auction, May 1980, cat. no. 241.

[7] Malingue, *Lettres*, letter 43, pp. 95-96.

[8] Ibid., letter 42, p. 94.

[9] Ibid., letter 44, p. 96.

[10] Ibid., letter 61, p. 124.

[11] Ibid., letter 62, pp. 124-25.

[12] Ibid., letter 63, p. 128.

[13] Wildenstein, *Paul Gauguin, catalogue raisonné*, nos. 217, 288, 289, 290, 291, 293, 294.

[14] André Salmon, *Souvenirs sans fin* (Paris: Gallimard, 1969), vol. 2, p. 239.

[15] E. Jourdan, quoted by Léon Tual in the newspaper *La Dépêche de Brest*, August 24, 1924.

[16] Malingue, *Lettres*, letter 67, p. 134.

[17] Ibid., note 15.

[18] Ibid, letter 67, p. 134.

[19] Ibid.

[20] Ibid., letter 66, p. 133.

[21] Ibid., letter 67, p. 134.

[22] Ibid., letter 68, p. 136.

[23] Ibid., letter 71, p. 140.

[24] Ibid., letter 71, p. 141.

[25] Vincent van Gogh died in 1890.

[26] Malingue, *Lettres*, letter 75, p. 150.

[27] Ibid., letter 77, p. 152.

[28] Painted in 1888, this canvas was acquired in 1978 by the Samuel Josefowitz Collection, Lausanne, from the Ambroise Vollard Collection.

[29] See Elisabeth Walter, "Le Seigneur Roy: Louis Roy," *Bulletin des Amis du Musée de Rennes,* numéro spécial: Pont-Aven, no. 2 (Summer 1978), pp. 61-72. A colleague of Schuffenecker at the Lycée de Vanves, Roy printed the proofs of many of Gauguin's prints.

[30] Malingue, *Lettres*, letter 74, p. 148.

[31] In 1894 Roderick O'Conor painted *The Farm at Lezaven, Finistère*, which now belongs to the National Gallery of Ireland, Dublin, and was exhibited at the Post-Impressionism exhibition at the Royal Academy, London, 1979, cat. no. 324.

[32] Malingue, *Lettres*, letter 84, p. 162.

[33] Ibid., p. 162.

[34] Port-Manech: a small fishing harbor, six miles from Pont-Aven, on the Aven estuary.

[35] Malingue, *Lettres*, letter 86, pp. 164-65.

[36] Ibid., letter 87, p. 167.

[37] This villa belonged to the De Mauduit family and was later converted into the Castel-Tréaz Hotel.

[38] Malingue, *Lettres*, letter 87, pp. 167–68.

[39] Ibid., letter 91, p. 171.

[40] In 1893, Marie Poupée moved to Moelan with her two young daughters, Ida and Marie, before going on to Kerfany, where she was visited by Slewinski in 1911. At that time, she still had some twenty of Gauguin's pictures.

[41] "Yes, I walk with a limp and am in deep dispair, not being able to go far to paint." Gauguin to William Molard in Malingue, *Lettres*, letter 92, p. 260.

[42] Annah the Javanese, of whom Gauguin did a spectacular portrait. Wildenstein, *Paul Gauguin, catalogue raisonné*, no. 508.

[43] Verkade (1868-1946) was nicknamed "le Nabi obéliscal" because of his tall, thin physique. Arriving from his native Holland in Paris in 1891, he soon joined the Nabis and converted to Catholicism in 1892.

[44] Mögens Ballin (1871-1914) was a Danish artist. He was present at the farewell dinner given in Gauguin's honor in Paris in March 1891, armed with a letter of introduction from Mette Gauguin to her husband. Introduced into the Nabi group by Verkade, he came under the theoretical influence of Sérusier and Denis. After a number of visits to Brittany between 1891 and 1894, he returned to Copenhagen, where he abandoned painting to set up a bronze foundry.

[45] Emile Bernard's visit to Pont-Aven, after the 1891 departure of Gauguin, produced a number of extraordinary paintings, such as *Breton Women Going to Church with Their Children*, 29½ × 39⅜ in., Mr. and Mrs. Francis Lombrail Collection, France; *Breton Women with Umbrellas*, 32⅝ × 46⅛ in., Musée d'Orsay, Paris; *Two Breton Women on a Wall*, 31⅞ × 45⅝ in., Samuel Josefowitz Collection, Lausanne.

[46] Armand Séguin (1869-1903) was twenty-two when he arrived in Pont-Aven for the first time, in 1891. Initially he came under Bernard's influence. His first known Breton engraving, which is dated 1891, took its inspiration from Gauguin's *Dance at Pont-Aven*. Séguin did not meet and work alongside Gauguin, however, until 1894. In the intervening years, he felt the influence first of Louis Legrand, then of Maufra in 1892, and O'Conor in 1893.

[47] Cuno Amiet (1868-1961) was a Swiss painter, who discovered Pont-Aven in 1892 and returned again in 1893. He was a friend of O'Conor and Bernard in particular.

[48] Roderick O'Conor (1860-1940) arrived in Pont-Aven from Ireland in 1892. *Yellow Landscape at Pont-Aven* (Barnet Shine Collection, London) dates from the year of his arrival. In 1894 he became friendly with both Gauguin and Slewinski. Besides his paintings, his engravings are among the most important, although relatively unknown, of the Pont-Aven school.

[49] Leaving Pont-Aven in 1893, Emile Bernard visited Italy, Turkey, and the Greek islands, before marrying an Egyptian woman of Syrian origin in Cairo. He did not return to Europe until ten years later.

[50] Georges Chaudet, a painter, acted as Gauguin's "salesman" for many years; he died in 1899.

[51] Eric Forbes-Robertson (1865-1935) first went to France in 1881 as a student at the Académie Julian. He first visited Pont-Aven in August 1890, probably accompanied by Robert Bevan, and lived at the Hôtel Julia until 1894. At the end of 1891 Forbes-Robertson became friendly with Séguin. Both Gauguin in 1894 and Séguin in 1897 painted Forbes-Robertson's portrait.

[52] Robert Bevan (1865-1925) was also a student at the Académie Julian. He was at Pont-Aven in 1890-91, 1893, and 1894. His extraordinary small wax paintings display the mysticism of Filiger and the sinuous arabesques of Art Nouveau, and show especially the impact of cloisonnism. See *Post-Impressionism in Europe* (London: Royal Academy of Arts, 1979), p. 183.

[53] Henry Osawa Tanner was a black American painter who stayed in Pont-Aven in 1890. As Gustave Loiseau recorded in his memoirs (quoted by Thiébault-Sisson, *Gustave Loiseau* [Paris: Georges Petit, 1930], p. 24), Tanner was clearly influenced by the religious and mystic elements of Symbolism. His work, unknown in France, is a transatlantic continuation of the work of the Nabi group. Séguin painted his portrait, which was exhibited in 1895 at Le Barc de Boutteville, Paris. The African Art Museum in Washington, D.C., has put on several retrospectives of his work.

[54] Alfred Jarry, the creator of *Ubu Roi*, was in Pont-Aven from 1893. In June 1894 he paid homage to Gauguin's talent in the *Livre d'or* of the Pension Gloanec.

[55] Malingue, *Lettres*, letter 152, p. 261.

[56] Ibid., letter 152, pp. 259-60.

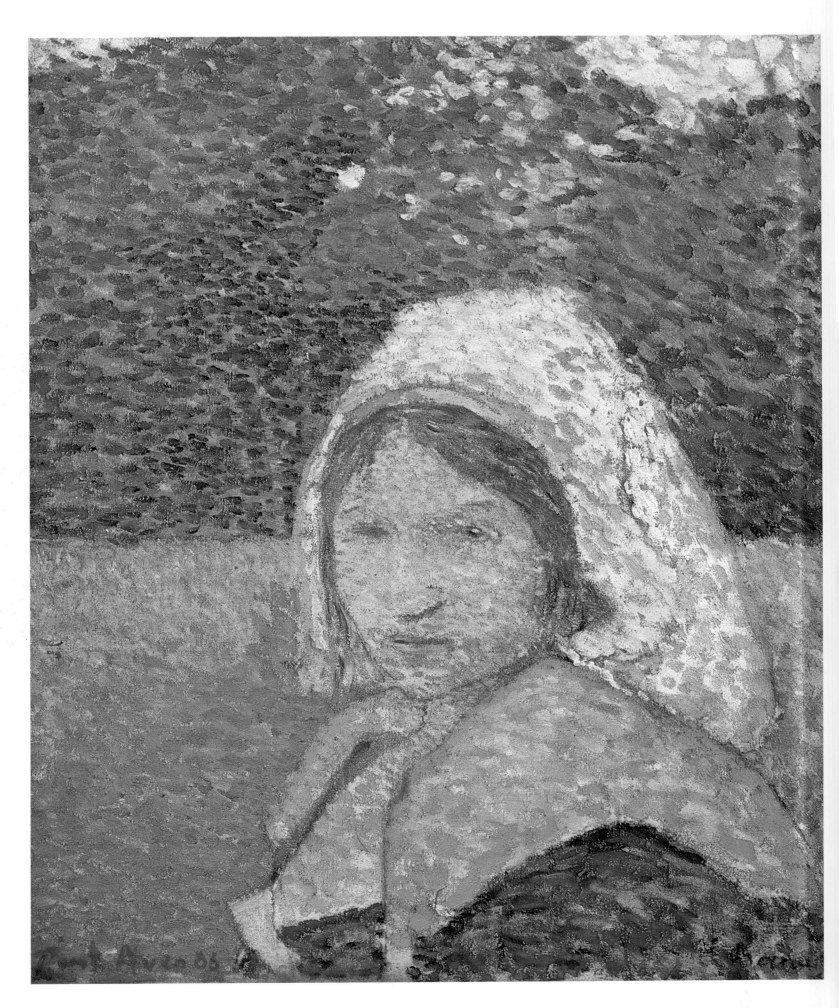

100

EMILE BERNARD

1868–1941

The Fugitive Experience (1884–1888)

EMILE BERNARD entered Fernand Cormon's studio at the Ecole Nationale des Beaux-Arts in Paris in 1884, at the age of sixteen. His father consented grudgingly, hoping that when Bernard had spent several months painting and drawing he would return to a more normal life and choose an honorable and lucrative profession. Bernard was amazingly precocious. His exceptional vivacity and extreme sensitivity sharpened his curiosity for everything intellectual. Extremely cultured for his age, he had a classical education to which he added a lively interest in the latest current trends both in literature and in the plastic arts.

In Cormon's studio,[1] which was extremely classical and academic in its form of instruction, Bernard's sympathies lay with the least conformist of his young comrades. These students also proved to be the most talented: Henri de Toulouse-Lautrec, a deformed dwarf but a witty man with a passion for art, and Louis Anquetin,[2] tall and strong, seven years older than Bernard and a respected figure in the studio. The three soon became inseparable, and their impassioned discussions led to aesthetic creeds further and further removed from the lessons handed down by Cormon's academic teaching. Im-

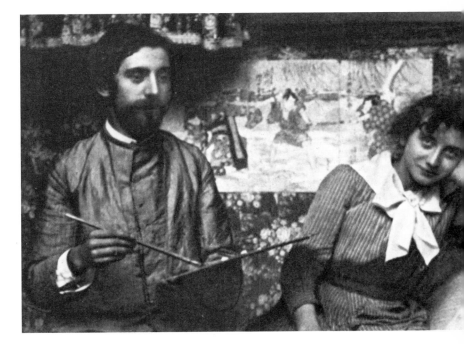

Emile Bernard and his sister Madeleine.
Photograph taken in the painter's studio at Asnières, c. 1890.

pressionism was central to the artistic life of the period. Although still controversial, it now had many advocates.

Young Bernard viewed enthusiastically the exhibitions at the Durand-Ruel gallery and the paintings hanging in the small shop in the rue Clauzel run by the famous Père Tanguy,[3] a committed socialist and generous supporter of impecunious artists. It soon became obvious to Bernard and these other young, audacious artists looking for a way to progress with their paintings that Cormon's lessons had nothing to

Emile Bernard,
Young Breton Girl in a Bonnet (Pont-Aven), 1886,
oil on canvas, 21⅝ × 18⅞ in.
Private collection, Paris.

101

Henri de Toulouse-Lautrec,
Portrait of Emile Bernard, 1885,
oil on canvas, 21⅜ × 17⅝ in.
The Tate Gallery, London.

Emile Bernard, *The Seine and the Billancourt Road,* 1884,
oil on canvas, 9⅜ × 13 in.
Private collection, Paris.

offer. In 1885, after a heated argument with his teacher about those "revolutionary" Impressionists, Bernard was expelled for insubordination.

Bernard's father, in his anger, is said to have burned his son's paintbrushes and forbidden him to paint again, ordering him to choose an honorable profession. In continual and open conflict with this authoritarian, hostile father, Bernard turned to his young sister Madeleine[4] and his maternal grandmother[5] for the affection and understanding he needed. His aesthetic sensitivity awakened the sympathy of these women.

Emile Bernard buried himself in literature, writing macabre poems in the style of Baudelaire. Already, in both their discussions and their work, he and his friends Lautrec and Anquetin were inspired by the contemporary Symbolist movement in literature. Their choices of subjects illustrate the spiritual preoccupations that mark the reaction against the

Emile Bernard,
△ *The Square at Saint-Briac*, 1886,
oil on canvas, 19⅝ × 28⅝ in.
Private collection, France.

Emile Bernard,
◁ *L'Allée du Reposoir, Jour de la Fête-Dieu, 26 Juin 1886,*
incorrectly titled *The Fountain at Asnières*,
oil on canvas, 17⅝ × 13 in.
Private collection, Paris.

positivist and rationalist spirit of the time. The three of them began meeting regularly in Lautrec's studio. There, they laid the foundation for their new theory of suggestive color and discovered Japanese prints. From these meetings grew a mutual passion for colored wood engraving and simplified design. During this early era, Bernard produced his first known wood engraving. This work, *Nativity* of 1885, was intentionally rustic and naive.

At the end of a difficult winter in a tense family atmosphere, Emile Bernard left Paris in April 1886 and set out on foot for Brittany.[6] With an extremely modest allowance from his generous and under-

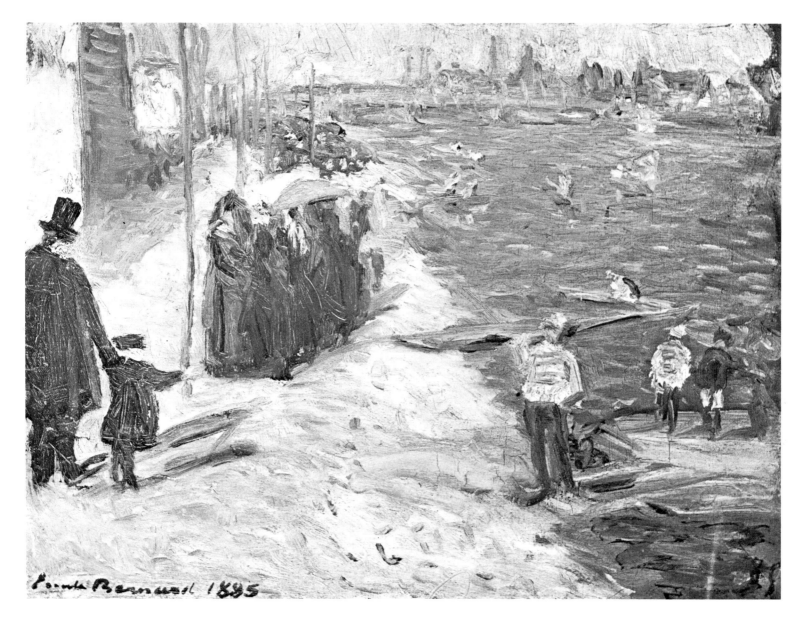

Emile Bernard, *Boating Party on the Seine at Asnières*, 1885, oil on canvas, 16⅞ × 21⅝ in. Private collection, France.

standing grandmother, he made his way across Normandy, sketching the countryside. Enjoying his unaccustomed freedom (he was only eighteen), he slept in barns or under the stars and traveled without the constraint of timetables or itineraries.

In June he arrived at Saint-Briac on the northern coast of Brittany and took a room at the Lemasson inn, intending to stay only the night. He remained until the end of July, having instantly fallen in love with the landlady's daughter, the young Marie Lemasson. During this first visit to Saint-Briac he decorated one of the rooms in the inn with scenes of the Nativity, inspired by the woodcut he had done the

previous winter. These scenes were representative of Bernard's interest during that period, for he was absorbed in a cycle of mystical works, like *The Yellow Christ* of 1886.[7] The creation of these religious works, which show Bernard's Symbolist preoccupations at the time, did not preclude him from producing other paintings in an essentially Impressionist style and spirit during the same period. These Impressionist works painted at Saint-Briac include *L'Allée du Reposoir, Jour de la Fête-Dieu, 26 Juin 1886*, incorrectly titled *The Fountain at Asnières* (illus., p. 104), and *The Square at Saint-Briac* (illus., p. 104), which shows the Lemasson inn in 1886.

These paintings are a continuation of a line of Impressionist works that Bernard had painted in the preceding years (1884-85), such as *The Seine and the Billancourt Road* (illus., pp. 102-3) and *Boating Party on the Seine at Asnières* (illus., p. 105).

In late July, Bernard left Saint-Briac for Brest, promising his friends the Lemassons that he would return the following year. He stayed only one day in Brest which, with its heavy industry, had nothing to interest him. Bernard sought in Brittany the wilderness of an unspoiled landscape, the richness and beauty of the native costumes, the Gothic architecture of the churches and chapels, the naïveté and originality of folk art (the Breton ceramics and pottery that he often included in his paintings), and the mystical and evocative Breton crosses and statues. In Brittany, Bernard discovered what he was looking for: a world reminiscent of the medieval past.[8] He continued along the southern coastline in search of new material and sights, arriving in Concarneau, which owed its charm to the old walled town in the middle of the harbor. Surrounded by ramparts and water, these walls formed a backdrop to the sardine fleet moored in the protected harbor. This setting had been attracting painters for many years, and during the summer the town was filled with artists avidly searching for the picturesque.

This was the situation when Bernard, in the middle of a walk along the rocks, stopped to look over the shoulder of an unknown, solitary painter. His Impressionist style of painting was far removed from anything Bernard had witnessed in Concarneau. Soon Bernard was engaged in a friendly conversation with Claude Emile Schuffenecker, one of the founders of the Salon des Indépendants in 1884, and friend of Odilon Redon, Armand Guillaumin, Edgar Degas, and above all, Paul Gauguin. This meeting at Concarneau between Schuffenecker and Bernard, seventeen years his junior, in August 1886, laid the foundation for a long friendship.[9]

Schuffenecker, who admired Gauguin's talent, pressed Bernard to visit Pont-Aven in order to meet Gauguin. With a note of introduction from Schuf-

fenecker, Bernard went to Pont-Aven. There he immediately moved into the Pension Gloanec,[10] the cheapest of the three inns in the village and the one in which Gauguin was staying.

Gauguin had been in Pont-Aven since the end of July. Also in Pont-Aven were Charles Laval, Emile Jourdan, Henri Delavallée, and Ferdinand du Puigaudeau, all young artists whom Gauguin dominated by virtue of his age, strength of personality, experience, and the prestige gained from having exhibited with the Impressionists in Paris. In the eyes of these young men, Gauguin was the head of the "Impressionist" clan. This did not mean those artists all adhered to a definite style or specific technique. The meaning of the term "Impressionist" was still vague, implying only a tendency toward modernity. Gauguin was delighted, if not with his new life, at least with his new role.

Emile Bernard,
Boat on the Aven River, 1892,
charcoal sketch.
Private collection, France.

106

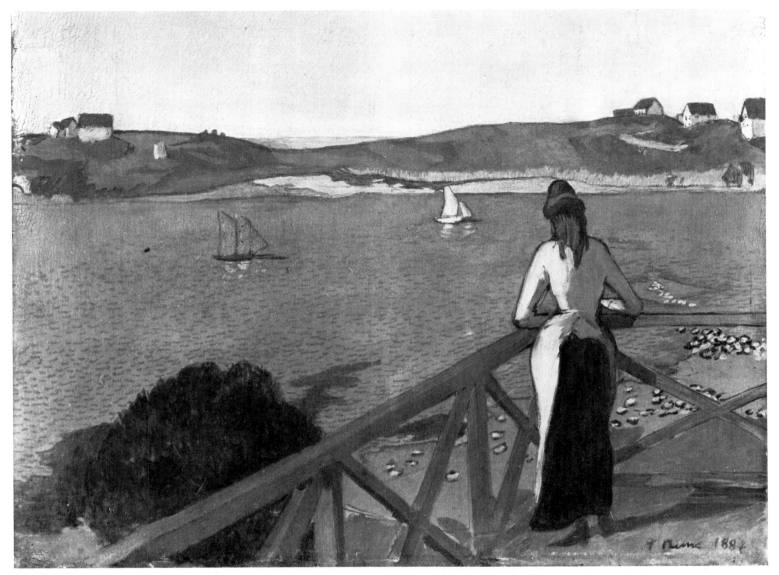

Emile Bernard, *Afternoon at Saint-Briac*, 1887, oil on canvas, 17⅝ × 21⅝ in. Musée d'Aarau, Aarau, Switzerland.

When Bernard introduced himself, Gauguin showed little interest, either in him or in Schuffenecker's letter of introduction. Achille Granchi-Taylor, whom Bernard had known at Cormon's studio, finally took Bernard to see Gauguin's paintings: "Granchi-Taylor, a painter friend of Gauguin took me to his studio ... but my visit to Pont-Aven passed without us becoming friends; we didn't even talk to each other, and yet we sat next to each other at meals."[11] In relation to Bernard, Gauguin was both old enough to be his father and had an entirely different type of personality. Cultured, curious, enthusiastic, sensitive, and discerning, Bernard had much more in common with Gauguin's companions than with the master himself.[12]

One of these young painters, Henri Delavallée, shared with Bernard a mutual interest in the theories of Divisionism and Pointillism. Delavallée, who had arrived from Paris, was following in the footsteps of Seurat, whose paintings he had seen in the eighth Impressionist exhibition, held from May 15 to June 15, 1886. Bernard painted, in August 1886, his *Orchard at Pont-Aven* (illus., p. 109). This scene, painted on a wooden panel in the pension, was completely Pointillist in treatment,[13] as was the *Young Breton Girl in a Bonnet* (illus., p. 100), from the same year.

Bernard continued his work in what seemed to be two opposite directions, but which were in fact complementary. On the one hand, he was painting Poin-

tillist works in which he explored the division of tone and the use of complementary colors. At the same time, he was making his first attempts at Synthetism — that is, at simplification of forms into schematic canvases with intentional similarities to icons or frescoes. An excellent example of Bernard's work from this period is *Le Pouldu*, painted in September 1886 (later acquired by the Edgar Garbisch Collection, New York).

In mid-October, Emile Bernard finally left Pont-Aven. Adhering to his original plan, he made his way, still on foot, through several Breton towns before returning to Paris. At the age of eighteen he had made a complete tour of Brittany, following in the footsteps of the medieval pilgrims.[14] Back in Paris at Père Tanguy's, a gallery and meeting place for artists, he renewed his friendship with van Gogh and also met Signac. He also became reacquainted with his friends Anquetin and Lautrec. This was the start of a period during which the three artists fre-

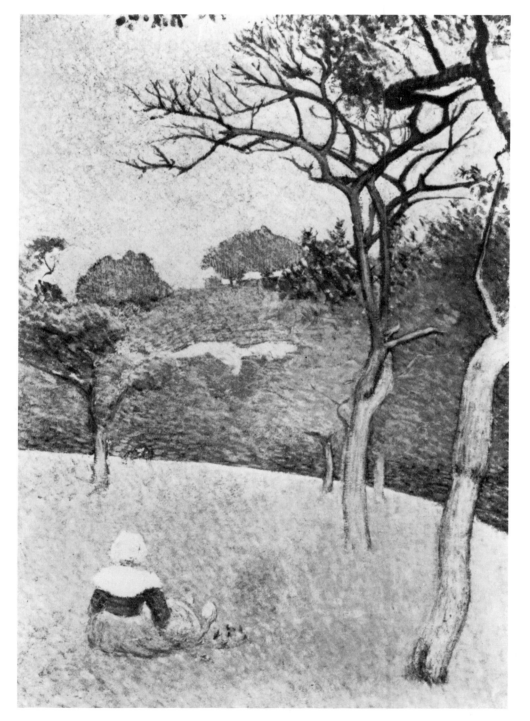

Emile Bernard,
Breton Woman in a Field
(landscape of Pont-Aven), 1886,
oil on canvas, 31⅛ × 21⅞ in.
Private collection, Switzerland.

Emile Bernard, *Orchard at Pont-Aven,* August 1886, oil on wood, 20½ × 20⅞ in. Private collection, Paris.

quently worked together, sometimes in Bernard's studio at Asnières, sometimes on the banks of the Seine.[15] In December, Bernard took part with Signac[16] in the Salon Pointilliste of Asnières and made the acquaintance of Seurat.

Yet Bernard remained preoccupied with Saint-Briac and his girlfriend, Marie. In May 1887 he left Paris, this time by train. He stayed two months with Madame Lemasson, continuing the series of decorations he had begun the previous year and painting the windows of the inn to look like Gothic stained glass. This work caught the attention of Albert

Aurier,[17] a young journalist and art critic, who became an instant convert to the theories of the young artist.[18] Bernard was later to introduce Aurier to Gauguin. As a result of this introduction, Aurier incorrectly described Gauguin as the master of Bernard in several articles.[19]

Throughout the spring and summer of 1887 Bernard continued with his work, exploring further the two paths on which he had embarked the previous year. He was painting highly structured cloisonnist works in which volumetric forms were reduced to their essentials (such as *Stoneware Pots and Apples,*

109

Emile Bernard,
◁ *Meadow at Saint-Briac*, 1887,
oil on canvas, 17⅝ × 21⅜ in.
Private collection, Amsterdam.

Emile Bernard,
Red Poplar Trees, 1887, ▷
oil on canvas, 38⅝ × 27⅝ in.
Private collection, France.

Emile Bernard,
▽ *Meadow, Saint-Briac*, July 7, 1886,
pencil drawing.
Private collection, Paris.

1887, now in the Musée National d'Art Moderne, Paris). These demonstrate the influence of the Cézanne canvases[20] he had seen at Père Tanguy's. Simultaneously, he was producing Divisionist paintings, such as *Afternoon at Saint-Briac* of 1887 (illus., p. 107). It is possible that in this canvas, which is similar to those Signac was to paint the following year at Portrieux, the girl with her back to us, leaning on a railing and gazing out to sea, is Marie Lemasson. Although this canvas is Neo-Impressionist in its treatment of natural subject matter, its composition and construction indicate a concern with synthesis, which was increasingly prevalent in Bernard's work in 1887.

During the summer of 1887, Pont-Aven was quieter. The "Impressionist gang" of the year before had dissolved. Gauguin and Laval were in Martinique. Henri Delavallée, now married to the painter Gabrielle Moreau, was working with Pissarro at Marlotte near Fontainebleau. Ferdinand du Puigaudeau was doing his military service at Hyères in the south of France. Avoiding the cliques, quarrels, and arguments to which the artist colony was prone, Bernard was happy to experiment with his own ideas and to try to perfect his theory of cloisonnism and artistic

synthesis by himself. From the summer of 1887 spent in Pont-Aven, Bernard was to take back canvases reflecting this innovative spirit, such as *Women and Geese*, 1887, and a number of canvases featuring varied Breton motifs.[21]

In autumn he returned to Paris, where he again met van Gogh, Anquetin, and Lautrec. He aroused van Gogh's anger by quarreling with Signac; yet the quarrel was hardly surprising, as Signac and Ber-

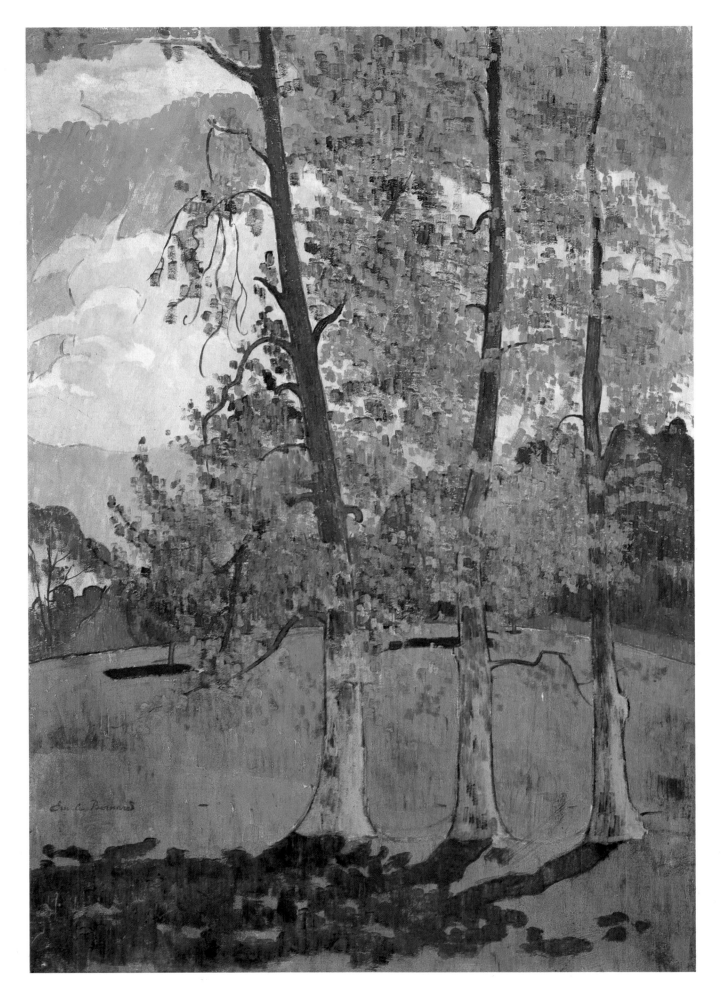

La bonne de chez Gloannec — Emile Bernard 1886

Emile Bernard,
◁ *Maids at the Pension Gloanec, Catherine and Marie,* 1886,
charcoal drawing.
Private collection, Paris.

Emile Bernard,
▽ *Pont-Aven Seen from the Heights of the Bois d'Amour,*
oil on canvas, 31⅞ × 23⅝ in.
M. and Mme. Bonger Collection, Netherlands.

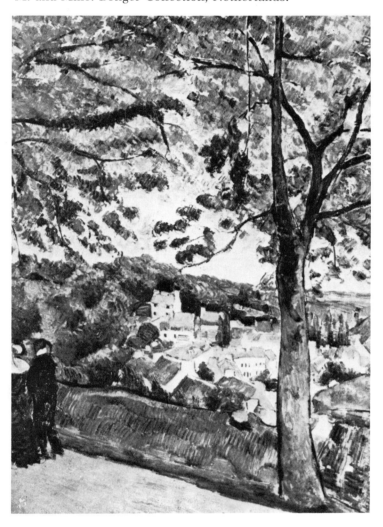

nard were now following completely different paths. For Bernard, his affair with Impressionism was over.[22] It had been no more than a stage in his search for new forms of expression. The rigorous visual analysis of Neo-Impressionism did not suit Bernard's mystical spirit. His education and literary tastes led him naturally toward Symbolism and medievalism. Nevertheless, the brief period of friendship and collaboration between Bernard and Signac in Paris was mutually beneficial. From Signac, Bernard learned to use and apply color more freely, while Bernard suggested to Signac a stronger, more solid construction, a more simplified composition and arrangement based on planes of pure color. Signac's canvases, painted at Collioure in 1887 and at Portrieux in 1888, contain a spirit of Synthetism concealed beneath a Pointillist treatment of color and form.

Bernard's Impressionist era had come to an end, as van Gogh simultaneously reached a similar impasse within the Impressionist style. The two friends parted in February 1888 on the boulevard de Clichy in Paris, never to be together again. Years later,

Bernard wrote sadly, "I was never going to see him again. I did not find myself beside him again until the day of his funeral."[23] As their later paintings diverged according to the two central artistic currents at the end of the nineteenth century, van Gogh found an expressionistic style based in the sunny south, and Bernard became even more deeply involved with his new way of depicting the gray landscape of Brittany. In Brittany, Bernard was to become, in the words of Félix Fénéon, "L'initiateur" for Gauguin and the father of Synthetism.[24]

NOTES

[1] Fernand Cormon (1845–1924) was one of the most famous of the official painters of the Belle Epoque, specializing in historic paintings in epic style. His famous canvas *Returning from Bear Hunting in the Stone Age* was enthusiastically acquired by the French Government. He had earlier been awarded the Légion d'Honneur for *Caïn*, a work in the same style, exhibited at the Salon of 1880.

[2] Louis Anquetin (1861–1932) was one of Emile Bernard's closest friends from 1884 to 1890; good-looking, persuasive, and inquisitive, he had a profound influence on Lautrec, Bernard, and van Gogh, all of whom he met at Cormon's studio. His artistic evolution paralleled that of Emile Bernard. After the audacious and original canvases of his youthful years, Anquetin's style tended toward a return to classicism. Both his style and his subjects imitated those of the old masters (Rubens and Jordaens in particular). Among those who exhibited at the Café Volpini in 1889, he was undisputably at the origin of the very earliest attempts toward Synthetism.

[3] Julien Tanguy (1825-1894) fought for the Commune and would have been shot but for the intervention of Ernest Rouart, a friend of Degas. An art supply dealer, he knew Monet, Renoir, Pissarro, and Cézanne, and was, in his own way, a patron to the artists of the time, often providing materials free of charge. He built up a collection of unsalable pictures which he paid for himself when he was unable to find a buyer. His little shop in the rue Clauzel in Montmartre gradually turned into a "museum" and a meeting spot for young painters. At the time, it was the only place where one could see the works of both Cézanne and van Gogh. "It was in his gloomy lair," said Emile Bernard, "that for almost twenty years the Cézannes hid their light.... The school known as the Pont-Aven school really ought to be called the Rue Clauzel school" (*Mercure de France*, issue 16, vol. 12, 1908).

[4] Madeleine Bernard, three years younger than her brother, modeled for several of Bernard's paintings, as well as for Gauguin, Laval, and Anquetin.

[5] Bernard's maternal grandmother, Sophie Lallemand, a former laundress, brought up her grandson. Bernard painted several portraits of her in 1886 and 1887.

[6] For full details of this period of Bernard's life, see extracts of his partially published memoirs, "L'Aventure de ma vie," in Michel-Ange Bernard-Fort, *Lettres de Paul Gauguin à Emile Bernard, 1888-1891* (Geneva: Pierre Cailler, 1954).

[7] This expressionistic painting is comparable to the later works of Edvard Munch, who was to meet the Nabis in Paris in 1890. Countess de Navaro Collection, New York.

[8] Many of the canvases Bernard painted at this time, both esoteric and medieval, such as the *Fight of the Knights*, 1891, and *The Fairies*, 1889, are virtually unknown. They were sold to Ambroise Vollard in 1893 by Bernard, before his departure for Egypt. There exists a handwritten inventory of all the pictures involved in this transaction between Vollard and Bernard (formerly in M.-A. Bernard-Fort Collection, present whereabouts unknown).

[9] There exists a fine portrait of Schuffenecker and another of his wife painted by Bernard in 1888. Reproduced in Wladislawa Jaworska, *Gauguin et l'école de Pont-Aven* (Paris: Bibliothèque des Arts, 1971), pp. 54, 55.

[10] Bernard had his meals at the pension but did not sleep there. "I had a room in the village where I slept, read and worked. I only turned up at the pension at meal times." Bernard, "L'Aventure de ma vie."

[11] Charles Chassé, *Gauguin et son temps* (Paris: Bibliothèque des Arts, 1955), p. 48.

[12] Bernard became friendly with Charles Laval, who later was the fiancé of his sister Madeleine, but a marriage never took place.

[13] This Pointillist painting figured in Bernard's centennial exhibition, organized by the Musée de Pont-Aven, in 1968 (cat. no. 1).

[14] The *Tro Breiz*, or tour of Brittany on foot, was, in the Middle Ages, a replacement for pilgrims unable to visit the holy places of Palestine.

[15] For the relationship among Bernard, Signac, and van Gogh in 1887 see Pierre Leprohon, *Vincent van Gogh* (Le Cannet: Corymbe, 1972).

[16] Bernard wrote: "Having seen some of my canvases and finding them interesting, Signac immediately went to my parents' house hoping to talk to me. He explained that he had seen my attempts at Divisionism, and that he had invented it along with Seurat. I was very pleased to make his acquaintance and he took me to see his pictures — his studio was near the Place Clichy. I saw large landscapes, extremely luminous but lacking life, and interiors in which all the people appeared wooden." Quoted by Françoise Cachin, *Paul Signac* (Paris: Bibliothèque des Arts, 1971), p. 39.

[17] Albert Aurier (1865–1892) was a poet and an art critic whom Emile Bernard introduced to Gauguin. He became the defender of the Symbolist movement in both art and literature. His activity is closely linked to that of the Pont-Aven school, as well as to the Nabis. His writings were published posthumously in 1893.

[18] "This [decorated] door brought me into contact with a poet attracted to the inn by its decoration. He was called Albert Aurier and was living at that time in Saint-Enogat, with his mother and sister. We felt ourselves joined by the innate sympathy which brings minds together. I went on long walks with Aurier. He read me his poems and a novel he was writing, which was completely naturalist. I enjoyed the style more than the subject. I showed Aurier letters from Vincent [van Gogh] and his drawings." Bernard, "L'Aventure de ma vie."

[19] In an article entitled "Symbolisme en peinture: Paul Gauguin," in the *Mercure de France* of March 1891, Albert Aurier makes Gauguin the sole and unique representative of the new school, without mentioning either Bernard or Anquetin.

[20] The still lifes of Cézanne are at the origin of the style characteristic of numerous still lifes painted by the artists of the Pont-Aven school: Bernard, de Haan, Slewinski, Sérusier, Loiseau, etc.

[21] "Gauguin was not there that year. He had gone to Martinique. None of my friends were there despite the large number of painters staying at the Gloanecs. I offered the inn a painting that caused something of a scandal. It showed women harvesting in a cornfield surrounded by dark trees." Bernard, "L'Aventure de ma vie."

[22] "I concluded that although the procedure was good for the living production of light, it robbed painting of color and so I threw myself into the opposite theory." Bernard, "L'Aventure de ma vie."

[23] On the burial of van Gogh on July 31, 1890, at Auvers-sur-Oise, at which Bernard was present with Charles Laval, see the moving letter from Bernard to Aurier; quoted in Leprohon, *Vincent van Gogh*, pp. 296-97.

[24] "Il [Gauguin] rencontrera en Bretagne un jeune peintre d'esprit aventureux et assez renseigné, M. Emile Bernard, qui est aujourd'hui son élève, mais paraît bien avoir été son initiateur." Félix Fénéon, in an article in *La Revue du Chat Noir*, June 23, 1891. (He [Gauguin] will meet in Brittany a fairly knowledgeable young painter with an adventurous mind, M. Emile Bernard, who is today his follower but seems indeed to have been his initiator.)

114

CLAUDE EMILE SCHUFFENECKER

1851–1934

IN the course of his life, Claude Emile Schuffenecker was a participant in the experiments and discoveries of Paul Gauguin and Emile Bernard, one of the earliest disciples of the Divisionist Georges Seurat, a Symbolist painter, and a friend of Odilon Redon. Yet, from this wide variety of influences, Schuffenecker emerged as a significant later Impressionist painter in his own right. By combining the subject matter and palette of the Impressionists with a graphic quality associated with Art Nouveau, Schuffenecker achieved in his pastels and paintings a distinctive poetic quality within the Pont-Aven school.

After his father's death when Schuffenecker was three, he was adopted by his uncle. From the age of twelve he had to earn his living as apprentice to a chocolate maker. As a child he showed a great talent for drawing. Later, in Paris, still fascinated by drawing, he attended evening classes for adults whenever work allowed him the time. He received the First Prize for Drawing awarded by the City of Paris in 1868. He worked in the civil service as a clerk in the Treasury, but left his job in 1872.[1] Soon he joined the brokerage firm of Paul Bertin,[2] where he met Gauguin, who had already been working there for several months.[3] Twenty-one years of age and slightly built, Schuffenecker appeared frail beside Gauguin, three years his senior. The two men got along well, as their common interest in painting and the arts drew them together.[4]

Claude Emile Schuffenecker,
◁ *Portrait of Mrs. Schuffenecker*,
sometimes referred to as *The Pink Dress*, 1883,
oil on canvas, 39⅜ × 31⅞ in.
Formerly Musée du Luxembourg, Paris.

Claude Emile Schuffenecker,
Self-Portrait, 1880, ▷
oil on canvas, 18⅛ × 15 in.
Formerly Mrs. Dudensing Collection, New York.

Henri Fantin-Latour,
Chrysanthemums in a Vase, 1873,
oil on canvas, 24⅜ × 20⅞ in.
Formerly André Meyer Collection, New York.

A stockbroker by necessity rather than inclination, Schuffenecker had one timid yet firmly held ambition: to devote all of his time to painting. At Bertin's, Schuffenecker transmitted his dreams and enthusiasm to Gauguin. Schuffenecker's praise and encouragement helped Gauguin in these early years toward an awareness of his own talent and his personal ambitions. Under the influence of Schuffenecker, who was both guide and teacher, Gauguin began to spend Sundays and holidays painting or visiting museums.

Schuffenecker attended evening classes at the studios of Paul Baudry[5] and Carolus Duran,[6] both teachers in the traditional academic manner, as can be discerned from Schuffenecker's earliest known canvas, the portrait of his grandfather dated 1875 (now in the Horst Collection, Chicago). From there he went on to the Académie Suisse[7] and Filippo Cola-

rossi's studio,[8] taking Gauguin with him. Gauguin progressed rapidly and was accepted at the Salon in 1876, a year earlier than Schuffenecker. Even at this early stage they had differing concepts of painting. Schuffenecker was still the pupil of Carolus Duran, as shown by his fine self-portrait of 1880 (illus., p. 115), while Gauguin was working at Pontoise alongside Pissarro and taking part in Impressionist exhibitions, first in the avenue de l'Opéra, in 1879, then in the rue des Pyramides, in 1880.

It was not until the early 1880s that Schuffenecker, having inherited a small legacy and having given up his job as a stockbroker, turned his back on his academic masters and their studio pieces. He began to paint in the open, making frequent trips to Meudon in particular, which he faithfully reproduced throughout fifty years of work.[9] Soon, his palette lightened under the new influence of the Impressionists. Through this movement he discovered his own personal manner of expression, characterized by its delicacy, poetry and finesse, yet based on mastery of the art of drawing. In 1883 he produced two important paintings, *Evening* and *Portrait of Mrs. Schuffenecker*, sometimes referred to as *The Pink Dress*[10] (illus., p. 114), which were refused by the Salon. In his disappointment, in May of 1884 he founded the Groupe des Artistes Indépendants, with Georges Seurat, Henri Edmond Cross, Odilon Redon, Charles Angrand, Louis Valtat, Paul Signac, Armand Guillaumin, and others, which exhibited in the wooden huts in the place du Carrousel in the Tuileries.[11] This exhibition of paintings refused by the Salon was extremely successful.

With the income provided by his legacy, Schuffenecker began buying paintings from his contemporaries, laying the foundations of a collection that was to be built over his lifetime. In addition to

Claude Emile Schuffenecker,
Flowers and Fruit, 1880,
oil on canvas, 24 × 19⅝ in.
Private collection, Paris.

paintings, drawings, sculptures, and ceramics by Gauguin,[12] it included major works by Cézanne, van Gogh, Degas, Redon (a friend whose portrait he painted),[13] Daumier, Delacroix, and others. His aesthetic sense made him one of the great avant-garde collectors of the era.

In 1883 Schuffenecker obtained the modest post of drawing master at the Lycée de Vanves,[14] a post that he held until the First World War, along with the painter Louis Roy.[15] His pupils remember Schuffenecker as a "little man with a big heart," who was an enthusiastic and fair-minded teacher.

In 1885 Gauguin, who had lost his job at Bertin's two years earlier, returned to France after an unhappy attempt to settle near his wife's family in Denmark. Short of money, he was taken in by Schuffenecker.[16] During this stay, while the two men were living in closer contact than at any other time thereafter, Schuffenecker's style and aesthetic preoccupations came closest to those of Gauguin, who was deeply involved in his Impressionist period. At the instigation of Gauguin and Pissarro (and despite the obvious hostility of Monet and Renoir), Schuffenecker joined Seurat and Signac in the eighth and last Impressionist exhibition, held in the spring of 1886. The Divisionist works of the new exhibitors made such an impression on Schuffenecker that he soon began to apply the principles of the division of color in his own work. The best example of this period is the canvas in the Fitzmaurice Collection, *Two Cows in a Meadow*, dated 1886.[17] This early Neo-Impressionist work closely resembles the contemporary works of Paul Signac, such as *Railway Junction at Bois-Colombes*.[18]

Gauguin and Schuffenecker, who had worked side by side throughout the winter and spring of 1886, decided together to spend the summer in Brittany, one installing himself at Pont-Aven and the other at Concarneau. As young Emile Bernard passed through Concarneau, he met Schuffenecker, who introduced him to Gauguin. This meeting between Schuffenecker and Bernard was the start of a long and close friendship. From this summer in Brittany, Schuffenecker took back many studies and paintings, of which approximately ten were exhibited at the Salon des Indépendants the following year.

In 1887, Gauguin, returning ill from Martinique, went once more to live with his friend Schuffeneck-

er, who comforted him, loaned him money, and introduced him to a man who was to become his most faithful admirer, the painter Georges Daniel de Monfreid.[19] The winter of 1887 found the two friends working again in close contact, as they shared Schuffenecker's studio. The snowscapes painted by Schuffenecker in 1887, *Cart on a Snowy Road*[20] and *Snow Effect*,[21] compared with similar canvases of Gauguin, such as *Snow, rue Carcel*, 1883[22] and *Garden in the Snow*, 1885,[23] demonstrate the similar aesthetic concerns that motivated the two artists and their mutual interest in the Impressionist conception of the landscape.

Claude Emile Schuffenecker,
The Hay Cart, 1889, ▷
oil on canvas, 18⅛ × 15 in.
Musée Municipal de Meudon, France.

Emile Bernard,
Hay Cart at Asnières, 1886, ▽
oil on canvas, 18⅛ × 13 in.
Private collection, France.

Claude Emile Schuffenecker,
Cart on the Road (project for an interior decoration), 1887,
oil on canvas, 20⅞ × 28⅜ in.
Private collection, Pont-Aven.

Nevertheless, in 1888, during a visit to Etretat and Yport in Normandy, Schuffenecker was again captivated by Divisionism. *View of the Cliffs at Etretat, 1888*[24] (now in the Holliday Collection in the Indianapolis Museum of Art), provides evidence of this change in style. Yet, after this brief Divisionist interlude in 1887 and 1888, Schuffenecker began a marked period of transition, eliminating detail and adopting a clear leaning toward the Synthetism and Symbolism favored by Gauguin and Bernard.

By 1889 his work had moved considerably toward Symbolism. Schuffenecker's *Women Gathering Seaweed at Yport*[25] of the preceding year illustrates the course of this change. It is a work very similar in its subject matter to the canvases painted by Gauguin and his disciples at Le Pouldu. The fact that its geographical location is Yport on the Normandy coast does not conceal the similarity of subject, attitude, and idea of these two painters' works. The use of sinuous lines, which became an essential feature of Schuffenecker's drawings, is demonstrated for the first time in this work. As a result of this innovation,

120

Claude Emile Schuffenecker,
Washerwomen, (project for an interior decoration), 1887,
oil on canvas, 20⅞ × 28⅜ in.
Private collection, Pont-Aven.

Schuffenecker's works began to assume a completely personal quality.

The same year, Schuffenecker also organized a show for the Universal Exhibition of 1889 at the Café Volpini entitled *Exposition de Peintures du Groupe Impressionniste et Synthétiste,*[26] a name that, over and above its apparent contradictions, signified a common feeling of opposition and revolt on the part of its participants. Both the Impressionists and the Symbolists were eager to clarify for the public and art critics the differences that separated them from the painters officially selected to exhibit as part of the Universal Exhibition. Schuffenecker showed twenty paintings at the Café Volpini, including two canvases painted at Concarneau in 1886, *Beach Scene* and *Sunset*, as well as *Women Gathering Seaweed at Yport*, painted in 1888. This exhibition, arranged entirely by Schuffenecker, had a strong impact on a whole generation of young painters.[27]

The year 1889 and the Volpini exhibition, however, marked a watershed in the friendly relations that had existed between Gauguin and Schuffeneck-

er. The best illustration of the developing animosity between the two artists is Gauguin's famous painting of 1889, *The Schuffenecker Family* (illus., p. 126). Schuffenecker is portrayed with his head bent in a ridiculous posture and wearing bedroom slippers. There is not only mockery here, but also a tinge of cruelty. From this point onward relations between the two steadily deteriorated. In June, Gauguin, who had gone to Paris for the exhibition, returned to Pont-Aven and then to Le Pouldu, where he stayed at the pension of Marie Poupée. Although he remained in Brittany, he dreamed constantly of being somewhere else. He hoped to go to Tonkin at this time but

was without money. With train fare provided by "Schuff," Gauguin set off to visit his old friend in Paris on February 8, 1890. Schuffenecker had moved to the rue Alfred Durand-Claye.[28] Once more he put his friend up, giving him a room on the second floor, next to the studio. Gauguin behaved as if it were his own studio and did not bother to hide from Schuffenecker the low opinion he had of his friend's painting. Since 1888, under the undeniable influence of Emile Bernard, Gauguin had embarked upon a new path, which was to lead him away from Impressionism. "The road to Synthetism," he said, "is full of perils and I've done no more than set my

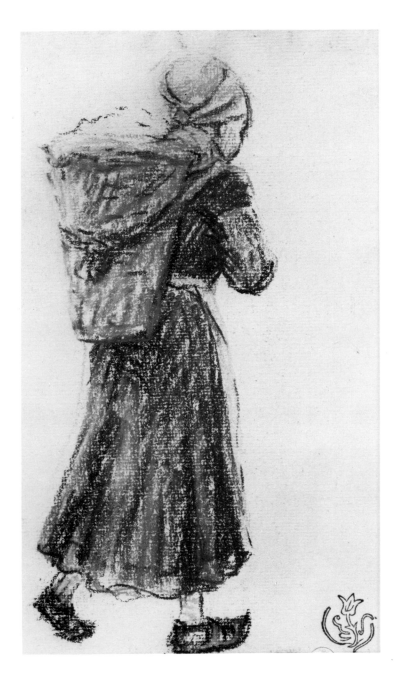

Claude Monet,
Sunset at Etretat, 1883,
oil on canvas, $23\frac{5}{8} \times 28\frac{5}{8}$ in.
Private collection, Switzerland.

Claude Emile Schuffenecker,
Peasant Woman with a Basket, near Etretat, c. 1890,
charcoal drawing.
Private collection, Paris.

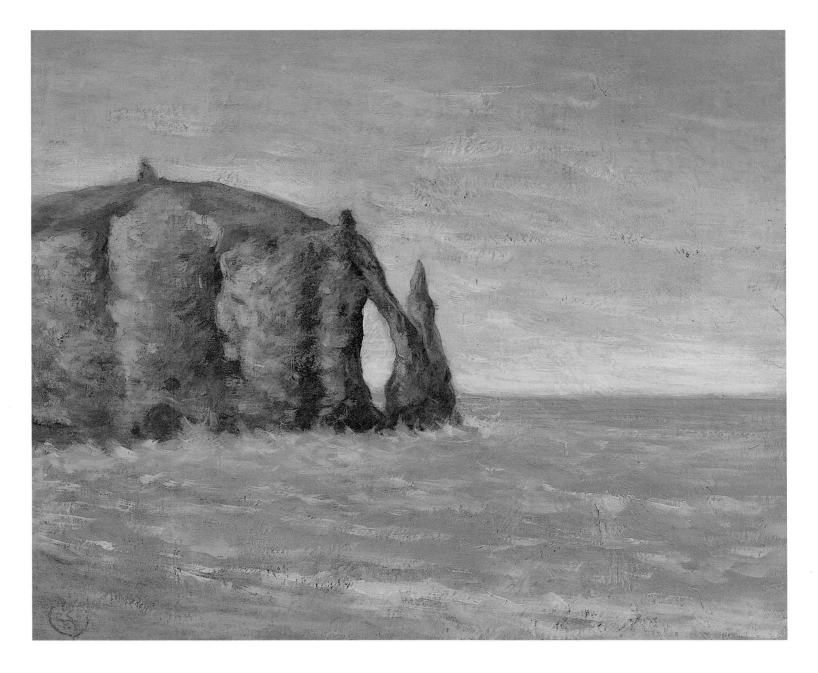

Claude Emile Schuffenecker, *The Needle at Etretat,* oil on canvas, 12⅝ × 16⅛ in. Private collection, France.

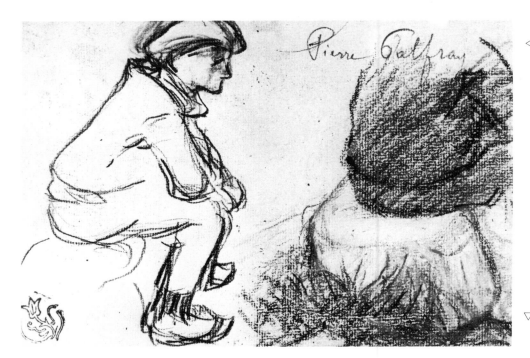

Claude Emile Schuffenecker,
◁ *Young Fisherman Seated,*
charcoal sketch.
Private collection, France.

Claude Emile Schuffenecker,
▽ *Little Boy Lying on the Beach at Etretat,*
oil on canvas, 21⅝ × 18⅛ in.
Private collection, France.

foot upon it ... What does it matter if I leave the others behind!"[29]

When a small jewelry business in which Schuffenecker had invested was sold at a profit,[30] Gauguin proposed using part of the proceeds to establish a studio in the tropics. But Schuffenecker preferred to invest the money in building a block of flats in the nearby rue Paturle. Gauguin saw this decision as "a ridiculously bourgeois idea." On the day that Theo van Gogh came to look at his latest paintings, Gauguin further insulted Schuffenecker by taking Theo into the studio, leaving "Schuff" outside the door. In June 1890, Gauguin returned to Le Pouldu for the summer. In November, his credit exhausted, he returned once more to his friend's house in Paris. This time Gauguin's thoughtlessness and egotism reached new heights, which caused the final break. Eighteen years of unreserved friendship and constant devotion on the part of "good old Schuff" came to an end in January 1891[31] with Schuffenecker's discovery of an adulterous relationship between Gauguin and Schuffenecker's wife.

Possibly as a replacement for his lost friendship with Gauguin, Schuffenecker renewed his friendship with Emile Bernard. This contributed to Schuffenecker's beginning to modify his style, moving even further toward Symbolism and mysticism, reflecting his interest in esoteric subjects and misty, dreamy atmospheres. In Schuffenecker's studio at

Claude Emile Schuffenecker,
On the Beach at Etretat, ▷
oil on canvas, 37⅜ × 23⅝ in.
Private collection, London.

124

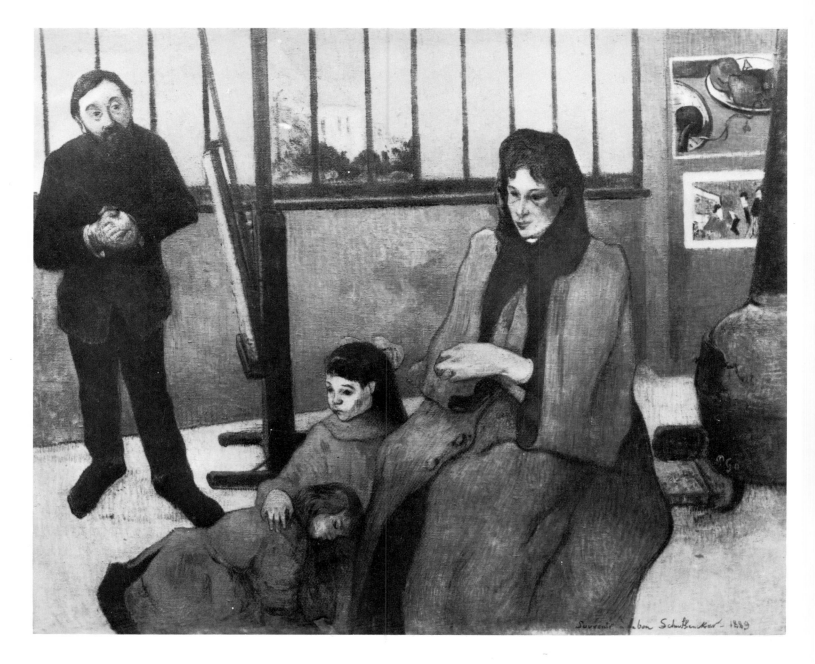

29 rue Boulard, and not at Pont-Aven (as the Breton landscape of Pont-Aven that forms the background to the picture might suggest), Bernard painted his fine portrait of Schuffenecker: "Profiled against a window, plunged in thought, the model is looking at a Breton landscape by Bernard."[32]

In 1891 Schuffenecker encouraged Bernard to create a noncommercial Salon.[33] Schuffenecker also undertook the writing of a laudatory article on his friend for the review *Les Hommes d'aujourd'hui*.[34] He continued to contribute to this review for several years. At this time Schuffenecker was also studying theology and mysticism, popularized by the books of Annie Besant and Madame Blavatsky. Schuffenecker designed for the latter author the cover of her book *Le Lotus bleu*.[35] This quest for mysticism explains his acquaintance with and commission to paint the portrait of the Comte de La Rochefoucauld in 1895[36] and how, at Emile Bernard's instigation, he joined the Rosicrucians in 1892 and collaborated with Bernard on esoteric reviews such as *Le Coeur* and *L'Ymagier*. Never were the artists as close as they were during this year. They spent the summer together at Etretat, from which they made a memorable boat trip to Le Havre.[37] Although it is not dated, it seems likely that Schuffenecker's fine *Portrait of*

The Schuffenecker family in the garden, Paris.
Photograph, c. 1886.
The painter is standing,
his wife is seated in front of him
with the eldest daughter, Jeanne;
the baby son, Paul, is on his nurse's lap.

Paul Gauguin,
◁ *The Schuffenecker Family*, 1889,
oil on canvas, 28⅝ × 36¼ in.
Musée d'Orsay, Paris.

Emile Bernard's Mother[38] was executed at that time. There was also a deep affinity and friendship between Schuffenecker and Odilon Redon, based on their shared love of music, poetry, and mysticism. Philippe Jullian illustrates this artistic affinity in his book *The Symbolists*: two pastels are shown side by side, one by Redon, *The Buddha's Curse*, and the other, *The Pink Tree*, by Schuffenecker.[39] With Bernard's departure for the Middle East, the ties between Redon and Schuffenecker became closer still, and they were to remain so until Redon's death in 1916. Schuffenecker was an ardent collector of pastels and lithographs by Redon.

Following Bernard's departure, Schuffenecker painted at Meudon, near Paris, when his teaching allowed, or in summer around Etretat, where he stayed at the hotel overlooking the beach. His numerous landscapes of this period could best be described as Romantic, were it not for the clear palette of the Impressionist. Some of the views of Etretat, with its white cliffs and green sea bathed by a hazy sun, would make excellent and poetic illustrations for the music of Claude Debussy. Setting up his easel directly on the beach, he loved to paint the fishermen, their lap-jointed boats, and their *caloges*, old boats covered with thatch, in which they lived.

127

Claude Emile Schuffenecker,
Portrait of Schuffenecker's Daughter Jeanne, 1894,
charcoal drawing.
Private collection, Paris.

In 1896, Schuffenecker's first one-man show, at the Galerie Charpentier, containing twelve oils, twenty-one pastels, and three drawings, was hailed by the critics. After his death, a number of other exhibitions were organized by his daughter and a few friends. The retrospective staged in 1935 at the Salon des Indépendants, of which he was one of the founders, consisted of twenty-four works. The exhibition included the *Portrait of Mrs. Schuffenecker,* sometimes referred to as *The Pink Dress* (illus., p. 114), which was refused by the Salon in 1884 and which, in 1936, joined the collection of the Musée du Luxembourg. Also included were a few etchings, now extremely rare, including the portrait of his wife.[42]

Among later exhibitions, mention should be made of the 1937 exhibition at the Château-Neuf in Meudon, the 1938 and 1939 exhibitions at the Galerie Contemporaine in Paris, followed by a retrospective at the Observatory in Meudon in 1939. In 1944 Maximilien Gauthier organized a retrospective at the Galerie Berri-Raspail in Paris, and it was at this point that the Louvre acquired Schuffenecker's *Rocks at Etretat.* In 1949 his work was included in the exhibition *Gauguin et ses Amis,* at the Galerie Kléber in Paris. In 1958, Hirschl and Adler Gallery in New York staged an important exhibition of his oils, pastels, and sketches. In 1963, sixty pastels and forty drawings went on view at the Galerie des Deux-Iles in Paris. On this occasion, the Musée des Beaux-Arts in Brest acquired eight pastels, described in the *Revue de Louvre.*[43] The museum of Pont-Aven showed one oil, seven pastels, and two charcoal sketches in 1971 as part of the *Autour de Gauguin* exhibition, two oils and six pastels in 1978, and two oils in the *Exhibition Centenaire autour de Gauguin* in 1986.

The paintings followed in quick succession — views of the "Needle," of the cliffs, and of Porte d'Aval, which Claude Monet had painted in 1883,[40] of Elephant Rock and the Manneporte. He returned to Etretat almost every year until his death in 1934. Edouard Deverin, one of his former pupils, said, "I knew him in days gone by at the Lycée Michelet.... I still have a vivid memory of the little man with the gleaming eyes, enthusiastic and energetic, who introduced us to Rimbaud, Tristan Corbière, and Mallarmé and revealed to our sixteen-year-old eyes those misunderstood and much-talked-about painters, Cézanne, Gauguin, van Gogh, and Odilon Redon."[41]

Claude Emile Schuffenecker, *Concert at the Tuileries*, Paris, 1886, etching.
Mr. and Mrs. Arthur Altschul Collection, New York.

NOTES

[1] The Horst Collection in Chicago includes various unpublished letters, which were consulted for the information on Schuffenecker's early life.

[2] In documents relating to this period of his life, Schuffenecker gives his occupation as finance employee (Horst documents).

[3] Gauguin, on the recommendation of his guardian, Gustave Arosa, joined Bertin's as a commissioner in April 1871.

[4] Charles-Guy Le Paul and G. Dudensing, "Gauguin et Schuffenecker." *Bulletin des Amis du Musée de Rennes, numéro spécial: Pont-Aven*, no. 2 (Summer 1978), pp. 48-60.

[5] Paul Baudry (1828–1886) won the Prix de Rome at the age of twenty-two. He also decorated the foyer of the Paris Opéra.

[6] Carolus Duran (1838–1917) was best known for his portraits. With Ernest Meissonnier and Pierre Puvis de Chavannes, he founded the Société Nationale des Beaux-Arts.

[7] Académie Suisse, on the Quai des Orfèvres, was a free studio where one could work without examinations or instructions. It was attended by Cézanne, Pissarro, and Guillaumin, among others.

[8] Atelier Colarossi was founded by the Italian sculptor and painter Filippo Colarossi. This studio was independent of the official schools and was unusual in that it allowed students to work with a model but without instruction.

[9] Before his marriage in 1880, Schuffenecker lived at Meudon (Sèvres), apparently near his mother, who was still alive in 1876 (Horst documents). This fact explains his attachment to the town and surrounding area.

[10] *Portrait of Mrs. Schuffenecker*, the painter's wife, sometimes referred to as *The Pink Dress*. Formerly Musée du Luxembourg, Paris.

[11] On this exhibition, see Henri Perruchot, "La Période héroïque des Indépendants," *Jardin des arts* (Paris: April 1966), pp. 39-45.

[12] In 1886 Félix Bracquemond introduced Gauguin to the ceramicist Ernest Chaplet. In 1889, while staying with Schuffenecker, Gauguin made a number of ceramic pieces, works of pottery and statuettes, which were fired in the kiln of the ceramicist Auguste Delaherche, rue Blomet. These works remained in Schuffenecker's possession.

[13] A painting that has since disappeared.

[14] Now the Lycée Michelet.

[15] Louis Roy (1862–1907) was born at Poligny (Jura). He exhibited seven paintings (three landscapes of Gif-sur-Yvette, one of Vanves, two still lifes, one twilight scene) at the Café Volpini in 1889. Through Schuffenecker, Roy became a friend of Gauguin, for whom he undertook the printing of the first woodcuts from Tahiti, apparently with no commercial success. He exhibited at Le Barc de Boutteville, Paris, and the Indépendants from 1890 to 1897. He also defended Douanier Rousseau in the *Mercure de France* in March 1895. His style, highly influenced by Gauguin and Bernard, is a prime example of the decorative tendencies of Synthetism. See Elisabeth Walter, "Le Seigneur Roy: Louis Roy," *Bulletin des Amis du Musée de Rennes, numéro spécial: Pont-Aven*, no. 2 (Summer 1978), pp. 61-72.

[16] Schuffenecker provided Gauguin with lodging on the following occasions:

In October-November 1885 on his return from Denmark.

In October-December 1886 and in January 1887 on his return from Martinique.

In December 1888 and in January-February 1889 on his return from Arles.

In May 1889.

In February-May 1890 on his return from Le Pouldu.

In November 1890, prior to his liaison with Juliette Huet and his departure shortly afterward for Tahiti.

[17] *Post-Impressionism in Europe* (London: Royal Academy of Arts, 1979), cat. no. 184.

[18] "However, the dominance of the pairing of red and green, together with the broken brushwork of this painting, indicates that Schuffenecker must have studied the Neo-Impressionist works on view in 1886 at the eighth Impressionist exhibition" (cf., P. Signac's *The Railway Junction at Bois Colombes*). Mary Ann Stevens, *Post-Impressionism in Europe,* p. 126.

[19] Georges Daniel de Monfreid (1856–1929) was a painter, sculptor, and engraver who became Gauguin's most faithful supporter and friend. After taking Gauguin into his Montparnassse studio in Paris, and then looking after Gauguin's business in Europe after his departure for Tahiti and the Marquesas Islands, Monfreid corresponded with Gauguin avidly. Monfreid was nicknamed the Captain, since he often went sailing in the Mediterranean. One of his *Nudes* is in the Musée d'Art Moderne, Paris, and another in the Musée de Béziers.

[20] Exhibition at the Hirschl and Adler Galleries, New York, 1970, cat. no. 57.

[21] Hôtel Drouot public auction, Paris, November 27, 1946.

[22] Georges Wildenstein and Raymond Cogniat,

Paul Gauguin, catalogue raisonné (Paris: Beaux-Arts, 1964), no. 80.

[23] Ibid., no. 140.

[24] Ellen W. Lee, *The Aura of Neo-Impressionism: The W. J. Holliday Collection*, cat. no. 61, reproduced in color. Compare this canvas by Schuffenecker with Monet's *Etretat, the Amont Cliffs*, 1885, Daniel Wildenstein, *Claude Monet: biographie et catalogue raisonné* (Lausanne, Paris: Bibliothèque des Arts, 1979), vol. 2, p. 169, no. 1010.

[25] This canvas, which has disappeared, was exhibited in 1889 at the Café Volpini. A black-and-white photograph has been published in *Bulletin des Amis du Musée de Rennes, numéro spécial: Pont-Aven*, no. 2 (Summer 1978), p. 58.

[26] Wladislawa Jaworska, *Gauguin et l'école de Pont-Aven* (Paris: Bibliothèque des Arts, 1971), pp. 75ff.: "The Exhibition at the Café Volpini."

[27] In particular Aristide Maillol, Paul Ranson, Maurice Denis, and Paul Sérusier. See Denis, *Etude sur la vie et l'oeuvre de Paul Sérusier* (Paris: Floury, 1942), p. 46.

[28] Through documents in the Horst Collection, a list has been compiled of Schuffenecker's various places of residence:

13 rue Vavin in Paris, in 1878
36 rue Vavin in Paris, start of 1879
13 boulevard Edgard-Quinet, end of 1879
29 rue Boulard, probably from 1880 to 1889
12 rue Alfred Durand-Claye, in 1890
4 rue Paturle, in 1893
108 rue Olivier-de-Serres, after 1917

[29] Maurice Malingue, *Lettres de Paul Gauguin à sa femme et à ses amis* (Paris: Grasset, 1946), p. 147.

[30] Inheriting the money from his family, Schuffenecker invested it in a jewelry business. In 1882 he became associated with M. Fontaliran. He withdrew his share of 75,000 francs in 1890 and reinvested his capital in a block of apartments situated at 4 rue Paturle.

[31] Letter from "Schuff" to Gauguin, quoted in Jaworska, *Gauguin*, p. 56: "My dear Gauguin: my wife tells me that you plan to call tomorrow. As I have to get out of this situation, I am warning you now to spare you a fruitless journey in case the purpose of your visit was to sort things out between us. Neither as men nor as artists are we suited to live side by side. I have known this for a long time and what has just happened confirms it. I have decided to cut myself off from you; everything inclines me that way, my tastes and my own best interests. For my part there is no hatred or animosity — it's just a matter of incompatibility, so we can at least part with mutual respect...." Gauguin, having used up all his credit and exhausted all his welcome, had no choice but to leave.

[32] Jaworska, *Gauguin*, p. 53; Schuffenecker's portrait is reproduced on p. 55.

[33] Bibliothèque Nationale, unpublished manuscript; inventory number Mss. n. a. fr. 14722, ff. 4.6.

[34] An article that was never published. Same manuscript as in note 33.

[35] Edward Lucie-Smith, *Symbolist Art* (Oxford, England: Oxford University Press, 1972), reproduced on p. 106.

[36] Now lost.

[37] Unpublished documents, Horst Collection.

[38] Jaworska, *Gauguin*, reproduced on p. 53.

[39] Philippe Jullian, *The Symbolists* (London: Phaidon, 1975), color plates 195, 196.

[40] See Wildenstein, *Monet: biographie et catalogue raisonné*, vol. 2, p. 100.

[41] Edouard Deverin, author of a collection of memoirs on the First World War: *Feuillets 1914–1918: du Chemin des Dames au Grand Quartier Général* (Paris: Maison d'Art et d'Edition, 1919).

[42] There are a few proofs in the Horst Collection.

[43] Germain Viatte: "Nouvelles Acquisitions," *Revue du Louvre*, 1964, nos. 4-5, p. 293. The Musée de Rennes owns *Seated Man*, pastel, reproduced in Jaworska, *Gauguin*, p. 50; the Musée de Quimper owns *Stevedores*, pastel, formerly in the Mélanie Collection, Riec-sur-Belon.

Pierre Auguste Renoir, *Young Girl and a Cow at Saint-Briac,* 1886, oil on canvas, 21⅜ × 25⅝ in. The Fitzwilliam Museum, Cambridge, England.

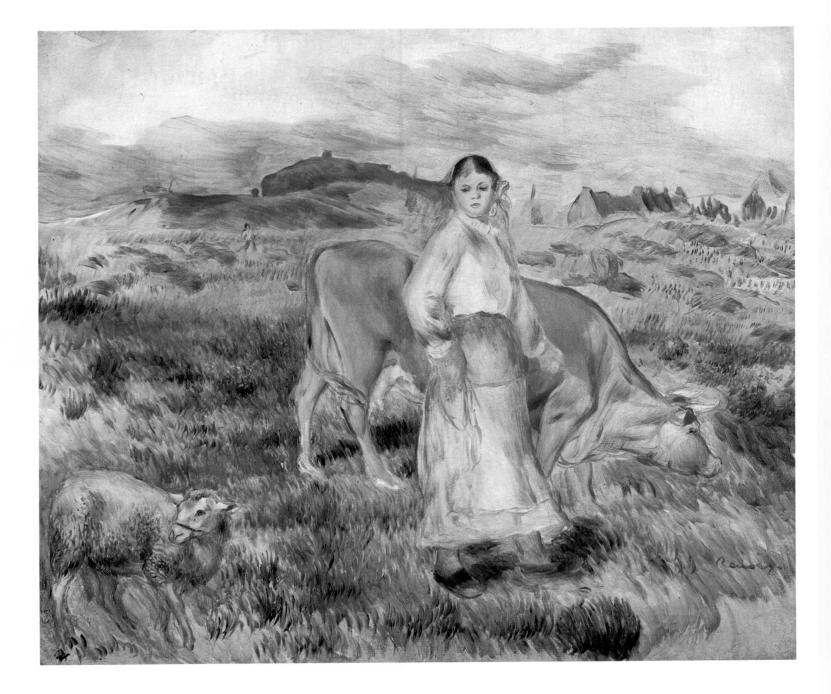

PIERRE AUGUSTE RENOIR

1841–1919

PON his arrival for the first time in Brittany, in 1886, Pierre Auguste Renoir wrote to Durand-Ruel: "I've found a nice quiet spot where I can proceed with my work very comfortably."[1] The success of this initial visit led Renoir to return to Brittany on three subsequent visits (1892, 1893, and 1895). During his brief stays, he produced a body of paintings that incorporate the wild, rugged landscapes of Brittany with the warm and intimate style he used to depict the more hospitable shapes of the Ile-de-France.

In 1886 Renoir had rented a house in Saint-Briac, on the northern coast of Brittany. Saint-Briac was already a well-known and popular place for the artistic community of Paris; Paul Signac had discovered it in 1885, and Emile Bernard stayed at the auberge of Madame Lemasson in the summer of 1886. It was in this village that Renoir, inspired by the birth of his eldest son, Pierre, the previous year, executed a series of paintings of Pierre and his mother in the garden of the house he was renting, the Maison Perrette (illus., pp. 134-35).

This series of paintings comprises two studies in oil and a completed version. An analysis and comparison of the three phases in the conception and

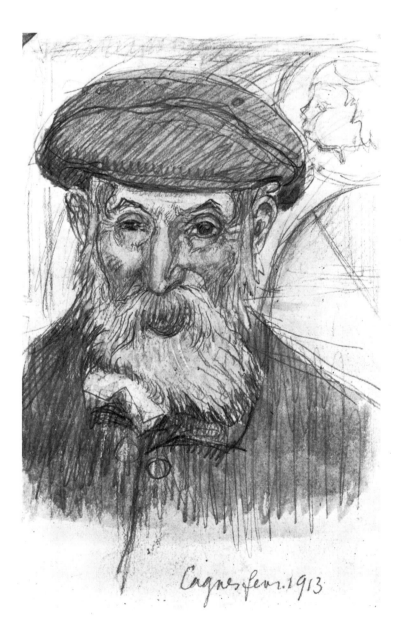

Maurice Denis,
Portrait of Renoir (Cagnes-sur-Mer),
February 1913,
pencil and watercolor.
Musée du Prieuré, Saint-Germain-en-Laye.

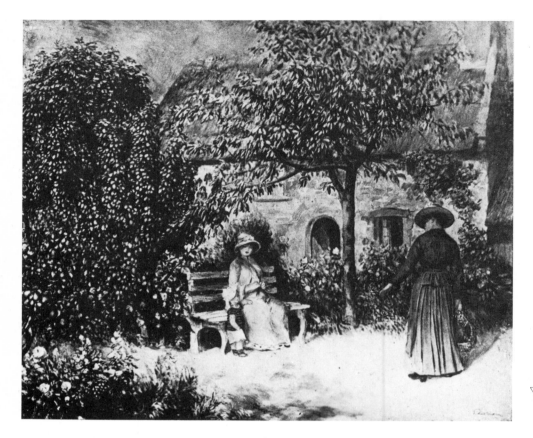

Pierre Auguste Renoir,
Garden Scene in Brittany at Saint-Briac, 1886,
oil on canvas, 21⅜ × 25⅝ in.
Barnes Foundation, Merion, Pennsylvania.

Pierre Auguste Renoir,
▽ *Garden Scene in Brittany at Saint-Briac*, 1886,
oil on canvas, 7⅛ × 9⅛ in.
Formerly Ambroise Vollard Collection, Paris.

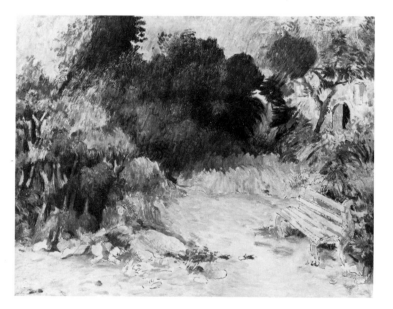

execution of this work shows Renoir as willing to experiment and be guided by his results. In the initial phase, during which Renoir produced the first study, without figures, the dynamism of the tangled vegetation, roughed in with energy and vitality, gave the painter a starting point and allowed him to proceed with the next stage of this composition. In the following canvas, the figures, who are the main theme of the painting, are introduced. The bench has been shifted to the left in order to focus on the child and mother. To avoid the painting's becoming too static, Renoir introduced a moving figure on the right. It is this woman, carrying a basket and talking to the child, which gives the scene its animation and vitality. Also, in this version the detail becomes apparent and readable. In the final phase, nothing new has been added, nothing deleted. However, the treatment has become more sober and classical. Fresh color has been added to the vision. The colors of the spectrum that he perceived in the actual Breton landscape passed through the filter of his sensitivity to his palette; bold without being violent, fresh without being naive, these warm and human tones reflect Renoir's deep love of life and people.

This orientation is reflected also in Renoir's painting of a young peasant girl with a cow, painted at

Saint-Briac that same summer (illus., p. 137), which shows greater interest in the subject's gestures and attitude than in the physical world in which she is portrayed. Yet the landscape that surrounds her is remarkably accurate, from the stone walls that border the fields to the thatched roofs in the nearby hamlet, constructed from the piles of hay that a peasant is cutting while a woman bends to gather them into sheaves. This canvas is an excellent example of Renoir's ability to retain the very real details of

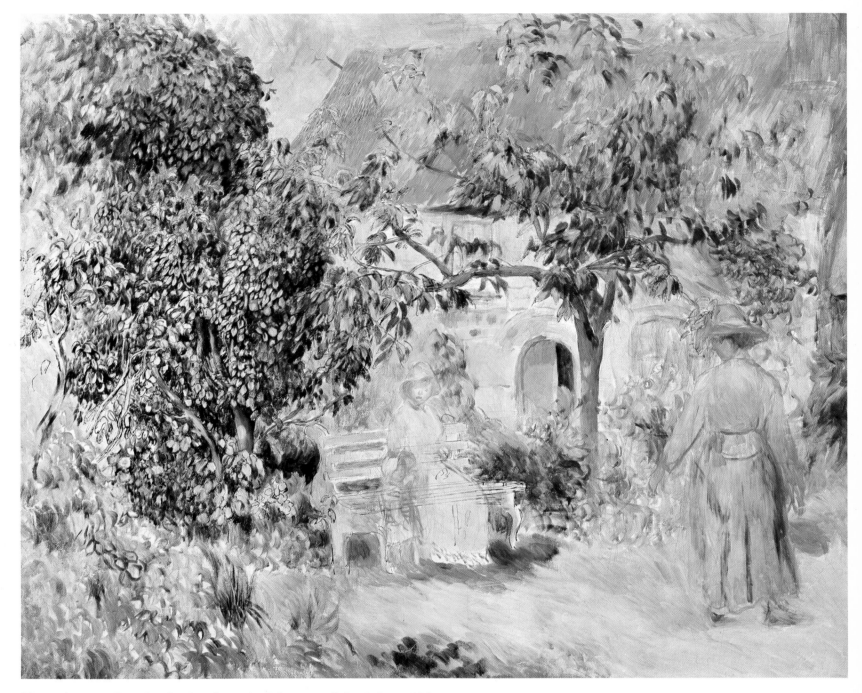

Pierre Auguste Renoir, *Garden Scene in Brittany at Saint-Briac,* 1886, oil on canvas, 17⅝ × 20⅞ in. Private collection, Paris.

his settings while not allowing them to overpower his human subjects.

Henri Rivière, twenty-two years old at the time, recounted later in his memoirs[2] how he met Renoir painting precisely this painting: "Returning from home one afternoon, we saw, seated on a folding chair, a painter who had in front of him, as a model, a peasant girl with a cow. I watched him from a distance and was convinced from looking at his painting, that this was none other than Renoir. With the self-assurance of youth I went up to him and raised my hat; 'Good afternoon, Monsieur Renoir.' 'You know me then, young man?' he said, turning around. 'No, Monsieur,' I replied nervously. 'Oh, how polite this young expert is' and noticing my paintbox, he continued: 'You are a colleague if I'm not mistaken.' So I had to show him my study, which he was kind enough not to find too inept." In 1890, recalling this meeting, Rivière was inspired to develop his earlier sketches into a colored woodcut enti-

tled *Woman with a Cow, De La Haye Point at Saint-Briac* (illus., p. 136), which was exhibited in the same year at the Durand-Ruel gallery.

Renoir was pleased with the summer spent at Saint-Briac and wrote to Durand-Ruel in August: "I have enough lovely subjects to paint here until the end of September." On his working methods at this time, he added: "I am doing a lot of drawings and watercolors so that I'll have something to work from this winter. I am very happy and I am certain now that I can paint more easily and better than in the past."[3]

Six years later, in 1892, Renoir returned to Brittany. He spent August and September in the towns of Pornic and Noirmoutier on the southern Atlantic coast. From the Châlet des Rochers (an annex of the Lion d'Or hotel at Pornic), where he was staying, Renoir wrote on August 29: "Everything is fine, I've quite a few things on the go, I expect to be finished around the middle of September."[4] The combination of an exceptionally mild and sunny environment and his discovery of the island of Noirmoutier, where he

painted several versions of the Bois de la Chaise, led him to write on September 8: "We are in a delightful, warm spot ... like you; as to when we will return ... it seems likely that I will stay here a little longer."[5] Having recovered from the torments of an unproductive period and returned to a more Impressionistic, more spontaneous style, Renoir painted several canvases that bear a striking resemblance to his paintings of the Midi and the landscapes of Cagnes-sur-Mer done several years later. This similarity is particularly evident in the canvases painted at Noirmoutier during the summer of 1892, and later in 1897 and 1900.

Noirmoutier was to Renoir a place to which he was always willing to return, to paint the woods overhanging a sea dotted with white sails or the young girls bathing among the rocks (illus., p. 143). More typical of Brittany itself, however, is Renoir's *Breton Farm in Pornic*, depicting a farm girl in her clogs, cap, and apron, looking after her geese, in an undulating landscape near Pornic.

Toward the end of September, Renoir and his

Henri Rivière, *Woman with a Cow, De La Haye Point at Saint-Briac*, 1890, colored woodcut. Private collection, Paris.

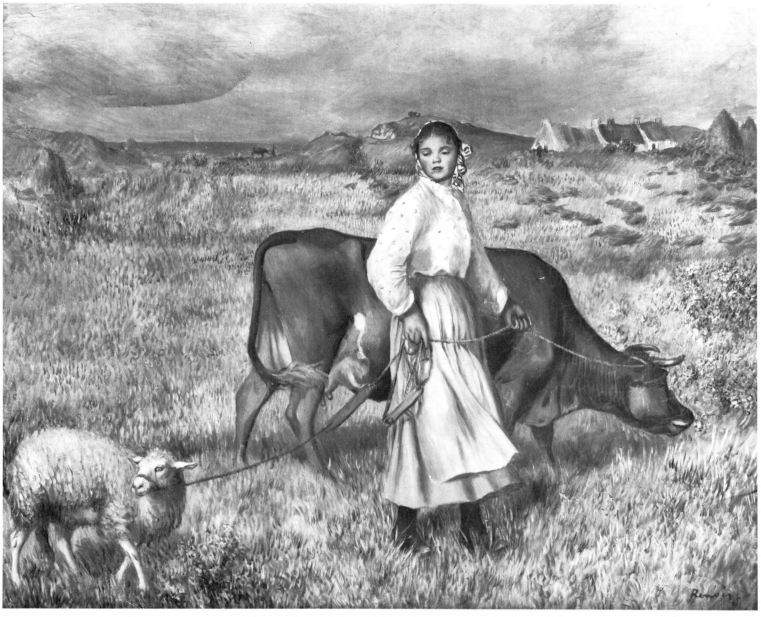

Pierre Auguste Renoir, *Young Girl and a Cow at Saint-Briac*, 1886, oil on canvas, 20⅞ × 25¼ in. Private collection, Tokyo.

Pierre Auguste Renoir, *Young Girl and a Cow at Saint-Briac*, 1886, drawing. Durand-Ruel Collection, France.

family moved to Pont-Aven and stayed at the Hôtel Julia, from where he wrote on October 13, 1892: "It is still nasty weather."[6] This weather, which made it impossible to work in the open, was nevertheless conducive to meetings and discussions. Since the Hôtel Julia was occupied by artists throughout the year, Renoir made the acquaintance of the painter Armand Séguin[7] who took him to see Emile Bernard. Bernard said of this meeting: "In 1892 I went directly to Pont-Aven, where I stayed the whole winter until March 1893.... It was during this visit that I met Armand Séguin, who came to see me often. He was living at the Hôtel Julia while I was lodging

137

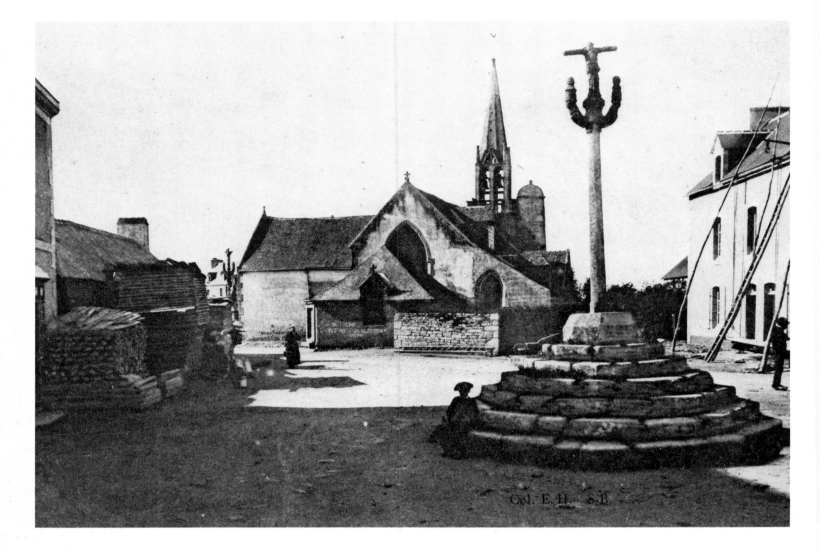

The cross and church at Nizon, near Pont-Aven.
Postcard, c. 1900.

Pierre Auguste Renoir,
Church at Nizon, near Pont-Aven,
oil on canvas, 18 ⅛ × 21 ⅝ in.
Private collection.

with the harbor master, Monsieur Kerluen. One day Séguin brought Renoir, who was also staying at Julia's, to see me. On seeing my canvases Renoir cried: 'You must have known Gauguin.' 'Yes,' I replied. 'Ah, now I see where he got it from. I always said that he had copied it from somewhere. We all know about his thieving.'"[8] These demeaning remarks made by Renoir about Gauguin, in the autumn of 1892, reinforce his sarcastic comments of the year before, when there was much agitation concerning Gauguin's departure for the South Seas: "One can paint just as well at Batignolles." On another occasion Renoir said of Gauguin: "He had taken it into his head to set on the right track all those painters who seemed too somber. He had converted to the 'painting of the future' an unfortunate hunchback called de Haan, who had until then made his living painting in the manner of Meissonnier. But de Haan stopped selling his paintings one day when, following the imperious advice of Gauguin, he substituted vermil-

lion for his darker colors."[9] The ties formed between Renoir and Séguin at Pont-Aven during the fall of 1892 were never broken. This friendship is spoken of in a letter that Séguin wrote to his friend the painter Roderick O'Conor, in June 1896. Probably referring to his *Nude in a Landscape*, which was finished about this time, Séguin wrote: "I think the painting must be finished, as I've signed it. Yet there is still a lot to do. Renoir came to see it and liked it very much and this gave me more pleasure than all the theories our friends have lavished on me. He advised me to continue painting as much as possible."[10]

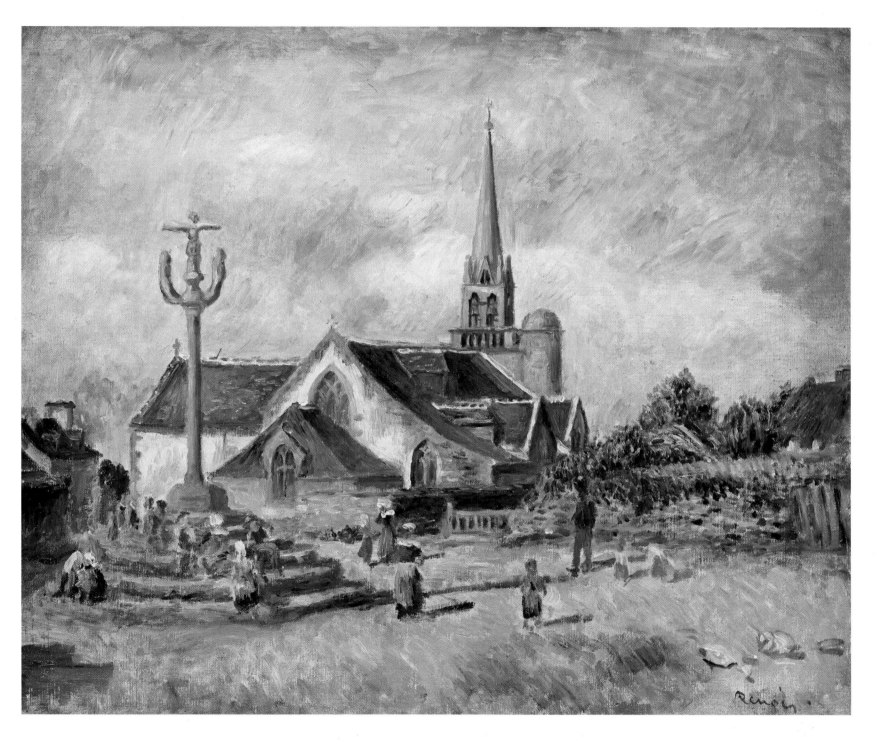

The town of Nizon is clearly the subject of Renoir's *Church at Nizon, near Pont-Aven* (illus., p. 139). The rendition of this scene is an elaborately descriptive work that, as a result of the accuracy of its architectural details and costumes, faithfully reproduces the peaceful atmosphere of this small Breton village. Previously the setting of this painting remained unidentified, as the cross in Nizon has been moved and the sacristy destroyed in the intervening years. Yet the discovery of a postcard of this village from several years later (illus., p. 138) certifies the location of this scene. The location of Nizon, only a few miles from Pont-Aven, makes it highly likely that this canvas was painted between October 1892 and March 1893, although the work is undated.

Eager to repeat the experience of his previous visit, Renoir returned to Pont-Aven with his family to spend the summer of 1893. In August he wrote to Durand-Ruel: "I am at Pont-Aven. I came just for a family holiday, but I've started a few things. I shall have to finish them and I am enjoying myself here. There are models. So I'm going to stay for a

while.... I shall work as much as possible. I feel that it will go well."[11] In another letter, this time to his friend Dr. Paul Gachet, he wrote: "I am at Pont-Aven with the family. I tried Normandy, mushroom country, but had to get away; I was bored to death in that humid area. In Brittany it rains just as often, but it's not the same thing at all, as you aren't up to your knees in mud. Here there are rocks and sand."[12] During this visit Renoir embarked upon a series of landscapes of the Aven estuary, painted from the wooded hills of Kerscaff, some two and a half miles from Pont-Aven on the Kerdruc road (illus., p. 140). The sea can be seen on the horizon, where the Aven enters it at Port-Manech. On the right, the pointed turrets of the chateau at Le Henan can be seen rising above the trees. A watercolor study, signed and dated, with a dedication, was given by Renoir to Mademoiselle Julia, his landlady, and for over twenty years it hung in the hotel dining room, as can be

△ **Pierre Auguste Renoir,** *The Aven River, Seen from Kerscaff,* oil on canvas, 18 1/8 × 21 5/8 in. Private collection.

Letter from Renoir to Durand-Ruel, facsimile. ▷ Durand-Ruel Archives, Paris.

▽ *Pont-Aven and Port-Manech: the mouth of the Aven River.* Postcard, c. 1900.

PONT-AVEN ET PORT MANECK (FINISTÈRE). — LA RIVIÈRE L'AVEN

140

Mon cher Durand-Ruel

Je serai à Paris
Dimanche pour
voter. J'irai
vous voir lundi,
si vous n'êtes pas
trop occupé de la
grande cérémonie.

à bientôt

amitiés

Renoir

31 août

P.S. vous avez dû recevoir
ma dépêche pour échanger
...

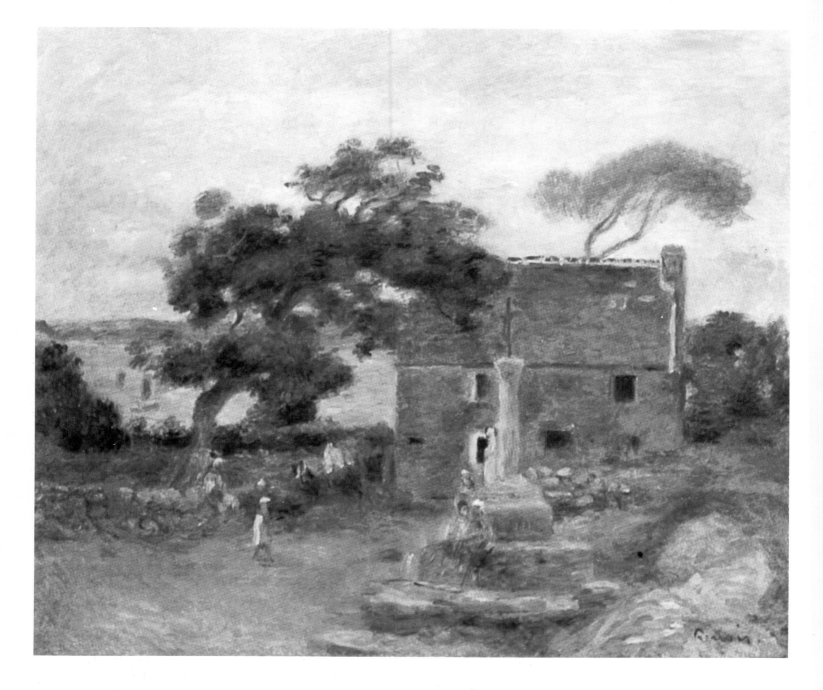

seen in a photograph published in 1928 by Léon Tual on the occasion of Julia's death.[13]

After spending the summer of 1894 in the Midi, at Beaulieu-sur-Mer, Renoir returned to Brittany for the last time, in 1895, staying this time at Tréboul. There he painted *Tréboul, near Douarnenez* (illus., p. 142), in which three peasant women in caps are sitting on the broad steps of the cross at the roadside. Renoir was particularly inspired by the nearby port of Douarnenez, famous for its sardine fishing. He noted: "I'm working like a slave — Douarnenez is superb."[14] The landscapes he painted in 1895 of the bay at Douarnenez, with its steep cliffs overhung by a few maritime pines and covered with heather, and

142

Pierre Auguste Renoir,
△ *Nude with a Straw Hat* (Pornic), 1892, oil on canvas, 16 ⅛ × 12 ⅝ in.
Private collection, Switzerland.

Pierre Auguste Renoir,
◁ *Tréboul, near Douarnenez,* 1895, oil on canvas, 21 ⅝ × 25 ⅝ in.
Formerly Durand-Ruel Collection, France.

◁ *Tréboul, near Douarnenez.* Photograph, c. 1890.

Pierre Auguste Renoir,
Child in a Landscape,
Wearing the Bonnet
of Douarnenez, 1895,
oil on canvas,
7 ⅛ × 9 ⅛ in. (detail).
Private collection.

with the hills of Menez Hom in the distance (illus., p. 264) demonstrate the attraction of the region for Renoir and other artists. Reminiscent of the landscapes of Chamaillard painted in the same area about the same time (illus., p. 265), the Impressionistic modernity of these Breton canvases contrasts with the more traditional paintings Eugène Boudin was to paint in the same place two years later, in June 1897.

Curiously, during all his visits to Brittany, Renoir showed no interest in painting the sea or its cliffs, beaches, or rocks. Despite the fact that he wrote to Monet in 1886 of landscapes "superb for him" when the latter was at Belle-Ile struggling with nature at its most rebellious, Renoir did not see Brittany in the same way. However, Brittany's rugged landscapes and medieval traditions left their imprint on Renoir, as on the other Impressionist painters. His choice of subject gradually shifted to the anecdotal or literary, as he depicted peasant women in coifs, medieval chapels, and granite Celtic crosses. His colors evolved toward the use of denser, deeper tones. His essentially warm palette began to include the silver grays, vibrant greens, and endless shades of blue in the Breton environment.

When Renoir left Brittany, his natural inclination toward warm and bright colors again became prevalent. The canvases produced during his visits to this province remain unique in his career. Renoir's natural inclination toward warm and bright colors was reflected in his move to Cagnes-sur-Mer, and the windy, rocky coast of Brittany became a memory.

NOTES

[1] There are three known letters that Renoir wrote during August 1886 from Saint-Briac to Durand-Ruel in Paris. This is the postscript to letter no. 2/86, in the Durand-Ruel Archives, Paris.

[2] Quoted by Georges-Henri Rivière (nephew of Henri Rivière) in the preface to the catalog of the Henri Rivière exhibition, Musée de Pont-Aven, 1977.

[3] Renoir to Durand-Ruel, letter no. 2/86, Archives, Durand-Ruel.

[4] Ibid., letter no. 1/92 to Durand-Ruel.

[5] Ibid., letter no. 2/92 to Durand-Ruel.

[6] Ibid., letter no. 3/92 to Durand-Ruel.

[7] Armand Séguin met Gauguin in 1894 during the latter's last visit to Pont-Aven. Séguin had discovered Pont-Aven in 1892, and he was influenced by Emile Bernard and Roderick O'Conor.

[8] Emile Bernard, *Souvenirs inédits sur l'artiste-peintre Paul Gauguin et ses compagnons* (Lorient: Imprimerie du Nouvelliste du Morbihan, n.d.), p. 18.

[9] François Fosca, *Renoir: His Life and Work* (New York: Praeger, 1969), p. 200.

[10] Armand Séguin to Roderick O'Conor, June 1896; quoted in Wladislawa Jaworska, *Gauguin et l'école de Pont-Aven* (Paris: Bibliothèque des Arts, 1971), p. 142.

[11] Renoir to Durand-Ruel, letter no. 1/93, Archives, Durand-Ruel.

[12] Renoir to Dr. Gachet; quoted in *Lettres impressionistes au Dr. Gachet et à Murer* (Paris: Gachet, 1957).

[13] Léon Tual, *Mademoiselle Julia Guillou de Pont-Aven* (Concarneau: Imprimerie Le Tendre, 1928), p. 17.

[14] Renoir to Durand-Ruel, letter no. 1/95, Archives, Durand-Ruel.

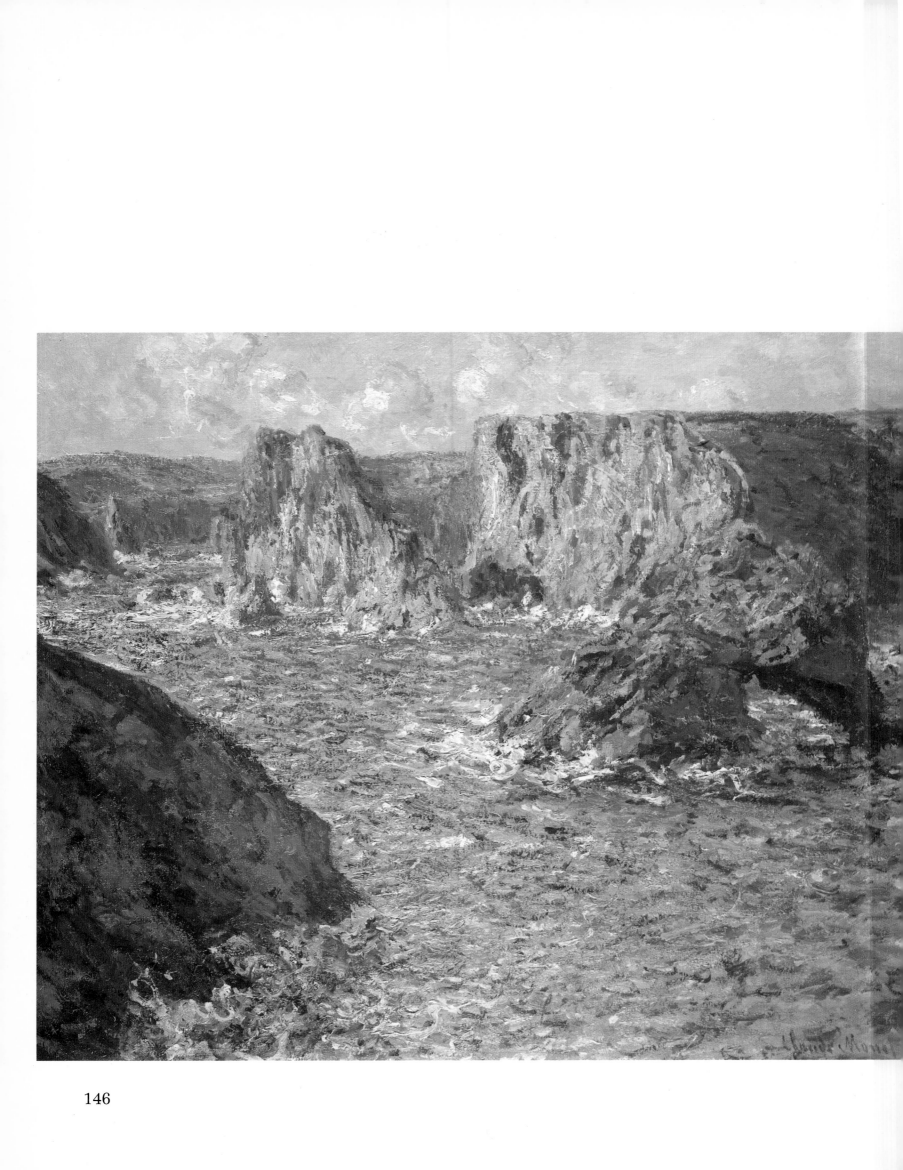

146

CLAUDE MONET

1840–1926

The Breton Sojourn of 1886

*He was able to conquer this landscape of granite
and its fearful waters.
For the first time the terrible seas down there
have found their historian...
their painter and poet.*

GUSTAVE GEFFROY, 1887

N O work on Impressionism would be complete without a reference to Claude Monet, the principal character and leading light of the entire Impressionist movement. In his search for new motifs and scenery, Monet explored various regions of France, including the wild province of Brittany. Monet's Breton period[1] stands as an excellent example of how his work was affected by the location in which it was produced. Though his stay in Brittany lasted only a few months, Brittany inspired Monet to produce a coherent body of work, clearly distinguishable from paintings he produced either before or after this visit.

This province inspired paintings with both more highly constructed forms and an architectonic quality, like Belle-Ile's own abrupt coastline. Having

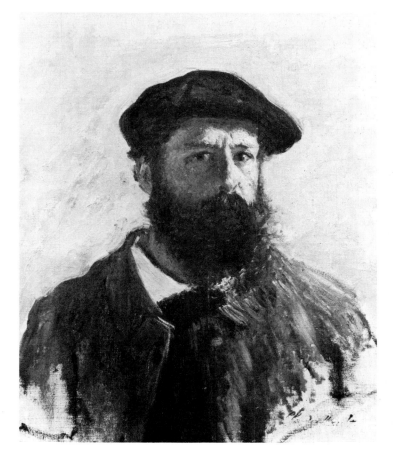

Claude Monet,
◁ *The Guibel Rock, Port-Domois*, 1886,
oil on canvas, 26 × 31 ⅞ in. (detail). Private collection, U.S.A.

Claude Monet,
Self-Portrait with a Beret, 1886, ▷
oil on canvas, 22 × 18 ⅛ in. Private collection, France.

147

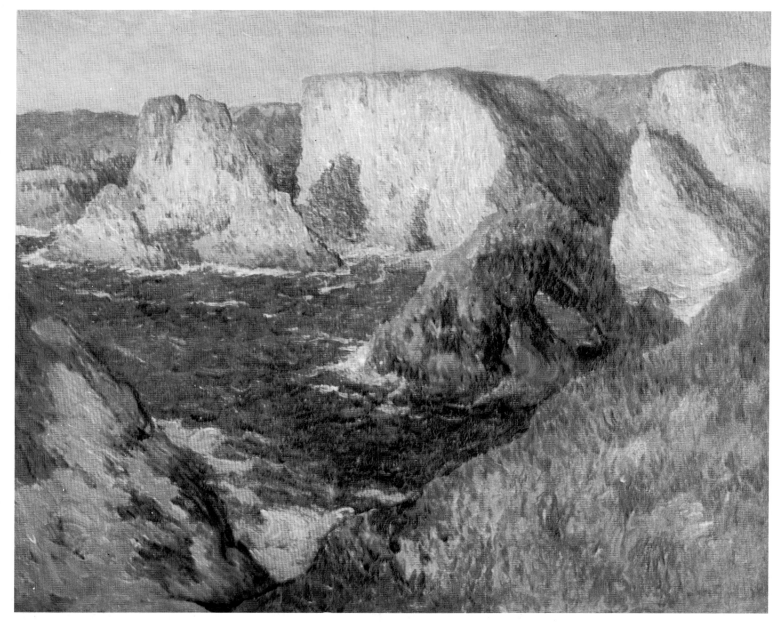

Henry Moret,
Belle-Ile, The Guibel Rock in the Bay of Domois, 1896,
oil on canvas, 23⅝ × 28⅝ in.
Private collection, Switzerland.

The Guibel Rock in the Bay of Domois.
Photograph by R. Missey, Le Palais, Morbihan.

chosen a "frontier zone" where the land and the tide meet, Monet devoted his Breton work to the image of the rock in water,[2] the solid contrasted with the fluid. Monet's paintings of Belle-Ile depict the eternal duet of the granite rock interacting with the undisciplined strength of the ocean. In depicting these two forces, Monet prefigured the experiments of many of his contemporaries. In the paintings done by Loiseau in Belle-Ile a few years later, for example, there is great emphasis on the effect of light on the movement of the waves and sky, and in the work of Moret the emphasis is on translating the solidity of the granite

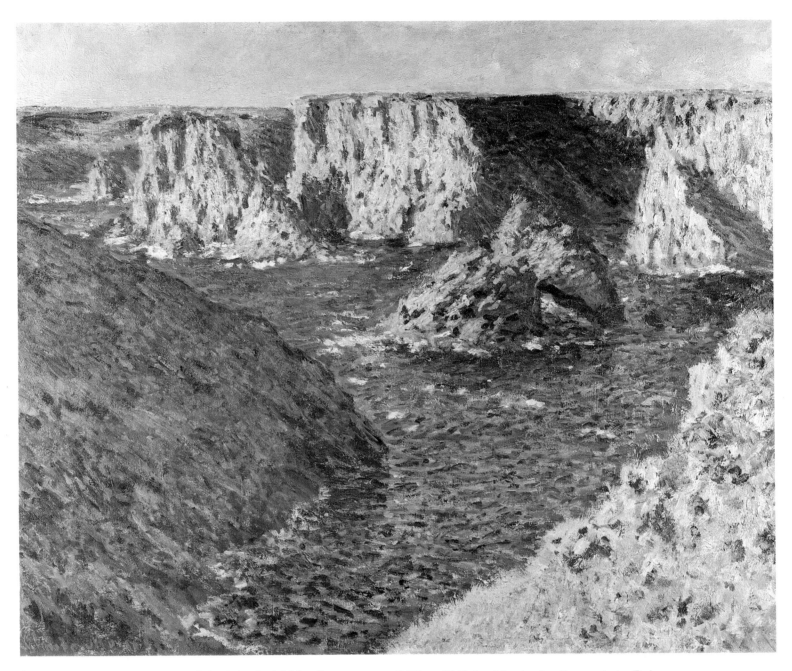

Claude Monet, *Belle-Ile: The Guibel Rock*, 1886, oil on canvas, 24⅞ × 31⅛ in. Musée des Beaux-Arts, Reims.

rocks into color (illus., p. 157). Concentration on the movement of the sea as a whole, communicated through the formal construction of the composition and the strength of the treatment of this subject,[3] is also found in the works of Maufra (illus., p. 158) and Dezaunay.

The fascination of these artists with changes in the various temporal elements (sun, rain, inclement weather) often led to noticeable mood swings among paintings of the same site. When the weather was foul and when a storm broke, Monet's treatment became harder, more violent, gaining in power what it lost in subtlety. The same emotions expressed in identical ways are also found in the works of Maufra and Moret. In Moret's work there is almost always some living element (fishermen on a boat, seaweed gatherers, cows, gulls) or some sign of life (a house, church tower, or village), whereas in Monet's Breton work there is only rock, sky, and water, with no trace of human presence, no picturesque elements. Nevertheless, these canvases evince an amazing vitality. Evidence of Monet's genius was his ability to bring his own emotions into paintings that are austere and "depopulated" in terms of subject matter.

149

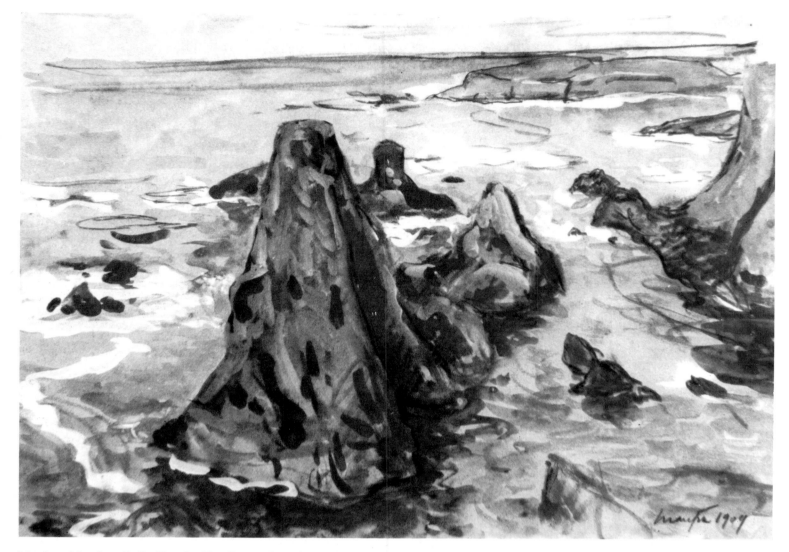

Maxime Maufra, *Belle-Ile, the Needles at Port-Coton*, 1909, watercolor and gouache. Private collection, Pont-Aven.

The Needles at Port-Coton.
Postcard, c. 1900.
Photograph, Archives of the Fondation Wildenstein, Paris.

Monet's Stay at Belle-Ile-en-Mer

The Creation of the Work

On September 12, 1886, Claude Monet landed alone on the quay at Le Palais, the small capital of Belle-Ile-en-Mer, dominated and defended by the famous fortress built by Vauban for Superintendent Fouquet. Arriving from Etretat, on the channel coast of Normandy, Monet visited Brittany for the first time. On the day of his arrival he wrote to his friend the art dealer Paul Durand-Ruel: "I suddenly decided to

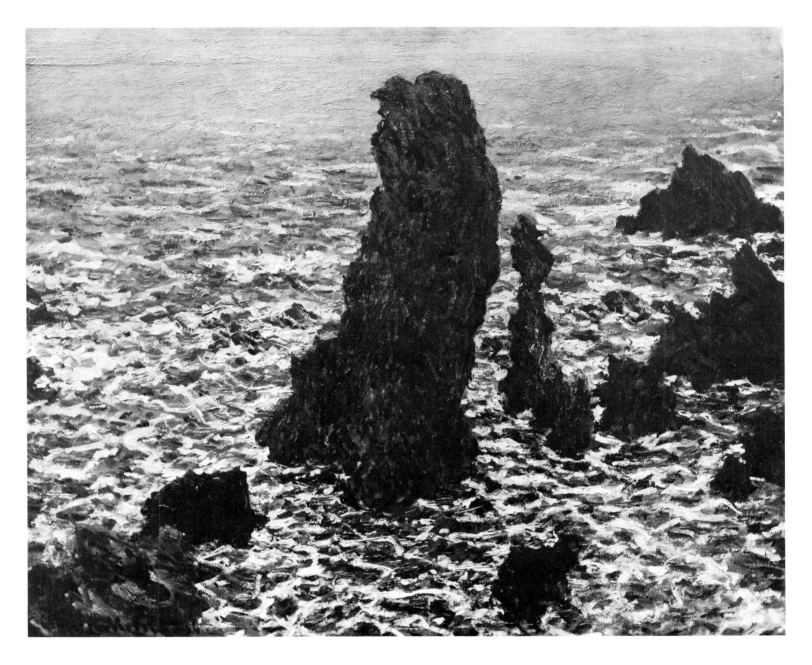

Claude Monet,
Rocks at Belle-Ile: The Needles at Port-Coton, 1886,
oil on canvas, 23⅝ × 28⅝ in.
Ny Carlsberg Glyptotek, Copenhagen.

take part in the famous voyage to Brittany." By 1886 Brittany had become even more fashionable,[4] following the publication of Pierre Loti's popular book *Pêcheur d'Islande*. Praised and described in detail by poets, writers, and painters, it attracted not only Monet but also his friend Renoir, who spent the summer of 1886 in Saint-Briac, on the northern channel coast.

For Monet, Belle-Ile represented the shock of the unknown. After walking around the island, he arrived on September 15 in the village of Kervilahouen, "a small hamlet of eight to ten houses near the spot known as the terrible sea." He wrote to his friend Alice Hoschedé: "It is so different from the channel that I will have to get used to this form of nature," and he described his new surroundings as follows: "Not a tree for ten kilometers around, only rocks and wonderful grottoes; it is sinister, diabolical, and superb." Despite the clear sun of his first few days and the heat that induced him to bathe "without a costume in a delightful spot where the water is extraordinary," the novelty of the spectacle

151

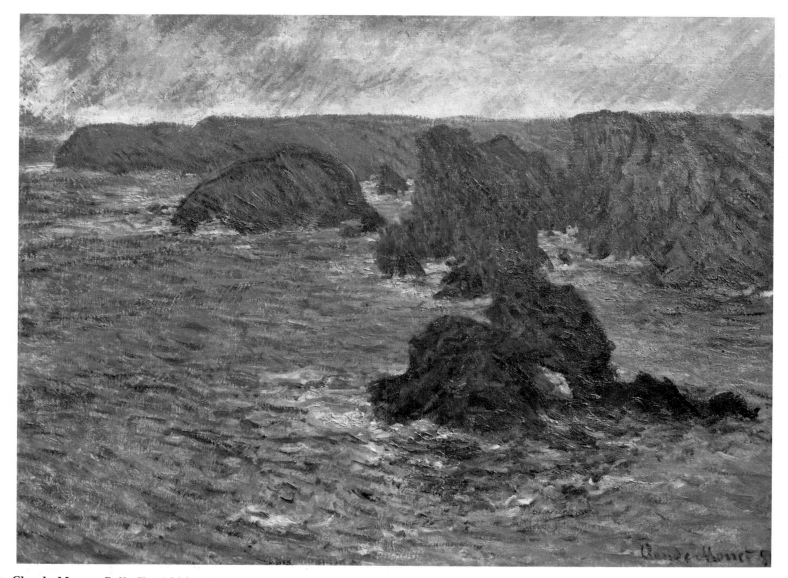

△ **Claude Monet,** *Belle-Ile*, 1886, oil on canvas, 23⅝ × 31½ in. Musée Rodin, Paris.

Paul Gauguin, *Rocks in the Sea*, 1886, oil on canvas, 28⅝ × 36¼ in. Tejima Collection, Japan. ▷

that confronted him on his arrival threw him temporarily into a state of disarray and depression. Three days after moving in with Père Marec, "a fisherman with a small inn who has agreed to cook for me," he wrote: "I've recovered my spirits and I'm working ... or I'm trying my best to and I'm having a lot of trouble."

Here, the ocean, with which he had long been familiar, seemed to produce colors and moods that were completely new and confusing. He explained: "It gives me a terrible pain; it is so different from what I have been used to painting." To his friend Gustave Caillebotte, he confided: "I had become

used to painting the channel and had my own routine that I followed, but the ocean was something completely new." On the power of the elements, Monet continued: "I had never seen the sea so rough.... It's extraordinary to see the sea. What a sight! It's so out of control it makes you wonder if it will ever be calm again." The color of the water fascinated him too: "Furious as it is, it does not lose its lovely green and blue color.... The water at Etretat is muddy in comparison." He was ecstatic at the sight of "a sea of unparalleled tones." The coastline, bordered by high granite cliffs, is extremely jagged and broken, with small, sheltered harbors like Port-Goulphar

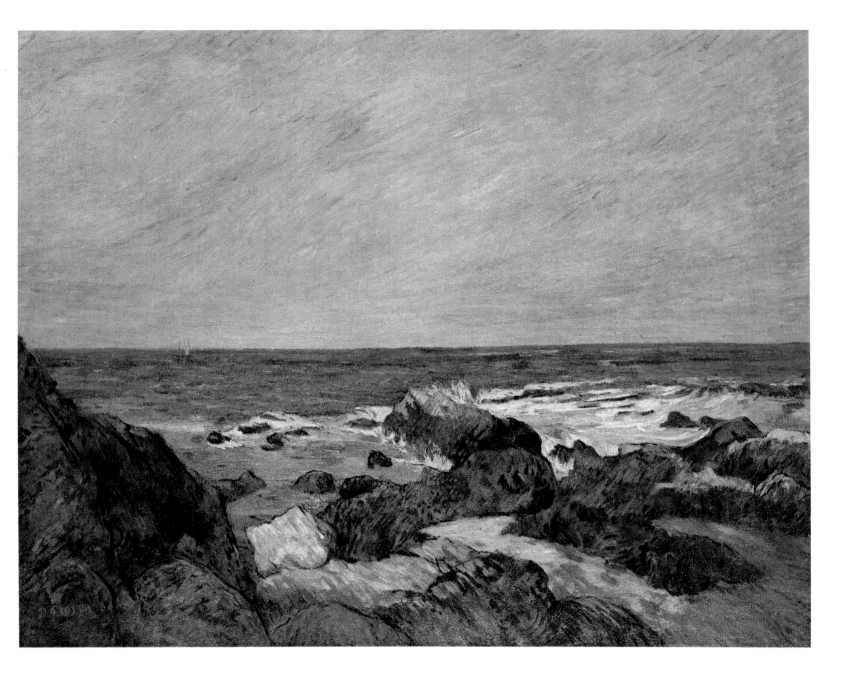

and Port-Coton, reefs and rocks of enormous bulk like the Lion rock scattered along its length and jutting rocks like those at Port-Coton pointing to the sky (illus., pp. 150-51). "As for the rocks, they are a mass of grottoes, points, extraordinary needles, but it takes time to reproduce their effect." This exposed part of Belle-Ile, aptly named "the wild coast," is open to the furious gales of the west wind, the assaults of the ocean swell, and rainstorms of great violence.

After several warm, sunny days, which were excellent for painting (during which Monet began several canvases at once, as was his habit), the weather deteriorated. Although conditions jeopardized the work in hand, they never lessened Monet's enthusiasm. "I am working solidly," he wrote on September 22, "despite the weather that has suddenly changed: I am doing three or four versions of the same motif." It was not long, however, before Monet encountered specific problems at Belle-Ile.

First, the arrival of the bad weather obliged him to prolong his stay from day to day, then from week to week, in the hope of getting another glimpse of the effect that he had begun to achieve on canvas. The images that he sought had been altered by the rain, wind, and hail. It was only with a great struggle that

153

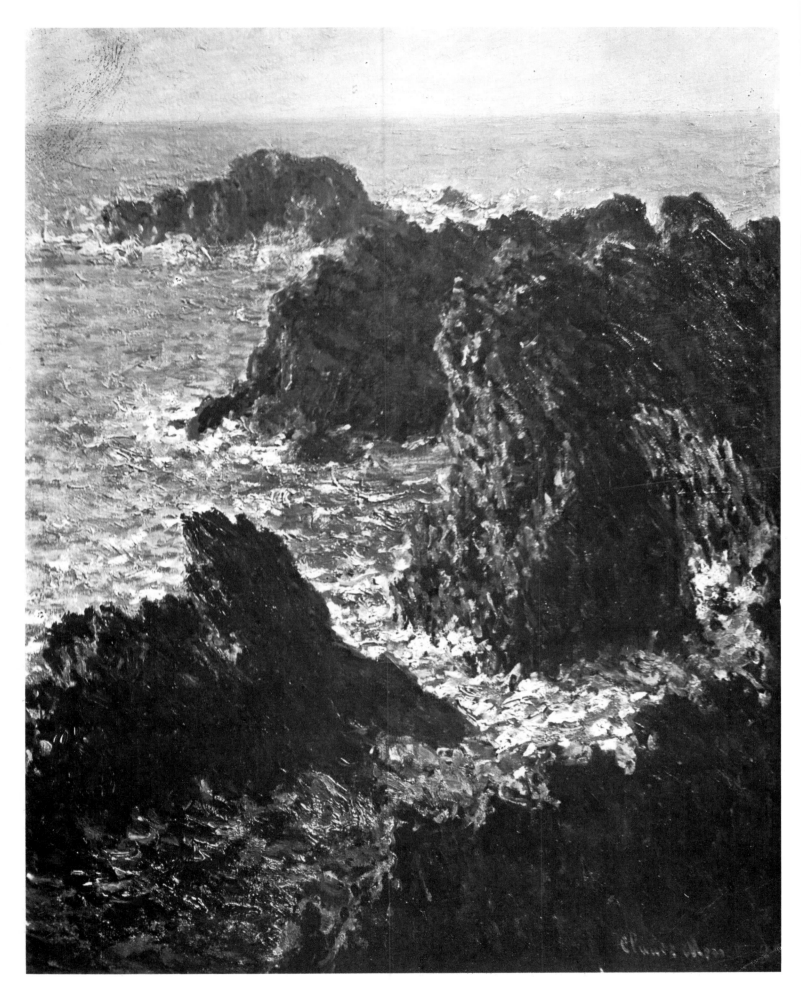

CLAUDE MONET

Monet's canvases of Brittany were produced. Obliged to enlist the services of a local porter ("good old Poly") to help him to carry his materials (including the numerous canvases that he was working on simultaneously) to the site at which he was working, he was often forced to rope down his umbrella, his canvases, and his easel. He described struggling for hours against the wind and spray in an attempt to continue with the work: "It has been dreadful weather," he wrote on November 11, "with rain, hail, and thunder. There has been so much hail that my face and hands are still sore this evening and at times I was afraid that it would make holes in my canvases." A few days later he added: "To spend hours in the

Claude Monet, *Rocky Point at Belle-Ile*, 1886, oil on canvas, 31⅞ × 25⅝ in. Private collection, U.S.A.

Claude Monet, *Portrait of Poly*, 1886, oil on canvas, 29⅛ × 20⅞ in. Musée Marmottan, Paris.

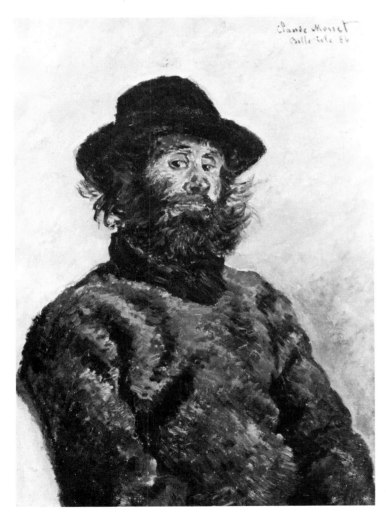

rain in the hope of being able to do a few brushstrokes, no, that is sheer madness."[5] On September 27 Monet complained that "the highest tide of the year has gone down a lot and that has caused problems for a number of my studies."

Alterations in light conditions also proved troublesome for Monet, since the sky was at one minute cloudy and gray and at the next bright and sunny. This problem was accentuated by the passage of the sun to its nadir as the winter advanced, a situation that deeply upset Monet: "Every day the sun's course becomes shorter so that it no longer shines on the same things.... Now there are two more canvases that I can't work on, for the sun is now falling completely differently. This breaks my heart, for there were still a lot of things I wanted to add." All these problems meant that Monet had to prolong his stay in this barren landscape. He was constantly met by disappointment: "Things are getting worse. I want to finish, but I need just the right effect and that is often impossible."

But Monet was slow to become discouraged. His work had gone well in the beginning. On September 22, only ten days after his arrival, he wrote: "All the canvases I brought with me are covered, it's just a matter now of finishing them off." Overcoming the difficulties inherent in his new surroundings, he wrote: "I am quite myself again now and am beginning to understand this region and what I can do with it." As for Belle-Ile, he wrote: "Moreover, I find the area superb, even away from the terrible rocks and the wild sea."

During his stay in Brittany, Monet produced thirty-nine paintings in all, for which he had to suffer discomfort, rain, cold, and loneliness, far from family and friends. Despite the visit of Octave Mirbeau, the friendship of the painter John Peter Russell, the devotion of his porter, Poly, the kindness of his landlord, and the daily exchange of letters with Alice Hoschedé, his two and a half months of self-imposed isolation in such a desolate spot, lacking many everyday comforts, required immense willpower. "Just think," he wrote on October 23, "that I have covered thirty-eight canvases ... and you will see that I've not been wasting my time and that I must be tenacious." Although recognizing the difficulty of finishing the works on hand because of the aforementioned obstacles, Monet wrote: "I'm not getting

on with my canvases as quickly as I had hoped ... but I'm right not to start anything new. I'm working in the same places in all weather."[6] It was not inspiration that he lacked, rather his determination to complete his unfinished works made him unwilling to start anything new. This situation caused him some regret: "On arriving at Le Palais I was amazed. It was high tide and the sardine boats were coming in. This had left me cold the first time but yesterday I was astounded by all the lovely things worth painting." He described some of the sights he would have liked to paint: "Over eight hundred boats coming and going at once, some with red sails, others with apple-green ones, all on a blue sea."

Similarly, it was only lack of time that prevented him from sketching the lobster fishermen who came to Père Marec's inn in the village: "In the modest inn where I eat there are characters who would be great to paint." Poly, his porter, sat for him on days of violent storms when the rain was too heavy to work out of doors. For Monet, Poly represented the admirable and sympathetic figure of the old seadog (illus., p. 155). "That hairy troglodyte face," as Anatole Le Braz described it, tempered the austerity and grandeur of Claude Monet's Breton work and added a gleam of malice and affection. This "quick sketch with its extremely good likeness," to quote Monet's description, demonstrates his interest not only in the geography of Brittany, but in the kindness and sincerity of its inhabitants as well.

The Daily Life of the Painter

The numerous letters that Monet wrote throughout his stay reveal not only the progress of his work and his problems as a man and an artist but also much about everyday life in this isolated spot on the Breton coast at the end of the nineteenth century.

After his first night in Le Palais, his first exploratory stroll led him to "beautiful things, admirable even, but far away, too far away, and admirable things where it is almost impossible to set up one's easel." He recounted his first impressions as follows: "It is tragic, but quite beautiful." Anxious to find somewhere to live near the scenery that appealed to him, he added: "Tomorrow morning I am going exploring again to see if I can find somewhere to stay in a small village, for Le Palais where I am

now is a real town." Le Palais was at that time an important port for sardine fishing and a haven for fleets of boats from every port in Brittany, attracted by the great schools of sardines in the waters around the island (illus., p. 156). Describing his life in Kervilahouen, a small hamlet on the west coast of the island, and a desolate stretch of grass and rocks where few houses had been built, Monet wrote: "I have found quite a large, clean room with a fisherman who has a small inn and has agreed to provide my meals for only four francs a day." He added: "I expect I will live on nothing but fish, lobster especially." The isolation of the island, and particularly that of the hamlet, meant that "the butcher comes only once a week, and the baker that rarely too." But Monet adapted to the way of life quickly. On September 24 he announced: "I am getting used to my modest way of life. Indeed, my landlord and landlady are doing their best to please me and I am eating a bit better. They have gotten in bread and meat and fruit too and I'm eating fruit at every meal." A few days later, on the twenty-seventh, he reiterated: "I am eating much better," and added, "I am so tired by the evening that I sleep like a log and am not bothered too much by the racket the rats make."

By October 2 the weather had turned foul, making outdoor work impossible. The weather conditions allowed Monet and Octave Mirbeau, who was visiting him, to sit longer over their meals: "This morning we had a real feast. We got them to make us some pancakes, which, upon my word, were delicious."

BELLE-ILE-EN-MER - 71 - Port de Palais et citadelle

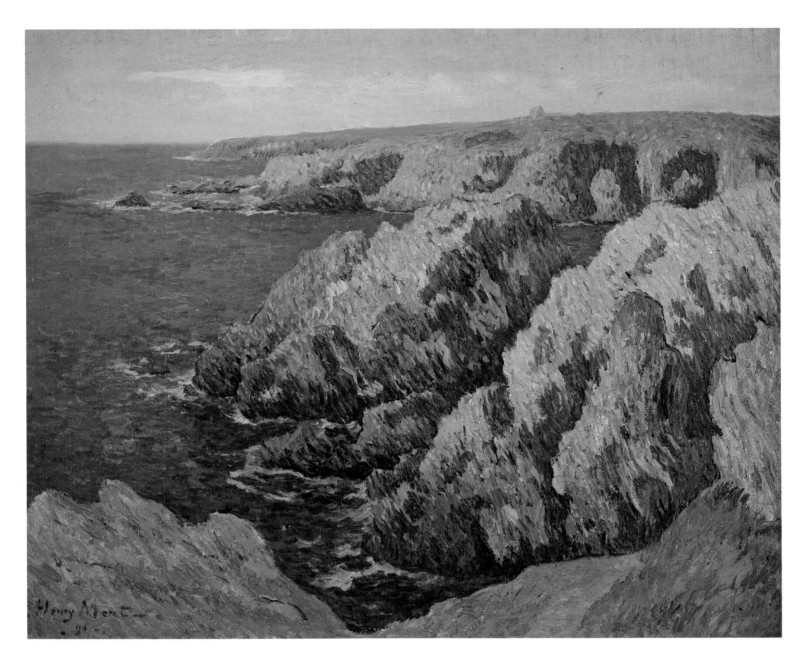

Henry Moret,
△ *Cliffs*, 1896,
oil on canvas, 24 × 28⅝ in.
Private collection, France.

◁ *Belle-Ile-en-Mer: the sardine fleet in the harbor of Le Palais.*
Postcard, c. 1895.

Almost complaining, he added: "Of course we had to have lobster with it."

On October 21 he wrote: "My landlord and land-lady are really nice and I am completely happy here, eating all the things I like; but as you can imagine, I am enjoying all the fish." He continued: "At the moment they are catching a lot of mackerel and mullet, and tomorrow I am going to have porpoise.

One of the fishermen has caught one three meters long. I have never seen it before, but this evening Père Marec showed me a plate of raw flesh and said that it was my steak for tomorrow. Laughing, he told me that it was porpoise. It looks just like beef and I will let you know if I enjoyed it." Monet was also served *ormeaux*, and he wrote: "Another delicious thing I have eaten is a type of shellfish that I had never seen before, since it is found only here. They catch a lot of them in winter." With the hunting season approaching, he declared: "The [lighthouse] keeper is waiting for the season to bring me wood-cocks. They have all sorts of game here." Nor was there any shortage of "extras": "Today [November

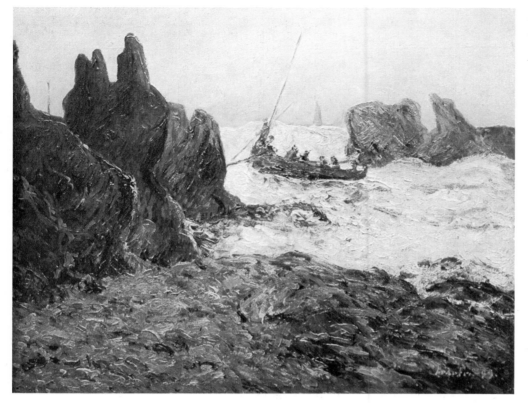

Maxime Maufra,
Rough Sea, 1899,
oil on canvas, 21⅝ × 25¼ in.
Private collection, Switzerland.

8] the Mirbeaus went mushrooming. There are masses of them here and we had a real feast."

Although anecdotal, these observations describe the simple, rustic life Monet chose to live at Kervilahouen. Day after day there are phrases and details in his letters, rich in savor, that illustrate the painter's environment, an ambience that has disappeared or changed over the course of a hundred years.

Concerning the richness of the animal life, he wrote on September 4: "The whole coast is full of extraordinary seabirds." He continued on November 2: "There are masses of migratory birds here at the moment. This morning in my room I caught a delightful hummingbird, even smaller than a wren, not much bigger than a butterfly. It did not seem to want to go. I put it out of the window twice, and twice it flew in again.... The lighthouse keeper finds hundreds every morning that have been killed against the glass, attracted by the light." He also mentioned the cruel custom of coastal people of taming gulls by cutting their wings, so that they can only waddle about around the house: "There are tame birds in front of every house." Monet, with the help of his porter, Poly, decided to capture a few and send them to his family, along with a bit of practical advice: "Gulls are fond of bread soaked in milk; you

have to spoil them at first to get them used to being indoors!" Besides these modest pleasures, Monet occasionally allowed himself a little time off: "As it was overcast yesterday, I took the opportunity of going out with the fishermen.... We had a great trip, there was a wind and we made good speed between the enormous rocks." This trip, made in the company of the Australian painter John Peter Russell, another inhabitant of Belle-Ile, almost ended in tragedy. Monet described the scene to his wife: "We got them to drop us in an enormous grotto, where I made a vain attempt at a quick sketch. It was one o'clock and the fishermen were to pick us up at four, since there was no way out by land and it was impossible to climb the rocks. At half past nine, there was no sign of them and we were beginning to get worried, especially as the sea and wind were becoming stronger.... Finally the fishermen showed up. They had been to collect their lobster traps and were delayed by the bad weather. It was no easy task for them to come alongside and take us on board." Untroubled by seasickness and with no regrets concerning his escapade, he brought his account to a close: "Then we had to sail home in a really heavy swell. It was breathtaking and delightful, how our poor boat was thrown about!" Delighted with another outing, he

158

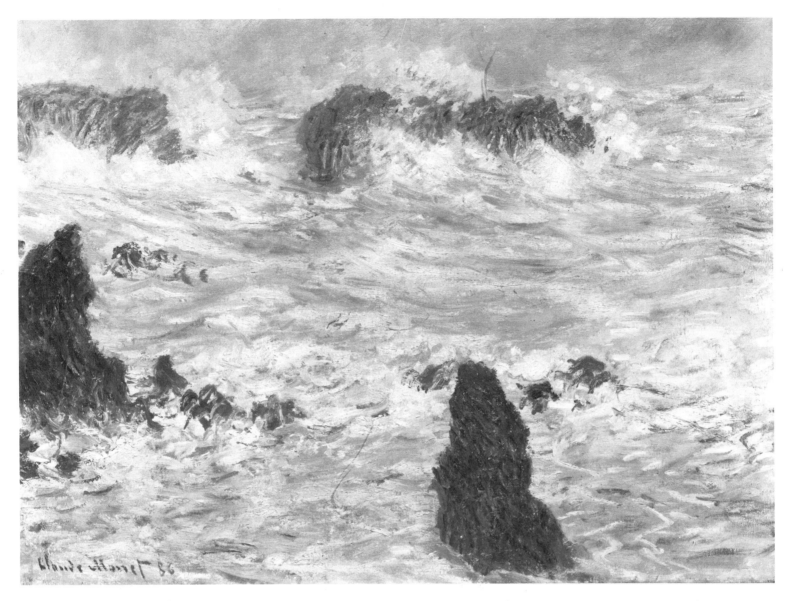

Claude Monet, *Storm, Belle-Ile Coast*, 1886, oil on canvas, 25⅝ × 31⅞ in. Musée d'Orsay, Paris.

recounted on November 11: "It is midnight.... I have just been fishing for conger eels in the innkeeper's boat. What an enjoyable evening I spent in bright moonlight, but we were rocked about a bit as the sea was not exactly like a millpond."

By mid-October, after outdoor work had become practically impossible, Monet was often forced to remain cooped up indoors. "You ask," he wrote to Alice, "how I spend the long evenings. First I go on painting as long as I can. At nightfall my good man [his porter, Poly] brings my things home, and I take the longest path I can. Then I look over what I have done. This takes me through to dinner, which goes on until half past seven or eight o'clock. Sometimes I stay even later, listening to the talk of the fishermen, who are always interesting, then I go up to my room

and spend an hour writing letters. A pipe and a last look at my canvases and then to bed. But the wind never stops, the house trembles, it is like being at sea." He described a local event to his companion: "Yesterday ... there was a wedding in the village. It was most curious, they danced in front of my window on the square, an amusing sort of round-dance, and sang as they danced. And in the evening, what a racket! They're continuing it today and tomorrow. Of course the women are well dressed, with their delightful bonnets." He concluded: "All in all, it was a curious wedding." Another day it was Poly who took a day off: "I've wasted the day," complained the painter, "my porter was killing a pig and though he sent a boy in his place I couldn't manage to set my easel up firmly against the wind."

Claude Monet,
Rain at Belle-Ile, 1886,
oil on canvas, 23⅝ × 23⅝ in. Musée des Beaux-Arts, Morlaix.

While the bad weather continued, he painted two canvases looking inland from his window. These works showed the little hamlet of Cosquet, lost in the heath and almost disappearing under a veritable deluge (illus., p. 160). "If this continues," cried Monet, "I will not be able to get to the scenes I am painting, for the paths and ground will be waterlogged.... It is becoming disastrous, the peasants can't plow or sow and everyone is as fed up as I am and saying that it can't last." Unhappy at being prevented from finishing his work, he added: "I am going very sadly down to dinner and then for a chat with Père Marec and the fishermen. That will take my mind off things for a bit." Forced into new company in this way, Monet came to appreciate the people of the village. "The longer I am here," he said, "the more I find the local people friendly and kind."

However, his stay was nearing its end. On November 24, he packed his things and collected his canvases, ready to embark on the pilot boat that was to take him to Noirmoutier. He had promised to join Mirbeau at this new spot: "I must," he said, "go and give my final instructions for the sending of my things, see about provisions for the journey, and

then have a drink with these good fellows." The idea of making the journey by boat appealed to him: "Two days traveling, two days that I shall enjoy, for you know how much I like going by boat." The weather was perfect for the journey: "It was superb. I've never seen such a beautiful sunset. It was like sailing on a sea of madder. It was wonderful." With these final words, his stay in Brittany came to an end: "I have left Kervilahouen and its good people with much regret. I think they will miss me too."

The Breton landscape encouraged Monet to use an unfamiliar palette. "This sea, under today's leaden sky, was so green that I was unable to reproduce its intensity." Monet explained: "It is a great effort for me to paint in somber tones, to reproduce this sinister and tragic aspect, for I am more inclined toward soft, tender colors." Mirbeau, writing to Rodin on November 22, aptly described the somewhat unusual aspect of Monet's work: "This shows a new side to his talent, a terrible, frightening Monet that we've never seen before. His work will appeal less than ever to the bourgeois."

Yet, while his painting became stormier, he did not renounce the Impressionist palette. "You have doubtless seen somber pictures of Brittany," Monet explained, "but it is quite different: it has all the most beautiful shades imaginable." With an increased luminosity, accentuated by a palette dominated by blues and greens, Monet recorded his impressions of Brittany. The waters of the Atlantic took on a depth of color, an unexpected intensity; they teem with mysterious life. As for the crystalline rocks, which were continually covered by water, to be revealed only as jagged forms surrounded by islands of foam, he wrote: "In the rain these wet rocks are blacker than ever, and that makes them all the more beautiful." Their outlines are clean, sharp, and strong. The coast of Brittany, with its hard rocks, is totally different from the more rounded and weathered chalk cliffs of the channel coast. Brittany's coastline has a hard, architectural quality with nothing hazy or soft about it. In order to reproduce this quality, Claude Monet's Impressionist works in Belle-Ile were enriched with an unusual intensity and precision of form. Rarely has the Atlantic Ocean, varying in mood from calm to fury, been better understood, observed, or depicted than during the course of Monet's Breton adventure.

NOTES

[1]This chapter is based on the monumental, definitive work by Daniel Wildenstein, *Claude Monet: biographie et catalogue raisonné*, vol. 2, *Paintings, 1882-86* (Paris: Bibliothèque des Arts, 1979). Besides photographs and descriptions of all the canvases painted at Belle-Ile-en-Mer, it contains the complete text of all the known letters sent by Monet during his stay, to Paul Durand-Ruel, Alice Hoschedé, Gustave Caillebotte, Georges Petit, Gustave Geffroy, Berthe Morisot, and Blanche Hoschedé, numbered 684 to 757 and dating from September 12 to November 24, 1886. The reader is highly encouraged to refer to this fundamental work for further information.

[2]"The horizon is often placed near the top of the canvas, showing that the interest of the painter was not the sky but the interplay of land and water; and the relationship between these two elements was extremely complex on this wild, jagged coastline, where there seemed to be an incessant battle going on even in calm weather." *Hommage à Claude Monet* (Paris: Musée du Grand-Palais, 1980), p. 264.

[3]"Monet managed to suggest the power of the waves and the wind by thick brushstrokes. He accentuated the contrast between the mass of the rocks and the sea." Ibid., p. 265.

[4]During the summer of 1886, when Gauguin, Bernard, and Schuffenecker arrived simultaneously in Brittany, Maurice Barrès and Charles Le Goffic, well-known nineteenth-century authors, were touring the moors and the beaches of Lannion and Tréguier.

[5]"Claude Monet works ... in wind and rain. He dresses like the men of the coast, in boots, covered in sweaters, wrapped in a raincape with a hood. The gusts of wind occasionally snatch his palette and brushes out of his hand. His easel is anchored with ropes and stones. Nevertheless, the painter carries on and goes at his work as into battle." Gustave Geffroy, *Claude Monet, sa vie, son temps, son œuvre* (Paris: Crès, 1922), p. 180.

[6]"The stay at Belle-Ile nevertheless marked an important stage in the artist's evolution: it allowed him instinctively to find a means of approaching the subject [series] that, a few years later, Monet was to transform into an intentional, systematic procedure." *Hommage à Claude Monet*, p. 267.

162

MAXIME MAUFRA

1861–1918

AXIME MAUFRA[1] had already developed considerable talent for drawing and sketching by the time he entered the lycée in his native town, Nantes.[2] In 1879, at the age of eighteen, he began to paint in oil under the direction of two local painters, Alfred Leduc[3] and Charles Le Roux.[4] Both were devoted landscape painters and introduced Maufra to painting outdoors. In 1881 Maufra was sent to Great Britain by his parents.[5] Maufra viewed this trip, which was intended to enable him to learn English and to improve his business skills, as an opportunity to study the landscape, to note his impressions, and to practice sketching. In the wild, desolate, and grandiose scenery of Scotland and Wales, Maufra later explained, he "experienced a presentiment of Brittany." The introduction to the English landscape painters, and particularly Turner,[6] proved especially decisive: "Turner's paintings dazzled me, and in my naïveté I exclaimed: 'But I can paint like that!' This is luminous painting like my own." In fact, the paintings of Maufra at this time were not luminous and bright and did not become so until several years later. The discovery of Turner's work, however, began to move Maufra, then twenty-three, away from traditional teachings, toward the same evolutionary path taken ten years earlier by Monet and Pissarro.[7]

Maxime Maufra,
Flower Bouquet, 1910,
oil on canvas, 43⅜ × 31½ in.
Formerly Oscar Ghez Collection.

Anders Osterlind,
Portrait of Maxime Maufra in Front of His Print, "The Wave,"
drypoint.
Mrs. Dudensing Collection, New York.

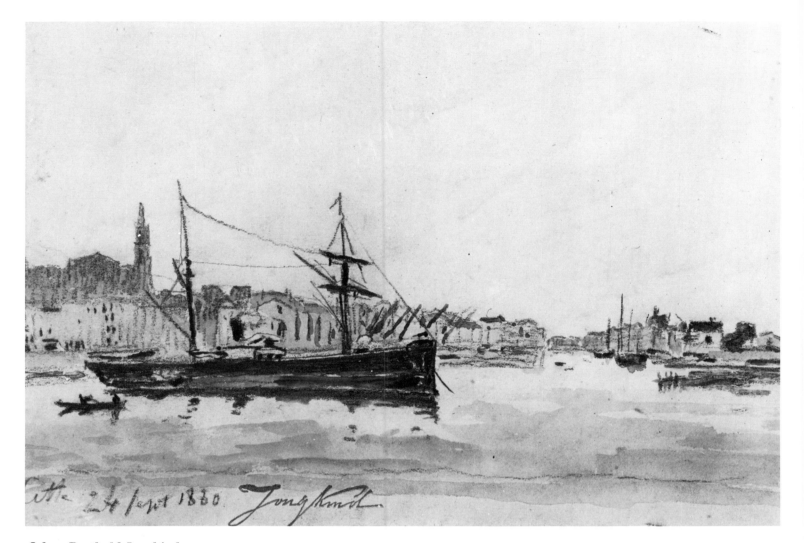

Johan Barthold Jongkind,
Boats in Sète Harbor, 1880,
watercolor.
Private collection.

Upon his return to France, Maufra launched himself immediately into painting from nature on the banks of the Loire. There, he produced canvases such as *Boat Aground near Loch Etive*,[8] 1884 (now in the Musée de Nantes).[9] During this period, Maufra's painting was still largely dependent on the French landscape tradition. Yet, even at this early stage, his choice of subjects, his impression of nature, and his light effects placed him within the Impressionist school. His movement away from conventional nineteenth-century painting was intensified by his friendship with the Nantes painter Charles Le Roux, as well as with John Flornoy,[10] an extremely active and dynamic Impressionist who described himself as the pupil of Pissarro.

Flornoy was responsible for organizing an important avant-garde exhibition in Nantes in 1886 containing close to two thousand works.[11] Maufra was among the artists Flornoy chose to include. For the first time, in Brittany, Impressionist paintings by Gauguin, Monet, Sisley, Pissarro, and Renoir were seen side by side with works by Seurat and Signac. Evidence of Flornoy's foresight as to the value of this school of painting was his persuading his family and friends to buy important works by Renoir, including *The Box at the Opera* (now in the Courtauld Institute,

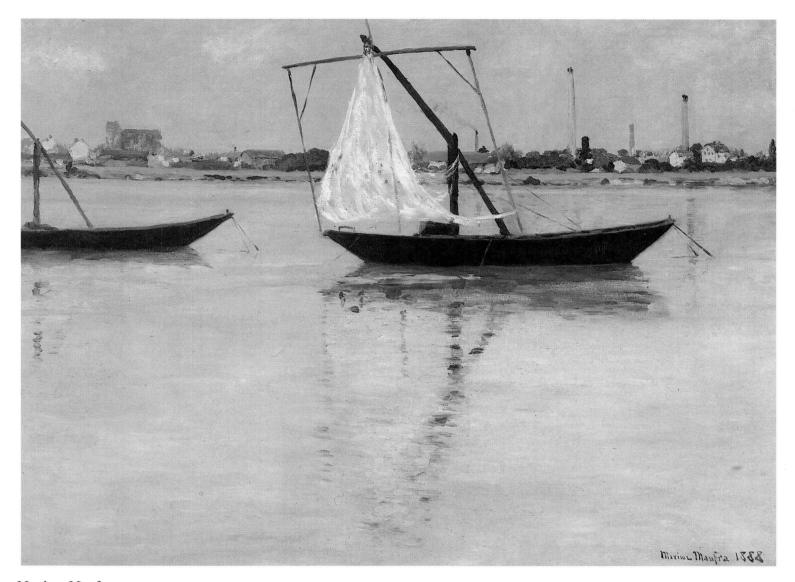

Maxime Maufra,
Boats at the Prairie d'Amont, near Nantes, 1888,
oil on canvas, 31⅛ × 42⅞ in.
Musée des Beaux-Arts, Nantes.

London). As a friend of Gauguin, Flornoy was also to serve as a liaison between Gauguin and Maufra at Pont-Aven a few years later.[12]

The same year, 1886, Maufra had his debut among the French artists at the Salon. The two canvases he entered, *Floods at Nantes* and *Fishing Boat at Haute-Ile,* dated 1885,[13] earned him an excellent review from Octave Mirbeau[14] in the journal *La France.* Mirbeau's description of these works placed Maufra within the Impressionist movement:[15] "I have just discovered a delightful landscape ... a charming painting. It was a simple landscape, a calm river with boats, but this quiet scene contained a special lumi-

nosity. It was delicate, harmonious and, despite the absence of a personal style, so refreshingly original after all the others, that I stood for a long time in front of this canvas." From the outset Mirbeau recognized the unique characteristics of Maufra's work. Although he was critical of Maufra's lack of a well-developed style, he added: "It was such a different type of art.... I looked for the signature, and read: Maufra. Was he young or old, where did he come from? He was neither the pupil nor the master of anyone." This independence upon which Mirbeau remarked remained an essential characteristic of Maufra's painting throughout his life.

165

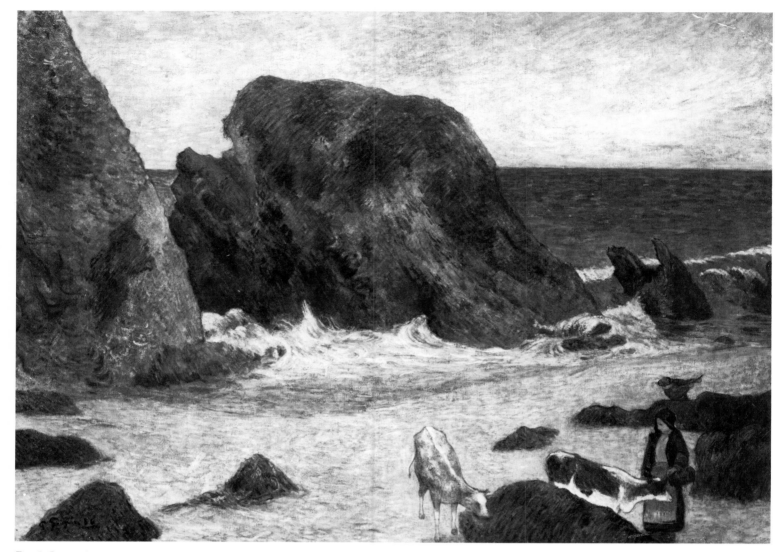

Paul Gauguin,
Breton Woman Herding Her Cows on the Beach at Le Pouldu, 1886,
oil on canvas, 29½ × 44⅛ in.
Private collection.

In 1890 Maufra met Gauguin at Pont-Aven and was influenced by Gauguin's Impressionist paintings. The impact is evident in Maufra's *Piles of Seaweed on the Beach at Le Pouldu,* 1891 (illus., p. 167),[16] which is comparable to Gauguin's *Breton Woman Herding Her Cows on the Beach at Le Pouldu*[17] of 1886 (illus., p. 166).

In 1892 Maufra decided to modify his treatment and vision and to embark upon a period of Synthetism.[18] There were many factors that influenced his change of style. The most important was a general interest at this time in the ideas and techniques of Synthetism. This movement developed in Camaret,[19] where Lacombe spent the summer, as well as in

Paris with the Nabis, in Perros-Guirec with Maurice Denis,[20] in Saint-Briac with Henri Rivière,[21] and in Pont-Aven with Emile Bernard[22] and Paul Gauguin. Another factor that precipitated Maufra's shifting focus was his friendship with both Filiger, who had remained at Le Pouldu after the departure of Gauguin, and Emile Bernard, who was once more in Pont-Aven. There were also conversations with Paul Sérusier and a meeting with Rivière at Loguivy, which marked the point of departure for Maufra's work as an engraver.[23] Finally, there was the influence of southern Brittany itself, a landscape of rounded reliefs that appeared cloisonnist and that suggested a natural evolution toward Synthetism.

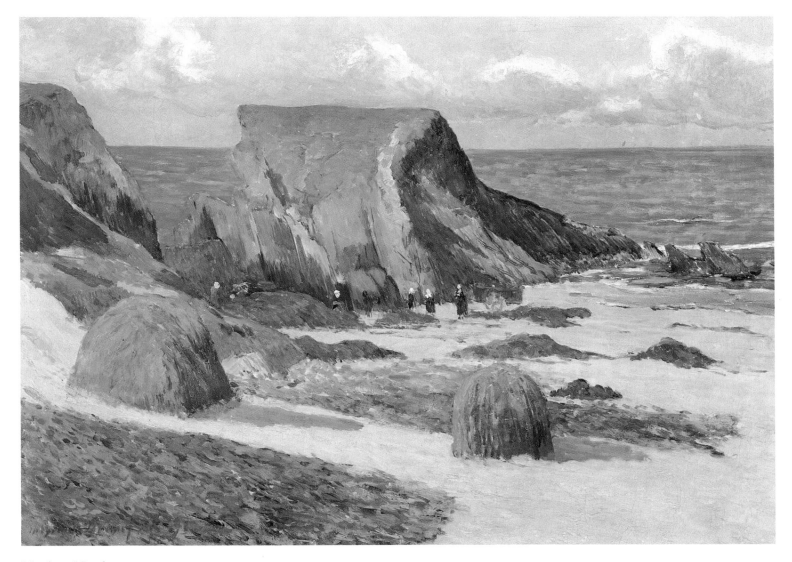

Maxime Maufra,
Piles of Seaweed on the Beach at Le Pouldu, 1891,
oil on canvas, 18⅛ × 24⅜ in.
Musée des Beaux-Arts, Nantes.

The gradual convergence of these elements led to a noticeable modification in Maufra's canvases in 1892.[24] When Gauguin visited Maufra's Paris studio in 1893,[25] he encouraged Maufra to continue painting according to his own personal conception of Synthetism. This unexpected visit is related by Maufra: "One afternoon in November 1893 I heard a knock at the door of my studio. I shouted 'Come in' and great was my surprise to see that old devil Paul Gauguin appear in the doorway. With his astrakhan hat, he looked as if he'd come from the North Pole rather than the tropics. Without saying a word he came in and, looking at the sketches pinned to the wall and the studies arranged on the floor along the wall, he exclaimed: 'I know that you defend my art, Maufra, and although we are following a different path, yours is a good one. Carry on with it.'"

Gauguin, who was not generally inclined to flatter, saw Maufra not as a disciple or follower, but as a pioneer, an independent artist going his own way. Gauguin, in dedicating a drawing to Maufra, added these words: "To my friend Maufra, the artist of the avant-garde."[26]

For Maufra, this marked the beginning of a six-year period during which he attempted to combine the constructive aspects of Synthetism with Impressionist subjects, "Communion with Pont-Aven was to modify his palette and his vision ... placing the

167

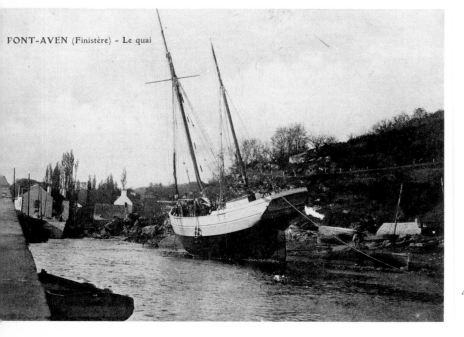

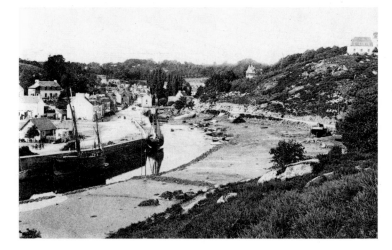

△ *Pont-Aven:*
the harbor and mudflats at Bas-Bourgneuf.
Postcard, c. 1910.

△ *Pont-Aven:*
schooner in the harbor at low tide.
Postcard, c. 1900.

▽ **Maxime Maufra,** *Caulking a Sailing Boat,*
Pont-Aven Harbor, 1892,
oil on canvas, 59⅛ × 118⅛ in.
Musée des Beaux-Arts, Quimper.

emphasis on the structure of the painting rather than 'catching nature in full flight.'"[27] It is this style that Alfred Mellerio, in his *Mouvement idéaliste en peinture*, published in 1896, described as "a sort of compromise between direct observation of objective nature and purely decorative and Synthetist vision." Maufra explained his goals in the following terms: "I

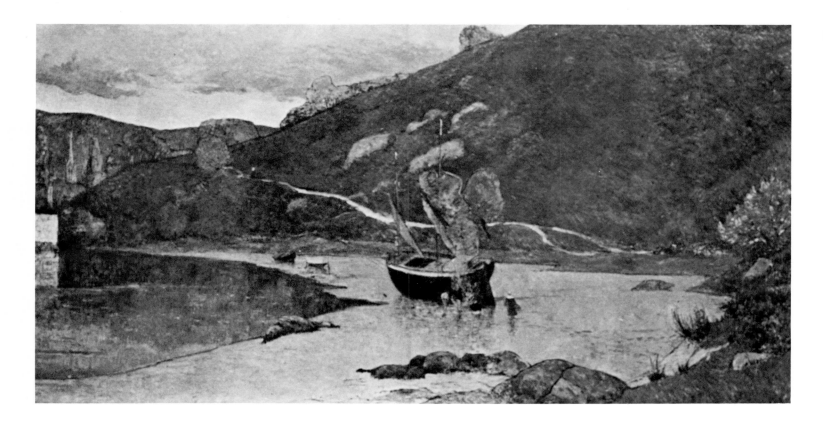

Maxime Maufra,
Red Sun,
oil on canvas, 17⅝ × 23⅝ in.
Private collection, Nantes.

am seeking to express the major sensations, the strange aspects of nature... everything that can be rendered not by an instantaneous impression of an effect but, on the contrary, by condensing everything contained in that effect."[28]

It is this statement of purpose that differentiates Maufra from many of his Impressionist contemporaries. His aesthetic concerns were opposed to those of Claude Monet, who depicted a succession of instantaneous impressions in a series of canvases.[29] Maufra's work developed in another direction; a succession of images gave way to one image. Maufra's

painting was characterized by his interest in capturing the essence of what he observed and penetrating its deeper, hidden meaning. His desire to express such visions in condensed form can be considered a type of Symbolism. Staying at Pont-Aven, Le Pouldu, and in Loguivy,[30] Maufra produced between 1892 and 1893 a succession of oils and drawings enhanced by watercolor. Although few in number, these works are extremely powerful.[31] *Red Sky at Pont-Aven* (now in the Musée de Quimper) is an excellent example of Maufra's objective subject matter combined with a symbolic atmosphere prevalent in those years.

169

During this period Maufra began to experiment with print-making. His earliest prints date from 1892–93, immediately after his meeting with Rivière at Loguivy during the summer of 1892. Rivière had influenced Maufra, both in his interest in engraving and lithography[32] and in his choice of subjects, and they shared a Synthetist approach toward painting. They both sought to eliminate the picturesque and anecdotal in favor of depicting the sublime aspects of nature. This approach is revealed in the titles that Maufra chose for his paintings at this time: *Twilight Melancholy*, 1892; *Golden Evening*, 1892; *The Abyss*, 1892; *The Road*, 1892; *Wheatfield*, 1892; *The Pond*, 1893; *The Hour of Dreams*, 1893; *Night*, 1893; *Stormy Sky*, 1893; and *Valley at Evening*, 1893. These general, nonspecific titles can be compared to those of Rivière's *Aspects of Nature*,[33] a series of color lithographs printed in 1897 and 1898 by Eugène Verneau. The inspiration for these lithographs was Rivière's watercolors, which were executed as early as 1891 (which places the work of Rivière and Maufra in the same time frame). Furthermore, Rivière was at that time producing his woodcut series *The Sea: Studies of Waves* (the first three having appeared in 1890), which inspired the subject of one of Maufra's first and finest etchings, *The Wave*.[34]

Maufra's compositions from this period all came to public attention in the magnificent Maufra exhibition at Le Barc de Boutteville[35] in Paris in 1894, which included twenty-five oils, seventy drawings, and four lithographs. The success of this Parisian exhibition proved to be extremely important. Many artists saw this exhibition and felt its impact. Gauguin agreed to design the poster. Pissarro, writing to his son Lucien on February 18, 1894, noted: "I wish you could have seen the exhibition by a young painter named Maufra.... This boy has talent. His work is Synthetist, observed from nature.... His sketches heightened with pastel are very good." Pissarro added: "Just between you and me, that's what you ought to do as an exercise." These works testified to Maufra's mastery of design and composition, about which he wrote: "Since my exhibition at Le Barc de Boutteville I have been loudly proclaiming the necessity of returning to constructed composition." Explaining the spirit in which these works were conceived, he continued: "They were not indica-

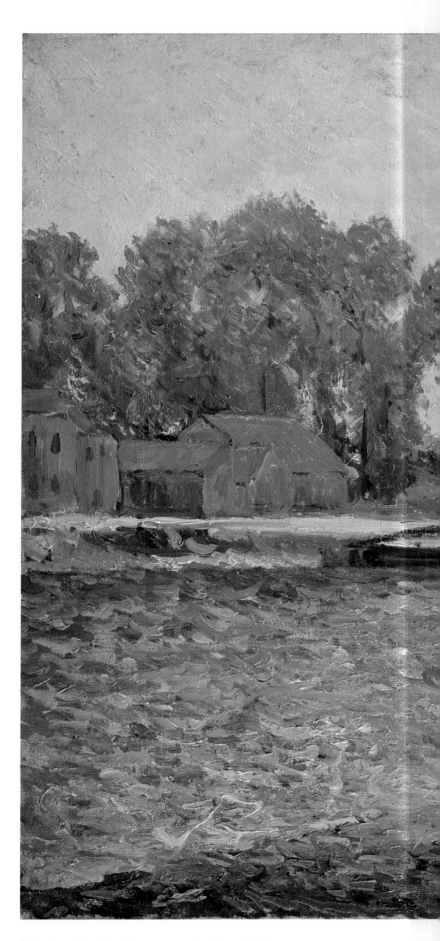

Maxime Maufra, *Barges on the Oise*, 1901, oil on canvas, 22 3/8 × 31 7/8 in. Durand-Ruel Collection, France.

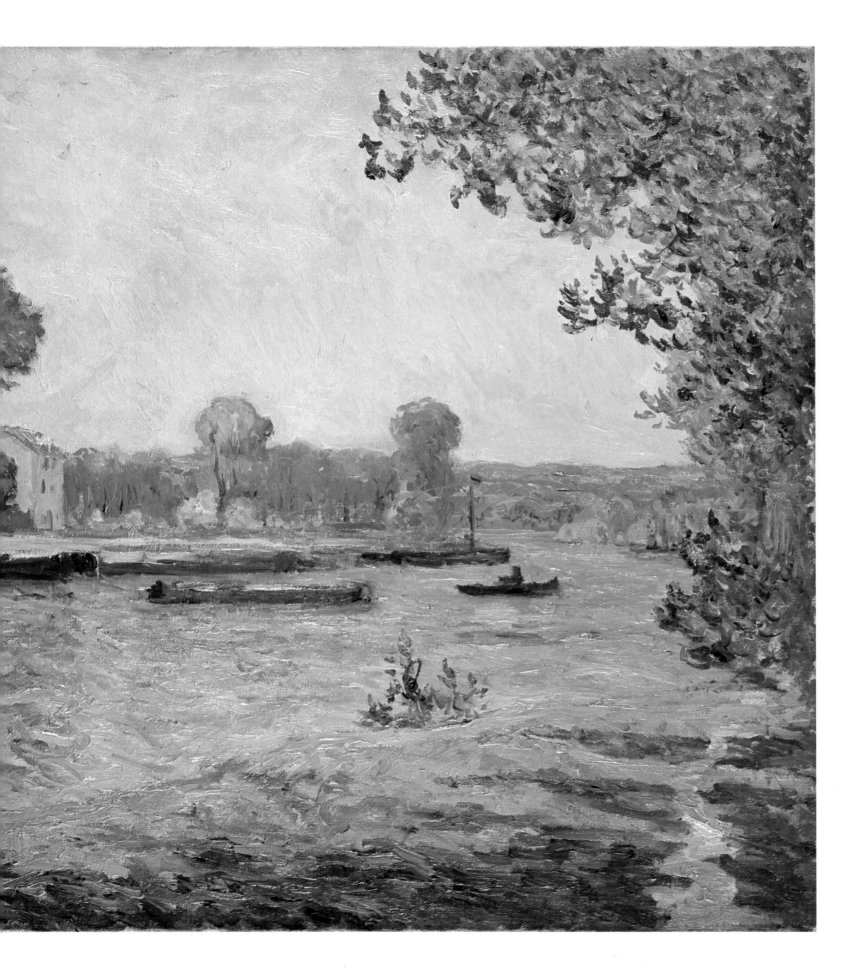

Claude Monet, *Waterlilies,* c. 1907,
oil on canvas, 41⅝ × 28⅝ in.
Musée Marmottan, Paris.

causing his paintings to appear more descriptive. When he painted the village of Camaret in 1896, it was specifically Camaret that he depicted and not an anonymous port on the Breton coast. Gradually returning by stages to the descriptive painting of instantaneous perception, Maufra's work became strictly Impressionist by 1900. Between 1905 and 1907, Maufra produced a series of paintings conceived as drawings on canvas, as colored sketches consisting of a few definitive brushstrokes. This bold technique gave the impression of a quick sketch. The white primer on the canvas acts as the drawing paper, the brush as charcoal. Yet they were not sketches; each canvas was finished and complete. This style of painting is similar to calligraphy in its highest form. In its audacity and its apparent freedom, it can be seen as a forerunner of twentieth-century action painting. "Brilliant virtuosity of design, boldness of simplification, freedom of signs, audacity of color, which combine to construct a poetic creation, which one would be inclined to place at the frontier of lyric abstraction."[38] This description of a composition of 1892, *Red Sky at Pont-Aven,* could also apply to a painting produced fifteen years later, *Iron Bridge at Tréboul*[39] or to *Riverbank,* painted in 1907 (see illus., p. 173), demonstrating that Maufra's deliberate boldness had not deserted him in his more mature years.

Both Impressionist and Synthetist, Maufra's work might be described as prefiguring the paintings of the Fauves. As early as 1905, his canvases were marked by thick strokes of pure color, as in his *Port of La Rochelle,*[40] painted in 1911. Yet this approach did not define the totality of his artistic production during his later years. From his earliest paintings of 1879, his conception of how to portray nature altered continually, as he synthesized the changing artistic currents of the time. Each time his conclusions led him back to Impressionism, which he ultimately considered to be the most appropriate means of observing nature.

tions of any precise moment, but more condensations of what I saw."[36]

The high point of this period came in 1895,[37] although Maufra continued to paint in this style until 1896. Having approached this virtual "sound barrier" of modern art — that is, the transformation of simplification into formal abstraction — Maufra retreated. Maufra's Synthetism and somewhat abstract conception of painting eventually led him to a decorative impasse. It was upon the following generation that the task would fall to break through this barrier.

Beginning gradually in 1896, Maufra increased his emphasis on his subjects. Little by little, detail reappeared, and his sites became more explicit,

Maxime Maufra, *Riverbank,* 1907,
oil on canvas, 28⅝ × 23⅝ in.
Private collection, Lorient.

NOTES

[1] Maxime Maufra was born May 17, 1861, in Nantes, where his father had a job connected with metallurgy. His mother, born near the Atlantic area of the Loire, was Angevin.

[2] His teacher at the lycée in Nantes, Edmond Chazerain, a draftsman and engraver, submitted Maufra's precocious works to the Concours Général.

[3] Alfred Leduc, younger brother of the seascape artist Charles Leduc, was born in Nantes c. 1850 and died in 1913. A pupil of Robert Lehmann in Paris, he decorated the church of Saint-Félix in Nantes.

[4] Charles Le Roux the elder, born in Nantes in 1814, was a landscape artist and pupil and friend of Camille Corot. He died in his native town in 1895. His son, of the same name, was born in Nantes in 1846. A pupil of his father,

[5] His father, intending him to follow a business career, sent him to Liverpool, where he lived with a family named Thomson and worked in the firm of Mr. de Stoess. Together with his young co-workers, he spent his vacations touring the country. Arsène Alexandre reports: "At Pentecost, he finally left Liverpool

and its grey river, the Mersey, for a while. A reduced price excursion boat took him to Llandudno and North Wales.... Maufra spent most of the journey drawing." The description he gives of Llandudno, set in a mountainous bay, prefigures even at this stage his future painting: "The wind blew with excessive force and the sun setting over the mountains produced a magnificent effect. Then, below, the sea was a stranger color than I had ever seen before: it changed from blue to violet, from red to green and yellow. The speed with which the clouds flew by contributed to these changes." Letter to his father, quoted in Arsène Alexandre, *Maxime Maufra, peintre marin et rustique* (Paris: Georges Petit, 1926), p. 30. Maufra was also continually affected by events of general interest, such as the departure of the emigrants for America or a great fire in Liverpool. In August 1883 he discovered Scotland: "Now, this was the real revelation of the grandiose.... He was mad with joy at the sight of rapids, lakes, the sea with the cormorants wheeling overhead, the mountains, the old castles. In the valley of Glencoe, on the banks of Loch Etive, where he did some of the fine studies that were to figure later in his exhibitions, he had such a strong impression of majestic lines and sublime harmonies that he resolved to return once he had become a painter." (Ibid., p. 34.) This was what he did twelve years later, in 1895, at the height of his Symbolist period. He brought back a very important series of pictures, which are, unfortunately, relatively unknown: *Valley of Glencoe*; *Solitude: Valley of Glencoe*; *Bad Weather*; *Loch Etive: Tranquillity*; *Loch Etive: Wildness*; *Sutherland: Isolated Peak*; *Glencoe: Pink Mist*; *Glencoe: The Three Sisters*; *Glencoe: In the Mountains*; *Glencoe: Clouds in the Mountains*; *Wick: Red Cliffs*; *Wick: The Abyss*; *Loch Eribol*; *Thurso: Black Cliffs*; *Thurso: Holburn Head*; *Pass of Brander: Calm*; *Loch Killean: Twilight*; *Ben Hope Kyle of Durness: Summer's Night*. While passing through London on his way back to France at the end of 1883, he came across the work of Turner at the National Gallery.

Charles Le Roux the younger also became an artist.

[6] Joseph Mallord William Turner (1775-1851). The greatest of the English landscape

artists, he took long, isolated walking trips around England with his knapsack on his back, living on the money he made selling his watercolors until he was elected to the Royal Academy in 1799, first as an associate and then, in 1802, as an academician. His works can be considered prototypes of Impressionist painting.

[7] Turner and the English landscape artists had a great influence on the Impressionists, which Pissarro later acknowledged: "The watercolors and oils of Turner and Constable, the canvases of Oldcrome, certainly had an influence on us." In France, the future Impressionists were working at the mouth of the Seine near Le Havre in the company of Eugène Boudin. This setting was not unlike the English landscape.

[8] From this first trip to Scotland, he also brought back *Inverary* and *Loch Lomond*, painted in 1883.

[9] The Musée de Nantes has a particularly fine collection of the works of Maufra, as the result of numerous bequests, including Maufra's gift of twenty-four oils and four drawings in 1911. On Maufra's works of this period see Alexandre Maillard, *L'Art à Nantes* (Paris: Monnier, 1888).

[10] John Flornoy, a painter from Nantes, died young, in 1893. He was the father of the painter Olivier Flornoy. When Pissarro wrote to his son Lucien about Maufra's work he described him as "a friend of good old Flornoy from Nantes." Letter dated February 1894.

[11] According to the catalog, 1,799 works exactly.

[12] On the meeting between Gauguin and Maufra, see the extract from "Propos de peintres," Maufra's memoirs, published in the *Bulletin des Amis du Musée de Rennes, numéro spécial: Pont-Aven*, no. 2 (Summer 1978), under the title "Comment je connus Paul Gauguin," pp. 19-20 and 21, corresponding to pp. 371-74 of the original manuscript, which is still in the possession of the Maufra family.

[13] Musée de Cholet.

[14] Octave Mirbeau was a writer, dramatist, and art critic, and a friend of Claude Monet.

[15] "When he painted *Boats at the Prairie d'Amont* (Musée de Nantes) [illus., p. 165] in 1888, he reminded one of certain works of

Claude Monet." Exhibition catalog *L'Ecole de Pont-Aven dans les collections publiques et privées de Bretagne*, Rennes, Quimper, and Nantes museums, 1978, introduction to Maufra.

[16] Collection of the Musée de Nantes, donated by Maufra in 1911. Exhibited in 1978, no. 51 in the catalog (see note 15); falsely identified there as the Isle of Raguénès when it is in fact Le Pouldu. This picture was listed by Alexandre under the title *Low Tide* and dated 1891 (p. 200).

[17] Georges Wildenstein and Raymond Cogniat, *Paul Gauguin, catalogue raisonné* (Paris: Beaux-Arts, 1964), no. 206.

[18] The start of this Synthetic period coincided with Maufra's prolonged stay at Marie Poupée's inn in Le Pouldu in the company of Filiger. When Verkade left Sérusier in Le Huelgoat in 1891 for Le Pouldu, he described his arrival thus: "She [Marie Poupée] asked me into the dining room. The painters Drahtmann [Verkade's pseudonym for Filiger] and Maufra introduced themselves. As is the custom in Brittany, they offered me a small liqueur.... Then I ate with them. It was agreed that I should sleep in the dining room for the time being.... After a few days I was given a nice little room and felt completely at home. The landlady... had a good heart and was an excellent cook. The fresh air producing its usual effect, I was able to breathe again and the bohemian life recommenced." When Verkade left in the autumn, Maufra stayed in Le Pouldu for a winter of solitude and reflection, during which he produced his first Synthetist works. "By mid-October Le Pouldu became most unpleasant — the beach deserted and windswept, the coast wild and inhospitable, the disorder in Marie Poupée's house drove me away. One morning I left Filiger and Maufra, my landlady, and her child [the natural daughter of de Haan] and departed on a two-wheeled cart for Quimperlé and from there by rail for Paris." Extracts from: Jan Verkade, *Le Tourment de Dieu* (Paris: Librairie de L'Art Catholique, 1926), pp. 113-16.

[19] See Lacombe chapter.

[20] See Denis chapter.

[21] Henri Rivière, painter, watercolorist, and engraver, famous for his Japanese-style woodcuts and his lithographs. In 1890 he produced his first nineteen woodcuts in the *Paysages bretons* series, inspired by sketches made at Saint-Briac during the summer. His prints are a personal and original attempt at graphic Synthetism. "His admiration for Japanese art and his knowledge of its techniques and styles led Rivière to assume a scientific technique, to redefine space, to adopt bold outlines; in short, to nourish a spirit of Synthetism as befitted the time." René Le Bihan, preface of the exhibition catalog *Henri Rivière en Bretagne*, Musée de Pont-Aven, 1977.

[22] See Bernard chapter.

[23] In 1892-93 Maufra was not involved exclusively with the "Pont-Aven group." His interest in engraving brought him into contact with Bracquemond and Auguste Lepère (the latter brought to Nantes by the art patron Alphonse Lotz-Brissonneau), and they worked together for *L'Estampe Originale*, which was founded by A. Marty in 1893. In the same year Maufra did his first color lithograph, *Road by the Sea*.

[24] From 1892 to 1895.

[25] This visit took place shortly after Gauguin's return to France at the end of his first stay in Tahiti. It is related by Maufra in his unpublished memoirs. Quoted in Jeanine Warnod, *Le Bateau-Lavoir* (Paris: Presses de la Connaissance, 1975), p. 31.

[26] Maufra Family Collection, Paris. Reproduced in Wladislawa Jaworska, *Gauguin et l'école de Pont-Aven* (Paris: Bibliothèque des Arts, 1971), p. 193.

[27] Jaworska, *Gauguin*, p. 194.

[28] Alexandre, *Maufra*, p. 86.

[29] The most famous of Monet's series are Haystacks, 1890; Poplars, 1891; Rouen: The Cathedral, 1892-93. His regular procedure was to produce a multiplicity of "snapshots" of the same subject, such as the views of Belle-Ile-en-Mer (see Monet chapter).

[30] 1892: Le Pouldu, Pont-Aven: Quimperlé area; Gâvres, Port-Louis, Lorient area. Ile de Bréhat, Plouézec, Loguivy: Paimpol area. During the winter he lived in Montmartre, rue Ravignan, at Le Bateau-Lavoir, on the recommendation of Gustave Loiseau (see Loiseau chapter).
1893: Plouézec, Bilfot Point: Paimpol region. Saint-Michel-en-Grève, Locquirec, Séhar Point: Lannion region. He returned to this area the following year, after his Paris exhibition, exploring the whole coast between Saint-Michel-en-Grève and Plougasnou (Beg an Fry, Saint-Jean-du-Doigt, Run Glas Point, Primel Point) on the north shore of Brittany.

[31] Two large color drawings of this period, exhibited at Le Barc de Boutteville in 1894, are now in the Paressant Collection, Nantes.

[32] The complete catalog of Maufra's prints has been recently published by the Musée de Pont-Aven for its 1986 exhibition *Maxime Maufra: From Drawing to Engraving*. Georges Turpin, in his article in *Beaux-Arts*, "L'Œuvre gravé de Maufra," nos. 36, 37 (September 1941), lists Maufra's engraved work as ninety-three etchings; drypoints and soft-ground etchings; six colored engravings from marked plates; and twenty-seven lithographs in black and white and in color. In 1978 the Musée de Pont-Aven exhibited twenty-one of these plates.

[33] 1. *The Bay*, 2. *Night at Sea*, 3. *The Cliff*, 4. *The Mountain*, 5. *Summer Evening*, 6. *The River*, 7. *The Island*, 8. *Twilight*, 9. *The Wood in Winter*, 10. *Moonrise*, 11. *Sunset*, 12. *The Stream*, 13. *The Forest*, 14. *The Beach*, 15. *The Hamlet*; the last three appeared in 1907.

[34] Exhibited in 1894 at the Salon des Indépendants. Eight different states are known.

[35] Maufra was presented to Le Barc de Boutteville by the painter Paul Vogler, whom he had met in 1893. Boutteville had a modest gallery at 47 rue Le Pelletier near the Bourse, which supported young artists following his sudden decision to open his doors to them in a show entitled *Impressionists and Symbolists*. "They show anything they like here." Alexandre, *Maufra*, p. 82.

[36] Remark made by Maufra in 1905, reported by Alexandre, *Maufra*, p. 85.

[37] As with Henry Moret, 1895 seems to mark both the height as well as the beginning of the decline of true Synthetism.

[38] Exhibition catalog *L'Ecole de Pont-Aven dans les collections publiques et privées de Bretagne*, p. 48.

[39] This canvas was exhibited under the title *Douarnenez*, no. 29 at the Maufra retrospective organized by the Art Mel gallery, Paris, 1978.

[40] Ibid., no. 11.

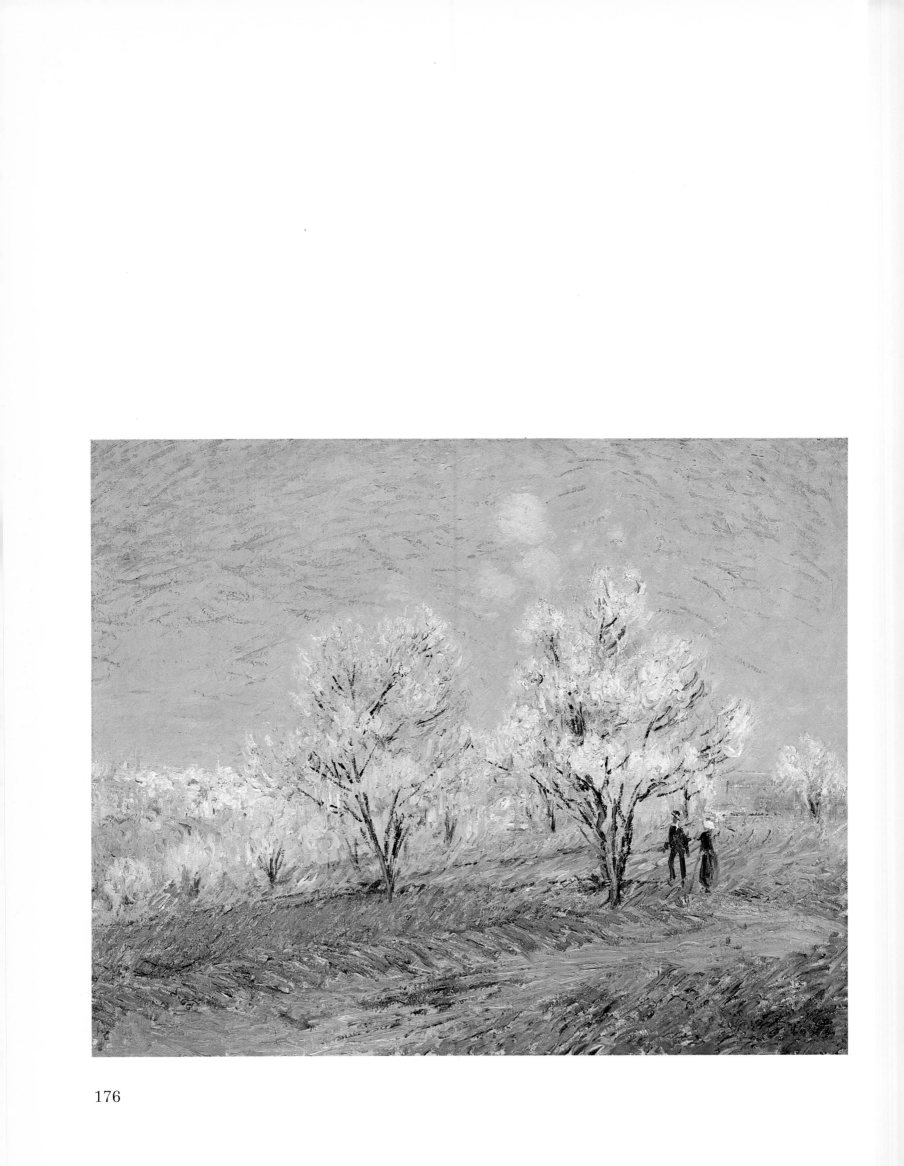

176

GUSTAVE LOISEAU

1865–1935

O a greater extent than those of any other members of the Pont-Aven school, the canvases of Gustave Loiseau come close to the style of Impressionism advanced by Sisley, Monet, and Pissarro. Enjoying an international reputation and represented in several museums,[1] the paintings of Loiseau have been well known and appreciated by the public since the end of the nineteenth century.

Gustave Loiseau's parents, who were small-shop keepers, moved to Ile-Saint-Louis in Paris soon after he was born.[2] The isolation and slow pace of life in this district were more characteristic of the provinces than of a capital city. His education was of an extremely elementary nature, since a primary-school certificate seemed more than enough to a family who thought only of having their son work in their store.

Though his parents demanded of him long hours in the store, he still found time to draw and copy the

decorative engravings that hung on the walls of his home. With his meager wages he bought Epinal prints, which he reproduced as watercolors. An attack of typhoid, however, brought him near to death. This bout with illness led him to explain to his

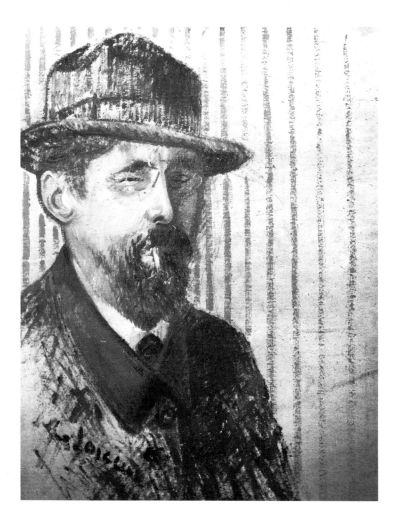

Gustave Loiseau,
◁ *Orchard in Flower, Ile-de-France*, 1913,
oil on canvas, 23⅝ × 31⅞ in.
Durand-Ruel Collection, France.

Gustave Loiseau,
Man with a Cigarette: Self-Portrait, 1919, ▷
oil on canvas, 21⅝ × 15 in.
Private collection, Paris.

parents his artistic aspirations. Although disappointed by his choice, they did not oppose his wishes. As soon as he was well, Loiseau was placed as an apprentice with a decorator friend of the family. His parents, realizing that he was unlikely to change his mind, soon sold their business and retired to Pontoise.[3] Pontoise and its environs were truly rustic in the early 1880s, and the setting influenced Loiseau's future decision to become a landscape artist.

In 1884, after one year of military service spent in Paris, Loiseau returned to civilian life and resumed his work as an apprentice decorator. He was, however, no longer happy with this occupation and wanted to paint. A legacy from his grandmother provided the opportunity for which he had been hoping.[4] In 1887 he established himself in Montmartre, first in the rue Myrrha and then at La Maison du Trappeur in the rue Ravignan, "a quiet house occupied only by workers oblivious to the tumult of crowds."[5] Loiseau was one of the first artists to live in this house, which was to achieve international fame as the Bateau-Lavoir of Picasso's early days. It was Loiseau who persuaded Maufra to move into the Bateau-Lavoir after meeting him in Pont-Aven.[6] Maufra had his Paris studio there beginning in 1892.

Living in Montmartre, without familial ties, Loiseau became acquainted with the members of the artists' colony living on "La Butte Montmartre" and with its folklore. The group consisted of such eccentric characters as Willette, the painter of Pierrots; Henri Pille; Jean Louis Forain, the satirist; and other bohemians less famous or forgotten today, such as Raymond Auguste Quinsac, Fernand Pelez, Joseph Faverot, Louis Morin, and Oswald Heidbrink.[7] With his overwhelming interest in nature and landscape, Loiseau had little in common with these indoor painters of genre scenes. Though scarcely twenty, his natural reserve and shyness made him recoil from the frenetic social life of "Willette's gang," whose ceaseless round of carousing took them from the Cabaret du Clou to the Chat Noir.[8] In 1888 he enrolled for one year at the Ecole des Arts Décoratifs, where he followed the courses in life-drawing that he felt he needed until an argument with his teacher prompted him to withdraw.

While he worked for the decorator, one of his jobs had been to redecorate the apartment of the painter Fernand Just Quignon.[9] Upon his departure from the

Ecole des Arts Décoratifs, Loiseau turned to this landscape painter as his teacher. Although he spent months at Quignon's studio and found his luminous and airy painting appealing, he was disappointed by both the approach and the methods of his mentor.

Quignon worked in his studio from rough outlines and sketches, enlarging and transferring to canvas the scenes he judged to be the most commercial. In the eyes of his pupil, this process robbed his subject matter of its spontaneity, freshness, and intensity. Loiseau, with his totally different concept of painting in the open, found it inconceivable that a canvas should not be painted directly from the subject. In this belief, he shared the ideas of Claude Monet. Loiseau's disappointment was further aggravated "as he picked up ideas from conversations with his artist friends in Montmartre. These young men agreed unanimously that, if a painting were to ring true, it had to be painted entirely from nature."[10]

Once he decided to leave Quignon's studio, Loiseau sought an attractive and inexpensive location where he could concentrate on landscapes and follow his inclinations and artistic convictions. Quignon was a regular visitor to Brittany and had done much painting there, especially at Pont-Aven. One of the works Quignon had painted there, in 1884, was a view of the harbor and quays (illus., p. 30), which had been successfully exhibited at the Salon that same year. From 1880 on, along with Léon Pelouze,

Pont-Aven:
rocks in the Aven upstream of David's mill.
Postcard, c. 1890.

Gustave Loiseau, *The Aven at Moulin David,* c. 1890, oil on canvas, 26 × 31⅞ in. Private collection, France.

Emile Charles Dameron, Théophile Deyrolle, and Achille Granchi-Taylor, he had been one of the many academic painters who had made the small Breton village famous, turning it during the summer into an annex of the Ecole Nationale des Beaux-Arts and the Académie Julian.[11]

On Quignon's advice Loiseau arrived in Pont-Aven for the first time on May 11, 1890, and took a room at the cheapest pension in the village, Marie-Jeanne Gloanec's auberge at the end of the square. There Loiseau met two young painters from Nantes: Maxime Maufra and Emile Dezaunay.[12] Loiseau and Maufra had much in common and quickly became friends. There was only a four-year age difference between them and they shared a similar artistic outlook. They both wanted to paint nature, not anecdotal scenes. Maufra was an outstanding and powerful draftsman who had a crucial influence on Loiseau's early style, particularly in his manner of capturing the shapes and massive outlines of the rocky coastline.[13] Loiseau was from the outset, however, naturally more inclined toward Impressionism than was Maufra. Maufra, under the influence of Gauguin's Breton period of Synthetism and cloisonnism, turned his back on the theories of Divisionism at the very moment when Loiseau was following a completely contrary track. He explained that "in many instances the juxtaposition of spots of color in the Divisionist manner gives an accurate and powerful interpretation of the effects of light."[14]

Gustave Loiseau,
The Green Rocks, 1893,
oil on canvas, 21⅜ × 28⅝ in.
Oscar Ghez Collection, Musée du Petit-Palais, Geneva.

Both Moret and Maufra urged Loiseau to exhibit at the Salon des Indépendants in 1891 and 1892. Also, in 1891, Maufra introduced him to Le Barc de Boutteville, an art dealer in the rue Le Pelletier, who was well-disposed toward young artists. It was in his gallery that the Rouen collector François Depeaux[15] became the first to discover Loiseau's paintings. He bought two canvases by Loiseau, including *View of Mortain in the Snow*, now in the Musée de Rouen as a result of Depeaux's gift to his native town of a magnificent collection of Impressionist paintings. This canvas probably dates from 1893, as it was in this year that Loiseau spent several weeks in Mortain in Normandy, where he executed numerous watercolors showing woodlands, streams, and waterfalls (illus., p. 182).

These watercolors, which are very close in style and coloring to those Maufra was producing at the same time on the Breton coast, are the most Synthetic of Loiseau's work and typical of the Pont-Aven school in their spirit and composition. Another painting of this period is *The Green Rocks*, dated 1893 (illus. pp. 180-81).[16] Despite its personal style, it is typical of the creations of the Pont-Aven school in its diagonal composition, its shortened perspective, and its limited and antipanoramic field of

△ *Pont-Aven, view of the Aven in the Bois d'Amour, downstream from the Moulin Neuf.* Photograph, c. 1876. David Sellin Archives, Washington, D.C.

Gustave Loiseau,
◁ *The Waterfall at Mortain*, 1893, watercolor.
Private collection, Paris.

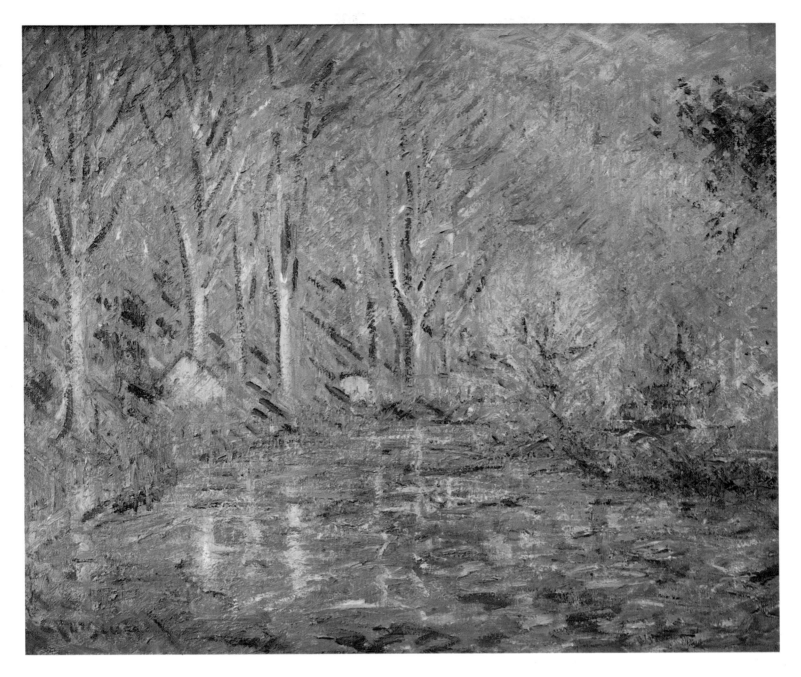

Gustave Loiseau, *River in Brittany: The Aven in the Bois d'Amour*, oil on canvas, 23⅝ × 28⅝ in. Private collection, France.

Claude Monet,
△ *Meadow at Giverny*, 1885,
oil on canvas, 23⅝ × 28⅝ in.
Private collection.

Camille Pissarro,
▽ *Sunset* (Eragny), 1895,
oil on canvas, 25⅝ × 21⅜ in.
Private collection.

vision. There is in this work, as in the Mortain watercolors, a deliberate attempt to frame and to limit the scene. The spirit of Symbolism is present even though Loiseau's use of a resolutely Divisionist technique makes no concession to the establishment of flat monochrome planes of color.

When Gauguin returned from Tahiti in 1894, a deep friendship developed between the two men in Pont-Aven. Gauguin even gave Loiseau one of his still lifes.[17] On his return to Paris after the summer in Brittany, Loiseau contacted Paul Durand-Ruel and ceased to exhibit at Le Barc de Boutteville. In the spring of 1895, he moved to Moret-sur-Loing and began to paint his surroundings. From that time on, Loiseau was to be one of the most sincere interpreters of the French landscape. He said: "I try to reproduce as best I can the impression I get from nature.... I am guided only by instinct."[18]

His life became that of the avid traveler, as he journeyed through Normandy, Brittany, and occasionally the Dordogne in summer, returning to the Ile-de-France each winter. From his paintings it is possible to follow his movements. He painted at Pontoise, where he lived every winter, and also at Saint-Cyr-en-Vaudreuil on the banks of the Eure,

Gustave Loiseau,
△ *Poplar Trees*, 1902,
oil on canvas, 28⅝ × 36¼ in.
Private collection, Lorient.

Gustave Loiseau,
◁ *Poplar Trees at Saint-Cyr-en-Vaudreuil*, c. 1905,
oil on canvas, 25⅝ × 31⅞ in.
Oscar Ghez Collection, Musée du Petit-Palais, Geneva.

Gustave Loiseau,
Poplar Trees, 1902, ▷
oil on canvas, 25⅝ × 31⅞ in.
Private collection, Switzerland.

1

2

3

1. **Claude Monet**, *The Cliffs at Grainval, near Fécamp*, 1881, oil on canvas, 24 × 31½ in. Private collection, U.S.A.

2. **Gustave Loiseau**, *The Cliffs at Cap Fréhel*, charcoal drawing. Durand-Ruel Collection, Paris.

3. **Gustave Loiseau**, *The Cliffs at Le Puy*, 1901, oil on canvas, 25⅝ × 31⅞ in. Private collection, France.

4. **Claude Monet**, *Fishing Boats, Etretat*, 1885, oil on canvas, 28⅝ × 36¼ in. Private collection, U.S.A.

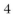

4

where he chose to paint often after 1899. His fine series of poplars from this period is reminiscent of the work of Claude Monet (illus., pp. 184–85). He spent time in the valley of the Eure, the Seine, and the Yonne; in Normandy in the areas around Dieppe, Fécamp, and Etretat; and of course in Brittany, to which he returned faithfully almost every year. When Loiseau was in Brittany he based himself at the inn of Marie-Jeanne Gloanec,[19] though he traveled extensively in the area: Belle-Ile in 1900, Saint-Herbot, Le Huelgoat in 1903, Cap Fréhel in 1905 and 1906, Notre-Dame-de-la-Clarté at Perros-Guirec in 1911, Douarnenez-Tréboul in 1913, and so on. From the windows of his room at Pension Gloa-

nec he painted views of the little town square at Pont-Aven, in a variety of different lights and times of year (illus., pp. 188–89). Each of these paintings is characterized by the steepness of the perspective,

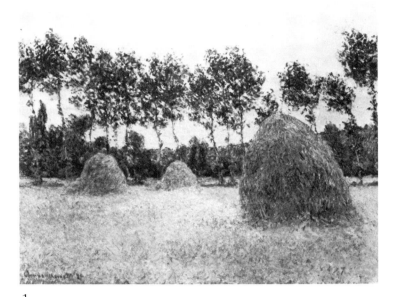

3

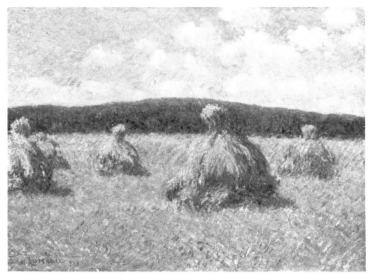

1

1. **Claude Monet,** *Haystacks, Hazy Sun,* 1884, oil on canvas, 25⅝ × 31⅞ in. Private collection, U.S.A.

2. **Gustave Loiseau,** *Boats Beached at Etretat,* 1902, oil on canvas, 23⅝ × 28⅝ in. Private collection, France.

3. **Gustave Loiseau,** *Haystacks,* 1903, oil on canvas, 23⅝ × 31⅞ in. Private collection, France.

4. **Pierre Auguste Renoir,** *Haystacks at La Roche-Guyon,* 1885, oil on canvas, 8⅝ × 11 in. Private collection, U.S.A.

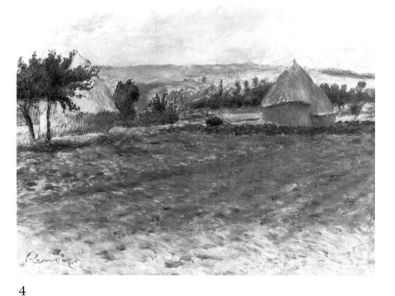

4

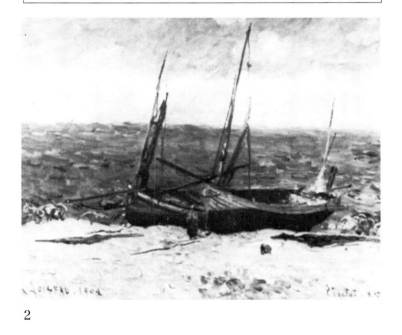

2

and all are almost identically framed. They provide a chronicle of the life of the village: market days, holidays, peasants in local costume, colorful crowds never without their umbrellas in either sun or rain.

In the Bois d'Amour upstream on the Aven (illus., p. 183), he captured the shimmer of the liquid elements in a truly Impressionist manner. At Pont-Aven, his landscapes took on a certain solidity. In some instances he used a blue line to outline contours, and his brushstrokes became wider and firmer. One of Loiseau's principal artistic attributes was his ability to adapt his technique and treatment to the subject being depicted. Whereas his landscapes reflected an Impressionist vision and a Divisionist style, his still lifes were often products of a Synthetist vision and cloisonnist technique (illus., p. 194). He also held the brush a variety of ways depending on the quality he sought: to depict the transparency and

187

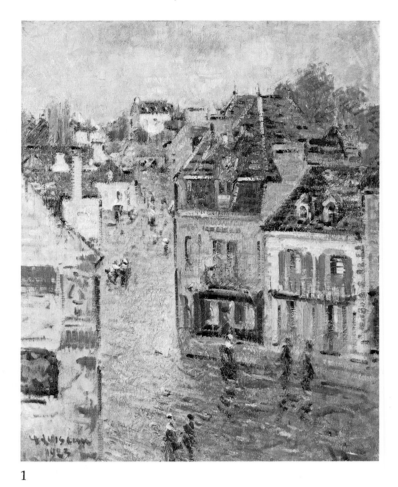

1

1. **Gustave Loiseau,**
 Pont-Aven, After the Rain, 1923,
 oil on canvas, 24 × 19⅝ in.
 Oscar Ghez Collection,
 Musée du Petit-Palais, Geneva.

2. **Gustave Loiseau,**
 *Pont-Aven from the Artist's Window
 at the Pension Gloanec,*
 oil on canvas, 21⅜ × 17 in.
 Private collection, Lorient.

3. **Gustave Loiseau,**
 The Petite Rue at Pont-Aven, 1926,
 oil on canvas, 21⅜ × 18⅛ in.
 Private collection, Switzerland.

4. **Gustave Loiseau,**
 Market Day at Pont-Aven, 1923,
 oil on canvas, 28⅝ × 23⅝ in.
 Private collection, U.S.A.

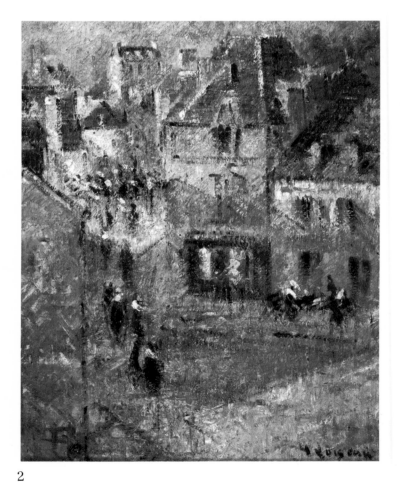

2 3

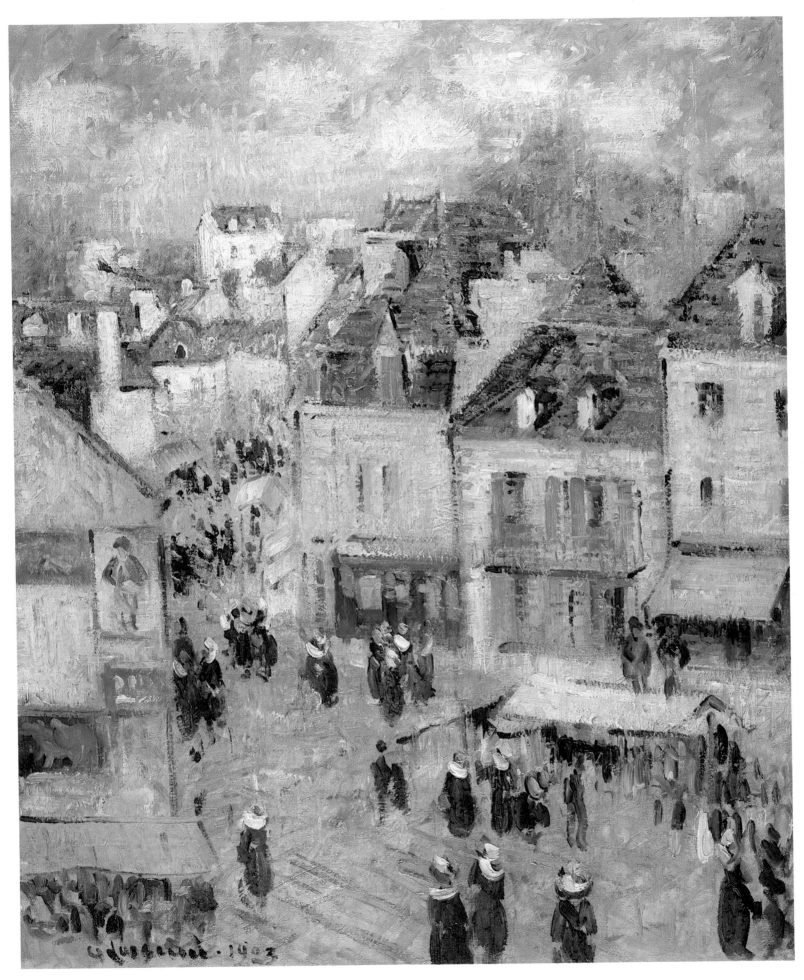

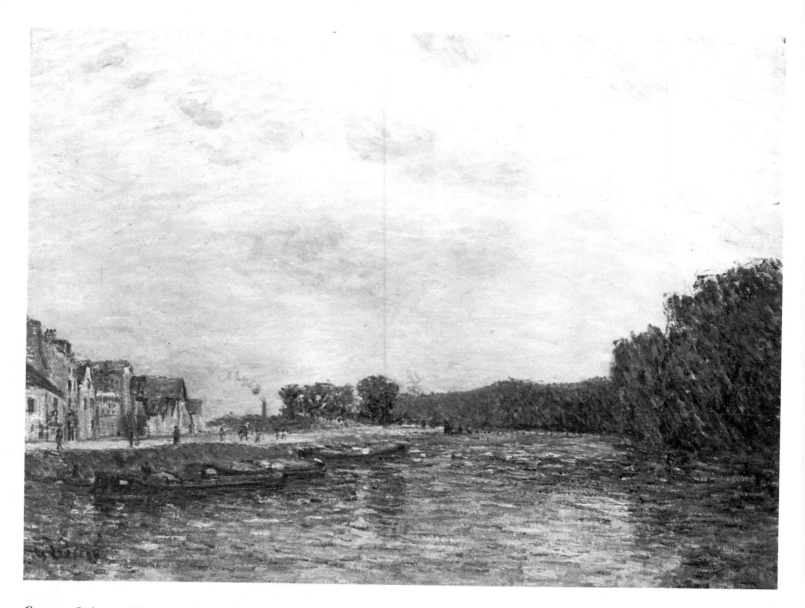

Gustave Loiseau, *The Loing at Saint-Mammès*, oil on canvas, 31⅞ × 39⅜ in. Durand-Ruel Collection, France.

Alfred Sisley, *The Loing at Saint-Mammès*,
oil on canvas, 21⅜ × 28⅝ cm. Private collection, New York.

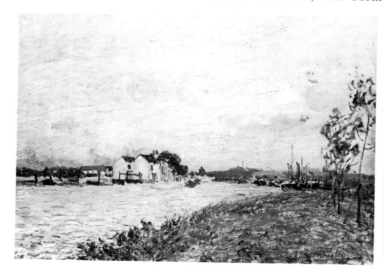

reflections of the clear water of the river Aven, his touch became broader, his hand became relaxed; to depict the rich, heavy, opaque depths of the ocean at the foot of a cliff, his touch became fragmented, divided, as taut as the mesh of a woven fabric, trapping the light to attain the deep intensity of seawater. The Belle-Ile canvases, painted in 1899 and 1900,[20] show — over and above their similarity to those that Monet had painted in 1886 in the same area — a different approach to the subject and a deeply personal style. In *Belle-Ile, Bad Weather*,[21] for example, the tight succession of choppy waves at the foot of the cliffs owes something to the Japanese prints of Hiroshige and Hokusai. Forming a counterpoint to the ocean and its waves, the sky, low on the horizon, is

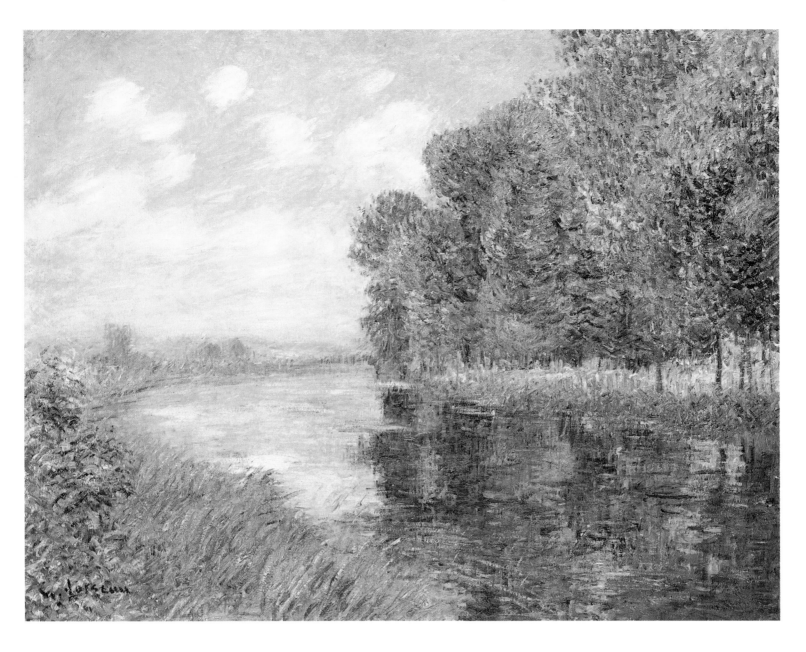

Gustave Loiseau, *Riverbank in the Ile-de-France,* oil on canvas, 25⅝ × 31⅞ in. Private collection, Geneva.

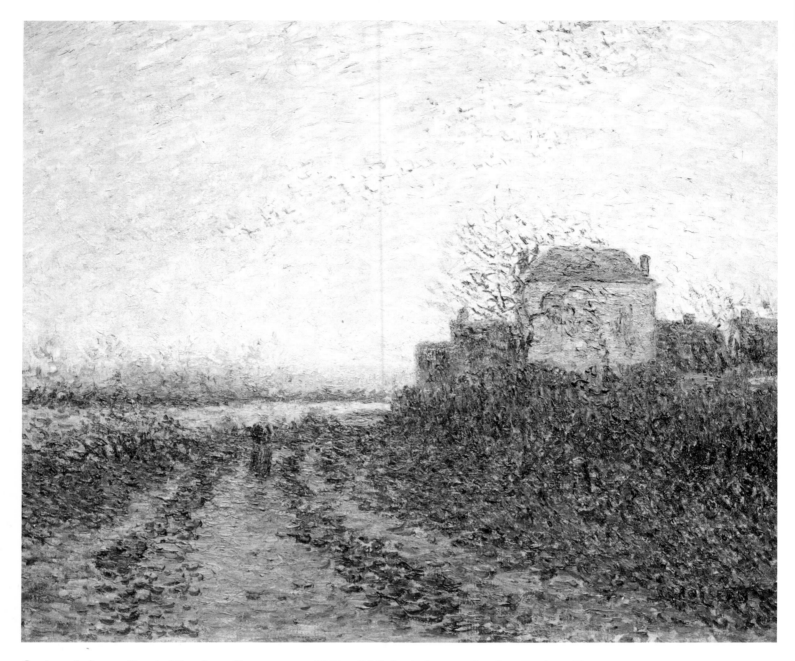

Gustave Loiseau, *Frosty Morning,* oil on canvas, 21⅜ × 25⅝ in. Private collection, Lorient, France.

filled with clouds and is heavy with rain. Loiseau captures the contrast between the jagged rocks, the breaking waves, and the sky above.

It was on the northern coast of Brittany, at Cap Fréhel, in 1905 and 1906, that Loiseau painted his fine series of the rocky cliffs called *Pointe du Jars,* which can be compared to similar series produced earlier by Monet.[22] These paintings show a taste for subtle variations on the same natural theme, as well as a joy in painting. Hardly changing the angle of his canvases one to the next, often painted in the same spot, he patiently depicted the transformation in

nature caused by changing light. This means of capturing appearances was a systematic method frequently used by Loiseau and Monet. As Thiébault-Sisson explains: "As the years went by [Loiseau] came to understand more and more the prime role that materials play in a painting. After sketching in the outlines, he covered his canvas with soft, thick daubs, and when the paint was thick enough, he made the whole thing vibrate by adding little flecks of color in all directions. This was enough to give the illusion of a moving sky, of fresh, lively air circulating, to give a sensation of life. This did not adversely

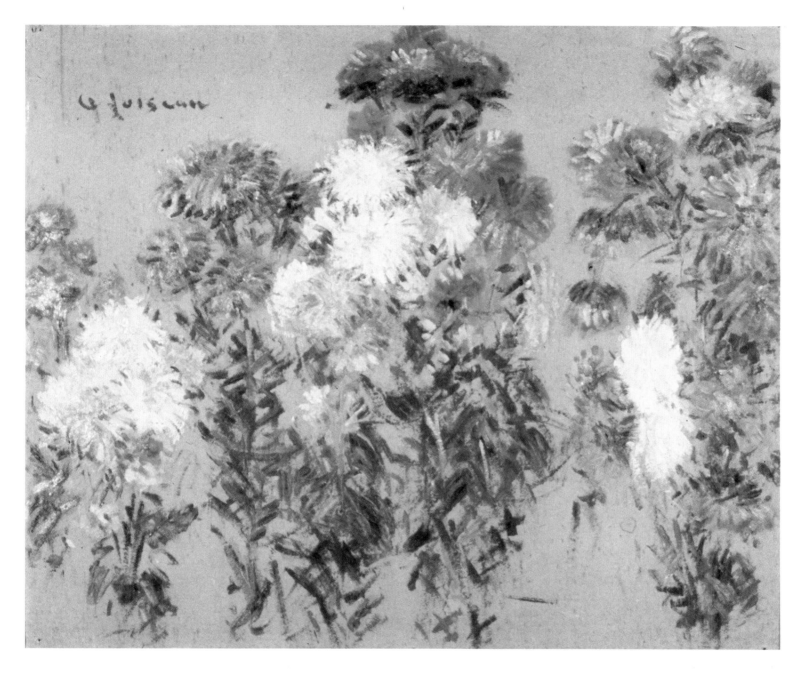

Gustave Loiseau, *Flowers,* oil on cardboard, 21⅜ × 25⅝ in. Private collection, Geneva.

Gustave Loiseau,
△ *Three Earthenware Statues*, 1916,
oil on cardboard, 17⅝ × 22¾ in.
Oscar Ghez Collection, Musée du Petit-Palais, Geneva.

Gustave Loiseau,
◁ *Two Earthenware Statues*,
oil on panel, 21⅝ × 18⅛ in.
Oscar Ghez Collection, Musée du Petit-Palais, Geneva.

affect the composition, and the drawing of his houses, trees, and geographical features left nothing to be desired. They are as solid and consistent, as firmly established as in a Cézanne landscape."[23]

With the exception of a few scenes located in the mountains of Isere that stand out among his works, "the subjects he chose were the same as Sisley's: the banks of the Loing, wooded hills, the hazy effect of fog or snow. The works he produced as he traveled the Ile-de-France, the home of the great Impressionists, place him midway between Pissarro and Sisley."[24] Yet there are differences between the work of Loiseau and that of his contemporaries. Sensitive as he was to every nuance, he refused to paint in the glaring midday light. As Mady Epstein wrote: "With his extreme sensitivity he rejected outright violent contrasts or garish colors,"[25] and Thiébault-Sisson confirms this: "Bright colors hurt Loiseau's eyes ...

so that he refuses to work in the heat of the day in high summer when the air is dry and when people and objects are starkly revealed."[26] Loiseau's preferences led him toward softer and subtler scenes: afternoons when the sky is dotted with clouds that filter the sun's rays, the soft golden light at the end of the day, morning fog spreading over water, evening mists, overcast weather, frost whitening the trees, and the dreamy effects of snow.

Toward the end of his life, while maintaining his studio on the quai du Pothuis at Pontoise, Loiseau took another studio, on the quai d'Anjou in Paris, where he painted from his window, as he had done in Pont-Aven. His life ended, in Paris, in 1935. Loiseau wrote of himself: "I only recognize one virtue in myself, sincerity." Throughout his life Loiseau remained faithful to this concept in art and in life.

NOTES

[1] Thirteen canvases, dating from 1893 to 1929, belong to the Oscar Ghez Collection in the Musée du Petit-Palais in Geneva, and nineteen others are in the Le Corronc Collection at Lorient. Numerous other canvases by Loiseau can be found in American collections.

[2] The Loiseau Family Archives, kindly put at our disposal by Mr. and Mrs. Meurant, the present owners of the Loiseau house at Pontoise, have been consulted for information. Gustave Loiseau's parents were butchers; originally from Pontoise, they set up shop at 10 rue des Deux-Ponts, on the Ile-Saint-Louis, in 1870. Loiseau had a brother, Pierre, to whom he became legal guardian in 1906. Loiseau was placed with a butcher as an apprentice before he joined a firm of decorators in 1880.

[3] Loiseau's parents retired to 6 rue de l'Epée in Pontoise. A few years later Loiseau himself went to live by the Oise, at 95 quai du Pothuis, on the road to Auvers-sur-Oise, where van Gogh died. In 1904 he had a fine studio built in his garden there, and many of his canvases are of views from this studio.

[4] He received his inheritance in 1887. The document drawn up by his attorney was consulted for this information.

[5] Thiébault-Sisson, *Gustave Loiseau* (Paris: Georges Petit, 1930), p. 20.

[6] Contrary to what Thiébault-Sisson says, the meeting between Maufra and Loiseau did not take place at the Bateau-Lavoir before 1890, since, up to that date, Maufra had an office job in Nantes. Maufra did not move into his studio at the Bateau-Lavoir until the end of 1891 or early 1892. In addition, Jeanine Warnod, *Le Bateau-Lavoir* (Paris: Presses de la Connaissance, 1975), explains that it was only from July 1, 1889, that the owner of the property received authorization to build artists' studios there. Thus it is unlikely that the building was completed and occupied before the following May.

[7] On this period and his paintings, see Jean Paul Crespelle, *Les Maîtres de la Belle Epoque* (Paris: Hachette, 1966).

[8] On life in Montmartre and its nightclubs, see Paul Yaki, *Le Montmartre de nos vingt ans* (Paris: Tallandier, 1933).

[9] Fernand Just Quignon, nicknamed "the harvest painter," became famous for his harvest pictures, exhibited with great success at the Salon. A member of the Société des Artistes Français from 1884 on, he won several prizes before being barred from competing. The Musée de Nantes has his *Black Corn* and the Musée d'Art Moderne in Paris has *Oats in Flower* (Bénézit, *Dictionnaire des peintres, sculpteurs, dessinateurs et graveurs* [Paris: Gründ, 1960], vol. 7, p. 77). The photograph of a painting by Quignon of the harbor of Pont-Aven, dedicated to his friend Claude Emile Schuffenecker, illustrates his early visits to Pont-Aven (illus., p. 30).

[10] Thiébault-Sisson, *Loiseau*, p. 13.

[11] On this aspect of Pont-Aven, see Denise Delouche, *Les Peintres de la Bretagne* (Paris: Librairie Klincksieck, 1977), and Denise Delouche, "Pont-Aven avant Gauguin," *Bulletin des Amis du Musée de Rennes, numéro spécial: Pont-Aven*, no. 2 (Summer 1978), pp. 30–39.

[12] Thiébault-Sisson, *Loiseau*, p. 24.

[13] On this influence, see Wladislawa Jaworska, *Gauguin et l'école de Pont-Aven* (Paris: Bibliothèque des Arts, 1971), p. 199: "It is to Maufra's style that his [Loiseau's] work came the closest."

[14] Thiébault-Sisson, *Loiseau*, p. 16.

[15] François Depeaux, a coal merchant and a famous collector, was a close friend of Claude Monet.

[16] Catalog of the Musée de Petit-Palais, Geneva, undated, no. 49; also reproduced in Mady Epstein, "Gustave Loiseau," *Vision sur les arts*, September 1975, p. 36.

[17] *Flowers, Blue Iris, Oranges and Lemon*, in Georges Wildenstein and Raymond Cogniat, *Paul Gauguin, catalogue raisonné* (Paris: Beaux-Arts, 1964), no. 406.

[18] Thiébault-Sisson, *Loiseau*, p. 63.

[19] In 1894 Marie-Jeanne Gloanec opened her annex near the Hôtel Julia, where the present Hôtel des Ajoncs d'Or stands.

[20] *Belle-Ile*, 1900, Geisser Collection, Switzerland.

[21] Durand-Ruel Collection, Paris.

[22] One version belongs to the Musée de Rennes (reproduced in Jaworska, *Gauguin,* p. 203). Two others were exhibited at the Musée de Pont-Aven in 1978, cat. nos. 1 and 2.

[23] Thiébault-Sisson, *Loiseau*, p. 32.

[24] Epstein, "Gustave Loiseau," p. 36.

[25] Ibid., p. 37.

[26] Thiébault-Sisson, *Loiseau*, p. 30.

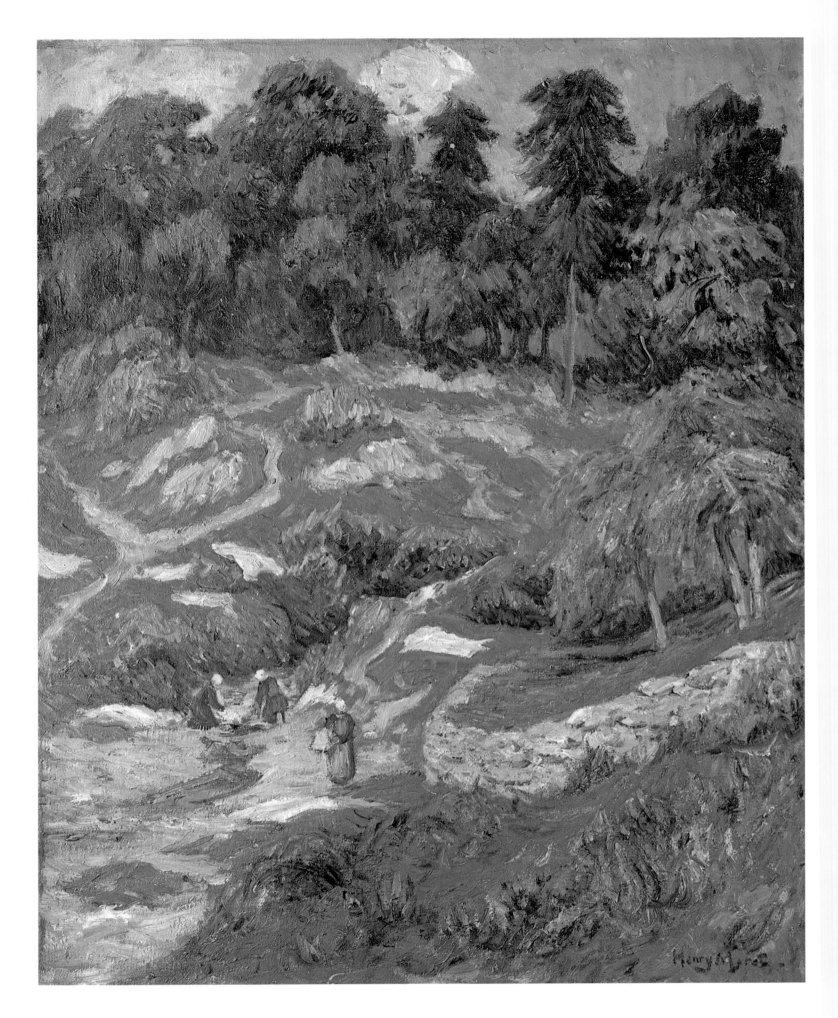

HENRY MORET

1856–1913

A T Pont-Aven in 1886, Henry Moret, thirty years old and already an established painter, met Gauguin. They were to become close friends. Along with Laval, Bernard, and Emile Jourdan, these artists formed a separate group at the Pension Gloanec, remaining aloof from the other, more academic residents of the establishment.

Moret had discovered Brittany in 1876 while performing his military service at Lorient and was so charmed by this region that he returned regularly for vacations. At the end of his military duty he returned to Paris to continue his studies at the Ecole Nationale des Beaux-Arts in the studios of Jean Léon Gérôme[1] and Jean Paul Laurens.[2] No paintings are known from the early years when Moret studied in Paris. However, the acceptance of his work by the Salon in 1880 shows that his paintings must have been fairly conventional, especially since he was awarded a medal at the Salon du Champ-de-Mars.

Returning to Brittany in 1886, he went to Pont-Aven, where he was already a regular visitor and which was then very much in vogue among artists from all over the world. Although it was during this visit that he met Gauguin, he did not reside at the

The ocean spoke to me in a fraternal strain
For the same clamour uttered by the sea
Rises from man to the gods,
eternally in vain.

JOSÉ MARÍA DE HEREDIA

Henry Moret,
Washerwomen at Doëlan, Finistère,
oil on canvas, 28⅝ × 23⅝ in.
Musée du Petit-Palais, Geneva.

Henry Moret,
Photograph, c. 1905.
Durand-Ruel Photograph Archives,
Paris.

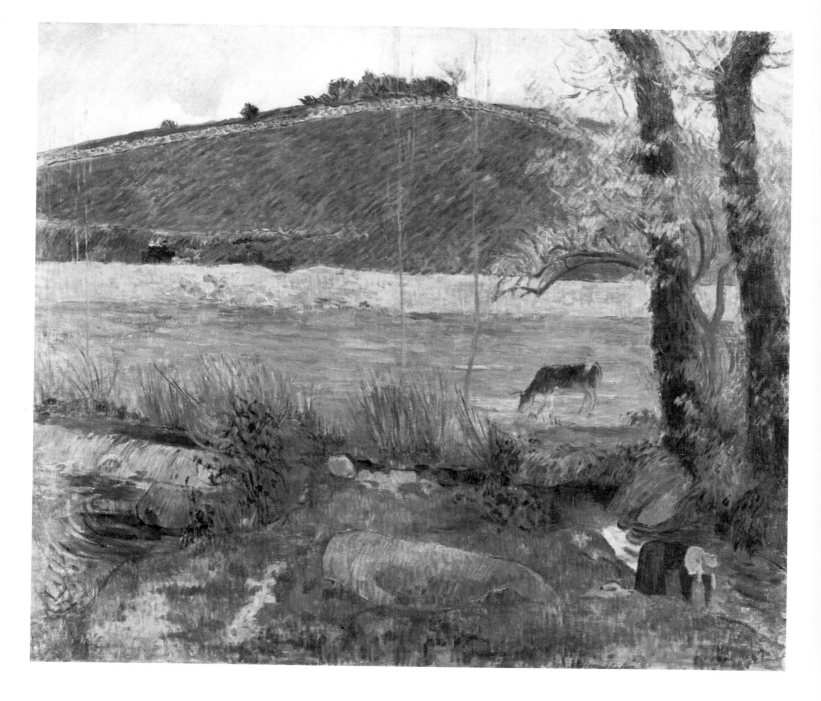

Pension Gloanec, where Gauguin and many of the other artists lived, but rented a studio from the harbor master, Monsieur Kerluen,[3] who shared his love of boats and fishing and with whom he was to leave a thick roll of studies.[4]

After a prolonged sojourn in Pont-Aven, Moret rejoined Gauguin, Filiger, Séguin, de Haan, and Jourdan at the end of 1889 at Marie Poupée's[5] inn in Le Pouldu. Very few surviving works by Moret date from this period. The *Breton Landscape: Girl with a Cow*, 1889, exhibited by Durand-Ruel in 1973,[6] and

Meadow in Brittany, painted at Le Pouldu in 1890 and inscribed *April*[7] (illus., p. 199), are examples of Moret's work in those early years.

He had found immediate acceptance in the group of Impressionists gathered around Gauguin, who, in 1888, had dedicated to Moret *Seascape*, painted at Le Pouldu.[8] Bernard described Moret as "a peaceful and sincere revolutionary,"[9] an Impressionist. According to Bernard, Moret's style was very close to that of the whole group. "At that time he changed his style in line with ours.... I had great respect for

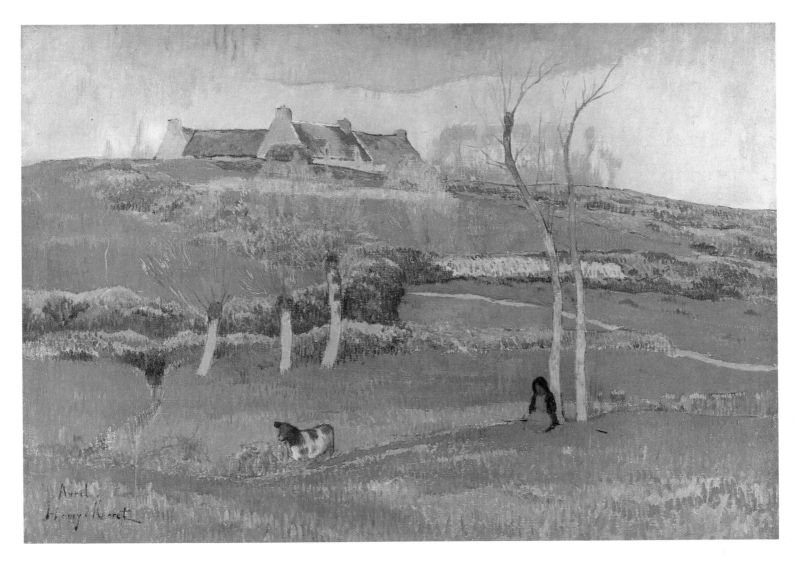

Henry Moret,
△ *Meadow in Brittany* (Le Pouldu landscape), 1890,
oil on canvas, 22¾ × 32⅝ in.
Oscar Ghez Collection, Musée du Petit-Palais, Geneva.

Paul Gauguin,
◁ *Meadow on the Bank of the Aven*, 1888, oil on canvas, 23⅝ × 28⅝ in. Private collection.

Henry Moret and we sometimes went walking together to look for subjects."[10] Bernard also wrote: "I knew him at Pont-Aven around 1888.... I saw him working long and hard. In 1892 his landlord, M. Kerluen, showed me a thick roll of studies from that period, including some very good ones."[11]

This long period of association with Gauguin seems to have been productive, yet few works from this period exist. One explanation is suggested by a careful study of the two works mentioned above, together with other paintings dated between 1891 and 1894, and by a comparison with the canvases executed by Gauguin from 1888 to 1891. Many of Moret's paintings from this period have been subsequently attributed to Gauguin, in some cases after the original signature has been erased and replaced with a spurious one. Gauguin's work from this period was characterized by enormous differences of style from one canvas to another. Painted in the same year, for example, were the Synthetist *Yellow Christ* and the Impressionist *Bonjour, M. Gauguin.* Because Gauguin's passage from descriptive Impressionism

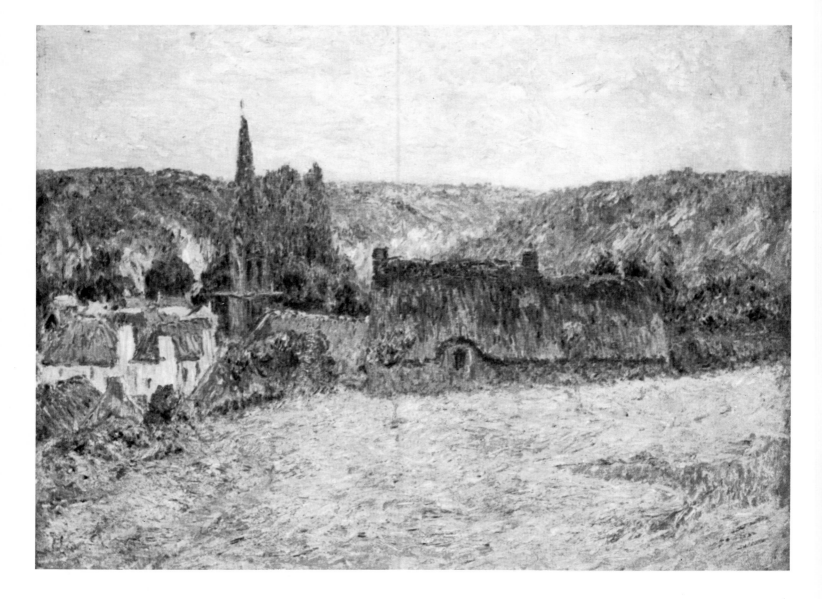

Henry Moret,
The Derout-Lollichon Field (Pont-Aven), 1900,
oil on canvas, 21⅜ × 28⅝ in.
Private collection.

of the real to the suggestive Symbolism of the imaginary was prolonged up to 1891,[12] the subsequent fraudulent attribution of the works of Moret to Gauguin was unwittingly encouraged.

At this time, Moret was working in close to the same spirit, style, and palette as Gauguin. Furthermore, their subjects were drawn from similar sites in Pont-Aven and Le Pouldu. Jaworska has written of Moret's painting *Breton Washerwomen*, 1890, in the Gloanec Collection: "The work is truly as 'Gauguinesque' as it could be. Its forms, colors, the way the paint is applied, and the brushwork are all amazingly close to those of Gauguin in his famous Breton farm painted in 1890 at Pont-Aven."[13] The same is true of *The Haymakers of Larmor*[14] and *The Hunter at Ploemeur*,[15] both painted in 1891 (in the Durand-Ruel Collection). A comparison of Moret's *Meadow in Brittany*, 1890[16] (illus., p. 199), with Gauguin's *Farm at Le Pouldu*, 1890[17] (in the Emery Reves Collection, U.S.A.), or with *The Field, Le Pouldu Landscape*, 1890[18] (in the Mellon Collection, U.S.A.), demonstrates the similarity of style developed by Moret and his friend Gauguin during 1890, a period of communal, almost symbiotic life at Le Pouldu.

However, landscapes of the countryside formed only a minor part of Moret's output during these

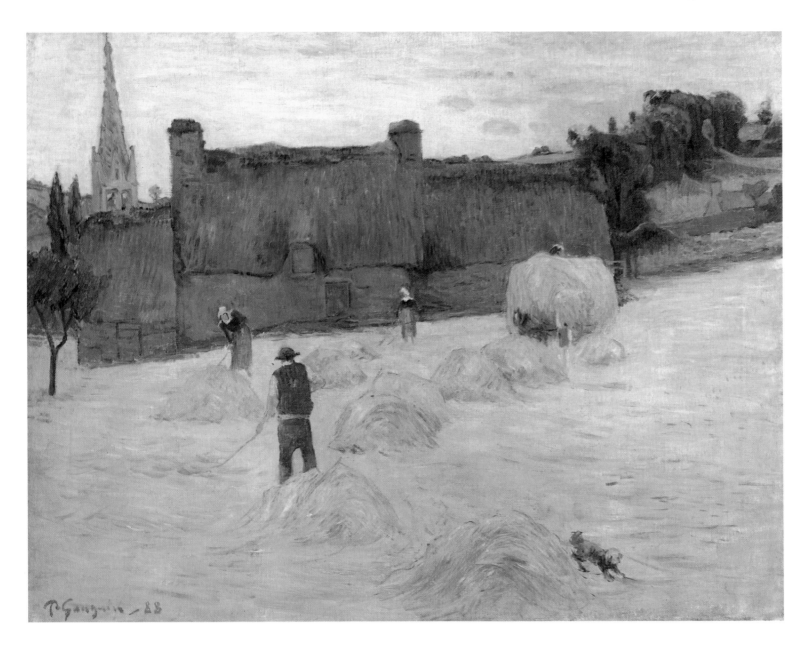

Paul Gauguin,
Haymaking in the Derout-Lollichon Field (Pont-Aven), 1888,
oil on canvas, 28⅝ × 36¼ in.
Musée d'Orsay, Paris.

years, which was not true of Gauguin. Instead, Moret chose marine subjects for his main theme. From 1890 to 1894 Moret hardly left the Lorient area, as indicated by the titles of his works, which correspond to sites in the immediate vicinity of Lorient.

These "avant-garde" paintings found no market. As a consequence, Moret owed much at that time to his future bride, who was a dressmaker with a workshop above the Café du Théâtre in the rue de la Comédie in Lorient. She supplied Moret with canvas, frames, and often money, when he or his friends were in financial straits. In 1894 and 1895 Moret exhibited at the Salon des Indépendants. Durand-Ruel bought several of Moret's paintings, and his financial situation began to improve. In 1895 Moret reached an agreement with Durand-Ruel, which freed him from financial worries. That year also marked the final departure of Gauguin, which gave Moret the impetus to develop on his own. Both factors contributed to a decisive turning point in Moret's work. This year was a highly productive one. His canvases show an amazing tightness and an intense luminosity in their depiction of the islands of Brittany: Groix, Belle-Ile, and Ouessant (illus., pp. 202-3).

In the years between 1895 and 1898, the work of Moret began to develop rapidly. Within the Impressionistic style, his canvases transposed the new theories of the Synthetists into contrasts of warm and cold colors. The principles of composition and design developed in Pont-Aven and Le Pouldu were carried to the extreme in these canvases. Foreground diagonals thrust the rest of the image into the background. The Symbolist spirit, evoked by highly suggestive colors, gave these paintings a new-found emotional content. Pinks, side by side with purples and greens, surrounded by blue, characterize these admirable canvases. In her preface to the Moret exhibition held at the Durand-Ruel gallery in 1973, France Daguet noted: "A more pronounced Synthetism is seen in the works of 1895.... The handling of flat areas of color, divided up by precise arabesques, shows clearly his abnegation of realistic space and of a strict imitation of nature."

In 1896 Moret settled down in the small port of Doëlan,[19] a modest fishing village on a stretch of heath-covered land, bordered by sheer cliffs. A deep estuary penetrated the land like a fjord. Although enchanted by this new region, Moret did not renounce his affection for the area he knew so well.

Lorient was twelve miles away, Le Pouldu six by road and four by the coastal path, Pont-Aven twelve. Moret moved into an old house on the cliff overlooking the harbor at Doëlan. He had an incomparable view, extending to the horizon beyond the Ile de Groix. According to the journalist René Maurice: "He took up residence in a converted guardhouse which had belonged to a coast guard battery in the eighteenth century and then, at the beginning of the last century, to the customs officers. This building was built at the harbor entrance on a spur like a promontory open to the sea. From time to time during heavy storms when the sea was rough, waves entered through the chimney with sea spray."[20] The art critic Henry Eon, Moret's friend and confidant, reports that about 1900 a "bourgeois" (which was for him synonymous with poor taste) bought the headland, pulled down the guardhouse, and replaced it with an expensive, ugly villa. Moret, deprived of his steep headland and his solitude, moved to a charming little fisherman's cottage on the other side of the harbor, owned by a retired schoolmaster named Monsieur Tonnerre.

After Moret's death in 1913, his cottage was occupied by other painters, including Pierre Talcoat,[21]

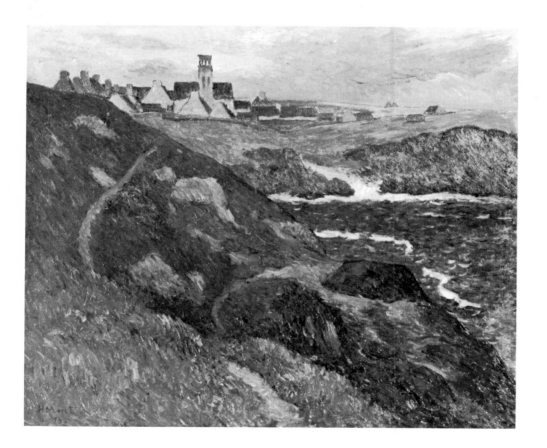

Henry Moret,
◁ *The Village of Lampaul,
Isle of Ouessant,* 1895,
oil on canvas, 23⅝ × 28⅝ in.
Private collection, U.S.A.

Henry Moret,
The Cliffs of Stang, Ile de Groix, 1895, ▷
oil on canvas, 36¼ × 28⅝ in.
Durand-Ruel Collection, France.

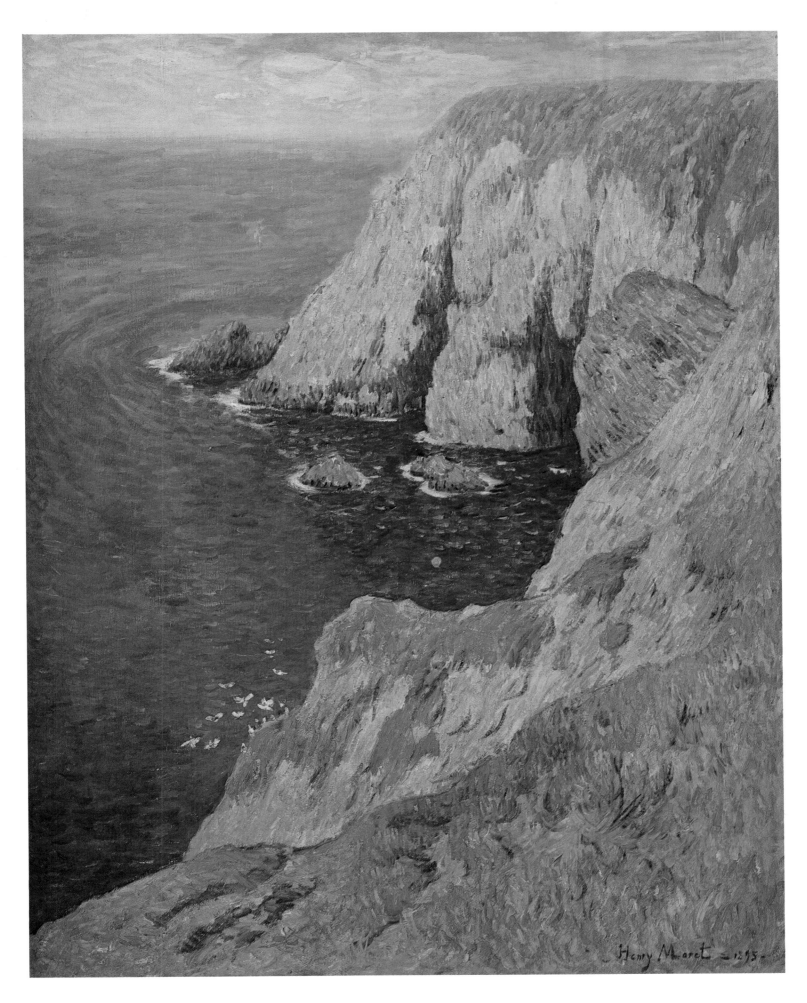

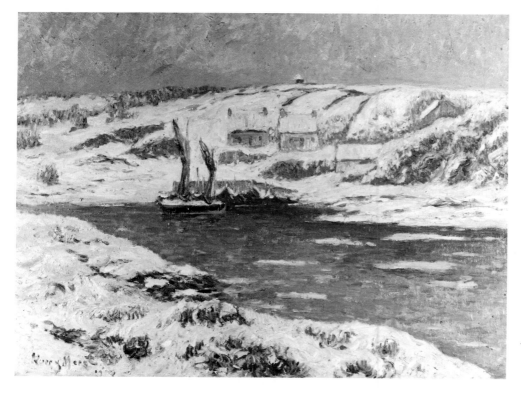

Henry Moret,
◁ *Snow Effect at Doëlan*, 1910,
oil on canvas, 20⅞ × 28⅜ in.
Oscar Ghez Collection,
Musée du Petit-Palais, Geneva.

Henry Moret,
▽ *Sailing Boats at Anchor at Doëlan*, 1896,
oil on canvas, 21⅜ × 25⅝ in.
Private collection, Quimper.

and Emile Compard.[22] René Maurice has described this new location: "Built on the crest of a hill, it provides from its windows one of the finest views in Brittany. Down below, the little harbor with its quay, its houses, its one street, and its fishing boats bobbing gently at anchor. To the right, the harbor entrance with its lighthouse and jetty against which the waves break, showering magnificent plumes of spray up into the azure sky. In the distance, the ocean with its colors constantly changing like those of a pigeon's breast, depending on the time of day and the color of the sky."[23]

From 1896 on, the paintings of Doëlan are numerous (illus., pp. 204–5). In changing his residence from one bank to the other, Moret changed both his perspective and his subject matter. The earliest views of Doëlan were painted from the right bank, and depicted the left bank with its heathland and windmill. In order to portray the perpetually shifting movement of such a dynamic scene, Moret had to modify his vision. He returned to Impressionism and the spirit of Monet, expressing in his work a naturalistic and objective view, concentrating on the landscape and omitting any intellectual content.

Without abandoning the characteristic tones of his palette and the contrast of warm and cold colors,

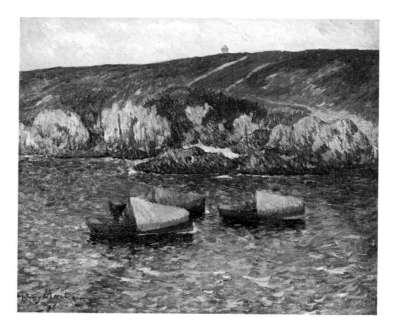

Moret increasingly applied the Divisionist theory of the separation of colors. "The principle is clear," explains Louis Gillet: "pure color is more intense than a composite shade. Violet, for example, is made up of red and blue. To obtain a vivid glowing violet, do not mix the colors either on the palette or the canvas; apply them separately side by side, a touch of blue and then a touch of red. This will give an impression of violet. The mixing is done on the retina."[24]

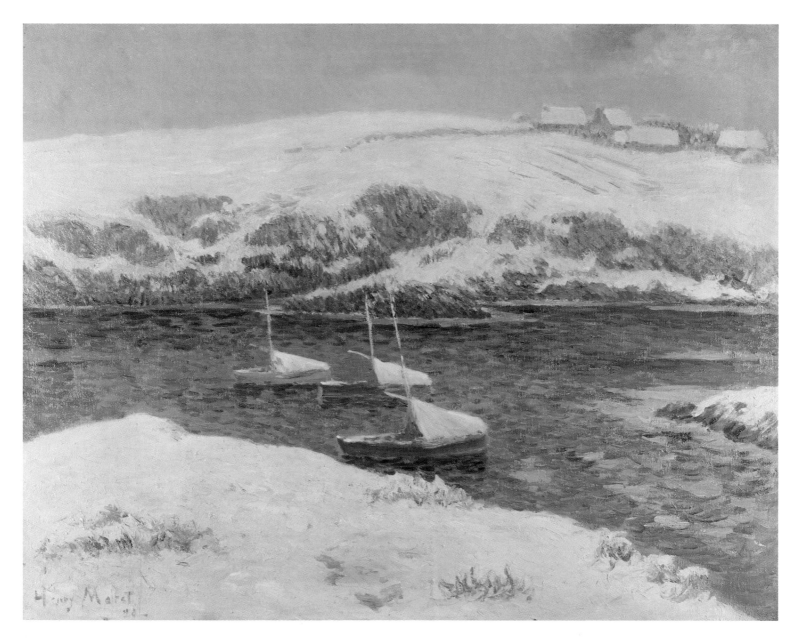

Henry Moret, *Snow at Doëlan*, 1898, oil on canvas, 28⅝ × 36¼ in. Oscar Ghez Collection, Musée du Petit-Palais, Geneva.

As was noted in the Durand-Ruel catalog of 1973, "The Synthetist apotheosis of the following year revealed a certain movement from Synthetism toward Impressionism, with Moret succeeding in balancing the two concepts." This change coincided with his move to Doëlan. Stressing the return of realism in Moret's concept of the pictorial work produced there, this analysis continues: "Admittedly he still divides the canvas in the manner of Gauguin, but he is now carried away by his objective love of nature, and this transformation makes itself felt in the works of 1897."[25]

This progression toward "the *plein-air* school of Monet" developed hand in hand with Moret's wanderings along the Atlantic coast of Brittany, which took him to Ouessant, Groix, Belle-Ile, the Nevez and Trégunc coastline, Merrien, Saint-Guénolé, Douarnenez, and Audierne. René Maurice has commented, "In applying this new artistic theory, Henry Moret succeeded in representing the Breton landscape as no one had done before him with the sole exception of Claude Monet in his grandiose views of Belle-Ile-en-Mer"[26] (illus., pp. 148–49). Moret never strayed far, however, from the Lorient and Doëlan area, except for two brief visits to Normandy in 1901 and 1912 and a short stay in Holland in 1900, at the suggestion of Durand-Ruel. From his visits to the museums of Amsterdam and The Hague he retained the impression of the majestic manner of Dutch paintings of the sea and sky under differing light conditions.

Despite his relative isolation, Moret never neglected his friendly relations with the other members of the Pont-Aven school or his friends in Le Pouldu, including Slewinski,[27] to whom he presented as a wedding gift *The Customs House* (1892).[28] During a visit to Chamaillard and Séguin[29] at Châteaulin in 1903, Moret painted *View of Port-Launay*,[30] which, after adorning the walls of a local inn, is now in the Hernigou Collection in Châteaulin. Moret also visited Filiger, who remained at Le Pouldu until he moved in with a family in Trégunc, where Moret also visited several times. He stayed in contact with Maufra, Loiseau, and Bernard in Paris, either at Durand-Ruel's gallery or at Le Barc de Boutteville, where the name of Moret could be read on one of the panels in the gallery until 1920.

Upon Moret's death, Henry Eon wrote, "The whole work of Henry Moret was a symphony vibrating with incomparable frankness: it was the symphony of the Sea."[31] A simple, calm, discreet, and peace-loving man, Moret left behind him only affec-

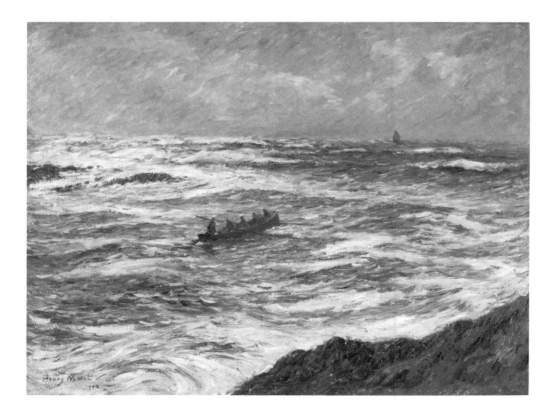

Henry Moret,
The Pilot, Doëlan, 1904,
oil on canvas, 23⅝ × 31⅞ in.
Private collection, France.

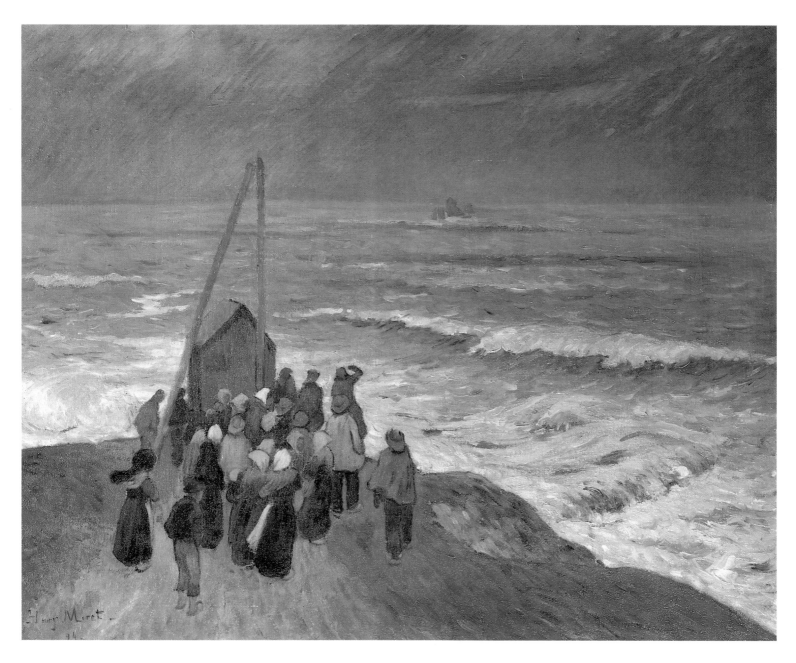

Henry Moret, *Waiting for the Fishermen to Return* (Doëlan), 1894, oil on canvas, 21 ⅜ × 25 ⅝ in. Oscar Ghez Collection, Musée du Petit-Palais, Geneva.

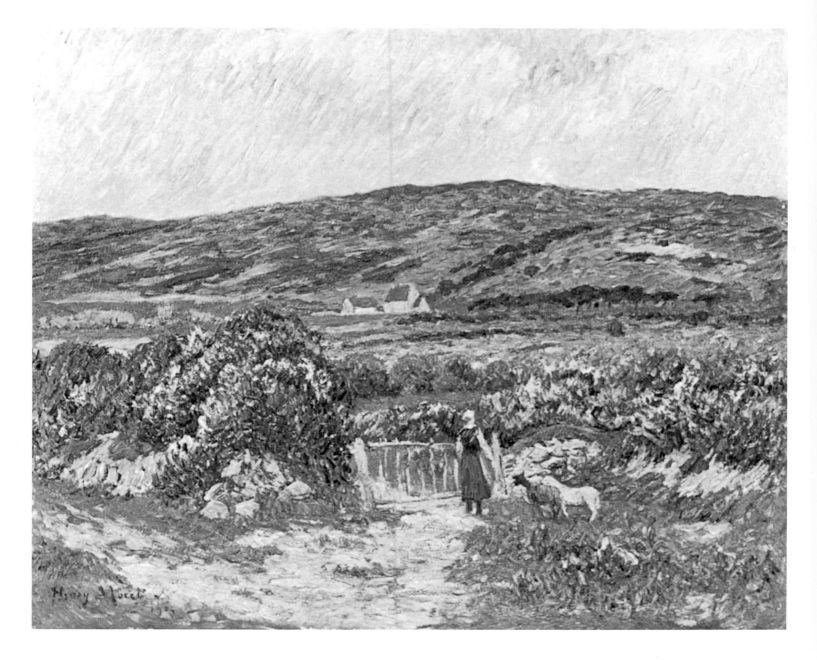

Henry Moret,
The Black Mountains, Finistère, 1904,
oil on canvas, 25⅝ × 31⅞ in.
Durand-Ruel Collection, France.

tion and regret when he died in 1913. At Doëlan, his landlord and friend Monsieur Tonnerre, who lived in the house next door and to whom Moret had given the painting *The Entrance to Doëlan at Sunrise*, liked to recall "the old days when Moret and I used to go fishing together in a small boat, as well as the times that we beat all the woods and moorland in the area hunting for game. An indefatigable fisherman and huntsman, a real seadog [often sailing with the customs officer Jacob, whose portrait he painted],[32] a

first-rate shot, and yet the kindest, gentlest, most generous, the best of men."[33]

After Moret's death, the Durand-Ruel galleries in both Paris and New York continued to exhibit his work, either in one-man shows or alongside canvases by Albert André, Maxime Maufra, Gustave Loiseau, and Georges d'Espagnat. The catalog for one of these posthumous exhibitions identifies the enduring attribute of Moret's work as his ability "to express the Breton landscape exactly, and he occupies a unique place in the evolution of art at the end of the nineteenth and the beginning of the twentieth century, as he has been able to fuse together two fundamentally opposing styles: the Synthetism of Pont-Aven and Impressionism."[34]

NOTES

[1] Jean Léon Gérôme (1824–1904) was a painter of great technical skill, famous for his pictures inspired by both frequent visits to the East and the antique. His "hyperrealistic" style produced such unusual works as *The Two Majesties*, which prefigures modern Surrealism. Most of his paintings are in private American collections, as are those of his English counterpart, Lawrence Alma-Tadema.

[2] Jean Paul Laurens (1838–1921) was one of many painters at that time whose subject matter was historical scenes. He devoted himself especially to French history and was involved in the decoration of the immense Hôtel de Ville in Paris. He taught at the Académie Julian.

[3] Monsieur Kerluen, a retired naval officer, gave fencing lessons and rented his attic to artists. His house was later occupied by Emile Bernard, in 1892, and by Emile Jourdan.

[4] Letter from Emile Bernard to René Maurice, 1937, published in *Souvenirs inédits sur l'artiste-peintre Paul Gauguin et ses compagnons* (Lorient: Imprimerie du Nouvelliste du Morbihan, n.d.), p. 20.

[5] Marie Henry, innkeeper at Le Pouldu, was commonly known as Marie Poupée.

[6] No. 1 in Durand-Ruel catalog.

[7] Exhibited at the Royal Academy of Arts, London, 1980: *Post-Impressionism in Europe*, no. 148 in catalog.

[8] Georges Wildenstein and Raymond Cogniat, *Paul Gauguin, catalogue raisonné* (Paris: Beaux-Arts, 1964), no. 285.

[9] Ibid., note 4.

[10] Ibid.

[11] Ibid.

[12] This date coincides with the final rejection of Impressionism in the work of Gauguin, in both his Breton and Tahitian paintings.

[13] Wladislawa Jaworska, *Gauguin et l'école de Pont-Aven* (Paris: Bibliothèque des Arts, 1971), p. 184.

[14] Henry Moret exhibition, Durand-Ruel gallery, 1973, cat. no. 4, reproduced.

[15] Ibid., cat. no. 2, reproduced.

[16] See note 7.

[17] Jaworska, *Gauguin*, reproduced in color, p. 99.

[18] Ibid., p. 103.

[19] Doëlan is equidistant (twelve miles) from Lorient (southeast) and Pont-Aven (northwest).

[20] René Maurice, *Le Nouvelliste du Morbihan* (Lorient, March 24, 1937).

[21] Pierre Talcoat was born in Clohars-Carnoët in 1905. After studying in Paris from 1924 to 1926 and military service, he lived in Doëlan from 1928 to 1931. On his return to Paris he was an active member of the *Forces nouvelles* group. He painted a portrait of Gertrude Stein, which won him the Prix Paul Guillaume in 1936. At the time of the Spanish Civil War, he painted his *Massacres* series.

[22] Emile Compard (1900–1977) was a friend of Félix Fénéon, whose collection included Compard's famous canvas *La Montée à 80*. A figure of Parisian society from 1925 to 1930, he was also a friend of Josephine Baker and Mistinguett. The subjects of his work include scenes from *La Revue nègre*, Bugatti cars, Eco petrol pumps. A remarkable witness of the pre-World War II years, he moved to Doëlan, near his friends Asselin and Curnonsky, who were staying with Mélanie at Riec-sur-Belon. The Doëlan paintings are violently expressionist in style. A series of paintings of 1944–55, inspired by the bombing of Lorient, recall simultaneously the *"misérabilisme"* of Gruber and Expressionism. Toward the end of his life, he left Doëlan for a studio in La Drôme. Before the war, he was under contract to the Petridès gallery in Paris.

[23] Maurice, *Le Nouvelliste*.

[24] *Encyclopédie de l'Impressionnisme* (Paris: Somogy, 1974), p. 92.

[25] France Daguet, *Henry Moret*, exhibition catalog, Durand-Ruel gallery, Paris, 1973.

[26] Maurice, *Le Nouvelliste*.

[27] Wladislaw Slewinski (1854–1918). On this Polish artist see Jaworska, *Gauguin*, pp. 107–120.

[28] Buffetaud Collection, Paris. Exhibited at the Pont-Aven museum, 1978, cat. no. 9, reproduced.

[29] Armand Séguin (1869–1903) is best known for his engravings and his portrait of Countess Zaposlka (Dominique M. Denis Collection). See Jaworska, *Gauguin*, pp. 139–48.

[30] Exhibited at the Pont-Aven museum, 1974, cat. no. 17, reproduced in color.

[31] Henry Eon, "Henry Moret," *Revue du Morbihan*, January 1, 1933.

[32] This portrait, in the form of a medallion, was painted on a wood panel door in a small bistro in Ros Bras. This painting is today in the Morice Collection, Tréboul.

[33] Maurice, *Le Nouvelliste*.

[34] Daguet, *Moret*.

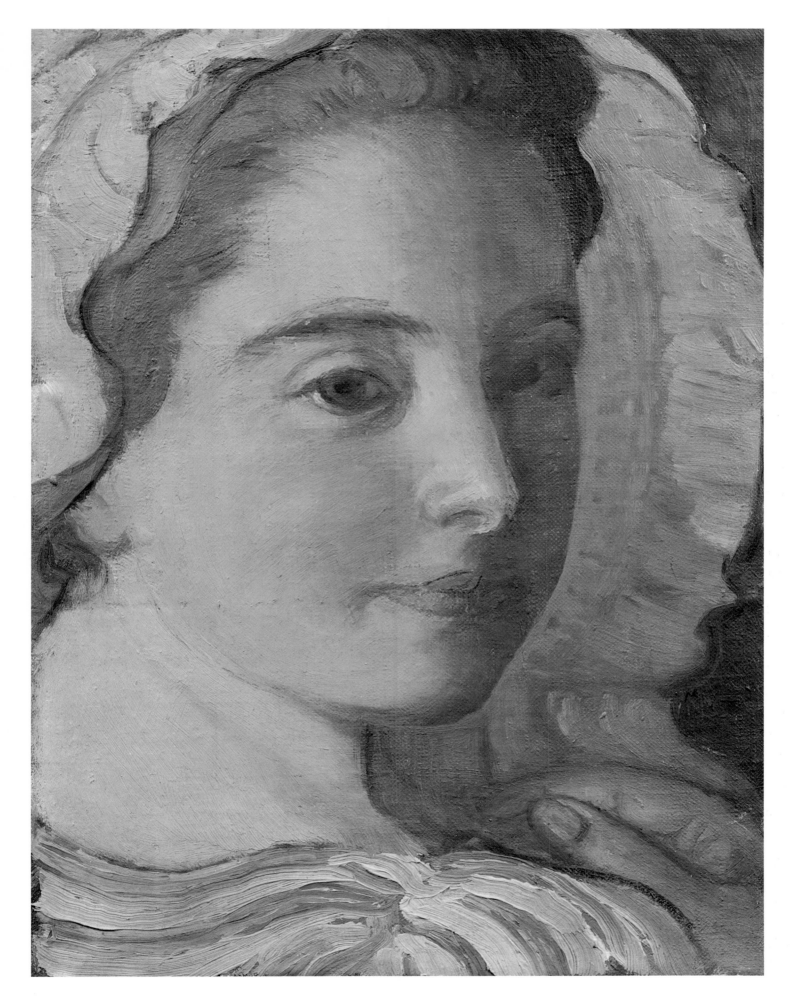

210

MAURICE DENIS

1870–1943

AURICE DENIS has traditionally been placed among the proponents of Symbolism. Yet, like most artists, he was subjected to different influences and he experimented; as a result, his art evolved. Ultimately, Denis's work is impossible to categorize under one heading.

Denis was born in 1870 at Granville on the Channel coast, his parents having abandoned their home in Saint-Germain-en-Laye[1] to escape the advancing Prussian army. His father worked for the Western Railway Company[2] during the construction of the Lannion-Plouaret line in northern Brittany during the 1880s. He had been sent to Brittany to check the accounts and took his wife and young son with him.

Maurice Denis's first artistic contact with Brittany occurred in 1883, to judge from a charming watercolor of the Pointe du Château at Trestrignel (illus., p. 213). His *Journal*, which he kept assiduously from 1884 until his death,[3] contains the following entry for August 26, 1885: "Yes, I love my Brittany. Were it not for the cursed River Couesnon [which divides Brittany from his native Normandy], I would be a Breton too."[4] In 1884, the year in which he started at the Lycée Condorcet in Paris, he spent the summer holidays at Granville. He returned there in 1887 to

I have observed that the interplay of light and shade is totally unable to give a colored equivalent of light. What might its equivalent be? Pure color! So, everything must be sacrificed to this!

MAURICE DENIS

Maurice Denis,
◁ *Portrait of Marthe in a Pink Hood*, 1893,
oil on canvas, 11 × 8⅝ in.
Bernadette Denis Collection, France.

Maurice Denis, his wife, Marthe, and their two daughters. ▷
Photograph, c. 1908.
Denis Family Archives.

△ **Maurice Denis,** *The Bay at Granville,* 1887,
pen-and-ink drawing. Bernadette Denis Collection, France.

Maurice Denis, *Seated Woman in Black Reading,* 1886, ▷
charcoal drawing. Bernadette Denis Collection, France.

do a remarkable series of pen and ink drawings that
are lively, witty, and well finished (illus., p. 212). In
spite of their modest dimensions, they have the
breadth and feel of much larger compositions. They
reveal his love of the sea, which later led him to buy a
house[5] on the north coast of Brittany, where he
never tired of looking at the ocean. He wrote, "I love
the sea, its roaring waves, this thing that never
changes and yet never fails to interest us."[6]

The diary of the fourteen-year-old Maurice Denis
demonstrates the precociousness of this adolescent.
He had already made up his mind to be a painter and
managed to persuade his father to pay for lessons
in drawing and perspective with a photographer-
painter named Zani in Saint-Germain-en-Laye.[7] At
the same time, the liturgies and mysteries of the

Maurice Denis, *Pointe du Château at Trestrignel*, 1883, watercolor. Bernadette Denis Collection, France.

Catholic religion, in which he had been brought up by his mother, were uppermost in his mind and had already inflamed his imagination.[8] This mixture of determination and religious faith, of culture and irrationality, was to remain with Denis throughout his life.

During his adolescent years Denis drew and sketched continually. He began his formal studies at the Lycée Condorcet, where his friends included Edouard Vuillard, Aurélian Marie Lugné-Poë,[9] and Ker-Xavier Roussel. After a year at the Lycée Condorcet, his parents allowed him to study with the Brazilian artist Julio Balla.[10] Totally involved with the artistic world and imbued with an insatiable curiosity, he visited avant-garde exhibitions as well as museums. He may have seen Seurat's *Bathing at*

Asnières, exhibited at the first Salon des Indépendants from December 10, 1884, to January 20, 1885, and probably visited the eighth and last Impressionist exhibition, where Seurat's *La Grande Jatte* was shown from May 15 to June 15, 1886. The sketches and watercolors that he produced at Perros-Guirec in the summer of 1886 unmistakably reveal Seurat's influence. Denis's drawing *Seated Woman in Black Reading* (illus., p. 212), which was later chosen to illustrate Paul Verlaine's *Sagesse* (as well as *Women Sewing, Milliners, Woman Kneeling,* and *Men Praying*),[11] is comparable to Georges Seurat's conté crayon drawings of the same period.[12] These sketches and watercolors, produced in the Perros-Guirec and Ploumanach area on the northern coast of Brittany, reveal the exceptional artistic

Maurice Denis, *Around the Lamp,* January 1889, charcoal drawing. Bernadette Denis Collection, France.

skill that this adolescent had already attained. The influence of Impressionism on both his technique and his vision can be confirmed by Denis's journal entry at a much later date: "In the first period of my painting ... my personal vision was Impressionist."[13] His contemporary writings also provide an idea of this vision. Writing about a landscape he had seen during the summer of 1885 in Normandy, he described it in Impressionistic terms: "Imagine a deep valley whose sides are closely covered with pines, a gray-green blanket from which emerge a few white rocks; down below a limpid stream winds between stones; in the distance a small blue lake surrounded by green woods."[14]

In the transitional year 1886, the Symbolist tendency of Denis's Impressionist works (*Terrace Walk at Saint Germain* and *Soldiers at Camp des Loges*[15]) was already evident. In the years that followed, he moved both intellectually and artistically toward the general idealism of the time. This was the great age of Symbolism; in both art and literature, attempts were being made to achieve a synthesis between image and thought. The concept of correspondences of ideas and emotions was common to music, poetry, drama, and the plastic arts.[16] In 1887 Denis visited the exhibition of Pierre Puvis de Chavannes and was deeply influenced by his work, as were all the future Symbolists, including Gauguin. In 1888, with his success in the Baccalauréat behind him, he entered the Académie Julian. There he met Paul Sérusier, Pierre Bonnard, Henri Gabriel Ibels,[17] Paul Ranson,[18] René Piot,[19] Jan Verkade,[20] and Armand Séguin, and became reacquainted with his friends from the Lycée Condorcet, Ker-Xavier Roussel and Edouard Vuillard. Thus began a decisive period in his life. Together with his companion and accomplice Lugné-Poë, he fraternized with poets and musicians and visited many of the avant-garde meeting

Maurice Denis, *Two Sisters Under a Lamp*, 1891, oil on canvas, 14⅜ × 24 in. Bernadette Denis Collection, France.

Maurice Denis, *Marthe in a Pensive Mood*, c. 1906, ▷
watercolor. Bernadette Denis Collection, France.

places. In July he was admitted to the studio of
Gustave Moreau, the celebrated proponent of Sym-
bolism.

At the end of the summer of 1888, at the Académie
Julian, Sérusier introduced Denis to Synthetism, a
new style of painting that had just been developed in
Pont-Aven. Sérusier, who was spending the summer
of 1888 in Pont-Aven, brought back to the Académie
Julian the fruit of his meeting with Gauguin: a small
landscape of Pont-Aven painted under Gauguin's
direction. This painting was named *The Talisman*[21]
because of its seeming prophetic qualities and
was described by Maurice Denis as a "misshapen
landscape built up in the Synthetist manner."[22]
This revolutionary work foreshadowed important
changes in the world of art: the artistic innovations

Maurice Denis,
◁ *Bernadette and Her Mother*, 1901,
pencil, chalk, and pastel.
Private collection, France.

Maurice Denis,
The Artist's Family, 1906, ▷
oil on canvas, 37 × 28⅝ in.
Oscar Ghez Collection, Musée du Petit-Palais, Geneva.

in this painting resulted in the creation of the Nabi group, headed by Sérusier and Denis, which carried the ideas of the Pont-Aven group to a new center, Paris. The exhibition the following year at the Café Volpini,[23] which included works by Gauguin, Bernard, Schuffenecker, and Laval, convinced many young artists of the importance of Synthetism.

To Maurice Denis this new idealism was by no means synonymous with a denial of the Impressionist approach. On the contrary, he kept and even developed his fascination with shade and color and the delicacy of touch characteristic of the Divisionist style. The canvases painted during the years 1890 through 1892 provide evidence of this dualism: for example, *The Catholic Mystery*, 1890;[24] *Trinity Eve*, 1891;[25] *The Orphans*, 1891;[26] *Easter Mystery*, 1891;[27] *Two Sisters Under a Lamp*, 1891[28] (illus., p. 215); *Princess Maleine's Minuet*, 1891;[29] *Portrait of Madame Ranson with Cat*, 1892;[30] *The Lerolle Ceiling*, 1892;[31] *Regatta at Perros*, 1892.[32] The first four paintings noted above are deeply idealist and bear testimony to Denis's preoccupation with mysticism at this time. The other paintings are more joyous and focus on lay subjects, which can be attributed to Denis's meeting with Marthe Meurier, his future wife.[33] Although this second group of paintings heralds the decorative symbolism of Art Nouveau, like those in the first group these canvases were painted in a Divisionist or Pointillist manner. This stylistic tendency focuses attention upon the relationship

between Maurice Denis and Paul Signac. At this time the two artists shared certain preoccupations. Both were interested in music and rhythmic harmony. They shared a love of Brittany and were often there at the same time during the years 1890-91 (Signac at Saint-Briac and Concarneau, Denis at Pont-Aven, Le Pouldu, and Perros).

Denis visited Pont-Aven during the summer of 1890, according to the Danish painter Jens Ferdinand Willumsen's account of his visit with Gauguin at Denis's studio.[34] Although Denis's diary does not discuss this visit, Willumsen's memoirs are detailed.[35]

On his return from Brittany after that summer, Denis formulated in *Art et critique* the famous lines: "Remember that before it is a war horse, a naked woman, or a commonplace anecdote, a painting is essentially a flat surface covered with colors assembled in a certain order."[36] Denis implies that subject matter is irrelevant. A painting should not be a mere copy of reality. Denis saw the object of artistic creation not as the portrayal of reality, but as the pictorial expression of ideas and feelings.

In 1891 Denis exhibited along with Signac, Maufra, and the Belgian artist van Rysselberghe in a show entitled *Peintres Impressionnistes et Symbolistes*,[37] at Le Barc de Boutteville in rue Le Pelletier. For Denis, this title could not have been more appropriate; his paintings were at the same time Impressionist in treatment and Symbolist in subject.

216

Claude Monet, *Apple Trees in Flower, near Vétheuil,* 1879, oil on canvas, 25⅝ × 36¼ in. Private collection, U.S.A.

During 1893, the year he married Marthe, Maurice Denis embarked upon a more stylized form of composition and design. His style began to evolve in Perros during the course of the summer. Neo-Impressionist technique was rejected in favor of large monochromatic areas of color. Several converging influences produced this result, including the work of Gauguin (particularly those paintings done in Tahiti) and Emile Bernard, Japanese prints, and his friendship with Samuel Bing,[38] for whom Denis designed wallpapers[39] and decorative schemes.[40] These changes are evident in several canvases painted in Perros in 1893, including the *Visitation to the Dovecote* and *Sea Effects,*[41] which show a radical technical departure from his earlier work. In November, Denis was struck by the exhibition at the Durand-Ruel gallery of forty-four canvases that Gauguin had brought back from his first visit to Tahiti. From that point onward, Gauguin regarded Denis as one of "the group." Gauguin wrote to Denis in 1895, after reading his article on Armand Séguin in *La Plume*: "I will soon disappear, but I have every reason to hope that the work I have begun will be completed.... You must all go on fighting."

Yet, Maurice Denis's work continued to alternate between the Symbolism of the Nabis and the realistic treatment of the Impressionists. *Girl with a Doll,* 1896;[42] *Maurice Denis's Parents,* 1899;[43] and *Tree in*

Maurice Denis, *Tree in Flower*, 1899, oil on panel, 10 × 13 in. Jean François Denis Collection, France.

These watercolors illustrate André Suarès's book
Le Crépuscule sur la mer (Paris, 1933):

 Maurice Denis, *Bretons on the Beach* (p. 217). △

 Maurice Denis, *Sailing Boats in Harbor* (p. 31). ▷

 Maurice Denis, *The Village Square* (p. 122). ▽

Flower, 1899 (illus., p. 219), indicate that the in-
fluence of the Impressionist school remained with
him. In the course of innumerable trips to Italy and to
Brittany, Maurice Denis continued his landscape
studies, assembling a collection of delightful water-
colors. He used those watercolors, painted on the

spot, to illustrate such books as *Carnet de voyage en Italie*[44] (1925) and *Le Crépuscule sur la mer*[45] (1933), which is about Brittany (illus., pp. 220-21).

Maurice Denis declared at the dawn of his seventieth year that he continued to feel "a subconscious Impressionism struggling with the decorative imagination."[46] These words of an old man show that the vision of the adolescent, spontaneously turning out his delightful Impressionist sketches at Perros-Guirec, had proved resistant to a single systemized technique or a codified style. His vision had remained that of the Impressionist painter.

Maurice Denis, *Granville,* August 30, 1887, pen-and-ink drawing. Dominique M. Denis Collection, France.

Maurice Denis, *Granville Sands,* August 26, 1887, pen-and-ink drawing. Bernadette Denis Collection, France.

NOTES

[1] Maurice Denis himself was to live all his life in Saint-Germain-en-Laye, and the scenes in many of his paintings are situated there. In 1914 he bought Le Prieuré, a large seventeenth-century house. The department of Yvelines bought the house in 1976 and turned it into a museum devoted to Maurice Denis and the Nabis. The museum was opened to the public in 1980.

[2] Information provided by the Denis family.

[3] Maurice Denis, *Journal* (Paris: Vieux-Colombier, 1957), 3 vols.

[4] Ibid., vol. 1, p. 44.

[5] In 1908, in a part of Perros-Guirec known as Trestrignel, he bought the villa Silencio, overlooking the beach and the Pointe du Château. He wrote: "What strikes me is the suitability of the house to a life dictated by children and painting. There is a beach and a studio. And then there are the woods, the solitude and the most spectacular sunsets." Ibid., vol. 2, p. 94.

[6] Ibid., vol. 1, p. 22.

[7] "Papa went to see Zani and arranged for me to start anytime I want at fifteen francs a month." Ibid., vol. 1, p. 13.

[8] "I return, believing more and more strongly in your artistic dogma, Master of all candor, Sacred initiator, Oh Angelic brother. I believe that art should sanctify nature; I believe that vision without intellect is vain." Ibid., January 1889, vol. 1, p. 73.

[9] Aurélian Marie Lugné-Poë was an actor, journalist, writer. In establishing the Théâtre de l'Oeuvre in 1893, he introduced French audiences to masterpieces of Scandinavian drama by Ibsen, Strindberg, Bjoernson.

[10] Julio Balla, an excellent draftsman, was born in Rio de Janeiro. He went to Paris, where he studied with Signol and Cabanel and participated in the international "Blanc et noir" exhibition in 1886.

[11] Dominique M. Denis Collection, Saint-Germain-en-Laye.

[12] César de Hauke, *Georges Seurat, catalogue raisonné* (Paris: Gründ, 1961).

[13] Denis, *Journal*, vol. 3, p. 214.

[14] Ibid., vol. 1, p. 51.

[15] Dominique M. Denis Collection, Saint-Germain-en-Laye.

[16] Arthur Rimbaud's "Sonnet des Voyelles." "A black, E white, I red, U green, O blue, vowels. Someday I will explain your latent births."

[17] Henri Gabriel Ibels (1867-1936) was a painter, pastelist, lithographer, cartoonist, writer, and a great friend of Toulouse-Lautrec. Much of his work portrays the circus: clowns, wrestlers, etc. His drawings illustrated the magazine *Le Sifflet* during the Dreyfus scandal.

[18] Paul Ranson, born in Limoges in 1864, died in Paris in 1909. He was the son of Deputy Gabriel Ranson and a great friend of Georges Lacombe. Very early he married France, who was named "the light in the temple" by the Nabis and supervised the famous Académie Ranson after her husband's death.

[19] René Piot (1869–1934) worked with Gustave Moreau, through whom he got to know Braque and Matisse. He created many designs for stage sets and costumes for Le Théâtre and wrote *Les Palettes de Delacroix*.

[20] Jan Verkade (1868–1946) was especially close to Sérusier and Denis. He visited Pont-Aven, Le Pouldu, and particularly Saint-Nolf in Morbihan, which he discovered with his friend the Danish painter Mögens Ballin in 1892. He published his memoirs in 1926 under the title *Le Tourment de Dieu*.

[21] Musée d'Orsay, Paris.

[22] Maurice Denis, *Théories* (Paris: Bibliothèque de l'Occident, 1912), p. 161.

[23] See Schuffenecker chapter.

[24] Jean-François Denis Collection, Musée de l'Orangerie, Paris, catalog, 1970, no. 10.

[25] Madame Dejean Collection, ibid., no. 27.

[26] Jean Baptiste Denis Collection, ibid., no. 24.

[27] Jean Baptiste Denis Collection, ibid., no. 26.

[28] Dominique M. Denis Collection, ibid., no. 22, reproduced.

[29] Dominique M. Denis Collection, ibid., no. 19, reproduced.

[30] Formerly Denis Family Collection, ibid., no. 42, Musée du Prieuré, Saint-Germain-en-Laye.

[31] Formerly Denis Family Collection, Musée du Prieuré, Saint-Germain-en-Laye.

[32] Formerly R. Ducroquet Collection, Paris; reproduced in *L'Oeil*, nos. 288-89, p. 41.

[33] She became his favorite model and appeared in numerous paintings until her death in 1919.

[34] On the visit of Gauguin and Willumsen to Denis, who was not at home, see John Rewald, *Post-Impressionism: From van Gogh to Gauguin* (New York: The Museum of Modern Art, 3rd ed., 1978), p. 280.

[35] On the presence of Willumsen and his new wife during their honeymoon at Pont-Aven in the summer of 1890, see Maxime Maufra, "Souvenirs de Pont-Aven et du Pouldu: Comment je connus Paul Gauguin," *Bulletin des Amis du Musée de Rennes, numéro spécial: Pont-Aven*, no. 2 (Summer 1978), p. 21.

[36] Maurice Denis, *Définition du Néo-Traditionnisme*, published under the pseudonym Pierre Louis (Paris: *Art et Critique*, 1890).

[37] See Maufra chapter.

[38] Samuel Bing, also known as "1900 Bing," "Modern Style Bing," and "Art Nouveau Bing," was a dealer whose personality, role, and influence on the art of the time have yet to be fully explored. He introduced Japanese art to France and popularized it through exhibitions and books.

[39] See *Catalogue raisonné de l'œuvre gravé et lithographié de Maurice Denis* (Geneva: Pierre Cailler, 1968), nos. 71-74.

[40] "Again for Bing, Maurice Denis designed a bedroom suite. Its extreme simplicity struck the Parisians of 1900 as more appropriate for the aesthetic doctrine of the Cistercian monks than that of the middle class of the Belle Epoque." Agnès Humbert, *Les Nabis et leur époque* (Geneva: Pierre Cailler, 1954), p. 122.

[41] Formerly Dudensing Collection, New York.

[42] Musée de Brême Collection, exhibited in 1970 at the Musée de l'Orangerie, cat. no. 101.

[43] J.-F. Denis Collection, exhibited in 1978 at the Musée de Pont-Aven, cat. no. 1.

[44] *Carnet de voyage en Italie*, 34 colored woodcuts by Jacques Beltrand. Text and illustrations by Maurice Denis (Paris: Jacques Beltrand, 1925).

[45] André Suarès, *Le Crépuscule sur la mer*, 26 color illustrations by Maurice Denis (Paris: Beltrand, 1933).

[46] Denis, *Journal*, January 1, 1940, vol. 2, p. 214.

GEORGES LACOMBE

1868–1916

ALTHOUGH Georges Lacombe painted in Brittany, he belonged to the Nabi group,[1] which developed the ideas of the Pont-Aven school in Paris beginning in 1888. Through Paul Sérusier, who became his teacher and friend in 1890, Lacombe became one of the first artists to hear about the Synthetist work being done at Pont-Aven and Le Pouldu.[2] Moreover, it was Brittany, particularly Camaret[3] and Huelgoat,[4] that provided him with his main sources of inspiration between 1888 and 1897. His Breton work, done in the same style and at the same time as the first Synthetist works of the Pont-Aven school, depicted similar subjects.

The development of Georges Lacombe mirrors that of many of the artists discussed in this book, including Loiseau, Moret, and du Puigaudeau. Often trained in the academic tradition and then working for varying lengths of time in the Synthetist manner, these artists eventually turned to the Impressionist style and remained with it to the end of their careers.[5]

The life of Georges Lacombe might well have been the basis for that of a character in a late nineteenth-century novel, midway between Zola and Proust.

Born at Versailles in 1868, Lacombe was raised in a manner appropriate to the son and heir of a wealthy family. As Agnès Humbert has explained, "Lacombe passed the *fin de siècle* in a well-off and cultured middle-class home, where, according to a contem-

Georges Lacombe,
The Red Beech Tree, 1908,
oil on canvas, 39 × 31½ in.
Private collection, Paris.

Portrait of Georges Lacombe in Breton hat.
Photograph taken at Camaret, Finistère, c. 1890.

porary phrase 'they threw money out the windows.'"[6] Although educated by the Jesuits, like the sons of the nobility and the upper classes, he nevertheless adopted the anticlerical attitude of the time,[7] a view that was to remain with him throughout his life. Curiously enough, these opinions did not prevent his friendship with ardent Catholic believers such as Denis, Verkade, and Ballin.

Handsome, rich, cultured, intelligent, Lacombe had a complex personality characterized by two diametrically opposed sets of traits inherited from parents who could not have been more unalike. These two opposing influences were to determine Lacombe's destiny.[8] The paternal influence was the basis of his revolutionary, anticlerical, anarchistic,

and antiauthoritarian tendencies. These attitudes were rooted in the proletarian background of his father, a son of the revolution who, by his own efforts, had fought his way to a social position and level of culture incommensurate with his origins.[9] His father's practical training accounted for Lacombe's extraordinary craftsmanship and manual dexterity, for as the son of a former cabinetmaker, he had access to all the necessary tips of the trade. This influence also explains Lacombe's impact as a sculptor who created such bold and powerful sculptures as *The Bed*, now in the Musée d'Orsay.[10] In many ways, his father influenced his entire production as a Nabi, a term that at the time was synonymous with the avant-garde and revolution.

Georges Lacombe,
Portrait of Sylvie, c. 1900,
pencil drawing.
Private collection, Paris.

Georges Lacombe,
Sylvie Lacombe, 1901,
pen-and-ink drawing.
Private collection, Paris.

Georges Lacombe,
The Little Bridge over the Briante, at the Hermitage, 1910, ▷
oil on wood, 21⅜ × 19⅝ in.
Private collection, Paris.

Georges Lacombe, *Fishermen*, oil on canvas, 50¾ × 98⅜ in. Private collection, France.

His young mother, much closer to him in years, showed him great tenderness throughout her life. Far from denigrating his artistic talents, she gave him his first lessons and encouraged him to continue painting.[11] Through his mother, Lacombe developed a more delicate and refined vision of the world, which facilitated his later adoption of Divisionist and Pointillist techniques. This part of his background explained Lacombe's characterization as a "perfect gentleman," with just a touch of the dandy about him. Lacombe retained his mother's affectation, ele-

gance, and sophistication, the traits of a favored but dying social class at the dawn of this privileged pre-war period.

In 1886, the eighteen-year-old adolescent (even more spoiled after his parents lost another of their sons[12] in 1880) had already been given his own studio at the bottom of the garden. This studio was to become famous among the Nabi community as the "Ergastère."[13] After painting lessons with the Versailles artist Georges Bertrand and later with the academic painter Alfred Roll,[14] in 1890 Lacombe

Fishermen (detail), Blache Archives, Versailles.

entered the Académie Julian. There he met Paul Sérusier, the *massier* (student in charge of the studio), who was to have great influence on him and the other artists who were to become his friends in the Nabi group: Denis, Ranson, Roussel, Bonnard, Vuillard, Ibels, Piot. From this point on, Lacombe's studio, its walls decorated with frescoes by Sérusier[15] and its bed carved by Lacombe himself, became a meeting place and center for discussions, scarcely less important than Ranson's studio, which the Nabis referred to as "Le Temple."[16]

Agnès Humbert, in her book on the Nabis, describes the young artist: "Tall and handsome, with tousled chestnut hair, tender hazel eyes, and a fashionable neatly clipped beard. He had his own individual style of dress. He always wore a velvet jacket of blue, gray, brown, rust, or purple. His ties were chosen by his mother. They were loosely knotted and of a soft 'Liberty' satin, a new fashion and a daring one at this time of ugly masculine clothes. In the country, Georges Lacombe wore shirts of scarlet silk, trousers of blue or white linen. Like Gauguin, he

liked wearing clogs, but his were made specially for him by a clog-maker in Caen."[17] This attractive young man regularly visited one of the most beautiful women in Versailles, Gabrielle Vinger. Her mother had been a lady-in-waiting to the Empress Eugénie. She inherited a fortune from her engineer husband, the inventor of the Westinghouse-Vinger brake used on railroad cars. Widowed in 1893 at the age of thirty-five, the beautiful Gabrielle kept an open house, and Georges Lacombe became her most regular guest at dinners and parties at her residence in the rue Albert-Joly.[18] There, he took his Nabi friends: "They were amazed by the parties they went to and often talked of the fine dinners served on a table decorated with orchids."[19]

For seven years this Proustian life continued in Versailles. Summers were spent in Brittany, at Camaret, a spot that Lacombe discovered with his family in 1888. Each summer he returned there to his boat and his artist friends. Painters, writers, actors, and poets had made Camaret a center for philosophy and the arts that rivaled Pont-Aven in the last decade of the nineteenth century.[20] These summer visits continued until 1897, when Georges Lacombe married Gabrielle's eighteen-year-old daughter, Mar-

the. This marriage brought an end to Lacombe's Parisian life-style and his Nabi period.

In the year of their marriage, the young couple bought a magnificent estate (Marthe had a dowry of three hundred thousand gold francs and Lacombe an income of ten thousand francs a year). This property was L'Hermitage (illus., p. 227), on the edge of the Forest of Ecouves in Normandy, eight kilometers from Alençon, where the couple's two daughters, Sylvie and Nigèle, were brought up. Although he continued sculpting during this time, Lacombe interrupted his painting until 1903. His new, family-oriented way of life, the remoteness from Paris, the different atmosphere of life in the country, the slower, and doubtless calmer, rhythm of life, as well as a new friendship with the Belgian artist Théo van Rysselberghe, under whose influence he took up painting again,[21] all led to a dramatic revision of his subjects and outlook. When he began painting again in 1903, he no longer produced decorative, Synthetist compositions but landscapes and portraits that were Impressionist, verging on the Divisionist and Pointillist styles (illus., p. 224).

His work during this Neo-Impressionist period can be compared to that of his friend van Ryssel-

Georges Lacombe,
Portrait of Lacombe's Daughter Sylvie,
February 27, 1899,
graphite drawing.
Private collection, New York.

Georges Lacombe, *Portrait of Sylvie and Nigèle, the Artist's Daughters*, 1904-05, oil on canvas, 20⅞ × 28¾ in.
Private collection, Paris.

berghe. This comparison holds both for his portraits, including the one of his two little daughters, Sylvie and Nigèle, painted in 1904–05[22] (illus. p. 231), and his landscapes. What differentiates them, however, is the essential characteristic of Lacombe's paintings, his vibrant color (which previews that of the Fauves). In this respect, his work can be compared to that of Louis Valtat, and the heightened coloring of his canvases is not unlike the most brilliant of Henri Edmond Cross's paintings of the southern coast of France.[23]

Taking as his theme and subject matter the subtle variations of atmosphere and the play of light on vegetation, he painted the surroundings of L'Her-

mitage, the undergrowth of the Forest of Ecouves, streams, rocks, meadows in flower, and the changing reflections in the waters of the stream that ran through the property. A wealth of light, color, and gaiety filled his canvases. Sensitive representations of woodland, autumn foliage, and spring flowers (illus., p. 232) demonstrate new-found peace and an attitude of serenity and contentment. One of the best examples of this period is the exceptional, unusually large canvas, conceived near Pont-Aven on the banks of the Belon (illus., pp. 228–29). This majestic, brilliant work adds one more link to the chain uniting Georges Lacombe with Brittany and the Pont-Aven group.

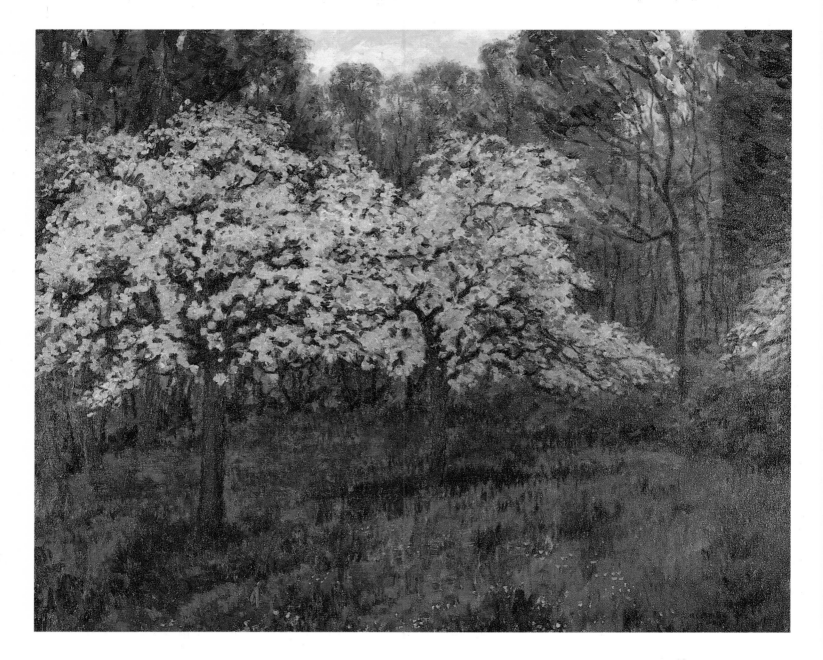

Georges Lacombe, *Cherry Trees in Flower,* oil on canvas, 25⅝ × 31⅞ in.
Formerly Mrs. Sylvie Mora-Lacombe Collection, Paris.

Two of Lacombe's finest compositions from the period between 1904 and 1910, *Oaks and Myrtles, Forest of Alençon* and *River and Woodland in Autumn,* are now in the important group of Neo-Impressionist paintings that constitutes the Holliday Collection in the Indianapolis Museum of Art.[24] Six others were exhibited for the first time at the Pont-Aven museum in 1978.[25] Lacombe's Neo-Impressionist work has remained relatively unknown primarily because this aristocratic artist disliked the idea of selling his creative work or living off his art.[26] He preferred giving them to his friends, often mak-

ing a gift of them to anyone who liked his work. He exhibited regularly at the Salon des Indépendants[27] from 1895 onward and the Salon d'Automne until World War I.

Georges Lacombe's Impressionist paintings are characterized by their elegance, harmony, delicacy, and richness of color. Unlike many of his contemporaries who were trained in the academic tradition and later turned to Impressionism without ever again altering their styles, Lacombe exhibited a flexible and adventurous artistic spirit and an exceptional capacity for self-renewal throughout his career.

NOTES

[1] The Nabis, or "Nebiim," a Hebrew word meaning "prophet." This term, chosen by Sérusier (who had studied the Hebrew language), refers to the privileged few who were allowed to share with him the ideas Gauguin had passed on while directing Sérusier's *The Talisman* at Pont-Aven at the end of the summer of 1888. The use of the Hebrew term and the fashion for Eastern art were reinforced by the introduction of Auguste Cazalis into the group. Nicknamed "the nabi ben Calyre," Cazalis was a specialist in Semitic languages.

[2] At the time of their meeting in 1890, Sérusier had just returned from a lengthy visit in Pont-Aven and Le Pouldu, where he had stayed at Marie Poupée's inn with Gauguin, de Haan, and Filiger.

[3] It was here that he painted, about 1892, his famous decorative and Japanese-style compositions:

Blue Seascape, Musée de Rennes, acquired in 1965.
Yellow Sea, Musée de Brest, acquired in 1965.
Vorrhor, Gray Wave, Musée de Brest, acquired in 1969.
The Green Wave, Indianapolis Museum of Art, acquired in 1985.

His earlier works executed at Camaret in 1888-89 were more academic in style; his landscapes of this period are not unlike the watercolors of Henri Rivière, another artist who spent several summers in Camaret.

[4] Sérusier moved to Huelgoat in 1891, before making his permanent home at Châteauneuf-du-Faou from 1893 until 1927. Marcel Guicheteau, *Paul Sérusier, catalogue raisonné* (Paris: Editions Side, 1976).

[5] "They were to succumb only briefly to the fascination of Synthetism. The Breton adventure did not prevent them from returning to the Impressionist formula." Wladislawa Jaworska, preface to the exhibition catalog *Le Mouvement impressionniste dans l'école de Pont-Aven*, Musée de Pont-Aven, 1978.

[6] Agnès Humbert, *Les Nabis et leur époque* (Geneva: Pierre Cailler, 1954), pp. 64ff.

[7] Ideas shared with his friend Maurice Hepp.

[8] "One can see, throughout the life of Georges Lacombe, flagrant contradictions caused by the two currents struggling within him: the patrician current carefully maintained by the mother and the popular verve which came from the plebeian origins of his father." Humbert, *Les Nabis*, p. 70.

[9] Jean Baptiste Lacombe published in 1888 at Versailles a collection of his own writings entitled *Chansons*: a pamphlet of satirical and humorous verse in the tradition of General Boulanger.

[10] This bed, one of the major works of French early modernist sculpture, was not acquired by a French museum until 1956. Intended for Lacombe's studio, it was made about 1894. It consists of four audacious compositions, which now appear far ahead of their time. For further information see Joëlle Ansieau, "Georges Lacombe," *Bulletin des Amis du Musée de Rennes*, numéro spécial: Pont-Aven, no. 2 (Summer 1978), pp. 84ff. Reproduced.

[11] Laure Lacombe (1834–1923) claimed to have given Douanier Rousseau his first paintings lessons. Humbert, *Les Nabis*, p. 67.

[12] Louis Lacombe.

[13] "At the age of eighteen, his mother wanted him to feel independent. She had built, at the bottom of the garden of her house at 32 avenue de Villeneuve-l'Etang, an impressive studio with a bedroom and bathroom. It was this place that the Nabis referred to as the "Ergastère." Humbert, *Les Nabis*, pp. 73–74.

[14] Alfred Roll (1846–1919). Academic painter, much honored (named commander of the Légion d'Honneur in 1900), who had just been barred from competing at the Salon in 1889. For more on this artist, nicknamed "the municipal painter" by Eugène Carrière, see Jean Paul Crespelle, *Les Maîtres de la Belle-Epoque* (Paris: Hachette, 1966).

[15] Letter from Sérusier to Verkade, 1893: "I have just finished a monumental decoration: seven life-size figures in an *ergastère* at Versailles. I am pleased with it; the *Nebiim* are coming to see it tomorrow."

[16] In 1889, Gabriel Ranson and his children [the painter Paul and his wife, France] moved to 25 boulevard Montparnasse. The apartment was on the first floor. They rented a studio on the fourth floor, which was to become "The Temple." Humbert, *Les Nabis*, p. 85.

[17] Ibid., p. 70.

[18] Other visitors included the famous painter Jules Bastien-Lepage and his Russian pupil, the young Marie Bashkirtseff, who died within a few days of each other when they were both very young; Bodigar Karageorgevitch, a Serbian prince turned goldsmith; the poet André Theuriet; the musicians of the Capet Quartet: Pierre Monteux, Schneklünd, and Geloso, etc. —in fact, the whole of Parisian society of Marcel Proust's era.

[19] Humbert, *Les Nabis*, p. 72.

[20] On Camaret and its artistic community, see Georges Toudouze, *La Communauté artistique de Camaret* (Brest: Les Cahiers de l'Iroise, 1955).

[21] Théo van Rysselberghe, born in Ghent in 1862, died at Saint-Clair (Var) in 1926. One of the earliest disciples of Seurat, he was a member of the Salon de la Libre Esthétique and Les Vingt of Brussels. His Divisionist style and choice of subject matter are reminiscent of Maurice Denis and Henri Edmond Cross.

[22] Mora Lacombe Collection.

[23] Henri Edmond Cross (1856-1910). Another Divisionist painter living at Saint-Clair (an isolated hamlet between the sea and the lower slopes of the Alps). His compositions are characterized by extremely bright colors and visual dynamism.

[24] William Steadman, *Homage to Seurat: The Holliday Collection at the University of Arizona* (Tucson: University of Arizona Art Gallery, 1968), cat. nos. 26 and 27.

[25] *Portrait of Sylvie and Nigèle, the Artist's Daughters*, 1904-05.
Vine-covered Rocks (Ecouves forest), 1908.
Beach in the Forest, 1908.
The Pond and the Bridge at the Hermitage (at Saint-Nicolas-des-Bois), 1910.
The Little Bridge over the Briante, at the Hermitage, 1910.
Woodland.

[26] This unwillingness to sell his paintings came from his mother, who repeated throughout her life: "One does not sell a work of art." "For Laure Lacombe art is a religion, a secret religion even, for she shows her drawings only to a few close friends. For her, art has some kind of mystical quality and is not for common people... Art produced to please an elite must not be besmirched, commercialized. This aristocratic outlook was to guide G. Lacombe's entire life." Humbert, *Les Nabis*, p. 67.

[27] "When one has not seen the blue seas, the vermillion pines, the red buckwheat cutters against the yellow and green sky of Mr. Lacombe, when one has not seen his *Isis* and his *Sower* in carved wood with a hand as big as the rest of the body; if one has not seen the indescribable exhibition of Mr. Henri Rousseau, who certainly can't have used his hands to paint them, etc. ... one has seen nothing." Extract from a review of the 1895 Salon des Indépendants in *Le Gaulois*.

234

HENRI DELAVALLÉE

1862–1943

HENRI DELAVALLÉE'S paintings of Brittany encompass the wide range of styles prevalent at the end of the nineteenth century. Although his later canvases are traditional and realistic, his early stays at Pont-Aven produced pioneering works of an amazingly innovative nature. An artist of great intellectual curiosity, Delavallée continued to modify his style and aesthetic creed throughout his life, often working in several modes simultaneously.

Born in Reims in 1862, he was a brilliant student who passed high school examinations in both the arts and the sciences and won the national first prize in the Concours Général de Philosophie. At seventeen, he enrolled simultaneously in the Sorbonne, "where he obtained an honor degree in the shortest possible time,"[1] and in the Ecole Nationale des Beaux-Arts. Taught by such academics as Henri Lehmann,[2] Luc Olivier Merson,[3] Ernest Hébert,[4] and Carolus Duran,[5] he was able to learn from them the art of drawing and to develop this skill. In 1881, one of his friends at art school, the painter Hersart du Buron, who was a cousin of the Breton writer Hersart de la Villemarqué (author of *Barzaz-Breiz*[6]), took him for a holiday to Brittany. During his stay at

Henri Delavallée,
◁ *Sunny Street*, 1887
(landscape at Port-Manech, near Pont-Aven),
oil on canvas, 18⅛ × 22¾ in.
Mr. and Mrs. Holliday Collection,
Indianapolis Museum of Art.

Henri Delavallée,
△ *Breton Walking with a Stick,*
near Pont-Aven, c. 1890,
lithograph in three colors.
Private collection, Quimper.

Henri Delavallée, *Cottage near Pont-Aven*, 1890, pastel. Private collection, Quimper.

the Château du Plessis,[7] overlooking the village, Delavallée discovered Pont-Aven.

He was immediately drawn to the scenery and decided that this area and the people who inhabited it would make ideal subjects for painting. Delavallée returned to Pont-Aven in subsequent summers, meeting Emile Bernard and Gauguin there in 1886, and Bernard again in 1887 while Gauguin was in the Antilles. Aided by his knowledge of drawing, between 1886 and 1888 he executed an impressive series of pastels[8] that display a remarkable and original sense of color that was, in part, to become

the basis of the new theory of suggestive color. The ideas for these pastels may have been garnered from Emile Bernard, who was later referred to as the "initiator" of Synthetism in art.[9] These works of schematized form, simplified undetailed outlines, sinuous lines, and subtle coloring, in which warm tones contrast with cold colors in monochromatic blocks, make Delavallée one of the pioneers of the Pont-Aven style. During this period, his delicate harmonies in green and pink and in blue and violet are the prototypes "of the bold colors of the best masters of the Pont-Aven school."[10] The colors in

Henri Delavallée, *Farm Courtyard near Pont-Aven*, c. 1890, lithograph. Mrs. Dudensing Collection, New York.

these pastels are also seen in the later works of Maufra, Jourdan, Moret, and Gauguin. These pastels, "serene and silent works, admirably constructed,"[11] are also examples of Symbolist art, whose graphic qualities, spirit, and composition show an amazing similarity to the later work of Charles Marie Dulac[12] and Emile René Ménard.[13]

After his experiments in the Synthetist style, Delavallée turned toward the discoveries of the founders of optical painting: "His intelligence and lucidity would not allow him to adopt any technique without discussing it or looking elsewhere. Under Gauguin's

banner in 1886, he was under that of Seurat by 1887."[14] As a friend of Mary Bracquemond, who took part in the eighth Impressionist exhibition, Delavallée met Pissarro and Seurat, with whom he worked at Marlotte from 1887, and later, Signac. His enthusiasm was immediately kindled by this new line of research. The canvases he painted between 1887 and 1890 are among the most beautiful by any of the early Divisionist painters. As William Steadman writes: "In reality he was one of the most vital forces among the Neo-Impressionists of the '90s ... and his transcription of the theories of Seurat produced some

of the most brilliant canvases of the Pointillist movement."[15] Steadman continues: "His style, at this stage of his development, was characterized by the force of his designs made up of delicate surfaces of color and tone and precision of construction."

One of the earliest canvases of this period is *Portrait of a Girl*, in the Marie Rouat Collection at Riec-sur-Belon.[16] Dated 1888, it combines "all the sober and intimate poetry of his master Millet" with his own personal color harmonies and the Pointillist technique. This canvas is comparable with one painted in the same style the following year by Gauguin at Le Pouldu, *Still Life with Fruit and a Pitcher*.[17] Signed satirically "Ripipoint," the name of the Pointillist artist invented by Bernard and Gauguin the previous year at Pont-Aven, and dedicated "To Marie" (Marie Poupée),[18] this work is a good illustration of the concern for Divisionism that Gauguin and his contemporaries had during this period. These two canvases, painted within a few months of each other in the Pointillist style, show that both artists were occupied with similar techniques. They also clarify the nature of Gauguin's remarks, usually of a technical nature, which Delavallée reported to Charles Chassé: "I remember that we were talking about Degas and Pissarro, whom Gauguin admired. He was much more preoccupied by technical questions than doctrinal ones. I paint, he explained, only with sable brushes, for with these color maintains its intensity. When you use ordinary brushes two adjoining colors mix together. With sable you get colors in juxtaposition."[19]

Among the outstanding works Delavallée painted during this period are *Landscape at Marlotte*, 1887, in the Musée de Brest;[20] *The Farmyard*, 1887, which was probably painted at Marlotte and is currently in the Samuel Josefowitz Collection in Lausanne;[21] *Sunny Street*, 1887, in the Holliday Collection in the Indianapolis Museum of Art[22] (illus., p. 234); *The Boot Polisher*, 1890, in the Rouat Collection at Riec-sur-Belon;[23] and *The Pink Lane*, 1887,[24] in a private collection in Quimper (illus., pp. 238-39).

Henri Delavallée,
The Pink Lane, 1887,
oil on canvas, 13 × 16⅛ in.
Private collection, Quimper.

In 1889, "still haunted by the memory of Jean François Millet,"[25] Delavallée visited Londemer, near Cap de la Hague, the birthplace of the painter he so admired. Here he met the engravers Pierre Vidal[26] and Louis Monzies,[27] who taught him the basics of engraving. His enthusiasm was such that engraving was to take precedence over all other techniques until his departure for Turkey, in 1893. This visit to Londemer marked the beginning of a new stage in his work, one for which he was not previously well known. Taking as models his earlier pastels, most of which were produced in Brittany near Pont-Aven and some of which were produced in Paris, on the Seine or at Gruchy in Normandy, from 1889 to 1893 he etched about one hundred plates. Several of these prints were exhibited at the Durand-Ruel gallery in 1890.

In the top left-hand corner of one of the finest of these etchings, *Breton Woman of Pont-Aven, Seated in a Landscape*[28] (illus., p. 240), there is a twisted tree, which recalls the tormented compositions of Vincent van Gogh, "the great absentee" of the Pont-Aven school, who had been introduced to Delavallée by his friends Bernard and Signac. Other etchings, including *The Farmyard, Cottage with Well, Woman Smoking a Pipe, Woman Carrying Firewood, Woman Looking After Pigs, Old Man by the Hearth, Cottages, Peasant Woman Carrying a Sack* (illus., p. 244), show the influence of Millet transferred to a rustic, Breton setting.

During this intense period of etching, Delavallée did not abandon painting completely. In two canvases now in the Musée de Brest, both of which date from 1892 — *Girl from Pont-Aven*[29] (illus., p. 242) and *The Delavallée Family Home at Apremont*[30] — Delavallée abandoned Divisionism in favor of a more traditional treatment.

In 1893, Delavallée left France for Turkey and established his home in Constantinople. He was accompanied by his wife, Gabrielle Moreau, herself a painter, whom Delavallée had met at the Ecole Nationale des Beaux-Arts in Paris. In 1893 he was visited by Emile Bernard,[31] who painted *The Bosphorus at Constantinople* before resuming his wanderings around the Mediterranean. In Turkey, Delavallée achieved a certain notoriety. He became the official portrait painter of the Grand Vizier and was granted the rare privilege of being allowed into the

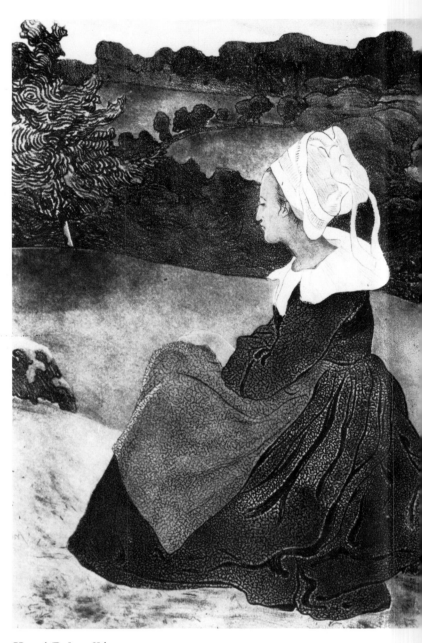

Henri Delavallée,
Breton Woman of Pont-Aven, Seated in a Landscape, c. 1890, Mrs. Dudensing Collection, New York.
(A preparatory charcoal drawing dated 1890 belongs to the Fuller Collection, Nice.)

harem to paint the ladies of the court. Delavallée introduced the cinema in Turkey. He was able to do this as a result of his connection with the Lumière brothers, whom he had met in Paris. He became interested in their work through his own research on the nature of light. During the ten years that he spent in Turkey, Delavallée became a principal figure in the cosmopolitan, international society of Constantinople. While in Turkey he also continued painting and engraving. During this period, he painted *Views*

of the Bosphorus, Turkish Market Scene, Moslem Cemeteries and Their Gravestones, Veiled Women, Women Carrying Water, Fellahs at Work, Hashish Smokers, Hills of Anatolia, and works depicting the beautiful forms of Moorish architecture, bathed in the incomparable enveloping light of the Orient. When he finally left Turkey, he was much missed. The English consul Swin, whom Delavallée had met in Turkey and who had always been fond of Oriental painters, did much to spread Delavallée's fame in Britain upon his return to England. Finally, returning to Paris in November 1902, the Delavallées moved into an apartment in the rue d'Alésia. During this time the artist became the beneficiary of an inheritance from his parents, who were industrial-

Henri Delavallée,
Old Angélique with Her Cat (Pont-Aven), c. 1890, etching.
Mrs. Dudensing Collection, New York.

Henri Delavallée,
Peasant Woman by a Gate, 1889, etching.
Mrs. Dudensing Collection, New York.

ists from Reims. About 1910 he moved permanently to Pont-Aven, where he divided his time between sailing (he kept a yacht anchored in the Aven) and painting.

His style, however, continued to diverge from his early Pointillism. His works became much more traditional, similar in spirit to the painters of the Barbizon school,[32] but with a more colorful palette, in which he remained faithful to Impressionism. Thus, Delavallée reemerged as the classical painter

Henri Delavallée, *Girl from Pont-Aven*, 1892, oil on canvas, 18 ⅛ × 15 in. Musée des Beaux-Arts, Brest.

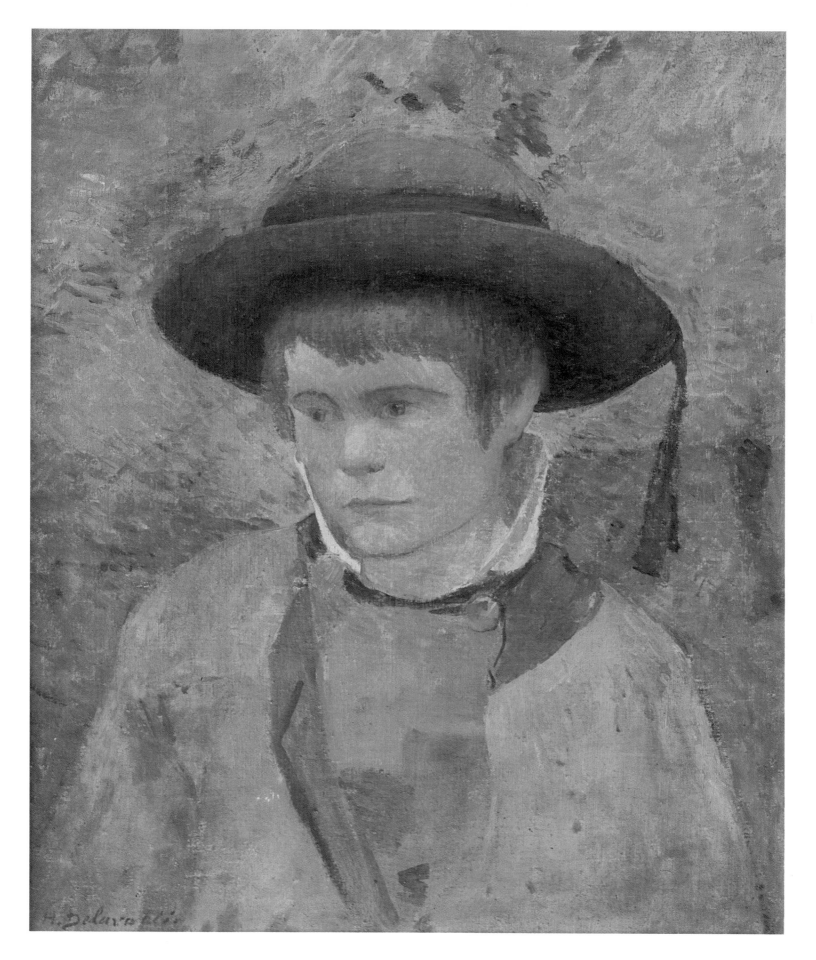

Henri Delavallée, *Breton Boy from Pont-Aven,* oil on canvas, 18⅛ × 15 in. Private collection, Châteaulin.

Henri Delavallée, *Peasant Woman Carrying a Sack,* c. 1889, etching. Mrs. Dudensing Collection, New York.

he had always been beneath the Synthetist character of his pastels and the Neo-Impressionism of his earlier oils. Yet he continued throughout his life to assimilate contrasting and occasionally contradictory theories of aesthetics, leaving behind at his death in Pont-Aven, in 1943, a lifetime of work in an amazing variety of styles.

In the post–World War II years, especially since the 1960s, there has been increasing interest in Delavallée among collectors of Pointillist works. As a result, Delavallée's paintings have become widely dispersed. Several museums, such as the Musée d'Art Moderne in Paris and the Vatican Museum in Rome, have acquired works from this period. In 1975 an important exhibition of Delavallée's work was held at the Pont-Aven museum, which included thirty oils, seventeen pastels, thirty-two etchings, and one lithograph. Since then, there has been an increasing interest in Delavallée prints,[33] and fine examples of his work have been exhibited at several museums in the United States in 1986 and 1987, including the Museum of Modern Art, New York, in a major traveling exhibition devoted exclusively to the prints of the Pont-Aven school.[34]

NOTES

[1] Jean Sutter, *Les Néo-impressionnistes* (Paris: Bibliothèque des Arts, 1970), pp. 171–74, 190–200.

[2] Henri Lehmann, born in Kiel in 1814, died in Paris in 1882, a naturalized French citizen. He was a pupil of Ingres, a member of the Institute in 1864, and a teacher at the Ecole Nationale des Beaux-Arts in 1875. He was also one of the artists responsible for the decoration of the Hôtel de Ville in Paris. An inveterate classical painter, he established a prize intended to encourage the academic tradition. In addition to portraits, at which he excelled, he painted numerous works inspired by mythology, the Bible, and history.

[3] Luc Olivier Merson (1846–1920). Winning the Grand Prix de Rome in 1869, he became famous for his neo-medieval works of post-Romantic inspiration. He was one of the most ardent defenders of classicism and the academic tradition. His most original work was in book illustrations; those for Victor Hugo's *Notre Dame de Paris* show a powerful imagination that makes him a precursor of Symbolism.

[4] Ernest Hébert (1817–1908). He was a pupil of both David d'Angers and Paul Delaroche, which helps explain his rigorous classicism. In 1839, he was awarded the Premier Grand Prix de Rome. He took his inspiration from evangelical and biblical scenes, which he transposed into an Italian atmosphere. Hébert was one of the most brilliant representatives of Neo-Classicism in the Romantic tradition.

[5] Carolus Duran: see note 6 in Schuffenecker chapter.

[6] *Le Barzaz-Breiz*, a famous collection of Breton poems and legends published in 1830, which was to influence not only Breton but French Romantic literature in general.

[7] This manor house, which still exists, is next to the chapel of Trémalo. Overlooking Pont-Aven, this chapel inspired Gauguin's *Yellow Christ*.

[8] Numerous pastels of this period are in private collections in Brittany. Five of them were exhibited in 1978 at the museums in Quimper, Rennes, and Nantes, nos. 26, 27, 28, 29, and 30 in the catalog. Another is in the Musée de Brest, inventory no. 66–1–1.

[9] It was Félix Fénéon, the famous art critic, who coined this epithet for Emile Bernard.

[10] *L'Ecole de Pont-Aven à travers les collections publiques et privées de Bretagne* (Quimper, Rennes, and Nantes museums, 1978).

[11] Ibid.

[12] Charles Marie Dulac (1865–1898). This great lithographer finished his collection *Le Cantique de créatures* in 1894 and followed it with *Suite de paysages*. His Symbolist landscapes caused Maurice Denis to say: "For the landscapist Dulac, nature is the book which contains the word of God." His pastels show great sensitivity. One is in the Musée de Brest, inventory no. 72–15–1.

[13] Emile René Ménard (1862–1930), classical painter in the pantheistic vein. He often spent his summers in Brittany, where he was joined by his friends Lucien Simon and André Dauchez. His style is a mixture of Neo-Classicism and Symbolism, comparable to that of Ker-Xavier Roussel.

[14] Sutter, *Les Néo-impressionnistes*, p. 172.

[15] William Steadman, *Homage to Seurat: The Holliday Collection at the University of Arizona* (Tucson: University of Arizona Art Gallery, 1968).

[16] *L'Ecole de Pont-Aven*, cat. no. 23.

[17] Georges Wildenstein and Raymond Cogniat, *Paul Gauguin, catalogue raisonné* (Paris: Beaux-Arts, 1964), no. 376.

[18] Marie Henry, nicknamed Marie Poupée, was the innkeeper for Gauguin and his friends at Le Pouldu from 1889 until 1893.

[19] Charles Chassé, *Gauguin et le groupe de Pont-Aven* (Paris: H. Floury, 1921), p. 19.

[20] Musée de Brest, inventory no. 41–2–2.

[21] Sutter, *Les Néo-impressionnistes*, p. 173, reproduced in color.

[22] Steadman, *Hommage to Seurat*, cat. no. 10.

[23] *L'Ecole de Pont-Aven*, cat. no. 24.

[24] Ibid., cat. no. 25.

[25] Sutter, *Les Néo-impressionnistes*. Jean François Millet (1814–1875) was born at Gruchy, near Gréville and Cherbourg. Delavallée, in homage to this artist whom he so admired, did pastel drawings of this area, which were later etched: *Entrance to the Hamlet of Gruchy*, 1888–89; *Well at Gruchy*, 1891; and others.

[26] Marie-Louis Pierre Vidal (born at Tours in 1864), engraver, draftsman, and illustrator. He worked in the Cabinet des Estampes beginning in 1876. The works he illustrated include Alphonse Daudet's *La Comtesse Irma*, Emile Goudeau's *Parisienne idylle*, Pierre Loüys's *Les Aventures du roi Pausole*, Louis Louiot's *Alice Ozy*, Guy de Maupassant's *En famille*, *Yvette*, and Henri Meilhac's *Contes parisiens du Second Empire*.

[27] Louis Monzies (born at Montauban in 1849) studied with Pils at the same time as Vidal, making his debut at the Salon in 1876. The Musée du Mans contains some of his works produced during visits to Normandy.

[28] Sutter, *Les Néo-impressionnistes*, reproduced on p. 172. The original copper plate belongs to the Monjour Collection in Pont-Aven.

[29] Musée de Brest, inventory no. 41–2–1, reproduced in 1978 exhibition catalog, p. 57.

[30] Musée de Brest, inventory no. 68–2–1.

[31] Bernard left Genoa by boat and landed in Constantinople on June 5, 1893. Like Delavallée, he painted the city's famous Janissaries' Cemetery (formerly Comte Antoine de La Rochefoucauld Collection). For further information see Jean Jacques Luthi, *Emile Bernard, l'initiateur* (Paris: Caractères, 1974), pp. 25–26.

[32] Reflecting the influence of Millet.

[33] Some of these prints are now in the collection of the Bibliothèque Nationale, Paris, and others are in private collections, including the notable collection of Samuel Josefowitz in Lausanne.

[34] Caroline Boyle Turner, *The Prints of the Pont-Aven School: Gauguin and His Circle in Brittany* (New York: Abbeville Press, 1987).

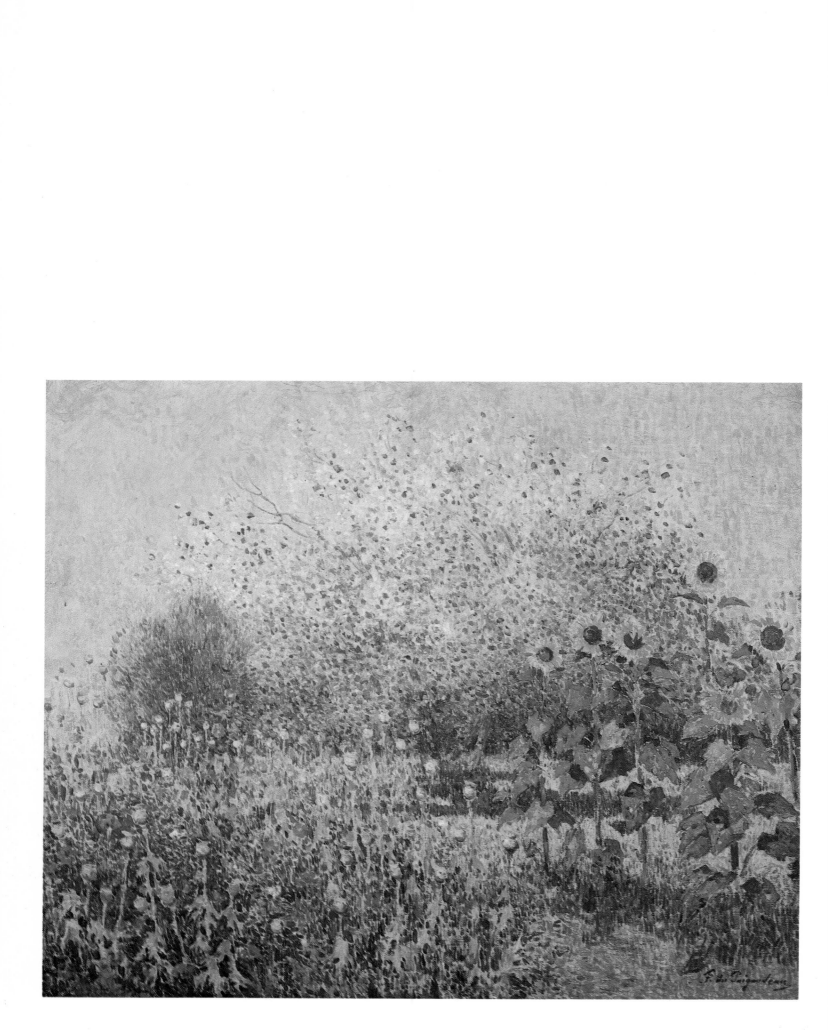

246

FERDINAND LOYEN DU PUIGAUDEAU

1864–1930

I N the context of the Pont-Aven school, Ferdinand Loyen du Puigaudeau is a painter difficult to classify. Though his work bears similarities to the Realist, Impressionist, Symbolist, and Romantic movements, he remained outside the mainstream of these styles. His painting appears full of contradictions; bold and yet restrained, with a mixture of technical know-how and naïveté. Representative of a stylistic approach almost unknown in France, his work is comparable to that of the American Luminist painters of the same period.[1]

Du Puigaudeau is linked with three distinct ideologies within nineteenth-century aesthetics. His painting is imbued with Romanticism, and his love of natural phenomena is clearly visible in his works. An interest in chromoluminarism[2] can be seen in the luminosity of his color and his Divisionist application of paint in small touches. Finally, du Puigaudeau's intellectual intentions, although often extremely subtle, link the artist with Symbolism.

Kervaudu Manor at Le Croisic. Postcard, c. 1915.

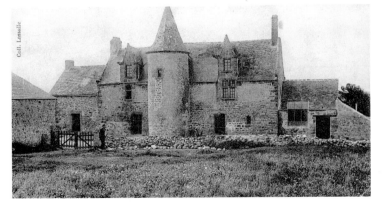

Ferdinand Loyen du Puigaudeau,
◁ *Sunflowers and Poppies,*
oil on canvas, 21⅜ × 25⅝ in.
Private collection, Nantes.

Ferdinand Loyen du Puigaudeau,
Kervaudu Manor at Le Croisic,
oil on canvas, 23⅝ × 31⅞ in.
Private collection, Nantes.

A systematic search for vivid, luminous color in nature, however, made du Puigaudeau unique, not only within the Pont-Aven school, but in the whole of French art of the late nineteenth century. Admittedly, the Neo-Impressionists had already used these extremes of color. Yet, although they had chosen identical subjects (for example, Maximilien Luce's paintings of sunsets at Herblay[3] on the Seine), the depiction of such subjects had never become the pivotal focus of their experiment.

Du Puigaudeau never turned to imaginative invention. He seized the often-exaggerated colors that he found in the real world, fleeting as they might be, and systematically transferred them onto canvas. His admiration for nature was highly Romantic. Du Puigaudeau's canvases also show a perfect mastery of draftsmanship, which was shaped by the painter's Symbolist aims. In this respect, du Puigaudeau can be situated stylistically midway between the apparent naïveté of Chamaillard and the graphic precision of Delavallée. He deliberately chose subjects that were both rare and extreme, concentrating on nocturnal scenes, and scenes verging on night, like dawn or dusk and unusual lighting effects. Du Puigaudeau sought spectacles, both natural and artificial, in which contrasts of light with darkness could be found, as in *Moonlight over La Brière* (illus., p. 249). Such paintings can be called luminist in character, since they exaggerate and dramatize the quality of light within a sublime nature. This love of the unaccustomed, juxtaposed with his careful, refined technique, gave each of his paintings a particularly *recherché* character, despite the fact that this sophistication was sometimes obscured by the intrinsically realistic nature of his subject matter.

Du Puigaudeau's aesthetic progress was that of the Mannerist, and it is only a short step from Mannerism to Symbolism, so similar are they in outlook. His own experience as a seventeen-year-old in Italy, under the Mediterranean sun, far from the studios and still under the influence of the Impressionists, caused his commitment to "color above all else" to remain with him throughout his life. In a short study of du Puigaudeau published in 1968, William Steadman wrote: "In painting the sun, du Puigaudeau followed the example of the Venetians in substituting the magic of light with the magic of color, which is even more suited for the pleasures of the eye."[4] At

first glance, du Puigaudeau's *Breton Woman Sitting by the Sea*,[5] a variation on his *Moonrise over the Sea*[6] (illus, p. 248), seems to reveal only the landscape itself. Yet, a closer look locates the small figure, sitting sheltered from the wind, in the middle of the landscape that she is contemplating. Night is falling in flamboyant colors over coast and sea while the trees and distant boats bend before a strong evening breeze. Man face to face with creation is the central feature of the painting, illustrating du Puigaudeau's eternal theme: his admiration for nature and its language, which he expresses in the incandescent colors of the sun or the mysterious reflections of the moon. In the whole range of the late nineteenth-century Symbolists, it is du Puigaudeau's vision that comes closest to the Romantic attitude toward nature. His love of the bold colors of nature brings him close to the American Luminist painters, such as Frederic Church,[7] and his great predecessor, the German artist Caspar David Friedrich.[8] Yet, unlike Friedrich, du Puigaudeau did not paint mountains and forests in all their vertical majesty, but the horizontal expanses of sea and sky. It was not his aim

Ferdinand Loyen du Puigaudeau, *Moonrise over the Sea,* oil on canvas, 25¼ × 35 in. Private collection, France.

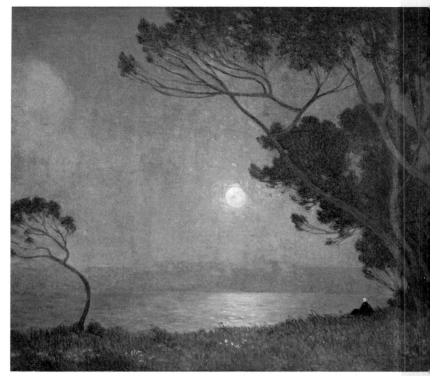

248

Ferdinand Loyen du Puigaudeau, *Moonlight over La Brière,* oil on canvas, 23⅝ × 28⅝ in. Private collection, France.

Ferdinand Loyen du Puigaudeau, *Sunset over the Sea*, oil on canvas, 23¼ × 28⅜ in. Private collection, France.

to portray man lost in an overwhelming or hostile nature, but merely to show man face to face with creation, in his role as spectator.

Du Puigaudeau's approach to nature was also different from that of Gauguin; yet neither artist was content to take a purely "impressionistic" view of nature. When Gauguin met du Puigaudeau during an early trip to Pont-Aven in 1886, they developed a friendship based upon a similar aesthetic understanding. The two became extremely close; according to a series of letters exchanged between Gauguin and du Puigaudeau (now lost[9]), du Puigaudeau was intending to join Laval and Gauguin in Martinique in 1887[10] until he received word that Gauguin was planning to return to France at the earliest opportunity.[11]

As in the case of Gauguin, the economic crisis and stock-market crash of the early 1880s ruined du Puigaudeau and his family.[12] The course of their lives converged at this point, as du Puigaudeau too was forced to earn his living as an artist. Du Puigaudeau decided to go abroad. Although his original intention had been to join Laval and Gauguin in the Antilles, he went to Africa instead. He first made his way to Naples, where he boarded a ship for Tunisia. North Africa, with its picturesque scenes and unique light, where he hoped life would be cheap, did not live up to his expectations. Like Gauguin, he was worn down by the climate and, in ill health, he returned to Marseille in a merchant vessel in 1888. Returning to Pont-Aven for the summer, he was present during the second, decisive collaboration of

250

Ferdinand Loyen du Puigaudeau, *Duck Hunting, Sunset over La Brière*, oil on canvas, 23⅝ × 31⅞ in.
Mr. and Mrs. Holliday Collection, Indianapolis Museum of Art.

Bernard and Gauguin, in 1888, and thus witnessed the birth of Synthetism.

Some insight can be gained concerning how du Puigaudeau was affected by this experience in Pont-Aven from a study of paintings he produced in Brittany a few years later, including his *Cliff, Seaside at Sunset*, painted in 1893 on a wooden panel and currently in the Van den Broucke Collection.[13] A strong comparison can be drawn between Chamaillard's *Coastal Scene with Cottage* of 1891 and Emile Bernard's *Cliff* of 1890.[14] The similarities among these works emphasize particularly the influence of Japanese art on the Pont-Aven school during these years.[15]

From 1890 on, du Puigaudeau exhibited at the Salon des Indépendants. Degas,[16] always on the lookout for new talent, noticed one of du Puigaudeau's canvases at the Salon. The painting that Degas acquired for his personal collection, *A Firework*, was prominent in the sale of the Degas Collection in 1918, following his death. The friendship and mutual esteem that was born from the meeting of these two artists lasted until the death of Degas in 1917. When du Puigaudeau finally retired to Brittany, this friendship was continued in a lengthy correspondence.[17] The numerous pastels that du Puigaudeau produced give a clearer picture of the affinities that drew him and Degas together. Although the subjects chosen by the two artists could hardly have been more different, there are similarities in the coloring, finesse, and delicacy of their works. One of the best examples of this kinship is du Puigaudeau's *Lighting the Candles for Candlemas* (private collection, Brest).[18] Over and above the similarity of technique and materials dictated by the use of pastels, a certain "transparency" brings du Puigaudeau's work close to Degas. Du Puigaudeau's pastels also display a high quality of draftsmanship, which Degas thought to be essential.

In 1890 du Puigaudeau met the art dealer Paul Durand-Ruel, a great patron of the Impressionists. Durand-Ruel made a verbal contract with the artist — three hundred francs per month in exchange for paintings completed up to the year 1900. With newly acquired financial stability, du Puigaudeau lived in Switzerland, Germany, and the Low Countries during the succeeding years. In Belgium he met the painters James Ensor, Hubert de Vos, and Henri de

Ferdinand Loyen du Puigaudeau,
Leaving the Church of Notre-Dame-de-Trémalo (Pont-Aven), 1898, oil on canvas, 25⅝ × 31⅞ in.
Private collection, France.

Groux, and the poet Emile Verhaeren, all of whom were to remain close friends.[19] During this period, when his painting was Divisionist in style, du Puigaudeau became closely associated with the Brussels group known as The Twenty and, in particular, with Théo van Rysselberghe,[20] since the two men had a common experience of Africa and the Mediterranean.

In 1893 du Puigaudeau married the portrait painter Henriette Van den Broucke,[21] who was originally from Saint-Nazaire in southern Brittany. He then moved to the nearby village of Bourg-de-Batz, whose square belltower appears so frequently in his work, and later to the village of Saillé, where his only daughter, Odette, was born, in 1894.

From 1896 to 1899, du Puigaudeau and his family were frequent visitors to Pont-Aven. Still fascinated by lighting effects, he produced some exceptional oils and pastels of night-time scenes which have no equivalent within the Pont-Aven school. During this

Ferdinand Loyen du Puigaudeau,
Breton Pardon, 1898,
oil on canvas, 25⅝ × 31⅞ in.
Private collection, France.

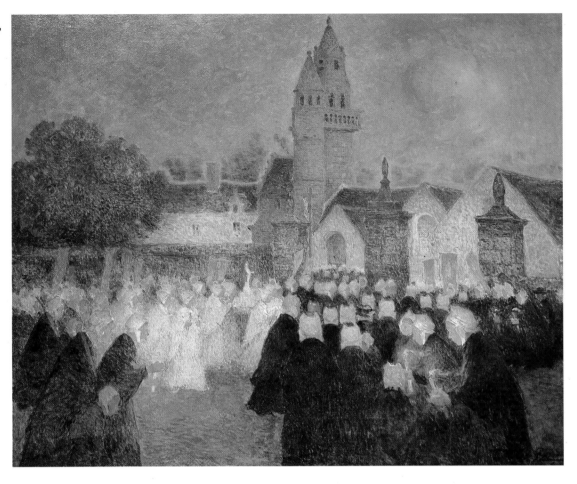

period, he painted *Merry-go-round at Night*[22] (illus., p. 254–55), in which the spectators, Breton villagers in clogs and local costume, appear in front of a superb carrousel. To entice the viewer to enter into the atmosphere of the carnival, under its twinkling lights, du Puigaudeau portrayed the characters facing away, toward the carrousel. It was also at this time that he painted *Leaving the Church of Notre-Dame-de-Trémalo*[23] (illus., p. 252); the church is outside Pont-Aven, and its crucifix inspired Gauguin's *Yellow Christ* of 1888.

In 1897 du Puigaudeau visited southern France, working near Renoir at Cagnes-sur-Mer. About 1900, when the Pont-Aven group dissolved, de Puigaudeau lived near Paris, first at Sannois and then at Saint-Cloud, at the insistence of his artist friends Henri de Groux, Florent Schmitt, and Mezzara. In May 1903 he had a highly successful exhibition at the Galerie des Artistes Modernes, rue Caumartin in Paris. One of his patrons, anxious to profit from this success, sent him to Venice for six months in 1904 and 1905, from where he returned with a fine collection of canvases.[24] Unfortunately, a lawsuit followed in which he lost most of his canvases and found himself financially ruined once more.

In 1910 du Puigaudeau moved permanently to Brittany, where he bought the Kervaudu manor at Le Croisic; the flower garden there, which he lovingly tended himself, became one of his favorite themes (illus., p. 247). World War I and the bankruptcy of a patron from Nantes caused du Puigaudeau to lose some sixty paintings for which he was never paid. Nevertheless, isolated and forgotten, du Puigaudeau, "the hermit of Kervaudu,"[25] went on painting. Magnificent views of the southern Breton scenery around Bourg-de-Batz, La Brière, Guérande, and Le Croisic, poppy fields (illus., p. 246), violent sunsets, and innumerable moonlight scenes show du Puigaudeau to be the only luminist painter of late nineteenth-century France.

Ferdinand Loyen du Puigaudeau,
Merry-go-round at Night (Pont-Aven),
oil on canvas, 25⅝ × 31⅞ in.
Private collection, Nantes.

Pont-Aven: view of the traveling fair by the harbor (detail).
Postcard, c. 1895.

254

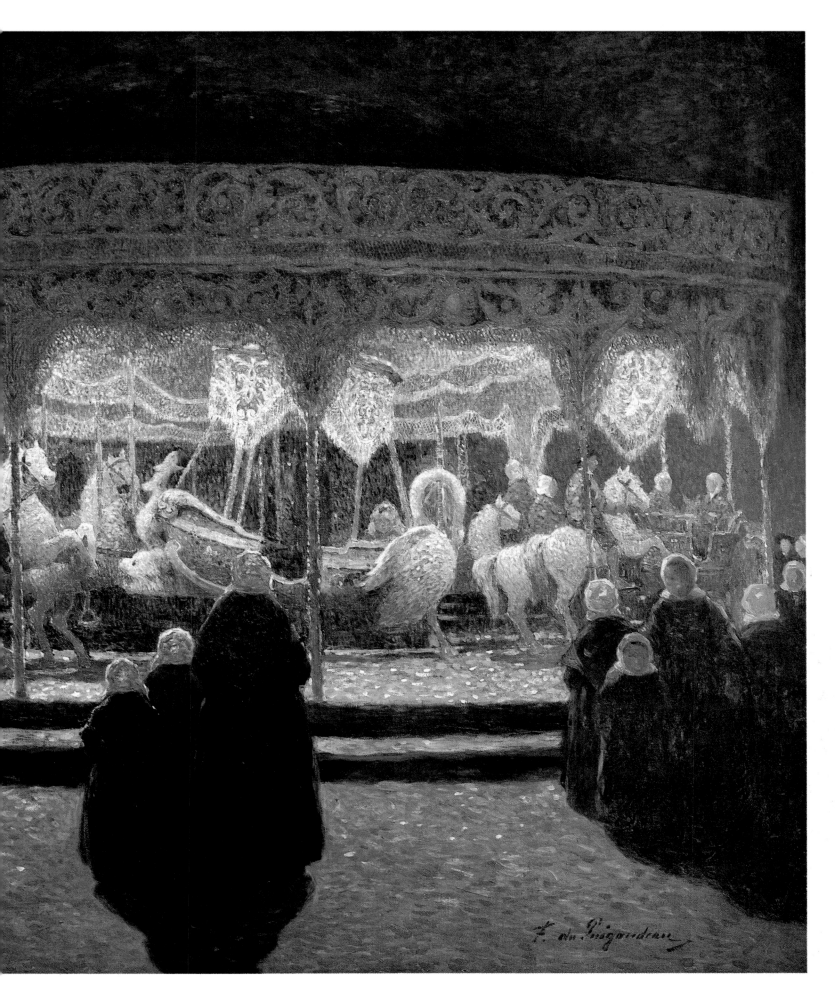

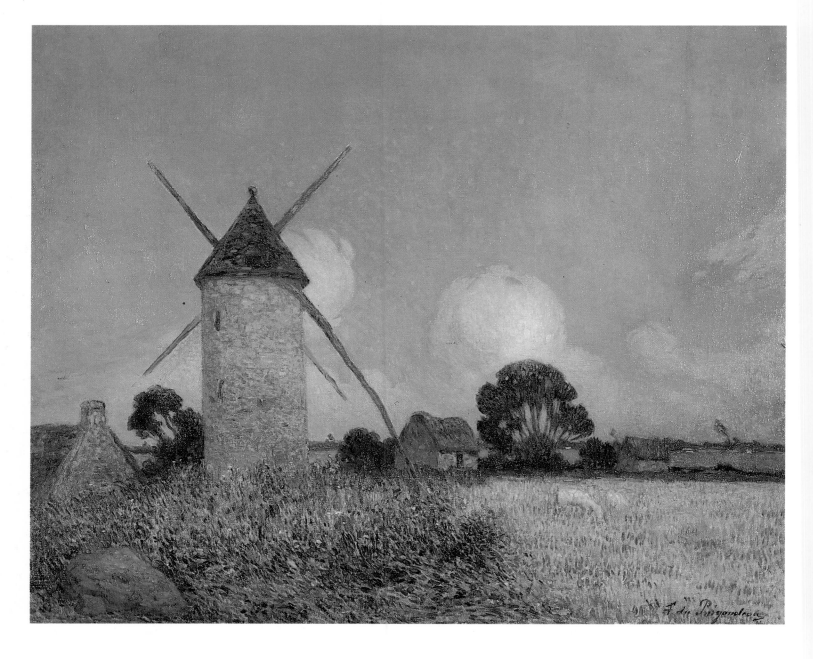

Ferdinand Loyen du Puigaudeau, *Windmill by the Sea*, oil on canvas, 21⅜ × 25⅝ in. Private collection, New York.

NOTES

[1] *American Luminism* (Washington, D.C.: National Gallery of Art, 1979).

[2] Chromoluminarism: a term invented by the art critic Félix Fénéon. Fénéon, "Les Impressionnistes en 1886," *La Vogue* (Paris), December 1886.

[3] In 1889 Luce was working with Paul Signac at Herblay. Here he painted the Seine in an opulently colored Pointillist style inspired by the fine sunsets. These paintings are reminiscent of certain works of du Puigaudeau.

[4] William Steadman, *Homage to Seurat: The Holliday Collection at the University of Arizona* (Tucson: University of Arizona Art Gallery, 1968).

[5] Oil on canvas, dated 1916, 30⅝ × 42½ in. Blache public auction, Versailles, April 25, 1979, lot 105 in the catalog, illustrated.

[6] Oil on canvas, 25¼ × 35 in., exhibited at Musée de Pont-Aven, 1979, no. 5 in catalog.

[7] Frederic Edwin Church (1826-1900) was a great admirer of Turner. He made numerous expeditions into the heart of such distant regions as the Andes and Labrador, bringing back grandiose images of undisturbed nature that made his reputation. He exhibited his *Niagara Falls* in Paris in 1867 and won a silver medal. He is rightly considered the most talented of the American painters of what has come to be called the Luminist movement.

[8] Caspar David Friedrich (1774-1840) was a member of the Dresden and Berlin academies. His personality and remarkable oeuvre have recently been highlighted by the extensive exhibition *Le Mouvement romantique en Allemagne*, held in Paris at the Orangerie des Tuileries in 1978. The titles of his works reveal something of his style and outlook: *Moonrise over the Sea, Two Men Gazing at the Moon, By Moonlight, The North Sea by Moonlight*.

[9] Formerly du Puigaudeau Collection.

[10] Summoned to Hyères in December 1886 for his national service, du Puigaudeau spent ten months decorating the officers' mess hall with murals before returning to civilian life in September 1887.

[11] On April 10, 1887, Gauguin and Laval sailed from Saint-Nazaire for Panama. In June, in ill health, they reached Martinique, where they rented a cabin in Turin Bay, near the road from Saint-Pierre to Fort-de-France. They remained there until November, when Gauguin returned to France.

[12] The crash of the Banque de Lyon and the Union Générale in January 1882 produced a serious financial crisis and caused the stock exchange to collapse. Many investors were financially ruined.

[13] *Le Mouvement impressionniste dans l'école de Pont-Aven*, Musée de Pont-Aven, 1978, cat. no. 1.

[14] Mélanie Rouat Collection, Riec-sur-Belon.

[15] For further information on this subject, see the exhibition catalog *Japanese Influence on French Art, 1854-1910*, Cleveland Museum of Art, Rutgers University Art Gallery, and the Walters Art Gallery, 1975; and Colta Feller Ives, *The Great Wave: The Influence of Japanese Woodcuts*, Metropolitan Museum of Art, New York, 1974.

[16] Edgar Degas (1834-1917), as an Impressionist, had already expressed ideas that Emile Bernard adapted to Synthetism. "It is much better to draw what one sees only in the memory. It is a transformation, in which the imagination collaborates with the memory; you only reproduce what strikes you — that is to say, the essentials." Emile Bernard, *Souvenirs inédits sur l'artiste-peintre Paul Gauguin et ses compagnons* (Lorient: Imprimeur du Nouvelliste du Morbihan, n.d.), p. 13.

[17] Du Puigaudeau Family Archives.

[18] *Candlemas Procession at Saint-Pol-de-Léon*, pastel, exhibition catalog, Musée de Pont-Aven, 1978, no. 3 of pastels.

[19] These painters belong to the Belgian Expressionist movement, as represented at the 1970 exhibition in Paris at the Orangerie des Tuileries, *L'Art flamand d'Ensor à Permeke*.

[20] Théo van Rysselberghe (1862-1926). Accompanied by Regoyos, he visited Spain and Morocco in 1883. He founded Les Vingt (The Twenty) in 1884 and the Libre Esthétique in 1894. He was at the center of many important groups and involved in all the original movements of his age.

[21] H. Van den Broucke was known mainly as a talented pastelist, producing still lifes of flowers and portraits in the eighteenth-century manner.

[22] Exhibited at the Pont-Aven museum in 1978, cat. no. 10.

[23] Sold at auction, Versailles, by Maître Martin, March 28, 1976, cat. no. 82, reproduced.

[24] Several canvases from this Venetian period are in the Van den Broucke Collection.

[25] This affectionate nickname was coined by Degas in his correspondence (a letter with this heading is in the du Puigaudeau Archives).

Ernest Ponthier de Chamaillard, *The Rance River at Dinan, Côtes-du-Nord,* oil on canvas, 26 × 32⅝ in. Private collection, Quimper.

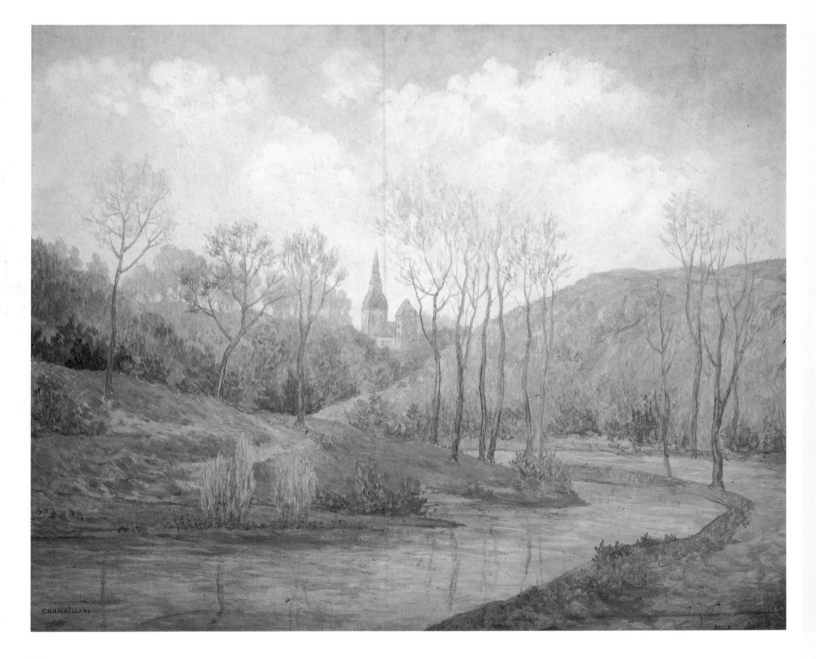

ERNEST PONTHIER DE CHAMAILLARD

1865–1930

B Y chance I found myself, one day in the month of June 1888, at a public sale at the Château du Hénan[1] near Pont-Aven (illus., p. 259), when I noticed a man among the crowd of elegant peasants. He was wearing a close-fitting sailor's jersey, he had a beret on his head and extraordinary carved clogs on his feet.[2] I was astonished to see this magnificent figure of a man wave to my companions and I asked them who this remarkable character might be. I was told that he was an extremely talented painter, but of such an original talent that it was difficult to understand him. He was in fact one of the youngest and most audacious of the Impressionists, who was just beginning to make a name for himself: Paul Gauguin. With my enthusiasm for art and poetry, I thought it would be nice to get to know this artist better, so I was pleased to see him heading for our group. He expressed himself simply but authoritatively, developing his artistic theories. He spoke of these things with such feeling that I felt myself drawn towards this fine artist. I admitted to him that I had become interested in art during the past fortnight and that I had just been trying my first paintings on small canvases. This was all it took to make us friends.[3]

The Castle of Le Hénan near Pont-Aven (where Chamaillard met Paul Gauguin in June 1888). Postcard, c. 1905.

These words of Ernest Ponthier de Chamaillard commemorate the start of the artistic career of one of the most interesting members of the Pont-Aven school. He began his career very much under the influence of Paul Gauguin and later, after Gauguin's departure for Tahiti, developed an Impressionistic style and technique. He showed great determination to learn and to progress, as Gauguin wrote to his friend Schuffenecker in August 1888: "I've taken on a pupil who is working out well."[4]

Chamaillard was born at Quimper on December 9, 1865, into a middle-class background, the son of a Quimper barrister who defended the clergy against the civil law. His brother, Henri, fourteen years his senior, was also a lawyer and was to be elected senator for Finistère. "In an environment such as this, the young man's [Ernest's] career seemed pre-

259

determined: after a solid schooling with the Jesuits at the Saint-François-Xavier college in Vannes, he was to study law in Rennes before becoming a lawyer.''[5]

Entering the college in 1874 as a boarder, he showed little enthusiasm for study and found his lessons difficult. His flippant, anticonformist attitude caused him to be expelled from the philosophy classes. Nevertheless, he embarked upon his legal studies in Rennes to placate his father. More inclined toward having a good time than studying jurisprudence, he proceeded to contract such debts that his family was obliged to appoint a guardian to deal with his numerous creditors. He graduated in 1885 and, since he was forced to leave Rennes, spent some time, first in Quimper, and then in Quimperlé, as a probationer in a legal firm. This life bored him; he sought a more exciting existence, outside the social mainstream.

Only a few miles separated Quimperlé from Pont-Aven and it was an easy journey between the two towns. Pont-Aven was famous at the time for its gaiety and its bohemian, carefree atmosphere, as a result of the innumerable artists who brightened up its square, cafés, and inns. In August 1883 the municipal council of Pont-Aven had even passed a motion "to extend licensing hours to 10 PM, considering the permanent artists' colony at Pont-Aven." By the time he first encountered Gauguin, in June 1888, Chamaillard was a regular visitor to Pont-Aven. Tired of the legal profession, he decided to give up law for painting, to abandon one way of life in order to adopt another. During these early years, Chamaillard became inseparable from Gauguin.

Having returned ill from Martinique and living alone since February at the Pension Gloanec, Gauguin looked kindly upon this younger son of a well-to-do family, who was open in his generosity and ready to listen to Gauguin's every word. He was the ideal disciple and Gauguin, usually so critical, did not have a word to say against him. On the contrary, this novice painter, who put a freshness, innocence, and *"Rustique naïveté"* into his canvases, brightened the master's disposition. Maurice Denis, recounting the words of Sérusier, said: "Chamaillard's awkwardness aroused Gauguin's admiration."[6] As Jaworska has explained: "The term 'awkwardness' was for Gauguin a compliment at that time when he

himself was seeking the primitive and the naive, finding it even in his childhood hobby-horse."[7]

That summer at the Pension Gloanec in Pont-Aven, Gauguin was surrounded by his numerous disciples: Chamaillard, Moret, who was lodging with Kerluen the harbor-master, Jourdan, Laval, Bernard and his sister, Madeleine. Mealtimes at the pension were lively occasions. The presence of pretty young Madeleine added grace and gaiety, while the brilliant ideas and advanced artistic conceptions of her brother stimulated and refreshed the group intellectually. The group met continually, sometimes in Moret's attic on the Concarneau road and sometimes at the house of Louise Lamour, the niece of the Pont-Aven postmistress, whom Chamaillard was courting.

Ernest Ponthier de Chamaillard, *Road near Pont-Aven,* ▷ c. 1892, oil on canvas, 28⅜ × 21⅜ in. Private collection, Lorient.

▽ **Paul Gauguin,** *Bare Trees, Normandy,* 1885, oil on canvas, 15⅝ × 10¼ in. Private collection, Paris.

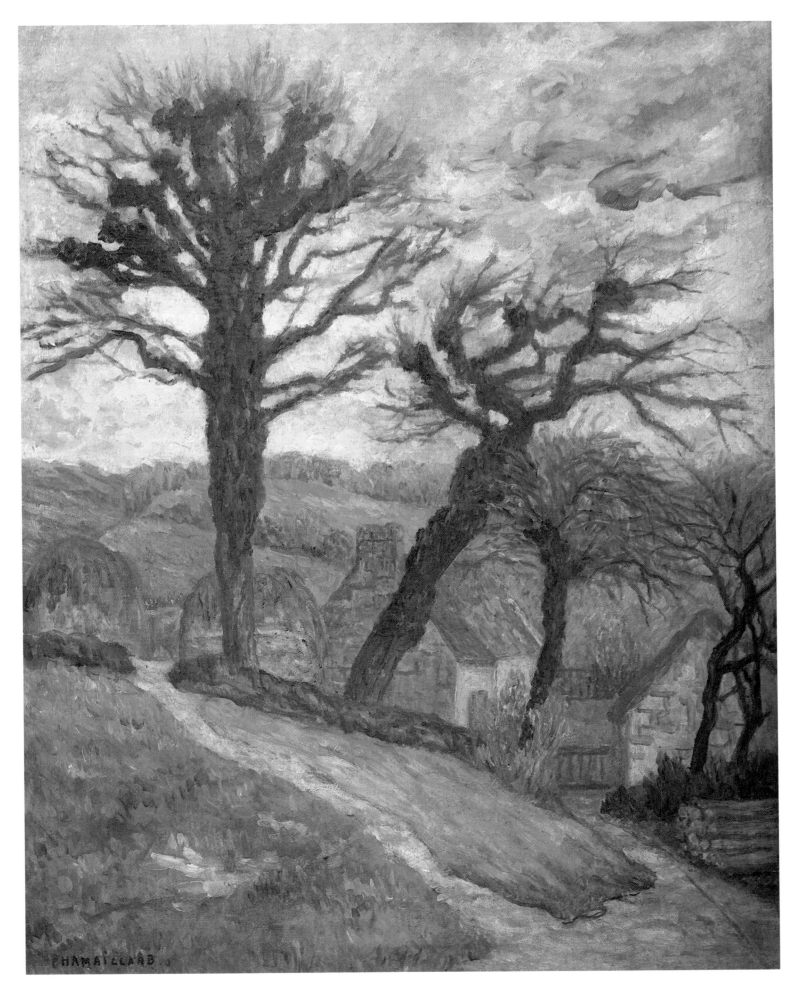

This house above the post office in the rue du Gac played an important part in the development of the Pont-Aven school.[8] From 1888 to 1891 it was almost an annex of the Pension Gloanec. Here, during that amazing summer of 1888, the new ideas born of discussions between Gauguin and Bernard were developed in the presence of Chamaillard. The entire interior of the building was covered with avant-garde paintings. The attic was used as a studio, so that this welcoming house was not only a center for discussions, but was a place where artists were able to paint, free from the bustle of the pension.

Until a few years before the Second World War this modest little house boasted two paintings by Paul Gauguin, window panes painted by Emile Bernard, an exceptional cloisonnist painting by Bernard on the panel of a first-floor door (*Girl Under a Red Parasol*[9] of 1888), and, of course, several works by Chamaillard, including the fine *Coastal Scene with Cottage* of 1891.[10] This painting is comparable to a similar work by Emile Bernard dated 1890, which is today in the Mélanie Rouat Collection at Riec-sur-Belon.

During that summer various projects took shape, including an exchange of self-portraits with Vincent van Gogh (who was alone in Arles) and other members of the Pont-Aven school: Gauguin, Bernard, Moret, and Laval. Laval and Moret expressed a wish to join Gauguin and van Gogh to create the Studio of the Midi (L'Atelier du Midi).[11] Chamaillard, however, wished to remain in Pont-Aven. He became engaged to Louise Lamour. Already unhappy to see him following a career as a painter, his family disapproved of this prospective marriage, even though Louise had money. Chamaillard and Louise eloped to the Channel Islands and were married in Jersey in 1889.

During this romantic episode, Chamaillard painted some charming watercolors, which also reveal his progress as an artist. The simplicity of shape and lightness of tone in these watercolors conform entirely with Chamaillard's attitude toward art: "I believe it impossible to produce a work of art without transposing, but such a work must be, as it were, involuntary."[12]

His return to Pont-Aven was unpleasant. In June 1889, harassed by creditors from Rennes, Quimper, and elsewhere who had learned of his marriage, Chamaillard was summoned to appear before the magistrate. So great was the scandal that the young couple was obliged to move some distance away and isolate themselves at a farm at Goulet-Riec near the mouth of the Aven. There he spent the summer of 1889 and the following winter. Then, with his debts paid from his wife's dowry, Chamaillard moved back to Pont-Aven.

The earliest of Chamaillard's surviving paintings that can be dated with any certainty are from 1889.

Ernest Ponthier de Chamaillard,
◁ *Breton Landscape*, watercolor.
Private collection, Quimper.

Ernest Ponthier de Chamaillard,
The Artist's Garden at Châteaulin, Finistère, ▷
oil on canvas, 21⅜ × 26 in.
Private collection, Châteaulin, France.

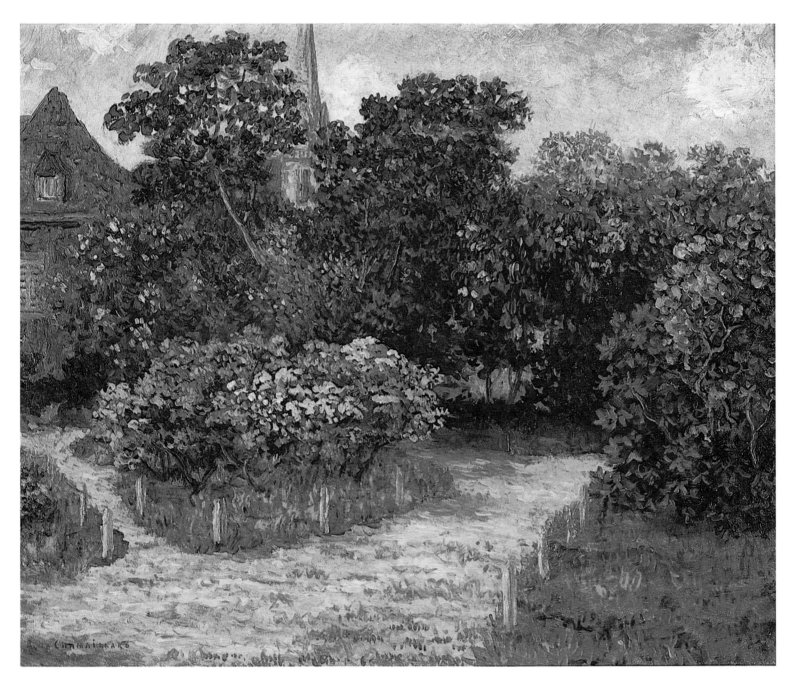

At Goulet-Riec, once more adopting a habit of the artists of Pont-Aven, he decorated his lodgings with a series of pictures painted on the wooden panels of dividing walls and doors. There were probably six of these originally, but only two are now known: *Landscape with Apple Tree*[13] and *Bell Tower at Saint-Beuzit*,[14] otherwise known as *Landscape with Chapel*. Dated 1889, they provide evidence of Chamaillard's artistic progress and his receptivity to Gauguin's teachings. They are examples of the awkward, rustic style that Gauguin so admired. Their style conforms to the novel desire for flattened forms, simplicity, and a plainer application of color as expressed by Gauguin and Emile Bernard from the very beginning of Synthetism. Each panel is made up of horizontal bands arranged so as to give a certain flatness to the subject. The superimposition of tones and the alternation of color give a feeling of proximity. The palette is restricted, based essentially on combinations of yellow, blue, and green, heightened now and again with touches of vermillion or a hint of gray. The yellow base, progressively enriched by the interplay of color combinations, recalls in every respect the lesson given by Gauguin to young Sérusier one year earlier in the Bois d'Amour.

During the course of 1889, while Chamaillard was secluded at the farm in Goulet-Riec, he saw less of Gauguin. Gauguin, who was renting a studio at the

263

Pierre Auguste Renoir, *The Sea at Tréboul near Douarnenez,* 1895, oil on canvas, 21⅜ × 25⅝ in.
Private collection, New York.

Lezaven manor, scarcely 150 yards from the Pension Gloanec, confided to Emile Bernard in July: "Things have changed here at Pont-Aven. We see nothing at all of Chamaillard. He is completely tied up by women [his wife and her aunt], who have warned him to be on his guard against me."[15] Newly married, crippled with debts, awaiting a lawsuit, Chamaillard had many reasons to keep his distance for a time. A few months later, in October, Gauguin wrote to Bernard: "Chamaillard has painted an excellent portrait of his wife,"[16] confirming both the progress of his pupil and that contact had been reestablished. Three other landscapes — *Goulet Farm,* painted at Goulet-Riec and exhibited at the Pont-Aven museum in 1976; *Riec Landscape*; and *The Ty-Meur Mill at Pont-Aven,* now in the Musée de Quimper[17] (illus., p. 49) — are the only other known paintings from this year.

In 1890, at Goulet-Riec, where he was visited by Filiger and Paul Emile Colin from Le Pouldu, Chamaillard produced his well-known series of Breton watercolors.[18] Midway between the theories of Synthetism and his own instinctive style, they are an example of both Chamaillard's adhesion to the doctrine of the Pont-Aven school and his simultaneous leaning toward Impressionism. In a few years Chamaillard would completely abandon Synthetism for a purer Impressionism.

Ernest Ponthier de Chamaillard, *Douarnenez Bay and the Menez Hom Hills, Finistère,* oil on canvas, 19⅝ × 24 in. Private collection, France.

On November 7, 1890, Gauguin, who had spent seventeen uninterrupted months in Brittany, thirteen of them at Le Pouldu (his longest visit), returned to Paris to prepare for his departure for Tahiti, on April 4, 1891. Thus it was Chamaillard, who had remained in Pont-Aven, who welcomed Verkade and Ballin when they arrived in the spring of 1891 on Gauguin's recommendation. The two artists took rooms at the Pension Gloanec, as did Emile Bernard and his sister when they returned the same summer. Everyone continued to meet in Chamaillard's apartment above the post office. Here they discussed aesthetics and painted. With Gauguin away, Bernard's influence was decisive. Chamaillard's *Coastal Scene*

with Cottage,[19] which he painted that year, shows this influence.

The year 1893 was one of great change not only for Chamaillard, but for the artists' community at Pont-Aven in general. Bernard was preparing to leave for the Orient. In mid-March he left Europe with no intention of returning. Gauguin was in Tahiti. At Le Pouldu, Marie Poupée sold her inn to Mademoiselle Trévières and moved, in November, to Moelan. At Pont-Aven, Marie-Jeanne Gloanec was getting ready to move to her new hotel on the square.[20] In the face of so many separations and under pressure from his family and his wife, Chamaillard gave up trying to earn a living from painting alone. He too

◁ **Paul Gauguin,** *Two Vases of Flowers*, 1890, oil on canvas, 25⅝ × 17⅜ in. Ordrupgaard Museum, Copenhagen.

Ernest Ponthier de Chamaillard, *Vases of Flowers*, 1900, ▷ oil on canvas, 21⅝ × 13¾ in. Buffetaud Collection, Paris.

263). For the next ten years (up to 1905) Chamaillard devoted himself alternately to his legal work and art, painting at locations all over Brittany, but especially in the area around Châteaulin: on the Crozon peninsula, at Camaret, Cap de la Chèvre, the bay at Douarnenez (illus., p. 265), the Arret mountains, the Nantes-Brest canal, the Aulne valley. The Chamaillard family home, Mesquéon castle, at Gourlizon near Quimper, was the starting point for many excursions during these years, and its environs provided subjects for many paintings. Left to himself, freed from Gauguin's influence, he followed his own path, painting in the open air in the tradition of Monet and Renoir, whom he had met at Pont-Aven during the summer of 1892. It is interesting to compare two views of Douarnenez Bay, one painted by Renoir in 1895 (illus., p. 264), the other by Chamaillard (illus., p. 265) at about the same time. These illustrate eloquently the influence that Renoir had on Chamaillard's later development.

Chamaillard's paintings of this period "are in general landscapes ... delicate, airy, harmoniously balanced between the surface of a river or lake, the blue of a pure sky, and the green (perhaps a little over-luxuriant) of the grass, bushes, and trees. The painter seems to have had a marked predilection for masses of greenery."[22] His works of these years had an air of great delicacy, with their muted colors suggesting the presence of streams, or rivers, or trees covered with leaves or bare, pollarded oaks overhanging sunken paths or sheltering cottages. Armand Séguin expressed their mood perfectly when he wrote: "What are these strange trees that look like seven-branched candlesticks, these masses of greenery like animals with gigantic tentacles, these unimaginable and gentle blossomings of color? Chamaillard created them."[23] Although Chamaillard was primarily a landscape painter, he also produced some beautiful still lifes, such as *Vases of Flowers* painted in 1900 (illus., p. 267), now in the Buffetaud Collection, Paris.

left Pont-Aven and set himself up as a lawyer at Châteaulin. Here, his three children were born. Yet, he did not turn his back entirely on his passion for painting. When Gauguin returned to Pont-Aven in April 1894, Chamaillard joined him there. As a lawyer, Chamaillard advised Gauguin in the lawsuit (which was lost) against Marie Henry, in which Gauguin attempted to recover the paintings and objects he had left at Le Pouldu in lieu of payment in 1890. When Gauguin, injured in a brawl at Concarneau, was hospitalized and then confined to bed at the Pension Gloanec, Chamaillard was by his bedside to comfort him.[21]

Chamaillard's return to Pont-Aven, however, was brief. He had to depend on his work as a lawyer to support his family; thus in 1895, the year that Gauguin left France forever for Tahiti, Chamaillard made his permanent home in Châteaulin (illus., p.

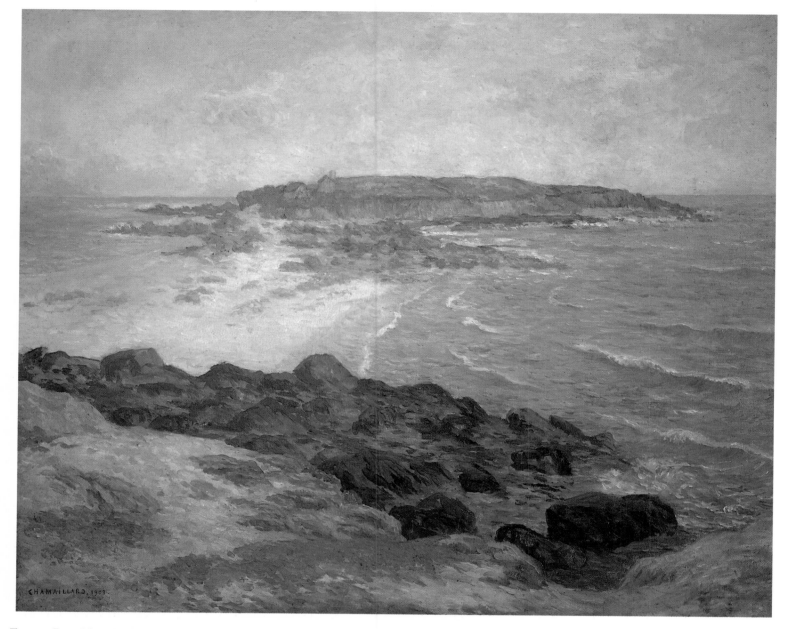

Ernest Ponthier de Chamaillard, *Raguénès Island*, 1903, oil on canvas, 29½ × 36¼ in. Private collection, France.

Raguénès Island. Postcard, c. 1900.

In 1901 he was visited by Armand Séguin, who was penniless, sick, and close to both madness and suicide. At Chamaillard's house, Séguin devised and produced his illustrations for Aloysius Bertrand's book *Gaspard de la nuit*, commissioned by the art dealer Ambroise Vollard. Séguin confided to O'Conor: "I have lived and am living very happily under the protection of a triple aegis: firstly the painter, secondly the tippler, and thirdly the lawyer. But seriously, he [Chamaillard] has been very good to me, he works hard and drinks very little. He encourages me, makes me work, gets me drunk, lectures me, and invites me to Sunday lunch." He continued:

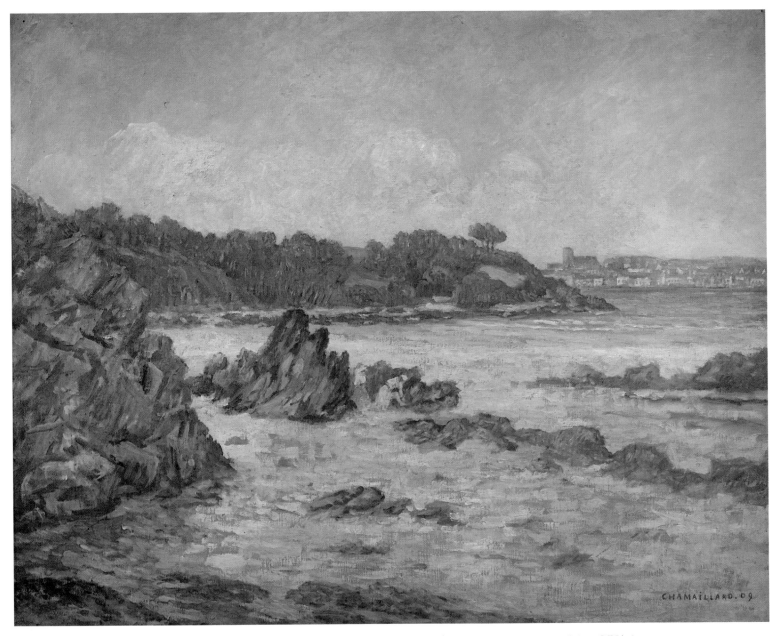

Ernest Ponthier de Chamaillard, *Douarnenez Seen from the Ris Beach*, 1909, oil on canvas, 24 × 25⅝ in. Private collection, Châteaulin.

"Without Chamaillard it would be awful here, but we amuse ourselves with our memories."[24] Moret, who painted his fine *View of Port-Launay* while he was in Châteaulin,[25] Séguin, and other members of the group including Sérusier, Maufra, O'Conor, and Denis, stayed at Châteaulin at various times as guests of Chamaillard.[26]

Chamaillard's first Parisian exhibition took place at the Galerie Bernheim in 1901. The preface to the catalog was written by a friend of the group, the writer and art critic Arsène Alexandre. Ambroise Vollard also exhibited Chamaillard's carved and painted furniture, along with a number of canvases.

Panoramic view of the Ris Beach (Douarnenez). Postcard, c. 1905.

269

This highly controversial exhibition produced a laudatory article by Frédéric Fagus in *La Revue Blanche*, entitled "Furniture by Chamaillard." From 1902, together with Maufra and O'Conor, Chamaillard shared in the creation of the Salon d'Automne, which opened its doors in 1903. That same year, he painted the beautiful view *Raguénès Island* (illus., p. 268), a little island a few miles from Pont-Aven.[27]

Though Chamaillard painted in the Impressionistic style, a certain awkwardness of composition and clumsiness of execution would always characterize his works and distinguish them from those of his Impressionist friends Moret, Maufra, and Renoir. Séguin, after a short trip to Paris to deliver work to Vollard, wrote to O'Conor in 1902: "I've seen his [Chamaillard's] canvases. Four of them are good. He is the only painter now at Pont-Aven who has rediscovered the colorful, simple, and naive qualities that are what we like in his work, and really two landscapes are charming."[28] At the same time, in April 1902, Sérusier was writing in a completely different vein to Verkade: "I saw Chamaillard too, who is still painting, but still in a realistic, Impressionist manner."[29]

At this point, partly to be in Paris, where his work was beginning to find a supportive public, and partly to take advantage of an offer of a regular income, Chamaillard left Châteaulin. In 1905 he moved to an apartment in Paris at 3 rue Bara. The following year, 1906, he exhibited his work for the second time at the Galerie Bernheim. The preface to the catalog was written on this occasion by Charles Morice. At the Salon d'Automne, where he was to be a regular exhibitor until 1925, he showed seven painted wood sculptures. Each summer he returned to Brittany, to the family home at Mesquéon, where he had a studio. From there he traveled all over Brittany, returning to Paris with his views of Vitré, of the Rance river at Dinan, of the coast at Trégunc, and of Douarnenez. Sunken paths, isolated farms, castles with imposing outlines, and river banks and streams caught his attention and made him a respected landscape artist who did much to popularize the Breton theme. Well reviewed by the critics, his one-man shows at the Bernheim-Jeune and Georges Petit galleries were quite successful.

In addition to painting, he continued sculpting and decorating furniture and bas-reliefs with colored motifs. André Salmon, the writer who was to become his biographer in his *Souvenirs san fin*, attributed to Chamaillard the invention of painted, sculpted furniture, which was found frequently in the work of the Pont-Aven artists, including Gauguin, Emile Bernard, Georges Lacombe, and Maurice Denis. "It was he who taught the 'summer visitor' who stayed indefinitely [Gauguin during his long visit to Pont-Aven and Le Pouldu in 1889 and 1890] the art of the old Breton carvers, sculpting their images in the same wood used to make the clogs the two friends wore on their feet. It was Chamaillard who first had the idea of painting these sculptures in two or three different colors, of which one was an acid green and the other a soft vermillion."[30] This active collaboration between Chamaillard and Gauguin is confirmed by a rustic two-door cupboard bearing both their signatures. Salmon recalls having seen this piece in 1911 at Mesquéon in Chamaillard's studio.[31] In 1914 the poet Guillaume Apollinaire wrote a laudatory preface for the catalog of an exhibition that was never to take place because of the war. "There is no doubt that the apostle of Cubism was captivated by the painting of Chamaillard and all the delights of his Impressionist palette."[32]

The war affected Chamaillard cruelly, for he lost his two sons. The financial embarrassment, illness, and neglect with which he was afflicted during the war years brought his life to a sad end. In 1916, over sixty canvases, together with his studio work, disappeared when the property at Mesquéon was sold to pay off a voracious creditor. These canvases have never reappeared. Two exhibitions, in 1925 and in 1930, organized by the Georges Petit gallery, were the only bright spots in the ensuing years. André Salmon wrote a moving obituary in *L'Art d'aujourd'hui* upon Chamaillard's death in 1931.

In Chamaillard the spirit of Synthetism is manifested by an instinctive naïveté, which remained with him throughout his life. His Impressionist style, his love of landscape, and the absence of intellectualism were enduring characteristics of his work. Having formulated from the outset a personal style, which delighted Gauguin in its purity and its lack of intellectual antecedents, and having dutifully acquired technical experience, Chamaillard never wavered from his "rustic Impressionist" style during his artistic career.

NOTES

[1] This feudal castle on the right bank of the Aven is about four miles from the village of Pont-Aven.

[2] This description of Gauguin's everyday dress conforms both with photos of him while he was in Pont-Aven and with Maufra's description in his unpublished memoirs (*Bulletin des Amis du Musée de Rennes, numéro spécial: Pont-Aven*, no. 2 [Summer 1978], p. 22).

[3] Chamaillard's account is reported by André Salmon in his *Souvenirs sans fin* (Paris: Gallimard, 1969, vol. 2).

[4] Letter dated August 14, 1888. Maurice Malingue, *Lettres de Paul Gauguin à sa femme et à ses amis* (Paris: Grasset, 1946), p. 134.

[5] Olivier Le Bihan, preface on Chamaillard in the exhibition catalog, *L'Ecole de Pont-Aven à travers les collections publiques et privées de Bretagne* (Quimper, Rennes, and Nantes museums, 1978).

[6] Paul Sérusier, *ABC de la peinture*, followed by Maurice Denis's *Paul Sérusier, sa vie, son œuvre* (Paris: Floury, 1942).

[7] Wladislawa Jaworska, *Gauguin et l'école de Pont-Aven* (Paris: Bibliothèque des Arts, 1971), p. 187.

[8] Situated in what is now called rue du Général-de-Gaulle, the house is today owned by the Le Naour family.

[9] John A. and Audrey Jones Beck Collection, Museum of Fine Arts, Houston, Texas.

[10] Jaworska, *Gauguin*, p. 190, illustrated.

[11] Letter from Vincent to Theo, Arles, September 1888. *Correspondance complète de Vincent van Gogh* (Paris: Grasset-Gallimard, 1960), vol. 3, p. 221.

[12] Chamaillard, in the magazine *Le Mercure de France*, 1905.

[13] "Chamaillard et le groupe de Pont-Aven," *Bulletin des Amis du Musée de Rennes*, fig. 2, p. 124.

[14] Ibid., fig. 3, p. 125.

[15] Jaworska, *Gauguin*, p. 124.

[16] Undated letter from Gauguin to Bernard. Pierre Leprohon, *Paul Gauguin* (Paris: Gründ, 1975), p. 147.

[17] Musée de Quimper, inventory no. 75-5-1.

[18] Many are in the Guyot Collection, Riec-sur-Belon.

[19] Jaworska, *Gauguin*, p. 190, illustrated.

[20] Now the Hôtel des Ajoncs d'Or.

[21] "My leg was broken at the ankle and the bone was sticking right through the skin. They threw stones at us in Concarneau because of Anna. With two puches I knocked out a sailor who attacked me, but he went to get the rest of his crew and fifteen men fell upon me. I held my ground until my foot caught in a hole, and I broke my leg. When I was on the ground they kicked me with their clogs until I was finally rescued. I had to be taken to Pont-Aven to be looked after. Finished ... can't manage any more." Gauguin, letter to William Molard, May 1894. Malingue, *Lettres*, p. 158.

[22] Jaworska, *Gauguin*, p. 187.

[23] Séguin, in the magazine *L'Occident*, 1903.

[24] Letter in the Denys Sutton Collection, London. Quoted by Jaworska, *Gauguin*, p. 187.

[25] Exhibited in 1974, Musée de Pont-Aven, reproduced in color in catalog. Hernigou Collection, Châteaulin.

[26] Moret, a close friend of Chamaillard, often stayed at Mesquéon-en-Gourlizon in the period between 1906 and 1911. During these visits he painted several canvases of the environs of Quimper.

[27] This is one of very few places that the painters of the Pont-Aven school frequented on the coast, which has remained unchanged both in terms of vegetation and buildings. At the end of the nineteenth century the Breton coast had hardly any trees, as can be seen from old postcards and, of course, from the paintings themselves. Moret painted the same spot around 1891: cf. *Raguénès Island* in the National Gallery of Art, Washington, D.C., Alicia Mellon Bruce Collection.

[28] "Lettres d'Armand Séguin à O'Conor, 1895-1903," manuscripts, Denys Sutton Collection, London.

[29] Jaworska, *Gauguin*, p. 188.

[30] André Salmon, *Revue de France*, January-February 1932.

[31] André Salmon, "Chamaillard et le groupe de Pont-Aven," *L'Art vivant*, July 1925.

[32] Jaworska, *Gauguin*, p. 190.

Conclusion

ETWEEN 1860 and the First World War, Pont-Aven became a point of convergence for artists from around the world. For ten years at the close of the last century, Pont-Aven lent not only its name but its unique spirit to a communal aesthetic movement that was to change the nature of modern art. During the brief period between 1886 and 1896, representatives of the three central currents in French art of this period intermingled in this small riverside and coastal town. Avant-garde painters, now ranging from the world-famous to the forgotten, were forced not only to battle against an entrenched academic tradition, but to compare the opposing ideologies of a still-revolutionary form of Impressionism and a radical doctrine called Synthetism. In such a heated intellectual atmosphere, it now seems inevitable that highly innovative painting would have emerged.

While these artists enriched the ambience of Pont-Aven at the *fin de siècle*, this little village and the wild Breton coast and countryside penetrated and added

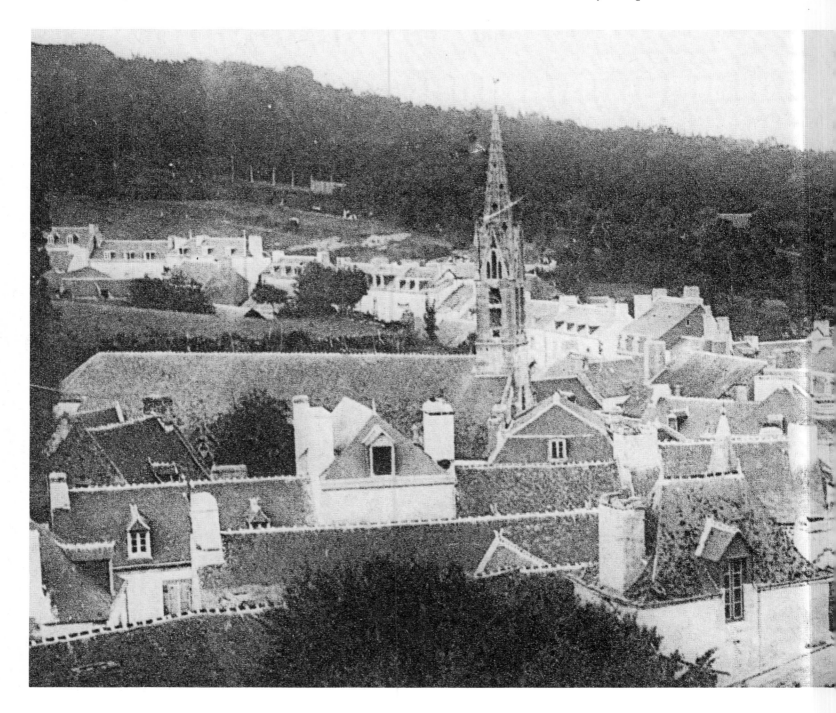

a new dimension to the oeuvre of these painters. The shifting colors and moods of the ocean and clouds inspired the Impressionists as much as the divided wheat fields; worked by the peasants and surrounded by uneven granite walls, the fields lent themselves to the development of cloisonnism and Synthetism.

Impressionism was the bond that united the Pont-Aven artists, from the early works of Gauguin to the unexpected late conversion of Lacombe. As a result of the intellectual-aesthetic influence upon one another and the impact of Brittany itself, the members of "Gauguin's gang" altered the nature of late Impressionism. As they shared the same experiences and explored the same sites, they produced, as a group, a body of work that for all its individual differences maintains its "Breton strength and power" a full century later. Gauguin's offhand comment "My work is the subject of many passionate debates" can now be seen as one of the great understatements in art history, for he and his companions from Pont-Aven went on to revolutionize early modern art.

Village of Pont-Aven. Postcard, c. 1900.

Henri Rivière, *Pont-Aven Harbor,* etching. Private collection, Paris.

ACKNOWLEDGMENTS

THE origin of this book can be traced back to the exhibition *The Impressionist Movement in the Pont-Aven School*, which I curated ten years ago for the Pont-Aven museum. This initial project led to seven years of research and many exciting discoveries of unpublished material, which culminated in the American edition of *Gauguin and the Impressionists at Pont-Aven*.

At this time I would like to underline the prominent role of the late Charles Durand-Ruel. His unceasing personal encouragement and interest during all those years, as well as his extraordinary archives, were invaluable to me.

I would also like to convey to his wife, Madeleine, all of my friendship and gratitude for her unfailing confidence.

Many thanks also to Daniel Wildenstein, Membre de l'Institut, for generously opening his archives to me in New York as well as in Paris.

François Daulte, who published the French editions and oversaw the long birth process of this book, was also very helpful in permitting me to consult his photographic archives. I am sincerely grateful to J. Carter Brown, director of the National Gallery of Art in Washington, D.C., for encouraging me to have the original French edition published in English.

My special thanks go to Abbeville Press. Mark Magowan's cooperation and patience reassured me during many trying times. Thanks also to Regina Kahney, Managing Editor, for her competence and supervision. Bernard Devigne of Lausanne, who followed this book from the first French edition to the present English version, deserves a special mention for his professionalism and his good humor.

Warm appreciation to Sophie Rosenfeld for her friendly contribution to the editing of the manuscript.

Many others participated in the realization of this project: collectors, curators, art historians, experts in different fields, as well as friends:

Mr. and Mrs. Arthur Altschul, New York.
Mr. and Mrs. John Anderson, Fort Lauderdale.
Madame Marie Amélie Anquetil,
Chief Curator of the Musée du Prieuré, Saint-Germain-en-Laye.
Madame Joëlle Ansieau, Paris.
Mr. J. C. Baillio of Wildenstein and Co., New York.
Monsieur Pierre Gaudibert,
Chief Curator of the Musée de Peinture et de Sculpture, Grenoble.
Maître Georges Blache, Versailles.
Maître Jean Edouard Bloch, Paris.
Maître Francis Briest, Paris.
Maître and Madame Eric Buffetaud, Paris.
Mademoiselle France Daguet of the Durand-Ruel Gallery, Paris.
Mr. Peter Davis, Virginia.
Monsieur Dominique Denis, Saint-Germain-en-Laye.
Monsieur and Madame Jean-Baptiste Denis, Paris.

Monsieur and Madame Jean-François Denis, Alençon.
Mademoiselle Claire Denis, Saint-Germain-en-Laye.
Mrs. J. Dudensing, New York.
Mrs. June Dunn Davis, Virginia.
Madame de Fèral, Paris.
Madame Martine Foltz-Lacombe, Moncontour.
Madame Alixe de Fontenay of the Fondation Wildenstein, Paris.
The Armand Hammer Foundation, Los Angeles.
Mrs. Ay Whang Hsia of Wildenstein and Co., New York.
Mr. and Mrs. Walter Horst, Chicago.
Mr. Johansson, Chief Curator of the Ny Carlsberg Glyptotek, Copenhagen.
Monsieur Samuel Josefowitz, Lausanne.
Professeur and Madame René Kuss, Paris.
Monsieur René Le Bihan, Chief Curator of the Musée des Beaux-Arts, Brest.
Mrs. Ellen Lee, Chief Curator of the Indianapolis Museum of Art.
Général and Madame Maldan-Lacombe, Versailles.
Mr. and Mrs. Paul Mellon, Upperville, Virginia.
Monsieur and Madame Pierre Mesguen, Nantes.
Monsieur and Madame Meurant, Pontoise.
Madame Véronique Mora, Paris.
Mr. and Mrs. Charles MacNeill, Toronto.
Dr. Jules Paressant, Nantes.
Madame Catherine Puget, Chief Curator of the Musée de Pont-Aven.
Monsieur and Madame Jean Pasteur, Paris.
Mademoiselle Odette du Puigaudeau, Morocco.
Monsieur and Madame Riener, Paris.
Mr. and Mrs. David Sellin, Washington, D.C.
Son Excellence Monsieur Etienne Manach,
Ambassadeur de France, Pont-Aven.
Mrs. Barbara Shapiro,
Curator of Prints at the Boston Museum of Fine Arts.
Mr. and Mrs. Smith-Harper, Palm Beach.
Monsieur Claude Souviron,
former Chief Curator of the Musée des Beaux-Arts, Nantes.
Mr. Michel Strauss,
Head of the Modern Painting Department at Sotheby's, London.
Mr. Brian Van der Horst, Paris.
Monsieur Villadier,
Chief Curator of the Musée Municipal, Meudon.
Monsieur and Madame de Wismes, Nantes.
Monsieur Rodolphe Walter of the Fondation Wildenstein, Paris.

My profound thanks to all of them for their constant help, cooperation, and support.

Selected Bibliography

NOTE TO THE READER

To keep this bibliography within acceptable limits, the author has not included all of her sources. The reader is therefore referred to the definitive bibliographies previously published on Impressionism, Post-Impressionism, and the Pont-Aven school in two works by John Rewald:

The History of Impressionism, fourth revised edition, 1980, Secker and Warburg, London, pp. 608-53.

Post-Impressionism: From van Gogh to Gauguin: third revised edition, 1978, The Museum of Modern Art, New York, pp. 513-72.

GENERAL REFERENCE WORKS

1905
GUSTAVE GEFFROY: *La Bretagne*, Hachette, Paris.

1921
PAUL SIGNAC: *D'Eugène Delacroix au Néo-Impressionnisme*, H. Floury, Paris.

1926
JAN VERKADE: *Le Tourment de Dieu*, Librairie de l'Art Catholique, Paris.

1947
GERMAIN BAZIN: *L'Epoque impressionniste*, Pierre Tisné, Paris.
CHARLES CHASSÉ: *Le Mouvement symboliste dans l'art du XIXe siècle*, H. Floury, Paris.

1949
Gauguin et ses amis, Galerie Kléber, Paris.

1960
Correspondance complète de Vincent van Gogh, Grasset-Gallimard, Paris.

1965
Neo-Impressionists and Nabis in the Collection of Mr. Arthur G. Altschul, Yale University Art Gallery, New Haven.

1966
JEAN-PAUL CRESPELLE: *Les Maîtres de la Belle-Epoque*, Hachette, Paris.
MICHEL CLAUDE JALARD: *Métamorphoses de l'Impressionnisme*, Rencontre, Lausanne.
JACQUES LASSAIGNE: *L'Impressionnisme*, Rencontre, Lausanne.
GÉRARD WHITE, DENIS SUTTON, RONALD PICKVANCE: *Gauguin and the Pont-Aven Group*, Tate Gallery, London.

1968
ROBERT L. HERBERT: *Neo-Impressionism*, The Solomon R. Guggenheim Museum, New York.
L'Aube du XXe siècle, de Renoir à Chagall, Musée du Petit-Palais, Geneva.

1971
JEAN CLAY: *L'Impressionnisme*, Hachette, Paris.
WLADISLAWA JAWORSKA: *Gauguin et l'école de Pont-Aven*, Bibliothèque des Arts, Paris.
ROBERT WALLACE: *The World of van Gogh, 1853–1890*, Time-Life Books, New York.

1972
EDWARD LUCIE-SMITH: *Symbolist Art*, Oxford University Press, New York.
CAMILLE PISSARRO: *Letters to His Son Lucien*, edited with the assistance of Lucien Pissarro by John Rewald, Paul Appel, Mamaroneck, N.Y.

1973
PHILIPPE JULLIAN: *The Symbolists*, Phaidon, Oxford.

1974
COLTA FELLER IVES: *The Great Wave*, Metropolitan Museum of Art, New York.
MAURICE SERULLAZ: *Encyclopédie de l'Impressionnisme*, Somogy, Paris.
Catalogue du Musée de Brest.

1975
PHILLIP DENNIS CATE: *Japonism: Japanese Influence on French Art, 1854–1910*, Jane Voorhees Zimmerli Art Museum, Rutgers University, New Brunswick.

1976
Rodolphe Salis et le chat noir: Châtellerault exhibition at the town hall.

1977
DENISE DELOUCHE: *Les Peintres de la Bretagne*, Librairie Klincksieck, Paris.
CHARLES-GUY LE PAUL: *Henri Rivière en Bretagne*, Musée de Pont-Aven.
Le Post-Impressionnisme, Palais de Tokyo, Paris.

1978
P. M. DORAN: *Conversations avec Cézanne*, Macula, Paris.
L'École de Pont-Aven à travers les collections publiques et privées de Bretagne, Quimper, Rennes, and Nantes museums.
Bulletin des Amis du Musée de Rennes, numéro spécial: Pont-Aven, no. 2 (Summer).

1979
Post-Impressionism in Europe, Royal Academy of Arts, London.

1980
HENRI DORA: "Excerpts from the Correspondence of Emile Bernard from the Beginning to the Rose-Croix Exhibition (1876–1892)," *Gazette des Beaux-Arts*, vol. 96 (December 1980), pp. 235-42.
RICHARD STUART FIELD: *The Prints of Armand Séguin*, Davison Art Center, Wesleyan University, Middletown, Connecticut.

1981
HÉLÈNE ADHÉMAR: *Chronologie impressionniste, 1863–1905*, Editions de la Réunion des Musées Nationaux, Paris.
JEAN-PAUL CRESPELLE: *La Vie quotidienne des Impressionnistes: Du Salon des Refusés (1863) à la mort de Manet (1883)*, Hachette, Paris.
CHRISTOPHER LLOYD: *Camille Pissarro*, Skira, Geneva.
BOGOMILLA WELSH OUCHAROV: *Vincent van Gogh and the Birth of Cloisonnism*, Art Gallery of Ontario, Toronto.
DAVID SELLIN: *Americans in Brittany and Normandy, 1860–1910*, Phoenix Art Museum.

1983
ELLEN W. LEE: *The Aura of Neo-Impressionism: The W. J. Holliday Collection*, Indianapolis Museum of Art.

1984
RICHARD R. BRETTELL: *A Day in the Country: Impressionism and the French Landscape*, Los Angeles County Museum of Art.

1985
Le Chemin de Gauguin, genèse et rayonnement, Musée Départemental du Prieuré, Saint-Germain-en-Laye.
L'Ecole de Pont-Aven, aquarelles, pastels, dessins, objets, Musée de Pont-Aven.

Exposition du Pointillisme, National Museum of Western Art, Tokyo.

1986

Cent Ans, Gauguin à Pont-Aven, Musée de Pont-Aven.
The New Painting: Impressionism, 1874–1886, The Fine Arts Museums of San Francisco.
Pont-Aven et ses peintres à propos d'un centenaire, Arts de l'Ouest, Rennes University, Rennes.

1987

CAROLINE BOYLE TURNER: *The Prints of the Pont-Aven School: Gauguin and His Circle in Brittany*, 2nd ed., Abbeville Press, New York.

PONT-AVEN

1836

CAMBRY: *Voyage dans le Finistère, ou état de ce département en 1794*, Paris; republished 1979.

1869

MRS. BURY PALLISER: *Brittany and Its Byways*, London.

1870

REVEREND G. MUSGRAVE: *A Ramble in Brittany*, London.

1877

BETHAM EDWARDS: *A Year in Western France*, London.

1880

HENRY BLACKBURN: *Breton Folk, An Artistic Tour in Brittany*, London.

1880–1900

"*Comptes-rendus des délibérations du conseil municipal de Pont-Aven,*" manuscripts, Pont-Aven, Municipal Archives.

1899

G. W. EDWARDS: *Brittany and the Bretons*, London.
A. S. HARTRICK: *A Painter's Pilgrimage Through 50 Years*, Cambridge, England.

1901

S. BARING-GOULD: *A Book of Brittany*, London.

1905

F. MILTOUR: *Rambles in Brittany*, London.

1912

E. DAVIES: *Off Beaten Tracks in Brittany*, London.

1913

L. RICHARDSON: *Vagabond Days in Brittany*, London.
C. R. WELD: *A Vacation in Brittany*, London.

1919

A. DOUGLAS SEDWICK: *A Childhood in Brittany, Eighty Years Ago*, London.

1928

LÉON TUAL: *Julia Guillou, la bonne hôtesse*, Imprimerie Le Tendre, Concarneau.
LÉON TUAL: *Mademoiselle Julia Guillou de Pont-Aven*, Imprimerie Le Tendre, Concarneau.

1973

PIERRE TUARZE: *Pont-Aven, art et artistes*, La Pensée Universelle, Paris.

1980

BERTRAND QUEINNEC: *La Révolution à Pont-Aven, 1789–1800*, published by the author.

1986

RENÉ LE BIHAN: *Mémoire de Pont-Aven 1860–1940*, Société de Peinture de Pont-Aven.

PAUL GAUGUIN

1921

CHARLES CHASSÉ: *Gauguin et le groupe de Pont-Aven*, H. Floury, Paris.

1925

JEAN DE ROTONCHAMP: *Paul Gauguin*, Crès Editions, Paris.

1930

F. COSSIO DEL POMAR: *Arte y vida de Pablo Gauguin*, Léon Sanchez Cuesta, Madrid.

1946

MAURICE MALINGUE, ED.: *Lettres de Paul Gauguin à sa femme et à ses amis*, Grasset, Paris.

1949

JEAN LEYMARIE, RENÉ HUYGHE: *Gauguin, exposition du centenaire*, Musée de l'Orangerie, Paris.

1953

CHARLES ESTIENNE: *Gauguin*, Skira, Geneva.

1955

CHARLES CHASSÉ: *Gauguin et son temps*, Bibliothèque des Arts, Paris.

1958

GEORGES WILDENSTEIN, ED.: *Gauguin, sa vie, son œuvre, réunion de textes, d'études et de documents*, Presses Universitaires de France, Paris.

1960

JEAN LEYMARIE: *Paul Gauguin, aquarelles, pastels et dessins en couleurs*, Phoebus, Basel.

1961

RENÉ HUYGHE et Cie.: *Gauguin*, Hachette, Paris.

1962

RAYMOND COGNIAT and JOHN REWALD: *Paul Gauguin: A Sketchbook (Carnet de Bretagne, 1884–1888)*, Hammer Galleries, New York.

1964

GEORGES WILDENSTEIN and RAYMOND COGNIAT: *Paul Gauguin, catalogue raisonné*, Beaux-Arts, Paris.

1966

PATRICK O'REILLY: *Catalogue du Musée Gauguin, Tahiti*, Fondation Singer-Polignac, Paris.

1967

RENÉ HUYGHE: *Gauguin*, Flammarion, Paris.

1973

GEORGES WILDENSTEIN and RAYMOND COGNIAT: *Gauguin*, Thames and Hudson, London.

1975

PIERRE LEPROHON: *Paul Gauguin*, Gründ, Paris.

1980

GABRIEL P. WEISBERG: "Vestiges of the Past: The Brittany 'Pardons' of Late Nineteenth-Century French Painters," *Arts Magazine*, vol. 55, no. 3 (November 1980), pp. 134-38.
SUSAN WISE: *Paul Gauguin: His Life and His Paintings*, The Art Institute of Chicago.

1981

YVES BRAYER: *Gauguin et les chefs-d'œuvre de l'Ordupgaard de Copenhague*, Musée Marmottan, Paris.

1984

VICTOR MERLHÈS: *Correspondance de Paul Gauguin 1873–1888*, Fondation Singer-Polignac, Paris.

No date

EMILE BERNARD: *Souvenirs inédits sur l'artiste-peintre Paul Gauguin et ses compagnons*, Imprimerie du Nouvelliste du Morbihan, Lorient.

EMILE BERNARD

1893

EMILE BERNARD: "Inventaire de mes toiles fait le 17 mars 1893, avant de partir en Italie" (116 items), unpublished manuscript. Private collection.

1901

EMILE BERNARD: "Inventaire des toiles en atelier le 1 juin 1901 et en ma possession" (100 items), unpublished manuscript. Private collection.
EMILE BERNARD: "Inventaire des toiles vendues à Monsieur Vollard, le 22 mai 1901" (127 items), unpublished manuscript. Private collection.

1911

Lettres de van Gogh à Emile Bernard, Ambroise Vollard, Paris.

1946

A. MEYERSON: "Van Gogh and the School of Pont-Aven," *Konsthistorisk Tidskrift*, Stockholm.

1954

MICHEL-ANGE BERNARD-FORT: *Lettres de Paul Gauguin à Emile Bernard 1888–1891*, Pierre Cailler, Geneva.

1957

PIERRE MORNAND: *Emile Bernard et ses amis*, Pierre Cailler, Geneva.

1968

Emile Bernard, exposition du centenaire, Musée de Pont-Aven.
Emile Bernard, Göteborg Kunstmuseum.

1974

JEAN-JACQUES LUTHI: *Emile Bernard, l'initiateur*, Caractères, Paris.

No date

JEAN-JACQUES LUTHI: *Emile Bernard, chef de l'école de Pont-Aven*, Nouvelles Editions Latines, Paris.

CLAUDE EMILE SCHUFFENECKER

1886–1932

Unpublished manuscripts and photographs. Horst Collection, Chicago.

1896

Catalogue de l'exposition Emile Schuffenecker, Librairie de l'Art Indépendant, Paris.

1934

CHARLES KUNSTLER: Emile Schuffenecker, "*L'Intransigeant*," February 14.

1935

MAURICE BOUDOT-LAMOTTE: "Le Peintre et collectionneur Emile Schuffenecker," *L'amour de l'art*.
EDMOND CAMPAGNAC: "Paul Gauguin et Emile Schuffenecker," *Le Matin*, February 10.
ERNEST DEVERIN: "Un ami de Gauguin: Schuffenecker," *Les Marges*, vol. 125.

1944

MARCEL GAUTIER: *Un méconnu, Emile Schuffenecker*, Galerie Berri-Raspail, Paris.

1963

JACQUES FOUQUET: *Emile Schuffenecker, 60 pastels, 40 dessins*, Galerie Les Deux-Iles, Paris.

1964

GERMAIN VIATTE: "Nouvelles acquisitions," *Revue du Louvre*, nos. 4–5.

1970

Emile Schuffenecker, Hirschl and Adler Galleries, New York.

1973

PHILIPPE JULLIAN: *The Symbolists*, Phaidon, London.

1975

PIERRE LEPROHON: *Paul Gauguin*, Gründ, Paris.

1977

Claude-Emile Schuffenecker and the School of Pont-Aven, Norman Mackenzie Art Gallery, Regina, Saskatchewan, Canada.

1978

CHARLES-GUY LE PAUL and G. DUDENSING: "Gauguin et Schuffenecker," *Bulletin des Amis du Musée de Rennes, numéro spécial: Pont-Aven*, no. 2.

1980

JILL ELYSE GROSSVOGEL: *Claude Emile Schuffenecker, 1851–1934*, University Art Gallery, State University of New York, Binghamton.

PIERRE AUGUSTE RENOIR

1918

AMBROISE VOLLARD: *Tableaux, pastels et dessins de Renoir*, 2 vols., Vollard, Paris.

1931

L'Atelier de Renoir, 2 vols., Galerie Bernheim-Jeune, Paris.

1939

LIONELLO VENTURI: *Les Archives de l'Impressionnisme*, 2 vols., Durand-Ruel, Paris.

1969

FRANÇOIS FOSCA: *Renoir: His Life and Work*, Praeger, New York.

1971

FRANÇOIS DAULTE: *Catalogue raisonné de l'œuvre peint de Renoir, 1860–1890*, vol. 1, illustrations, Durand-Ruel, Lausanne.

1974

FRANÇOIS DAULTE: *Auguste Renoir*, Fabbri, Milan.

1981
JEAN RENOIR: *Pierre Auguste Renoir, mon père*, Gallimard, Paris.

For a full bibliography on Renoir consult François Daulte: *Catalogue raisonné...*, vol. 1. (See 1971, above.)

CLAUDE MONET

1922
GUSTAVE GEFFROY: *Claude Monet, sa vie, son temps, son œuvre*, Crès, Paris.

1979
DANIEL WILDENSTEIN: *Claude Monet: biographie et catalogue raisonné*, vol. 2, Bibliothèque des Arts, Paris.

1980
Hommage à Claude Monet, Musée du Grand-Palais, Paris.
DENISE DELOUCHE: "Monet et Belle-Ile, en 1886," *Bulletin des Amis du Musée de Rennes*, no. 4, pp. 27–55.

For a full bibliography on Claude Monet, consult Daniel Wildenstein: *Claude Monet, biographie et catalogue raisonné*, vols. 1–4. (See 1979, above.)

MAXIME MAUFRA

1888
ALEXANDRE MAILLARD: *L'Art à Nantes*, Monnier, Paris.

1894
FRANCIS JOURDAN: *Exposition Maufra*, Galerie Le Barc de Boutteville, Paris.

1908
VICTOR EMILE MICHELET: *Maufra, peintre et graveur*, H. Floury, Paris.

1926
ARSÈNE ALEXANDRE: *Maxime Maufra, peintre marin et rustique*, Georges Petit, Paris.
EDOUARD SARRADIN: *Maufra*, L'Art et les artistes, Paris.

1941
GEORGES TURPIN: "Les Gravures de Maxime Maufra," *Beaux-Arts Magazine*, nos. 36–37.

1960
JULIEN LANOË: *Maxime Maufra — Emile Dezaunay*, Musée de Nantes.

1974
Moret — Maufra, Musée de Pont-Aven.

1975
JEANINE WARNOD: *Le Bateau-Lavoir*, Presses de la Connaissance, Paris.

1978
MAXIME MAUFRA: *Souvenirs de Pont-Aven et du Pouldu*: "Comment je connus Paul Gauguin," *Bulletin des Amis du Musée de Rennes, numéro spécial: Pont-Aven*, no. 2, (Summer).
Maxime Maufra, Galerie Art Mel, Paris.

1986
DANIEL MORANE: *Maxime Maufra, catalogue raisonné de l'œuvre gravé*, Musée de Pont-Aven.
Maxime Maufra, Musée du Prieuré, Saint-Germain-en-Laye.

GUSTAVE LOISEAU

1872-1935
"Documents inédits, Archives familiales," Meurant collection, Pontoise.

1930
THIÉBAULT-SISSON: *Gustave Loiseau*, Georges Petit, Paris.

1964
Gustave Loiseau, Musée de Pont-Aven.

1975
MADY EPSTEIN: "Gustave Loiseau," *Vision sur les arts*, Béziers.

1978
JEAN MELIAS KYRIAZI: *Gustave Loiseau, historiographe de la Seine*, Bibliothèque des Arts, Paris.

1981
Gustave Loiseau, Musée Pissarro, Pontoise.

1985
Rétrospective Gustave Loiseau, 1865–1935, Didier Imbert Fine Art, Paris.

HENRY MORET

1904
CAMILLE MAUCLAIR: *L'Impressionnisme*, Librairie de l'Art Ancien et Nouveau, Paris.

1913
HENRY EON: *Henry Moret, discours des funérailles*, Imprimerie Durand, Chartres.

1923
CAMILLE MAUCLAIR: *Les Maîtres de l'Impressionnisme*, Librairie Ollendorf, Paris.

1933
HENRY EON: *Henry Moret*, Revue du Morbihan, Lorient, January 1.

1937
RENÉ MAURICE: "Henry Moret," *Le Nouvelliste du Morbihan*, Lorient, August 20.
RENÉ MAURICE: "Le Souvenir d'Henry Moret," *Le Nouvelliste du Morbihan*, Lorient, March 24–25.

1973
FRANCE DAGUET: *Henry Moret*, Galerie Durand-Ruel, Paris.

MAURICE DENIS

1912
MAURICE DENIS: *Théories*, Bibliothèque de l'Occident, Paris.

1942
MAURICE DENIS: *Paul Sérusier, sa vie, son œuvre*, Floury, Paris.

1945
SUZANNE BARAZZETTI: *Maurice Denis*, Grasset, Paris.

1957
MAURICE DENIS: *Journal*, 3 vols., Vieux-Colombier, Paris.

1963
Exposition Maurice Denis, Musée Toulouse-Lautrec, Albi.

1966
Maurice Denis illustrateur, Musée des Beaux-Arts, Tours.

1968
Catalogue raisonné de l'œuvre gravé et lithographié de Maurice Denis, Pierre Cailler, Geneva.

1970
ANTOINE TERRASSE: *Denis*, Bibliothèque des Arts, Paris.
Catalogue de l'exposition Maurice Denis, Orangerie des Tuileries, Paris.

1979
CHARLES-GUY LE PAUL: "Maurice Denis, l'inspiration et la vision bretonne," *L'Œil*, July–August.
JUDY and CHARLES-GUY LE PAUL: *Maurice Denis*, Musée de Pont-Aven.

1981
Symbolistes et Nabis, Maurice Denis et son temps, Musée du Prieuré, Saint-Germain-en-Laye.

1985
Maurice Denis, 1870–1943, Musée des Beaux-Arts, Alençon.
Maurice Denis et la Bretagne, Musée de Morlaix.

GEORGES LACOMBE

1954
AGNÈS HUMBERT: *Les Nabis et leur époque*, Pierre Cailler, Geneva.

1955
GEORGES TOUDOUZE: *La Communauté artistique de Camaret*, Les Cahiers de l'Iroise, Brest.

1968
WILLIAM STEADMAN: *Homage to Seurat: The Holliday Collection at the University of Arizona*. University of Arizona Art Gallery, Tucson.

1975
Georges Lacombe Drawings, Shepherd Gallery, New York.

1978
JOËLLE ANSIEAU: "Georges Lacombe," *Bulletin des Amis du Musée de Rennes, numéro spécial: Pont-Aven*, no. 2 (Summer).

1983
ELLEN W. LEE: *The Aura of Neo-Impressionism: The W. J. Holliday Collection*, Indianapolis Museum of Art.

1984
Georges Lacombe 1868–1916, Musée Lambinet, Versailles.

HENRI DELAVALLEE

1941
GABRIELLE SAVIGNY DELAVALLÉE: *Catalogue de l'exposition Henri Delavallée*, Galerie Saluden, Quimper.

1966
HENRI PERRUCHOT: "La Période héroïque des Indépendants," *Jardin des Arts*, vol. 137 (April 1966), pp. 38–45.

1967
PIERRE TUARZE: "Le Peintre H. Delavallée," *Ouest-France* newspaper, Rennes, September 12.

1970
JEAN SUTTER: *Les Néo-impressionnistes*, Bibliothèque des Arts, Paris.

1975
Henri Delavallée, Musée de Pont-Aven.

1983
ELLEN W. LEE: *The Aura of Neo-Impressionism: The W. J. Holliday Collection*, Indianapolis Museum of Art.

FERDINAND LOYEN DU PUIGAUDEAU

1883–1930
Unpublished manuscripts and photographs, Odette du Puigaudeau Archives.

1968
WILLIAM STEADMAN: *Homage to Seurat: The Holliday Collection at the University of Arizona*, University of Arizona Art Gallery, Tucson.

1983
ELLEN W. LEE: *The Aura of Neo-Impressionism: The W. J. Holliday Collection*, Indianapolis Museum of Art.

ERNEST PONTHIER DE CHAMAILLARD

1901
ARSÈNE ALEXANDRE: *Exposition Chamaillard*, Galerie Bernheim-Jeune, Paris.
F. FAGUS: "Un Meuble de Chamaillard," *La Revue blanche*, vol. 182.
CHARLES MORICE: "Chamaillard," *Mercure de France*, August.

1906
MAURICE GUILLEMOT: "Exposition Chamaillard," *Mercure de France*, June.

1910
"Exposition Chamaillard à la Galerie Bernheim-Jeune," *L'Art et les artistes*, December.

1925
ANDRÉ SALMON: "Chamaillard et le groupe de Pont-Aven," *L'Art vivant*, July.

1930
Exposition Chamaillard, Galerie Georges Petit, Paris.

1932
ANDRÉ SALMON: "L'Ecole de Pont-Aven, à l'occasion de la mort de Chamaillard," *L'Art d'aujourd'hui*, vol. 1, pp. 98–116, 280–300.

1969
ANDRÉ SALMON: *Souvenirs sans fin*, vol. 2, Gallimard, Paris.

1978
OLIVIER LE BIHAN: "Chamaillard et le groupe de Pont-Aven," *Bulletin des Amis du Musée de Rennes, numéro spécial: Pont-Aven*, no. 2 (Summer).

1979
OLIVIER LE BIHAN: "Chamaillard après Pont-Aven," *Arts de l'ouest, études et documents*, Rennes University, pp. 30–39.

INDEX

PHOTOGRAPHY CREDITS

Unless otherwise indicated, all the postcards and old photographs
reproduced in this book are from the author's archives.
Archives Georges Blache, Versailles
Archives Durand-Ruel, Paris
J. Bocoyran, Brest
Bibliothèque des Arts, Lausanne
Dominique M. Denis, Paris
Armand Hammer Foundation, Los Angeles
Fondation Wildenstein, Paris
Galerie des Granges, Geneva
Museum of Western Art, Tokyo
Musée des Beaux-Arts, Nantes
Musée Municipal de Meudon
Musée de Peinture et de Sculpture, Grenoble
Musée du Petit-Palais, Geneva
National Gallery of Art, Washington, D.C.
Ny Carlsberg Glyptotek, Copenhagen
Luc Robin, Pont-Aven
David Sellin, Washington, D.C.
Studio Ifot, Grenoble
Studio Lourmel (Georges Routhier), Paris

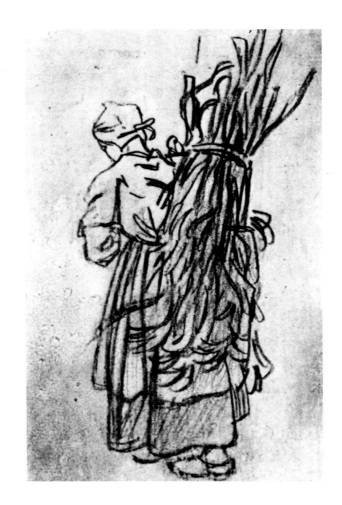